# Portraiture

# Oxford History of Art

Shearer West is Professor of Art History at the University of Birmingham. Her publications include *The Image of the Actor: Verbal and Visual Representation in the Age of Garrick and Kemble*, *Fin de Siècle: Art and Society in an Age of Uncertainty*, *The Visual Arts in Germany 1890–1940*, and the edited books *Visions of the 'neue Frau': Women and the Visual Arts in Weimar Germany* (with Marsha Meskimmon), *The Bloomsbury Guide to Art*, *The Victorians and Race*, and *Italian Culture in Northern Europe in the Eighteenth Century*.

# Oxford History of Art

Titles in the Oxford History of Art series are up-to-date, fully illustrated introductions to a wide variety of subjects written by leading experts in their field. They will appear regularly, building into an interlocking and comprehensive series. In the list below, published titles appear in bold.

## WESTERN ART

**Archaic and Classical Greek Art**
Robin Osborne

**Classical Art From Greece to Rome**
Mary Beard &
John Henderson

**Imperial Rome and Christian Triumph**
Jas Elsner

**Early Medieval Art**
Lawrence Nees

**Medieval Art**
Veronica Sekules

**Art in Renaissance Italy**
Evelyn Welch

Northern European Art
Susie Nash

Early Modern Art
Nigel Llewellyn

**Art in Europe 1700–1830**
Matthew Craske

**Modern Art 1851–1929**
Richard Brettell

**After Modern Art 1945–2000**
David Hopkins

Contemporary Art

## WESTERN ARCHITECTURE

Greek Architecture
David Small

Roman Architecture
Janet Delaine

**Early Medieval Architecture**
Roger Stalley

**Medieval Architecture**
Nicola Coldstream

Renaissance Architecture
Christy Anderson

Baroque and Rococo Architecture
Hilary Ballon

**European Architecture 1750–1890**
Barry Bergdoll

Modern Architecture
Alan Colquhoun

Contemporary Architecture
Anthony Vidler

**Architecture in the United States**
Dell Upton

## WORLD ART

**Aegean Art and Architecture**
Donald Preziosi &
Louise Hitchcock

**Early Art and Architecture of Africa**
Peter Garlake

African Art
John Picton

**Contemporary African Art**
Olu Oguibe

**African-American Art**
Sharon F. Patton

**Nineteenth-Century American Art**
Barbara Groseclose

**Twentieth-Century American Art**
Erika Doss

**Australian Art**
Andrew Sayers

**Byzantine Art**
Robin Cormack

**Art in China**
Craig Clunas

East European Art
Jeremy Howard

Ancient Egyptian Art
Marianne Eaton-Krauss

**Indian Art**
Partha Mitter

Islamic Art
Irene Bierman

Japanese Art
Karen Brock

Melanesian Art
Michael O'Hanlon

Mesoamerican Art
Cecelia Klein

**Native North American Art**
Janet Berlo & Ruth Phillips

Polynesian and Micronesian Art
Adrienne Kaeppler

South-East Asian Art
John Guy

Latin American Art

## WESTERN DESIGN

**Twentieth-Century Design**
Jonathan Woodham

American Design
Jeffrey Meikle

Nineteenth-Century Design
Gillian Naylor

**Fashion**
Christopher Breward

## PHOTOGRAPHY

**The Photograph**
Graham Clarke

**American Photography**
Miles Orvell

Contemporary Photography

## WESTERN SCULPTURE

**Sculpture 1900–1945**
Penelope Curtis

**Sculpture Since 1945**
Andrew Causey

## THEMES AND GENRES

**Landscape and Western Art**
Malcolm Andrews

**Portraiture**
Shearer West

Eroticism and Art
Alyce Mahon

Beauty and Art
Elizabeth Prettejohn

Women in Art

## REFERENCE BOOKS

**The Art of Art History: A Critical Anthology**
Donald Preziosi (ed.)

Oxford History of Art

# Portraiture

Shearer West

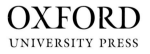
OXFORD

UNIVERSITY PRESS

# OXFORD
UNIVERSITY PRESS

Great Clarendon Street, Oxford OX2 6DP

Oxford  New York

Auckland  Bangkok  Buenos Aires  Cape Town
Chennai  Dar es Salaam  Delhi  Hong Kong  Istanbul  Karachi
Kolkata  Kuala Lumpur  Madrid  Melbourne  Mexico City  Mumbai
Nairobi  São Paulo  Shanghai  Taipei  Tokyo  Toronto
and associated companies in Berlin  Ibadan

Oxford is a registered trade mark of Oxford University Press
in the UK and in certain other countries

10  9  8  7

British Library Cataloguing in Publication Data
Data available

ISBN 978-0-19-284258-9

Picture research by Elisabeth Agate
Copy-editing, typesetting, and production management by
The Running Head Limited, Cambridge, www.therunninghead.com
Printed in China on acid-free paper by C&C Offset Printing Co. Ltd

# Contents

| | Acknowledgements | 7 |
|---|---|---|
| | Introduction | 9 |
| Chapter 1 | What Is a Portrait? | 21 |
| Chapter 2 | The Functions of Portraiture | 43 |
| Chapter 3 | Power and Status | 71 |
| Chapter 4 | Group Portraiture | 105 |
| Chapter 5 | The Stages of Life | 131 |
| Chapter 6 | Gender and Portraiture | 145 |
| Chapter 7 | Self-portraiture | 163 |
| Chapter 8 | Portraiture and Modernism | 187 |
| Chapter 9 | Identities | 205 |
| | Notes | 221 |
| | Annotated Bibliography | 227 |
| | Timeline | 236 |

**Websites**      **242**

**List of Illustrations**      **243**

**Index**      **249**

# Acknowledgements

More people than I can name helped me in some way with this book, and I owe an immense debt to the many friends and colleagues whose books and articles on portraiture I cite in the bibliography. However, I would like to single out the production team at Oxford University Press, especially Lisa Agate and David Williams, who were both cheerful and indefatigable in their work. I would also like to thank the anonymous reader who gave a bruising but astute critique on a much earlier draft. I benefited enormously from the reader's extensive suggestions, but take full responsibility for the problems that remain. As always, my husband Nick and daughter Eleanor saw me through the pockets of stress that accompanied the writing of this book and helped make it a pleasurable experience. Finally, I would like to dedicate this book to my mother, who has always been there for me when I've needed her.

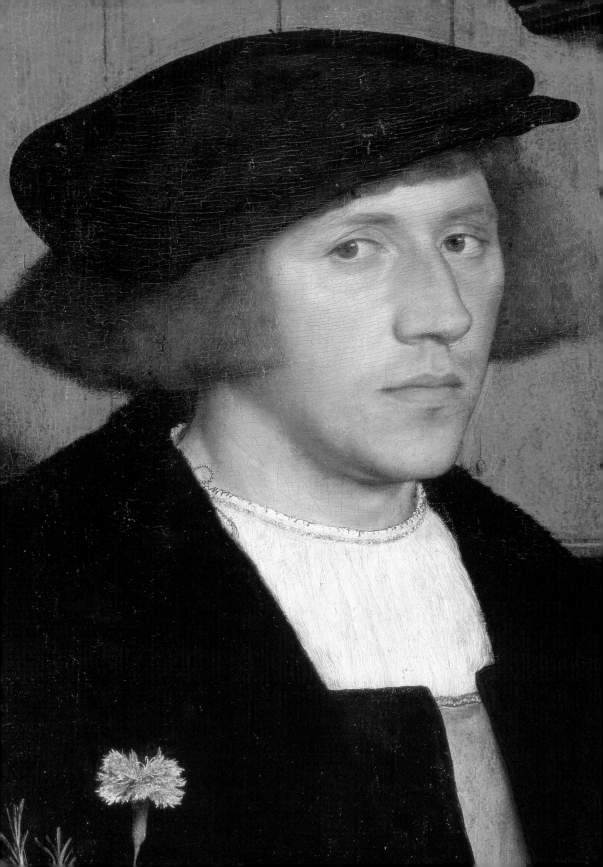

# Introduction

Hans Holbein the Younger's portrait of George Gisze [1] depicts a member of the Steelyard, a group of German merchants who represented the Hanseatic League in London during the reign of Henry VIII. What we can see in this portrait is a man with a sombre expression, gazing out of the picture but past the viewer, wearing a well-made but unornamented costume and a plain flat cap. Gisze is surrounded by objects: the table, covered with a patterned cloth, is littered with account books, quill pens, and money boxes; the shelves are cluttered with instruments of measurement and cartography. The effect of Gisze's workroom is paradoxical: it is chaotic, yet claustrophobic; a utilitarian space decorated with an incongruous (and precariously placed) flower in a glass vase. The setting and accoutrements in the room are painstakingly delineated, with the textured effects of the thick tablecloth contrasting with the grain of the wooden walls, the sheen of Gisze's sleeve, the feathery waves of his hair, the copper and brass boxes, and the delicate glass of the vase. The subtle crafting of the detail contrasts with the lack of attention to laws of perspective. The room seems to exist in an unreal space, and the profile of Gisze's face is tilted at an impossible angle, allowing us to see the whole visage, rather than only a part of it. The pieces of paper that are seemingly left casually about the room contain legible writing. Several of them repeat Gisze's name, including the letter in his hand addressed 'to the excellent Gisze, in London, England'. An inscription on the back wall, written in a mixture of Greek and Latin, translates, 'The countenance which you perceive is an accurate image of Gisze', and it gives his age as 34, and the year of the portrait as 1532.[1] In contrast to this documentary reference, another inscription, apparently carved on the wall itself behind Gisze's left shoulder, is more oblique. It reads: 'Nulla sine merore voluptas' ('No pleasure without sorrow'). This motto is signed by Gisze himself.

Holbein's portrait of Gisze gives the effect of providing a definitive image of a specific sixteenth-century London merchant in his workplace. We can gauge some idea of Gisze's work from these objects: they suggest that he was literate and numerate, that he was busy and prosperous, and that he conducted his business beyond the confines of England. But even a cursory examination of the portrait provokes more

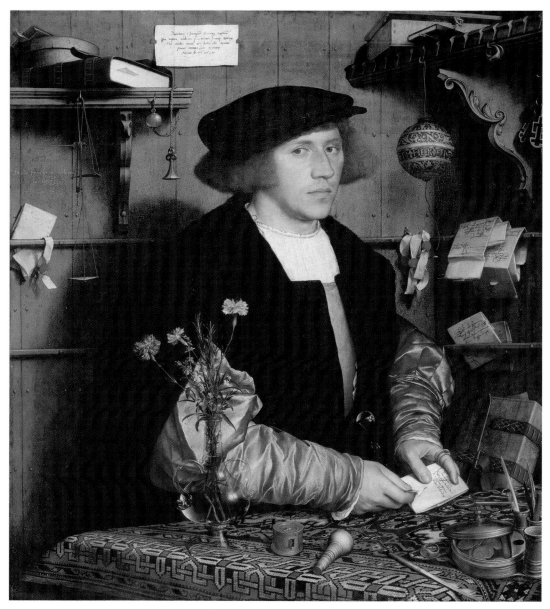

questions than it answers. Why did Holbein paint this particular mer-
chant? To what extent is this representation faithful to the sitter's
likeness? Why use such a chaotic profusion of objects, when a simple set
of scales and account books would have been ample to signal his trade?
What do the tags on the wall signify? What was Gisze like—are we to
see his character as melancholy or arrogant, neither, or both? What
appears at first to be a virtuosic exercise in the representation of objects
dissolves into ambiguity when we take into account the enigmatic
demeanour of Gisze, the cluttered and oppressive surroundings, and

**1 Hans Holbein the Younger**

*George Gisze*, 1532

Although associated with Basel, Holbein came to England twice—in 1526–8 and again in 1532—and both times he specialized in painting portraits. During his first trip he gained the patronage of Thomas More and members of his circle. On his second visit he began by producing portraits of German merchants, but soon came to the attention of Henry VIII. This was one of Holbein's first London portraits during his visit in 1532. Gisze was a merchant who was a member of the Steelyard—the Hanseatic League in London.

the conspicuous reminder that life is filled with sorrow. Holbein's portrait of Gisze seems to evoke the literalism of a specific person in a specific time, but its indeterminacy engages the imagination and prevents a closed and definitive interpretation.

Holbein was an exceptionally skilled portraitist, but the tensions and ambiguities apparent in the portrait of Gisze hold true for most portraits. The *Oxford English Dictionary* defines portraiture as 'a representation or delineation of a person, especially of the face, made from life, by drawing, painting, photography, engraving, etc.; a likeness'. Other semantic roots of the term attach it to the idea of likeness: for example, the Italian word for portrait, *ritratto*, comes from the verb *ritrarre*, meaning both 'to portray' and 'to copy or reproduce'. However, this simple definition belies the complexities of portraiture. Portraits are not just likenesses but works of art that engage with ideas of identity as they are perceived, represented, and understood in different times and places. 'Identity' can encompass the character, personality, social standing, relationships, profession, age, and gender of the portrait subject. These qualities are not fixed but are expressive of the expectations and circumstances of the time when the portrait was made. These aspects of identity cannot be reproduced, but they can only be suggested or evoked. Thus although portraits depict individuals, it is often the typical or conventional—rather than unique—qualities of the subject that are stressed by the artist, as demonstrated in Holbein's *George Gisze*. Portraiture has also been subject to major changes in artistic practice and convention. Even though most portraits retain some degree of verisimilitude, they are nonetheless products of prevailing artistic fashions and favoured styles, techniques, and media. Portraiture is thus a vast art category that offers a rich range of engagements with social, psychological, and artistic practices and expectations.

Portraits are worthy of separate study because they are distinct from other genres or art categories in the ways they are produced, the nature of what they represent, and how they function as objects of use and display. First of all, in terms of their production, portraits nearly always require the presence of a specific person, or at the very least an image of that person. Although not universally the case, the production of portraiture has typically involved sittings requiring a direct involvement between the artist and subject(s) during the process of making the work of art. In the case of sitters who were too important or too busy to undertake frequent visits to an artist's studio, portraitists could use sketches or photographs of their subject. In seventeenth- and eighteenth-century Europe, portraitists could reduce the number of sittings by concentrating solely on the head and employing professional drapery painters to complete the work. The English artist Sir Peter Lely, for example, had a pattern book of poses that enabled him to focus on the head and require fewer sittings from his aristocratic

patrons. Portraitists could be asked to provide likenesses of individuals who were deceased, as, for example, with portraits of children before the twentieth century—many of whom died before a portrait commission was completed. In such cases, prints or photographs of the model could be copied. Portraitists could in principle rely on memory or impression in producing their work, but documented examples of such cases are rare. However, whether they based their work on sittings, copying another likeness, or memory only, the practice of portraiture is closely connected with the implicit or explicit presence of the sitter.

Portraiture can also be distinguished from other art categories such as history, landscape, and still life by its relationship with likeness. All portraits show a distorted, ideal, or partial view of the sitter, but portraiture as a genre is historically tied to the idea of mimesis, or likeness. Portraiture's putative association with copying and imitation has often caused the art form to be dismissed or to suffer from a low status. An emphasis on the need for the creative artist to invent and represent ideal images lingered from Renaissance art theory to the early nineteenth century and served to relegate portraiture to the level of a mechanical exercise, rather than a fine art. Michelangelo's famous protest that he would not paint portraits because there were not enough ideally beautiful models[2] is only one example of a dismissive attitude to portraiture that persisted among professional artists—even those who, ironically, made their living from portraiture. The tendency to undermine the practice of portraiture prevailed in the period of modernism in the nineteenth and twentieth centuries, when the rhetoric of avant-garde experimentation led to a valuing of abstraction over mimesis. However, such artists, from many different countries, continued to practise portraiture—despite their theoretical objections. For example, Picasso built his early reputation on Cubist still-life painting, but some of his most effective early experiments in this new style were his portraits of the art dealers, such as Daniel-Henry Kahnweiler [2]. Picasso has provided enough detail in this portrait to distinguish the features of his sitter. Unlike some of his other Cubist works, such as his many still lifes, the subject here remains legible and distinctive, despite the fragmentation of the form of the face.

The low status of the mimetic art of portraiture was belied in other ways. When the French Royal Academy codified a hierarchy of artistic genres in the seventeenth century, portraiture was placed second after history painting. The idea here was that portraits should represent only the most important people and/or those who had distinguished themselves by virtue or heroism, so portraiture was considered to be an alternative to history painting in providing models of emulation for the spectator. The disdain for portraiture that seemed to accompany early twentieth-century abstraction was transformed to fascination after the Second World War, when portraiture took centre stage in the experi-

**2 Pablo Picasso**

*Portrait of Daniel-Henry Kahnweiler*, 1910

Kahnweiler was an art dealer who was largely responsible for handling the market for Picasso's early Cubist work, thus protecting the artist from the need to exhibit and promote his experimental paintings on his own initiative. Picasso's decision to represent Kahnweiler in his innovative Cubist style was therefore an apt homage to a supporter of the avant-garde, but it was also part of a tendency among avant-garde artists to produce portraits of prominent art dealers who helped foster their careers.

mental practice of artists like Robert Mapplethorpe, Jo Spence, and Cindy Sherman. Thus portraiture's prevailing association with mimesis had both a negative and a positive effect on the reputation of the genre.

A final way in which portraiture is unique is in the diversity of its forms and functions. Perhaps more than any other art form, portraiture comes in a variety of media. Portraits can be paintings, sculptures, drawings, engravings, photographs, coins, medals. They can appear as images in newspapers or magazines or on mosaics, pottery, tapestry, or bank notes. In ancient Peru, portrait jars were common, while in eighteenth-century England there was a brief vogue for portraits woven from hair. Portraits can show individuals or groups in different ways, either partially or minimally, as busts or silhouettes, or full-length in a well-defined setting. Portraits can also be found in a range of contexts

and locations: they share with other genres a place in galleries and private homes, but they can also be held in the hand (for example coins), worn as lockets (miniatures), displayed as garden decorations (busts) or public monuments. Each of these settings endows the portrait with a different kind of significance. The all-pervasiveness of portraiture means that it is perhaps the most familiar of all art forms. For example, the least-educated slave in ancient Greece would have recognized Alexander the Great's visage on a coin or on an equestrian monument; mugs with the faces of famous politicians were common in the lowliest eighteenth-century English, French, and American taverns; in the twenty-first century, even those without knowledge of art might have a mantelpiece or desk full of formal portrait photographs of family members. The functional aspects of portraiture, and its use-value, familiarity, and popularity arise in part from the indeterminacy of portraits. They appear to have the tangibility of a document or a fact, but these specifics are inevitably partial and mediated, and subject to the contexts of their production, display, and reception.

In each of these ways, portraiture is a unique art category. However, there are two prevailing stereotypes about portraiture in general that are worth investigating before the genre is considered in detail. The first of these is that portraiture was an invention of the Renaissance; the second is that portraiture is a predominantly Western art form. While the first of these assertions can be refuted, the second is arguably true. It is certainly correct to say that before the fifteenth century, the practice of commissioned painted portraits of individual sitters was rare. Nevertheless, there is evidence that portraiture existed as early as the neolithic period, when Polynesian skull cults privileged the individualized head. By 5000 BC, skulls were modelled out of clay in Jericho.[3] The ancient world was replete with portraits: in Greece they usually represented prominent people and took the form of tomb sculpture or public statues; and in Rome the individualized portrait bust became an important object in the private home. Portraiture is mentioned by such ancient writers as Pliny the Elder, Aristotle, Xenophon, Plato, Cicero, Quintilian, and Horace. Some of the most effective portraits in history were produced in the Fayum district of Roman Egypt from the first to second century AD [3]. Although little portraiture remains from the medieval period, there are some notable exceptions in the form of tomb sculpture and portraits of emperors, such as the monumental mosaic figures from the first half of the sixth century of the Emperor and Empress Justinian and Theodora at the church of San Vitale in Ravenna [4].

The fifteenth century is a significant turning point in the history of portraiture as it represented the beginning of a professionalization of European portrait painting. In both Italy and the Netherlands, individual likenesses first appeared as donors in religious paintings, such

**4 Anonymous**

*Justinian I, c.546–8*
This mosaic is one of a series that forms the decorative scheme of the church of San Vitale in Ravenna. Most of the series is devoted to the life of Christ, but it also includes this portrait of Justinian. This portrait evinces both the stylized manner of sixth-century Byzantine art and a clear use of imperial symbolism. Justinian was one of the earliest Roman emperors to support Christianity wholeheartedly, and it is notable that the formal robes he wears in the mosaic echo those of the garments worn by Christ in the mosaic on the opposite wall.

**3 Anonymous**

*'Isidora': Portrait of a Woman*, AD 100–110

This is an example of one of the Fayum portraits, produced in the first to second century AD in Roman Egypt. A number of these highly naturalistic portraits appeared on mummy cases. The portraits may have been painted retrospectively, but it is also possible that they were produced before the death of the individual represented. They were most likely carried in funeral processions. In the first century AD the Fayum was populated by a mix of races, including Romans (who ruled), Egyptians, and Greeks. The combination of cultural influences from these different civilizations may have inspired the unique combination of naturalism and ritual function in their portraiture.

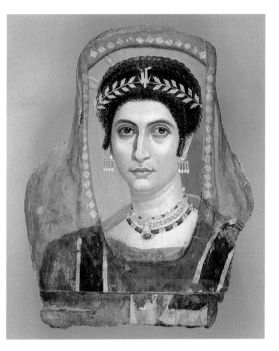

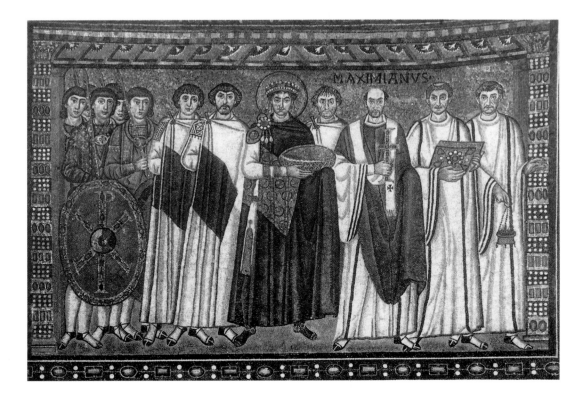

as the Master of Flémalle's *Merode Altarpiece* (*c.*1425) and Masaccio's *Trinity* in Santa Maria Novella, Florence (*c.*1427). In subsequent decades, artists such as Van Eyck in Flanders and Pisanello in Italy began to produce free-standing portraits of named individuals. From these early beginnings, sixteenth-century portrait practice exemplified greater diversity: sitters began being placed in detailed settings, as we have seen in Holbein's *George Gisze* [1]; full-length figures replaced half-length figures as the norm, as in portraits of the nobility by the Italian artist Bronzino; the subjects of portraits became increasingly varied, including court dwarfs, tailors, and other tradesmen (notably appearing in works by Velázquez and Titian), as well as monarchs, courtiers, and ecclesiasts.

Evidence of an increasing artistic interest can be found in the growing presence of portraiture within art theory from the sixteenth century. Francisco de Holanda's Portuguese treatise on portraiture of 1548 was translated into Spanish in 1563 and represents the first full consideration of the genre. More famously, Giovanni Paolo Lomazzo (1538–1600) in Italy devoted a whole section to his *Trattato dell'arte della pittura, scoltura et architecttura* (*Treatise on the Arts of Painting, Sculpture and Architecture*) of 1584 to portraiture, and in England, Nicholas Hilliard's *The Arte of Limning* was written between 1598 and 1603, although not published until the twentieth century. Portraiture also became the subject of religious controversy after the Council of Trent (1545–63) examined the place of art in the Church as part of its revision of Catholic theory and practice. The Bolognese bishop Gabriele Paleotti in 1582 devoted sections of his celebrated *Discorso intorno alle immagini sacre e profane* (*Discourse on Sacred and Profane Images*) to a consideration of acceptable and unacceptable aspects of portraiture.

These changes accompanied the greater professionalization of portrait painters. By the sixteenth century, there were some artists who were portrait specialists, and in the seventeenth and eighteenth centuries it became common practice in Europe, and later America, for itinerant portrait painters outside the metropolis to travel from town to town or house to house offering their services. In the eighteenth and nineteenth centuries, many artists gained reputation and fortune primarily through the practice of portraiture. Artists, as well as sitters, recognized the publicity value of showing portraits at public exhibitions, and further notoriety could be gained from portraits that were stylistically daring, grandiose, or offered subtle insights into the character of the sitter. The American artists Thomas Eakins and John Singer Sargent, and the French painter Degas, were among many artists in the nineteenth century whose exhibited portraits evinced such striking qualities.

As portraiture became more of a professional specialized practice, the range of sitters became more diverse, and by the end of the nine-

teenth century portrait painters began experimenting more frequently with new ways of evoking the personality, status, or profession of their sitters. While conventional, formal, commissioned portraiture has remained popular to the present day, artists have also produced portraits to explore their own psyches, represent their intimate circles, or serve as manifestos of artistic style or purpose.

There is no doubt that this widespread practice of portraiture can be dated to the Renaissance, although its origins are earlier. However, another common conception is that portraiture is a largely Western phenomenon, and this is more difficult to refute. Certainly, there are portraits from non-Western countries, such as China, where a portrait tradition can be traced back to the Han dynasty in 200 BC,[4] or India, where a special form of portrait miniature painting was associated with the Mughal dynasty of the seventeenth century. However, as portraiture represents specific people, its practice tends to flourish in cultures that privilege the notion of the individual over that of the collective.[5] As Stephen Greenblatt has shown, the Renaissance in western Europe was a period of increased self-consciousness, in which concepts of unique individual identity began to be verbalized.[6] In the seventeenth and eighteenth centuries, these considerations were enhanced by the rapid development of the genres of biography and autobiography, and by increasingly articulated ideas about character and personality. In the nineteenth and twentieth centuries, new developments in the science of psychology led to deeper explorations of individuality and personality. This historical trajectory encompasses the flourishing of portraiture as an important artistic practice and cultural commodity.

In many non-European cultures, this probing of the nature of the individual is either non-existent or has not developed in the same way. For example, a great deal of the art of African tribal cultures is based on masks [5], but the mask is stylized and functions to represent personhood rather than a particular person. Furthermore, in traditional Jewish and Islamic cultures a prohibition on imagery has made portraiture a taboo in a large part of the non-Christian world. The assigning of a specific identity to a represented face and body is thus a strongly Western phenomenon. Deleuze and Guattari's reference to the 'faciality' of Western culture signifies the obsessive concern of the West for the face as a signifier, but also what they see as a Western illusion of individual subjectivity.[7] The very idea of individuality is thus socially and historically constructed and contingent, and portraiture both grows from and reinforces this particularly Western concept. A study of world portraiture could be valuable, but in a book of this nature it would falsely elide a range of discrete cultural phenomena. This book is therefore concerned largely with Europe and North America, where individual identity and the possibilities of its representation are most fully explored through the artistic category of portraiture.

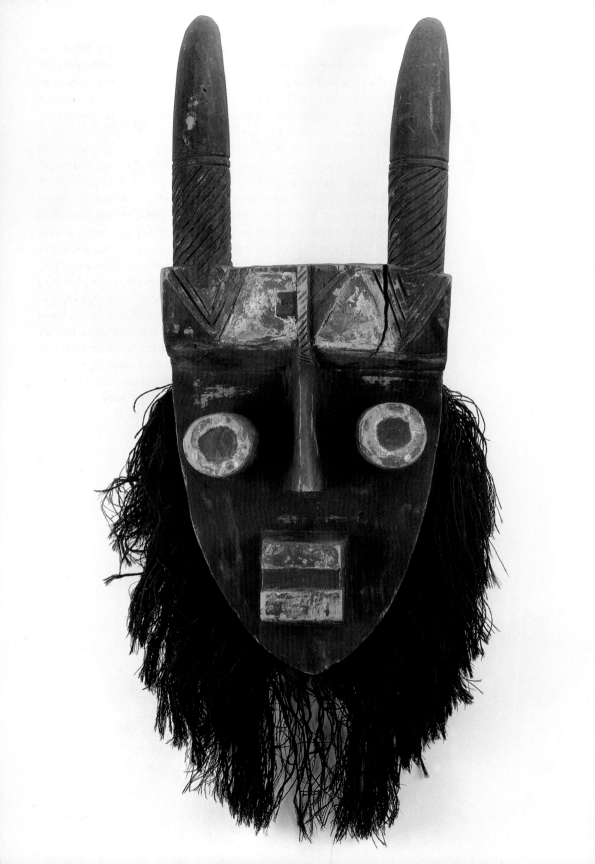

**5 Anonymous**

*Grebo Mask*, date unknown
Masks fulfilled a variety of
ritual purposes in different
African ethnic groups. Among
these functions, a mask could
be considered a substitute for
a spirit or dead ancestor; thus
it could have the portrait-like
quality of acting as a
manifestation of a specific
individual. However, masks
were also used in
performances as part of
religious rituals; the power of
the mask was thus seen to
supersede the person or type
it was meant to represent. This
mask has been identified as
originating with the Grebo
peoples of what is now
modern Liberia. The Grebo
was both a linguistic and
ethnic group, which
specialized in grotesque
masks such as this one.

Although the practice of portraiture is ubiquitous in the West, the distinct artistic histories and social and political developments of different countries have led to variations in the ways portraits have been used and the extent of their popularity. For example, while autonomous portrait painting appeared simultaneously in Italy and Flanders in the fifteenth century, artists in Italy idealized the features of their sitters more frequently than Flemish artists. Portraiture in England and Holland has played a fundamental role in their histories and artistic identities, and thus portraits from these countries have a prominent place in this book. In the seventeenth century trends in court portraiture varied in Spain, the German states, and England, although in all of these countries portraits served the purpose of glorifying the monarch. This book will note these distinctions in specific cases, but the focus here will be on how the portraits discussed engage with shared themes.

Although this book is organized in a broadly chronological shape, the focus of each chapter is thematic. Of major concern throughout the history of portraiture are the purposes portraits were intended to serve and how they answered those purposes in terms of style, media, sites of display, and presentation of facial expression, gesture, dress, and setting. The ways portraitists negotiated the problems of representing identity, and the role of the portrait as both a mode of representation and as a functional object will be the principal concerns of this book.

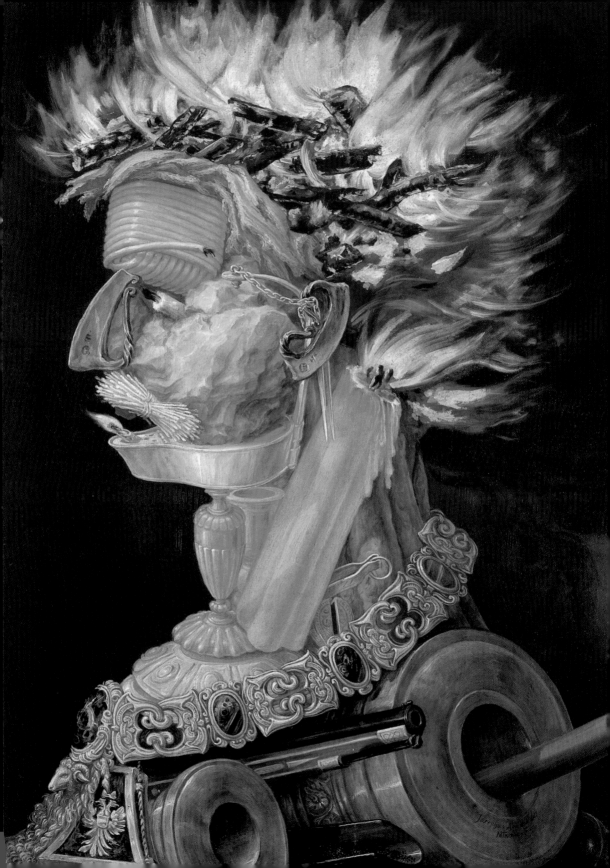

*Grebo Mask*, date unknown
Masks fulfilled a variety of
ritual purposes in different
African ethnic groups. Among
these functions, a mask could
be considered a substitute for
a spirit or dead ancestor; thus
it could have the portrait-like
quality of acting as a
manifestation of a specific
individual. However, masks
were also used in
performances as part of
religious rituals; the power of
the mask was thus seen to
supersede the person or type
it was meant to represent. This
mask has been identified as
originating with the Grebo
peoples of what is now
modern Liberia. The Grebo
was both a linguistic and
ethnic group, which
specialized in grotesque
masks such as this one.

Although the practice of portraiture is ubiquitous in the West, the distinct artistic histories and social and political developments of different countries have led to variations in the ways portraits have been used and the extent of their popularity. For example, while autonomous portrait painting appeared simultaneously in Italy and Flanders in the fifteenth century, artists in Italy idealized the features of their sitters more frequently than Flemish artists. Portraiture in England and Holland has played a fundamental role in their histories and artistic identities, and thus portraits from these countries have a prominent place in this book. In the seventeenth century trends in court portraiture varied in Spain, the German states, and England, although in all of these countries portraits served the purpose of glorifying the monarch. This book will note these distinctions in specific cases, but the focus here will be on how the portraits discussed engage with shared themes.

Although this book is organized in a broadly chronological shape, the focus of each chapter is thematic. Of major concern throughout the history of portraiture are the purposes portraits were intended to serve and how they answered those purposes in terms of style, media, sites of display, and presentation of facial expression, gesture, dress, and setting. The ways portraitists negotiated the problems of representing identity, and the role of the portrait as both a mode of representation and as a functional object will be the principal concerns of this book.

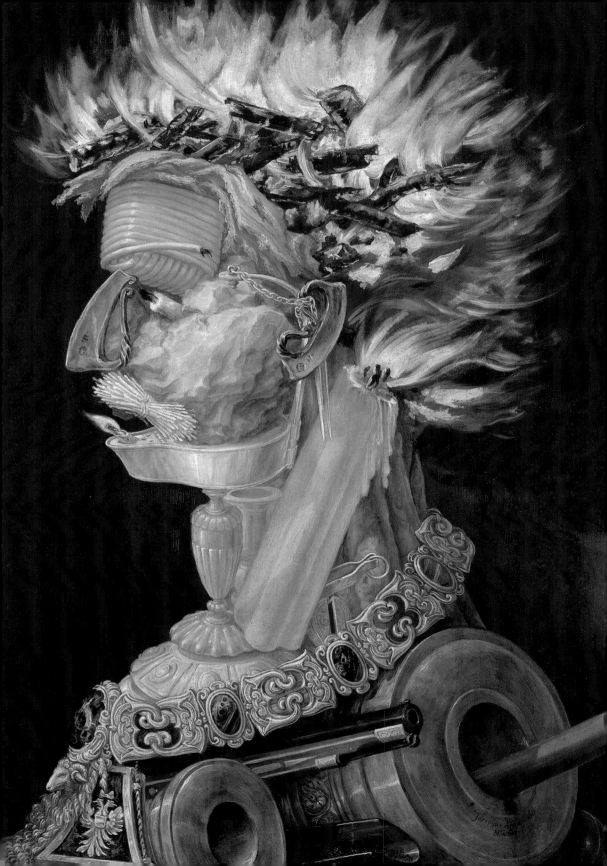

# What Is a Portrait?

1

Although the meaning of the term 'portraiture' may appear to be self-evident, there is often only a fine distinction between objects that could be considered portraits and those that are best classified differently. Usually a portrait is a work of art that represents a unique individual, but this simple definition belies the complexity and contradictions of portraiture. While a portrait can be concerned with likeness as contained in a person's physical features, it can also represent the subject's social position or 'inner life', such as their character or virtues. A portrait can be subject to social or artistic conventions that construct the sitter as a type of their time; it can also probe the uniqueness of an individual in a way that sets the sitter apart from his or her context. Portraiture's capacity to do all these things at once makes it such a powerful form of representation.

In attempting to unpick the complexities of portraiture, it is useful to consider three factors: first of all, portraits can be placed on a continuum between the specificity of likeness and the generality of type, showing specific and distinctive aspects of the sitter as well as the more generic qualities valued in the sitter's social milieu. Secondly, all portraits represent something about the body and face, on the one hand, and the soul, character, or virtues of the sitter, on the other. These first two aspects relate to portraiture as a form of representation, but a third consideration is concerned more with the processes of commissioning and production. All portraits involve a series of negotiations—often between the artist and the sitter, but sometimes there is also a patron who is not included in the portrait itself. The impact of these negotiations on the practice of portraiture must also be addressed.

## Likeness and type

The etymology of the term 'portraiture' indicates the genre's association with likeness and mimesis. Portraiture expresses the likeness of a particular individual, but that likeness is conceived to be a copy or duplication of his or her external features. Some artists took a literal approach to the idea of copying a likeness. In ancient Rome the common practice of using death masks allowed facial features to be

**6 Giuseppe Arcimboldo**
*Fire*, 1566
Arcimboldo was from Milan, but he made his reputation in the courts of Emperors Ferdinand I of Vienna and Rudolf II of Prague. Although known for his religious works, he was hired at the court of Vienna as a portraitist. Few of his straightforward portraits survive, and he became better known for composite heads such as this one, which use inanimate objects to achieve a portrait-like quality. From the contemporary poems of Giovanni Battista Fontana, who also worked in Vienna, we know that Arcimboldo's heads were allegories of imperial authority, and they were valued for their humorous *double entendre*.

reproduced with exactitude, as did some subsequent western European artists. For example, the fifteenth-century Italian artist Verrocchio and the nineteenth-century American artist Gilbert Stuart took life masks of their subjects to enhance the verisimilitude of their portraits. After the invention of photography in the nineteenth century, artists such as Degas in France employed photographs to help them achieve as exact a likeness as possible. The ability to reproduce recognizable and lifelike features was considered to be a valuable asset to portraitists, although they could also be condemned for what was perceived to be a slavish imitation of reality.

However, likeness is not a stable concept. What might be considered a 'faithful' reproduction of features relates to aesthetic conventions and social expectations of a particular time and place. Different approaches to likeness can also be taken by artists working within the same context and conditions. An observation of any two portraits of the same individual by different artists reveals just how unstable ideas of likeness can be. In fifteenth-century Flanders, where close observation of the material world was appreciated, both Jan Van Eyck and Rogier van der Weyden painted portraits of the same individual, Nicolas Rolin, who held a major political administrative role as Chancellor of Burgundy [7

**7 Jan Van Eyck**
*Madonna with Chancellor Rolin*, c.1433
Rolin was a powerful figure in the court of Philip the Good, the Duke of Burgundy. This altarpiece, representing Rolin, not only demonstrates Van Eyck's skill as a portraitist but also reveals his versatility both in its detailed rendering of symbolic detail and in the precisely delineated townscape seen through the arcade in the background.

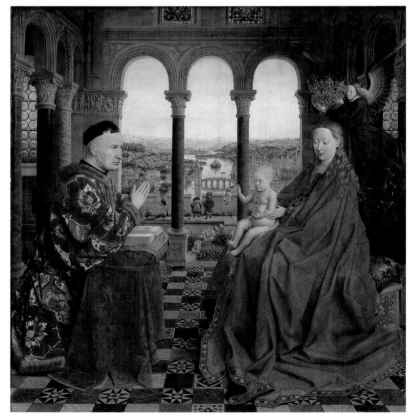

**8 Rogier van der Weyden**

*The Donor, Chancellor Rolin, Kneeling in Prayer*, from the reverse of the *Last Judgement Polyptych*, c.1445–50

Portraits of donors, or individuals who 'donated' works of art to churches, were common features of altarpieces in fifteenth-century Italy and the Low Countries. There were different conventions for including donor portraits within altarpieces. Van Eyck placed Chancellor Rolin within the same panel as the Virgin and Child, whereas Rogier van der Weyden chose the more common practice of placing his portraits on separate panels in his Last Judgement altarpiece at the Hôtel Dieu in Beaune. Rolin is shown here on the lower left outer panel. The outside panels of altarpieces were often sombre and blandly coloured like this one, in contrast to the open altarpiece, which was lavishly coloured and reserved for masses and feast days. The portraits here would have been visible when the altarpiece was closed.

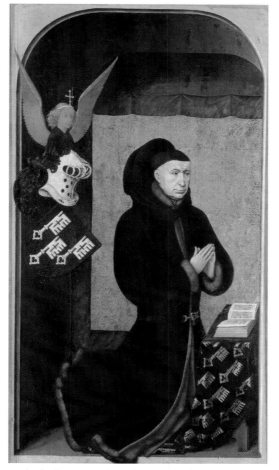

and **8**]. A comparison between the two portraits shows the same fleshy lips, prominent chin, and slim tapered ear. It is clear we are looking at two versions of a single person. However, Van Eyck's Chancellor has a dignity of expression and seriousness of demeanour that is lacking in the frail and sadder image of Rogier van der Weyden's Rolin. Part of this difference could be attributed to the age of the sitter: Van Eyck's *Madonna with Chancellor Rolin* was painted in the 1430s, at least a decade before van der Weyden's version. However, Rolin was already in his sixties when Van Eyck painted his portrait, so in both instances, it is an elderly man being portrayed. It is more likely that the different decisions made by these artists could have been inspired by the diverse purposes for which these portraits were produced. Although both works are altarpieces, Van Eyck's bold Chancellor, who visually holds an equal status to the Virgin, may have been painted for Rolin's son, the Bishop of Autun Cathedral. Van der Weyden's portrait was only a single panel in a polyptych (multi-panelled altarpiece) on the theme of the Last Judgement donated by Rolin to the chapel of a hospital in the

Flemish town of Beaune. The difference between an arrogant Rolin and a humble one is stressed through the way each artist has suited his altarpiece to the purpose for which it was intended—the first a context of family power, and the second a place of disease and death. While the function of these two portraits may have dictated different approaches to likeness, the individual style of the artists who produced them can also account for their differences. Van Eyck was known for his microscopic and penetrating analysis of facial features and van der Weyden's portraits were more stylized and less detailed.[1] Thus both works are likenesses, but the likenesses are mediated by the varying functions of the portraits and the distinct styles of the artists.

Thus the drive for likeness in much portraiture must be balanced against the limitations of representation, which can only offer a partial, abstracted, generic, or idealized view of any sitter. Many writers have drawn attention to the duality of portraiture—its simultaneous engagement with likeness and type. Bernard Berenson famously distinguished between 'portrait' and 'effigy'—the former representing the likeness of an individual and the latter an individual's social role.[2] Erwin Panofsky provided one of the most concise statements about portraiture's dualism:

A portrait aims by definition at two essentials . . . On the one hand it seeks to bring out whatever it is in which the sitter differs from the rest of humanity and would even differ from himself were he portrayed at a different moment or in a different situation; and this is what distinguishes a portrait from an 'ideal' figure or 'type'. On the other hand it seeks to bring out whatever the sitter has in common with the rest of humanity and what remains in him regardless of place and time; and this is what distinguishes a portrait from a figure forming part of a genre painting or narrative.[3]

Although portraits convey a likeness of an individual, they also can demonstrate the imagination of the artist, the perceived social role of the sitter, and the qualities of the sitter that raise him or her above the occasion of the moment. Furthermore, portraits can reflect conventions of behaviour or art practices that originate in the sitter's social and cultural milieu. In these respects, portraits become less about likeness and more about the typical, the conventional, or the ideal.

These ambivalent qualities of portraiture may explain why, for example, it was common practice in the sixteenth century for artists to paint portraits of sitters they had not seen for some time or, indeed, had never seen. In the 1530s Isabella d'Este most famously asked Titian to paint her portrait, but instead of sitting for him, she sent him a portrait by Francesco Francia to copy. Francia's portrait had itself been copied from another portrait 25 years previously. Thus Titian's portrait was a copy of a copy, without direct reference to the real age and appearance of the sitter who commissioned it. The ideal qualities of the sitter were what concerned Lomazzo in his art treatise of 1584, in which he advised

that only worthy, virtuous, or high-born individuals should be the subjects of portraits. Lomazzo's implication was that by merely representing a likeness of a worthy individual the artist would somehow absorb and reproduce their virtuous qualities for the edification of the viewer.[4]

Generic qualities attributed to a sitter could be conveyed through gesture, expression, or role-play; artists also used props as clues to a sitter's worth. A monarch could be represented with robes of state; a landed family could be shown sitting in the landscaped garden of their country seat; an individual known for learning would be shown with books or other attributes. The last is demonstrated in the German artist Johann Zoffany's portrait of Francis I surrounded by scientific instruments redolent of his fascination for natural history and Enlightenment invention [**9**]. Although Zoffany's portrait uses specific objects to express the interests of a particular man, some settings and accoutrements became artistic conventions. For instance, the practice of using a curtain and column in portraits may have originated in paintings of the Virgin and Child seated under an awning or draped throne. In Renaissance altarpieces of the Virgin and Child, especially those of the Low Countries, the draped awning often had a liturgical association, as it could represent the altar cloth or canopy, and, by extension, could refer to the Eucharist.[5] These associations endowed the column and curtain with vestiges of authority, appropriated in portraits of monarchs and aristocrats. By the eighteenth century such elements commonly accompanied many portraits of sitters from several different classes of society, but by this time they functioned more frequently as often gratuitous theatrical props.

Other conventions in portraiture had social or artistic, rather than religious, origins. For example, for centuries after Raphael's famous representation of the courtier Castiglione (1514–15), portraitists adopted Raphael's half-length format with a sitter leaning on a ledge or parapet. Some eighteenth-century portraits in both England and France represented their sitters with a hand in the waistcoat pocket, but while this was a social mannerism among the elite in France, in England it was associated with portraiture, rather than actual behaviour.[6] Similar social conventions have been traced in the widespread inclusion of gloves and fans in French nineteenth-century portraits of women, and in the adoption of plain black tunics in seventeenth-century Flemish paintings of old men.[7] Each of these poses or props served as signs of the sitter's actual or desired social position, but in many cases, they became conventions of portraiture that enabled the artist to express typical qualities of the sitters concerned.

This duality of likeness and type can be traced back to the ancient world. Although archaic Greek sculptures of *kore* and *kouros* figures from before the fifth century BC are stylized and repeated, from that

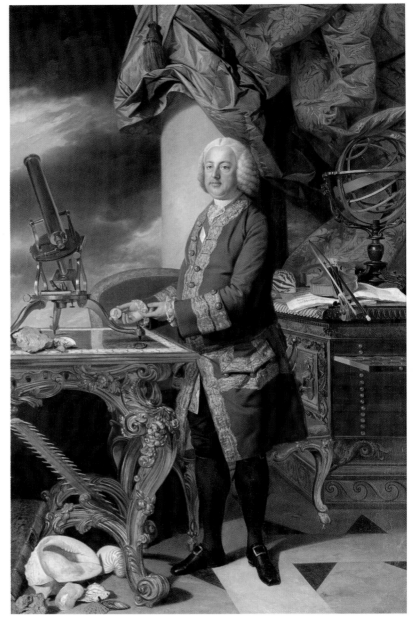

**9 Johann Zoffany**

*Francis I, c.1770s*

This richly detailed portrait has been identified as depicting Maria Theresa of Austria's husband—an enthusiastic supporter of Enlightenment scientific and philosophical discovery. However, Zoffany's period of employment by the Habsburg family is confined to the mid- to late 1770s, when he worked for them in Vienna and Florence, whereas Francis I died in 1765. This may therefore be a posthumous portrait, but it lacks some of the stiffness normally present in portrait likenesses copied from prints or other paintings.

time classical and Hellenistic Greek art distinguished between different individuals. Sculptures of famous philosophers and writers such as Socrates [10], Aeschylus, and Euripides can be differentiated from each other by physical features that were clearly associated with each individual. Likeness allows the viewer to see the figure as an individual, but it was also important for the Greeks to evoke virtues that transcended individuality. The portrait subject therefore became a symbol for higher human qualities. Even the Romans, whose portraiture was

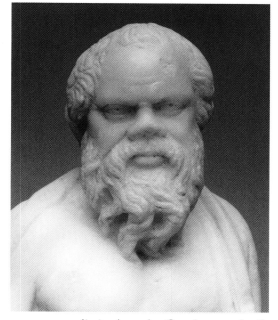

**10 Anonymous**

*Socrates*

Ancient Greek portrait sculpture frequently represented prominent public individuals, such as philosophers (for example Demosthenes) and playwrights (for example Euripides). There are many copies of these portrait busts, and they tended—like this one—to repeat certain key features. They therefore represented individuals through typical qualities. The philosopher Socrates was known for his goat-like visage, which became the standard signal for his portrait type in Greek sculpture and later Roman copies.

more naturalistic than the Greeks, sought for the general within the particular. The widespread use of statues of Roman emperors as cult objects, for example, attested to the importance of the ideal qualities of the individual, despite the emphasis on likeness in the sculpture. Although there were both stylistic and functional differences between them, portraits in ancient Greece and Rome were therefore like enough to enable a human association with the individual depicted, but they were idealized to reflect those qualities felt to be worthy of admiration and emulation. As the Greek moralist Theophrastus wrote, 'only a flatterer tells a man that he looks like his portrait'.[8]

This tension between likeness and the generic qualities of the sitter remains in some twentieth-century portraiture. A representation of a 'rural bride' from German photographer August Sander's album of photographs, *Menschen des 20. Jahrhunderts* (*People of the Twentieth Century*), exemplifies how this tension can test the boundaries of portraiture [11]. Sander's project, which he began in the mid-1920s, was conceived within the aesthetic of the *neue Sachlichkeit* or 'New Objectivity', which dominated German visual and literary culture at the time. It was characterized by a desire to represent reality in a sober and detached manner, and a belief that 'objective' representation of the world was possible. Christopher Isherwood—an English writer who lived in Berlin during this period—expressed it succinctly in the phrase: 'I am a camera with its shutter open, quite passive, recording, not thinking.'[9] Sander intended that his photographs should represent types of people in contemporary Germany, and he divided his subjects into social categories such as farmers, craftsmen, and professions. Because

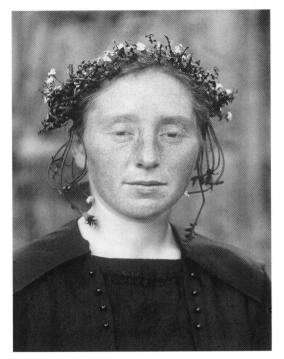

Sander's project was concerned with types rather than individuals, he did not identify most of his sitters by name. However, his use of real people in these professions as his subjects enhanced the unique qualities of the sitters, whose individuality undermines the idea that they stand for whole categories of people.[10] Sander's works are portraits of individuals, but these portraits were conceived as representing qualities of class and profession.

The duality of likeness and type can also be investigated by looking at portraits that are accepted as faithful likenesses because they represent their sitters in an unflattering way. The portrait of an old man with a deformed nose (c.1480) by the fifteenth-century Italian artist Ghirlandaio is an early example of a work that lingers on a physical detail that would have been considered at the time as an unsightly sign of disease. Such deviations from the ideal were unusual in the Renaissance, but they became common in portraits from the nineteenth century onwards, even those representing sitters who might be expected to require a flattering likeness. For example, the New Zealand artist Oswald Birley was sought after in England by politicians, members of the royal family, and other public figures, but his portrait of Arabella Huntington [12] as stern, short-sighted, and prim suggests that visual frankness did not deter his patrons. However, there is no indication that such uncompromising views of sitters are more 'like' than other kinds of portraits.

Likeness is thus at best a problematic concept, and while artists

**12 Oswald Birley**

*Arabella Duval Huntington,* 1924

Although born in New Zealand, Birley was educated in England and became a fashionable society portrait painter after the First World War. He was also known for his portraits of members of the royal family and political figures such as Churchill and Eisenhower.

nearly always produce portraits with some hint at the likeness of the individual, portraits also stress the typical, conventional, or ideal aspects of their sitters. These signals emerge through pose, expression, setting, or props. Likeness is subject to the quirks of artistic style and, for the viewer, is a slippery and subjective notion. It is not possible for us to compare most portraits we see with the sitters who posed for them, and therefore our impression of likeness is one that comes through the skill of the artist in creating a believable model of a real person.

## Body and soul

Whether a portrait veers towards likeness or type, all portraits engage in some way with the identity of the sitter represented. The concept of identity has a complex history. The twenty-first-century notion of identity as those aspects of character, gender, race, and sexual orientation unique to an individual is the legacy of the seventeenth century, when the idea of 'the self' began to be explored philosophically.[11] Previously identity was seen to be rooted in those external attributes, conveyed through the body, face, and deportment, that distinguished one individual from another.[12] This earlier notion of identity is crucial to the history of portraiture. The idea that portraits should communicate something about the sitter's psychological state or personality is a concept that evolved gradually and became common only after nineteenth-century Romanticism fuelled the idea of a personality cult, that is, a fascination with the particular qualities, idiosyncrasies, and actions of a celebrated individual. Portraits represent the external features of a

unique individual, and they also place their subjects within conventions of behaviour, dress, and deportment. All of these are fundamental components of individual identity. Portraits are filled with the external signs of a person's socialized self, what Erving Goffman referred to as the 'front' of an individual.[13] These external signals have been remarkably persistent in portraiture, even after ideas of character and personality were well developed. A good example of this is the series of portraits of English Grand Tourists in Rome painted by the Italian eighteenth-century artist Pompeo Batoni, such as George Gordon, Lord Haddo [**13**]. Batoni's portrait shows the young aristocrat standing in a cross-legged pose that was a conventional posture of politeness. He is

**13 Pompeo Batoni**

*George Gordon, Lord Haddo,*
1775
Although also known for his altarpieces and other religious paintings, Batoni's reputation rested on portraits such as this one, which were produced in Rome for English Grand Tourists. The English aristocracy and gentry tended to seek portraitists, like Reynolds, who had social aspirations, and they found Batoni a sympathetic character when they were in Rome. Batoni was part of the circle of the German antiquarian Johann Joachim Winckelmann in Rome, and he was hired as curator of the papal art collections. He endowed his portraits with the faithfully reproduced trappings of classical Rome, to the delight of his clients.

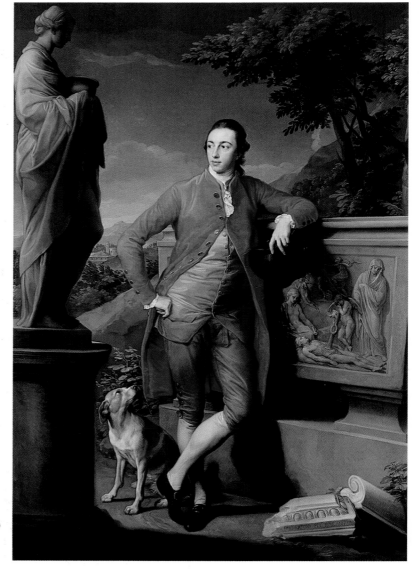

surrounded by the signs of Roman artistic greatness in the form of an antique statue, a Renaissance frieze, and a crumbling column. The Roman countryside is visible in the background. A very English hunting dog sitting at his feet reinforces these signals of Haddo's social status. As only landed men of a certain income could hunt or participate in the Grand Tour, Haddo's 'front' is represented as that of a high-born gentleman. Although Batoni attempted to convey something of the character of Haddo in his portrait, the viewer is directed to read more generic signs of status through such external attributes.

Despite the persistence of this emphasis on the external, most portraitists engage with individual identity in ways other than reproducing such social signs as physical appearance, dress, and deportment. One of the great challenges of portraiture for the artist is probing the sitter's character, personality, or individuality. Many portraits seem to do this, but the messages they send to the viewer, and the way those clues are interpreted, can vary from one period to another. There is also the problem that viewers tend to respond to the faces in portraits as they would to faces in real life, and therefore any reading of character or personality in a portrait tends to be highly subjective.

The problematic relationship between the communication of external and internal aspects of identity in portraiture can be demonstrated by comparing two sixteenth-century portraits by the Italian artists Giuseppe Arcimboldo and Lorenzo Lotto [6 and 14]. Arcimboldo's depiction of *Fire* has the format of profile portraits common to both ancient Rome and the Italian Renaissance. However, he has composed this portrait-like head from candles, kindling, embers, cannon-mouths, flints, and lamps. The viewer sees a face-like object, but is constantly forced to correct this impression by lingering over the still life. Such a work stresses the external aspects of portraiture: the viewer sees a face but not a personality. In contrast, Lotto's portrait of a young man can suggest many different things to an observer. Although the portrait is conventional in its half-length format and in the focused expression of the sitter, Lotto's emphasis on the sitter's distant gaze, slightly downward-curving mouth, and youthful features conveys a sense of either arrogance or melancholy, depending on how you wish to read it. However, Lotto himself was presenting us not with a clear view of the sitter's personality but a series of riddles about the young man's inner life. As Norbert Schneider has shown, the curtain in the background is a common emblem of concealment, and reveals a glimpse of a small oil lamp behind it. While the lamp in Arcimboldo's *Fire* becomes a physical feature, the lamp in Lotto's portrait seems to be a symbol of this individual's spiritual state, as it may allude to the passage in the Gospels which refers to 'light shining in darkness'.[14] In Lotto's work, we see the beginnings of what might be considered a psychological view of portraiture, but here it is a matter of symbol, suggestion,

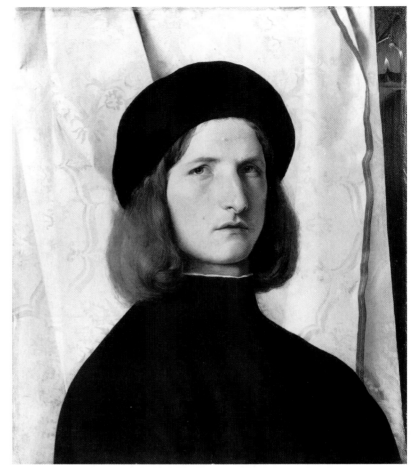

**14 Lorenzo Lotto**
*Young Man before a White Curtain*, c.1505–8

Lotto's contribution to the art of northern Italy included more than 40 portraits. His early works showed an affinity to the portraits of his predecessors, such as Antonello da Messina, in that they were simple half-length or bust figures. As his career developed, Lotto became known for his three-quarter-length portraits employing complex gestures and more elaborate settings. He enhanced the psychological qualities of his portraits through his use of emblems and symbols to encode aspects of the sitter's disposition and character. The meaning of many of these symbols, such as the candle glimpsed in this portrait of a young man, is no longer clear.

and riddle, rather than revelation of the character or personality of the sitter. That emphasis would come only much later.

Although it is possible to trace a gradual shift from portraits that stress identity through external signs to those that focus on character or personality, it is important to note that attempts to reconcile the inner life with the outer appearance were common from the Renaissance onwards. The mechanism for making this reconciliation was the revival of ancient treatises on physiognomy, which claimed that the face could be an index of the mind. Writings on physiognomy attributed to Aristotle became the basis for discussions of the face's meaning by authors such as Giacomo della Porta in the sixteenth century.

The best known proponent of physiognomic theory was the eighteenth-century Swiss writer Johann Caspar Lavater, whose massive three-volume *Physiognomische Fragmente* (*Fragments on Physiognomy*) of 1775–8 was translated into several languages [15]. Lavater's work argued that each facial feature could reveal something significant about the character of the person represented. Using a huge array of illustra-

**15 Johann Caspar Lavater**
Silhouettes of clerics, from
*Essays on Physiognomy*,
1792

The Swiss writer Lavater was
responsible for producing the
first full exposition of the
pseudo-science of
physiognomy, or the idea that
the face reveals the soul.
Although this belief was an
important staple of both
ancient and Renaissance
theory, Lavater's work evinced
an Enlightenment enthusiasm
for classification in his analysis
of the physiognomic signs in
hundreds of portraits. His
*Physiognomische Fragmente*
of 1775–8 was extensively
illustrated with prints after
famous portraits. Lavater also
employed the contemporary
fashion for silhouettes as a
way of isolating and analysing
individual profiles, as in this
example.

tions—many of which were portraits—Lavater demonstrated the
subtle differences between tilt of nose, size of forehead, and shape of
mouth that could convey specific aspects of personality. Lavater's work
also fuelled a popular fashion for the silhouette portrait, which reduced
the individual likeness to a black profile outline. According to Lavater,
this abstracted view of the face could reveal the attributes of individual
character in its most basic form. Although Lavater's work was popular

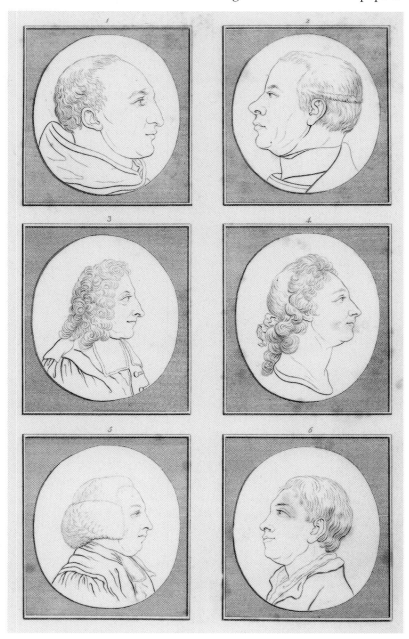

with artists and writers, it proved to be ultimately too reductionist to be of use in portraiture.

Of more benefit to portrait painters in employing the signs of the face and body to reveal the soul were theories of deportment and expression. As with physiognomy, ideas of gesture and disposition of the body were ultimately drawn from ancient texts. Sixteenth-century Italian examples, such as that of Castiglione's *The Courtier* (1528), followed the tradition of the ancient Roman orator Quintilian's ideas of rhetorical gesture. *The Courtier* instructed gentlemen on how they should deport themselves in society. Conduct manuals throughout Europe in the seventeenth and eighteenth centuries were similarly concerned with the revelatory qualities of contrived gestures. As mentioned earlier, these ideas came to portrait painting through a series of conventions of posing which could, but did not always, reflect social practice.

Theories of facial expression were also implicated in the body/soul duality of portraiture. Expression was distinguished from physiognomy: the former was about the temporary effects of the emotions on the face; the latter concerned those permanent facial features that revealed character. In the seventeenth century the French Royal Academician, Charles Le Brun, codified expressions of the passions, or emotions, such as fear, anger, and joy in his *Méthode pour apprendre à dessiner les passions* (*A Method to Learn to Design the Passions*), published posthumously in 1698.[15] Le Brun's ideas were popularly adopted by history painters who were able to employ his more extreme expressions in paintings depicting war, death, and acts of heroism. For portrait painters Le Brun's taxonomies of expression were more problematic. It was uncommon for portraits to show any extreme expression, as neutral and studied features gave sitters an air of dignified repose or concentration. Most sitters preferred to be represented in this way, as any facial expression in a portrait could appear ugly or unnatural. As expression also could be a means of conveying character, this absence of decisive expression from much portraiture may have served a social need, but it removed a tool of communication from the artist's repertoire. Occasionally portraitists would show the sitter smiling or laughing, but this emphasized the awkwardness of an expression that could seem grotesque when shown static. Before the twentieth century, examples of extreme facial expression in portraits are rare. For example, the Austrian sculptor Franz Xavier Messerschmidt exploited the grotesque aspects of exaggerated expression in portraiture when he used Le Brun's formula in a series of self-portrait heads, but these were supposedly produced when he was succumbing to insanity [16].

In the twentieth century the power of facial expression to convey the inner life of sitters was exploited by Expressionist artists whose main goal was to convey the substance of the inner life. Richard Gerstl's *Laughing Self-portrait* [17], like his fellow Austrian Messerschmidt's

*An Intentional Buffoon*, after 1777

This is one of 43 surviving 'character' heads by the Austrian baroque sculptor Messerschmidt, who modelled these expressive heads on his own face. These works date from late in Messerschmidt's career, after a dip in his prosperity and fortune coincided with a decline into eccentric behaviour. At the height of his career he created portrait busts of Maria Theresa and Francis I, as well as completing many private commissions. From 1777 he lived at Pressburg and concentrated most of his attention on producing metal and alabaster self-portraits like this one. Sculpted self-portraits were highly unusual at this time, but apart from a reflection of his state of mind, these heads may be experiments in the *têtes d'expressions* tradition of Charles Le Brun.

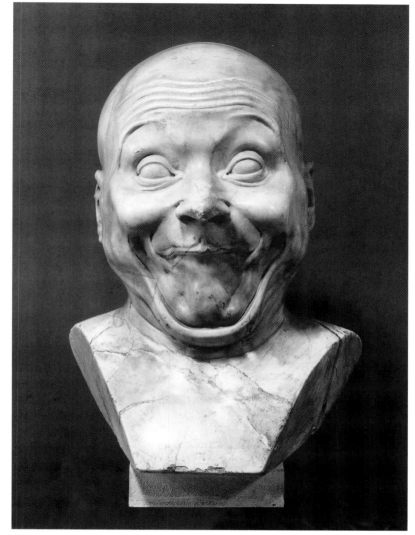

*outré* heads, has a disturbing ambience. Laughter, usually a sign of joy, here seems to be a mark of mania or despair. This kind of exaggeration was important to Expressionists in both Germany and Austria, who used a wider range of human emotion in their work as a means of tapping the spirit, soul, or psychology of their subjects.

But such decisive expression was uncommon, even in twentieth-century portraiture. While expression in portraiture could give the sitter an appearance of madness or ugliness, it was also associated with the less exalted art of caricature. From the Italian *caricare*, meaning to overload, caricature involved an exaggeration of feature, and the first examples of it can be found in the sixteenth century. Leonardo da Vinci drew caricatural heads, and Annibale Carracci reportedly justified the practice of caricature by claiming that ideal ugliness was no less

**17 Richard Gerstl**

_Laughing Self-portrait_, 1908
Very little is known about the
Austrian artist Gerstl, who
committed suicide at the age
of 25. Many of his works were
destroyed, but the majority of
the surviving paintings are
self-portraits. These portraits
demonstrate a variety of styles,
employing pointillist dots or
vivid Expressionist brushwork.
Gerstl's experimental self-
portraits owe a great deal to
Van Gogh, whose reputation
as a tortured genius was
fuelled by exhibitions of his
work in Vienna in the early
years of the twentieth century.

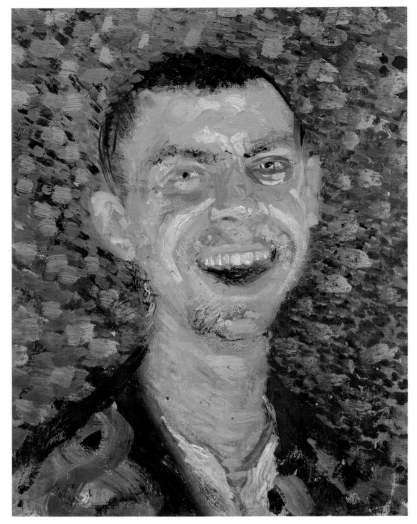

important a goal for artists than ideal beauty. Caricatural portraits in
eighteenth- and nineteenth-century England, Germany, and France
were often intended to satirize—through distortion of expression and
feature—individuals who were politically or socially notorious. To an
extent caricaturists acted as portraitists, inasmuch as they studied the
distinctive features of their sitters and used them as a stamp of identifi-
cation. But while the portraitist might reproduce a large nose in a way
that suggests the authority or dignity of the sitter, a caricaturist would
make the nose predominant to the point of being laughable. The
humorous side of facial distortion, and the eventual association of this
with caricature, is one of the many reasons why portraitists have gener-
ally avoided using extreme expression as a means of conveying the
sitter's personality.

Portraiture is thus about both body and soul. It represents the 'front'

of a person—their gesture, expression, and manner—in such a way as to convey their distinct identity as well as to link him or her to a particular social milieu. Such external signs have remained crucial to portraitists, but from the sixteenth century onwards, artists found new means of probing the inner life of their sitters: explicitly, by employing theories of physiognomy, deportment, or expression; or more frequently implicitly, with unstable or ambiguous clues laid in the face, gesture, or accoutrements contained in the portraits. Portraits seem to present us with an individual personality, but it is important to remember that ideas of character, personality, and psychology have evolved through time. Attempts to read all portraits as embodying more than the mere externals of the sitter can be anachronistic, but by the very nature of their mimetic function, portraits give the viewer an impression of the inner life.

## Artist, sitter, patron, and viewer

Any definition of portraiture needs to take account of the unique interrelationship of artists, sitters, patrons, and viewers that characterizes this genre. The methods by which portraits are produced, the variables of the relationships between artist and sitter, and the way portraits seem to refer to a specific moment of production are all significant for portraiture as an art form.

One of the special aspects of portraits is that they are often based on a sitting or series of sittings, in which the subject of the portrait has physical proximity to the artist representing him or her. The same could be said for studies from the life model, so it is important to distinguish the portrait subject from the artist's model (although in some cases the boundaries between these categories are indistinct). From the foundation of art academies in sixteenth-century Italy, artists employed models as part of their education in life drawing, or to represent fictional characters in scenes from history or literature. Models were usually hired and paid by the artist or by academies, ateliers, and other training institutions, and one of their principal roles was to pose in the nude. The identity of models is therefore often unknown, and even when they can be identified, their identity was irrelevant to the purpose they served for the artist.

Many portraits, on the other hand, were commissioned or at least the product of negotiation between the artist, the sitter, and sometimes a patron or patrons. In contrast to the model, the identity of the sitter is fundamental to the portrait transaction. It could be said that portraits were produced with the model as the principal subject, rather than as a tool or accessory. The relationship between the portrait artist and the sitter raises a number of issues. The first of these is the extent to which the portraitist is required by social or artistic convention to flatter or

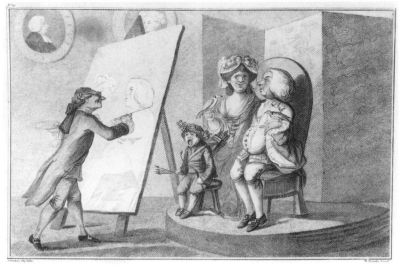

idealize the sitter. The process of negotiation over how the work should look could be carried on while the portrait was being produced, and it was exactly this sort of interference that led some artists to forbid the sitter to view the work until it was complete. William Dickinson's 1781 stipple engraving *A Family Piece* [**18**] satirizes the potential problems of an artist–sitter relationship in which the unprepossessing middle-class family is already being idealized from the first strokes of the portrait painter's brush. The eighteenth-century artist Elisabeth Vigée-Lebrun's advice to portrait painters concentrates as much on how to make aristocratic sitters feel at ease as on the technical aspects of the act of painting itself.[16] Vigée-Lebrun's experience indicates the extent to which the sitter's practical demands or social expectations could interfere with the creative process. The centrality of the sitter's preferences in the portrait transaction was notably challenged in much avant-garde portraiture from the late nineteenth century onwards. But as avant-garde portraits could show stylistic experimentation, bodily distortion, or human ugliness, the type of sitter represented was often a friend or admirer of the artist, rather than a formal commissioner.

This can be seen in the paintings of Lucian Freud. There is a debate about the extent to which Freud's grotesque and ungainly naked figures should be classed as portraits, as opposed to nude studies. The majority of his paintings depict nudes, and although many of these figures, such as the *Benefits Supervisor Resting* [**19**], are not specifically identified in the title, others are named. Freud's attention to details of facial characteristics distinguishes one likeness from another, and there is a strong sense of character in his nudes. However, he subverts the traditions of portraiture by avoiding conventional poses, displaying whole-length figures naked, stressing ugliness and extremes rather than the ideal or corrected face and body, and stripping the studio background of any

signs of the identity or status of the sitter. The *Benefits Supervisor Resting* is one such portrait: the title provides a specific occupation and putative identity for the sitter, who was Sue Tilley—an employee at the Department of Health and Social Security. However, the voluminous nudity, neutrality of the setting, and apparent obliviousness of the sitter to the presence of the artist give the work the effect of skilfully wrought painting of nudity. Most of Freud's portraits were produced with the consent and encouragement of his sitters, and through their uncompromising nudity, voyeuristic viewpoints, and lack of flattery they remind the viewer of the inevitably intimate relationship between a portraitist and a sitter.

Sometimes this kind of intimate relationship had problematic social implications. Before the eighteenth century, the majority of those who sat for portraits had a prominent position in society, the government, or the church, and artists therefore had to deal with an inequality of status between themselves and their sitter. Although artists like Titian, Van Dyck, or Velázquez received knighthoods or other royal commendations, artists were usually considered well beneath their sitters in class terms. In normal social interaction such classes did not meet, but in the portrait transaction they had to come together on quite intimate terms.

**19 Lucian Freud**

*Benefits Supervisor Resting,* 1994

By his own admission Freud was attracted to sitters with 'unusual or strange proportions', and he demonstrates this interest in this portrait of the government official Sue Tilley. Tilley was initially nervous of being painted by Freud, but she gradually relaxed into the role of sitter. Her initial sittings took place on a bare wooden floor, but Freud later introduced the couch we see in this portrait.

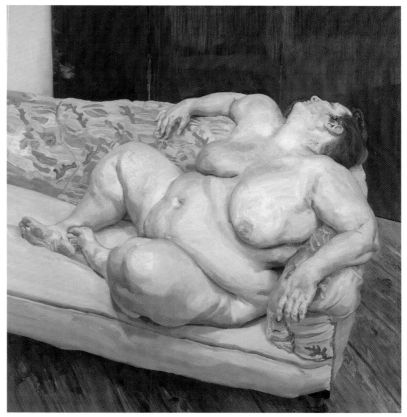

**20 Diego Rodríguez de Silva y Velázquez**

*Las Meninas*, 1656

This is one of the most complex and significant seventeenth-century court portraits. Velázquez produced a range of single-figure portraits for his patron Philip IV of Spain, but this unique group portrait contains several members of the royal household as well as the painter himself. A sense of informality is conveyed in the ragged arrangement in the foreground, which includes the Infanta Margarita, her court dwarf, and her maids of honour. Velázquez appears to be painting a portrait of the infanta, but in the mirror behind him we can see a reflection of King Philip and Queen Mariana who are thus the real subjects of the portrait. The reflection of the royal couple in the mirror also creates an interesting paradox for the spectator of the portrait, whose entrance into the picture is blocked by the placement of the king and queen effectively in the spectator's position. The clever and imaginative portrait allows the court painter Velázquez to have a central, even intimate, role within the royal family group.

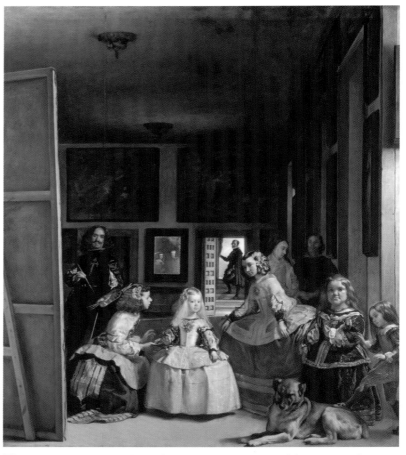

This interaction contributed to an enhancement of the status of artists. Velázquez's numerous portraits for the court of Philip IV in the seventeenth century gave him so prominent a place in the royal household that he could include his own self-portrait as the central figure in *Las Meninas* [**20**]. Velázquez dominates the centre of this portrait, while the king and queen (seen in a mirror on the back wall) are symbolically and perspectively central to the composition, but physically diminutive in comparison with Velázquez. A century later, this aspect of a portrait's production also meant that artists who specialized in portraiture were sometimes required to adapt their studios to accommodate the presence of high-born or wealthy subjects. Successful artists of eighteenth-century Europe, such as Pompeo Batoni in Rome, Joshua Reynolds in England, and Elisabeth Vigée-Lebrun in France, therefore had well-located and well-appointed studios which became fashionable outposts of society as well as workrooms.

Another point to make about the artist–sitter relationship is the potentially disruptive erotic element that could creep in. Although the portrait sitting could be a public affair, private encounters between

artist and sitter were more frequently the norm, and portraits often required male artists to stare for long periods at female sitters or—very rarely—vice versa. The most famous precedent for this sort of relationship was the ancient Greek artist Apelles, who painted a portrait of Alexander the Great's concubine Campaspe in the nude and proceeded to fall in love with her. In the eighteenth and nineteenth centuries, these relationships became the stuff of novels and anecdotal romance tales about the lives of artists. George Romney in England allegedly fell in love with the singer Emma Hart, later Lady Hamilton, when she sat for a series of portraits; in the mid-nineteenth century, Dante Gabriel Rossetti began an ill-fated affair with his model, Elizabeth Siddal, while he produced many portrait drawings as well as subject pictures representing her [see **96**]. Erotic tension was only one possible by-product of the portrait transaction; for women artists, such as the eighteenth-century Swiss painter Angelica Kauffmann, the control of the gaze during sessions with male sitters could be socially uncomfortable but empowering.[17] The delicate psychological engagement between the portrait artist and the sitter was one that was potentially overcome by the invention of photography, which separated the gaze of the artist from the body of the sitter by the bulky apparatus.

The social and psychological encounters between artist and sitter that eventually become a portrait point to another factor that makes portraiture different from other art forms. Most portraiture represents a particular occasion or moment, whether directly or by implication. Unlike a landscape painting or a history painting, which may seem to transcend a single moment in time, the presence of a specific individual in a portrait reminds us of the encounter between the artist and sitter. This special aspect of portraiture has been explained using C. S. Peirce's semiotic theory of the icon, the index, and the symbol. According to Peirce, an icon looks like the thing it represents; an index draws attention to something outside the representation; and a symbol is a seemingly arbitrary sign that is, by cultural convention, connected to a particular object.[18] A portrait has qualities of all three: it resembles the object of representation (icon), it refers to the act of sitting (index), and it contains gestures, expressions, and props that can be read with knowledge of social and cultural conventions (symbol). In this tripartite view, the indexical qualities of portraiture are particularly notable. These signs relate to the process of producing the portrait, and the traces of that process that remain in the final product. When we look at portraits, we see individuals who are now dead or are older than and different from the way they were represented, but portraits seem to transport us into an actual moment that existed in the past when the artist and sitter encountered each other in a real time and place. Whether or not a portrait was actually based on a sitting, the transaction between artist and sitter is evoked in the imagination of the viewer.

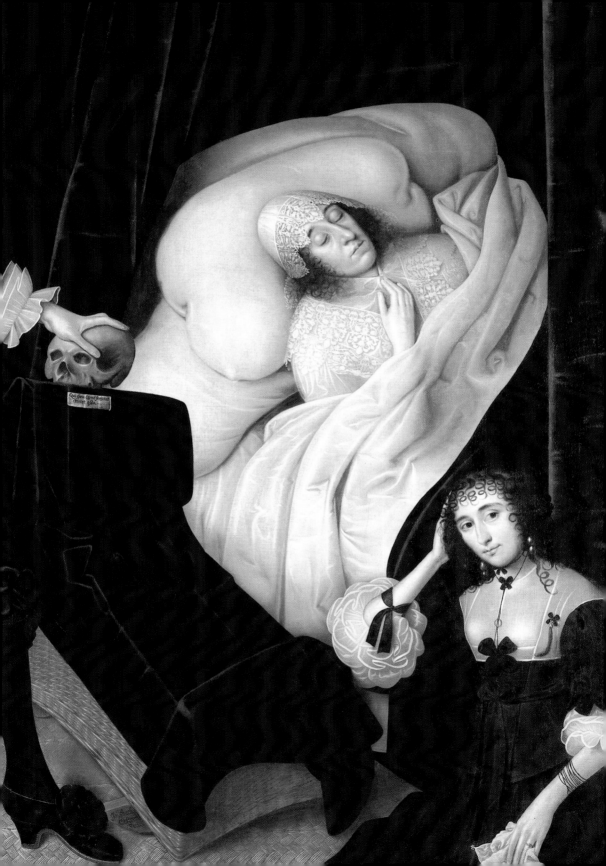

# The Functions of Portraiture

## 2

Portraits are representations, but they are also material objects, and as such they have had a variety of functions. As objects, portraits come in a range of media. Painting remains by far the most common medium of representation in portraiture, but prints, drawings, and portrait sculpture in the form of busts, tombs, and monuments are also prevalent. Portraits appear on objects of mass circulation, such as coins, banknotes, and stamps. They have a place on commemorative medals, plates, and mugs that are meant to be preserved, as well as fans, handkerchiefs, and other objects with finite use-value. Portrait photography is displayed in domestic settings, and appears in popular journalism through images in glossy magazines, for example. Portraits furthermore can be produced in media that do not seem particularly suitable to the close study of likeness, such as mosaic or stained glass.

Because of the many different forms they take, portraits have been and can be used for a variety of dynastic, commemorative, judicial, personal, and propagandist purposes. They can be considered aesthetic objects, but they can equally be seen to act as a substitute for the individual they represent, or as conveying an aura of power, beauty, youth, or other abstract qualities. Many portraits were produced for public places such as city squares, civic or religious institutions, or for mass dissemination in the form of coins or in prints, for example. However, even portraits that had an ostensibly private function, such as miniatures or family snapshots, are usually intended to be viewed and responded to by a group of individuals rather than a single person. Portraits therefore are normally created with the understanding that they will be in the public domain (however that may be defined) and that they will serve a special purpose. More than any other genres of art, portraits draw attention to themselves as objects that can be employed or exploited in a variety of ways.

Portraits therefore take a number of physical forms and serve a multiplicity of aesthetic, political, and social functions. This functionality is enhanced by the ways portraits transcend the temporal limits implied in the process of their making. As shown in the previous chapter, a portrait calls attention to the process of its production—to the appearance of an individual in the fugitive moment in which it was

produced. This is what the philosopher Hans-Georg Gadamer refers to as the 'occasionality' of portraiture.[1] But a portrait also serves magically to freeze time and to extend artificially the life of the represented individual. Portraits can thus appear to be both records of specific events and evocations of something more lasting. The power of portraiture rests largely in this tension between the temporal and the permanent.

## The portrait as a work of art

A portrait is a work of art like any other, but portraits are also a special class of object that can resist classification as art. As Richard Brilliant has put it, 'There is a great difficulty in thinking about pictures, even portraits by great artists, as art and not thinking about them primarily as something else, the person represented.'[2] One way of testing the portrait's status as an art object is to look at the history of portrait collections and portrait galleries and to map the motivations behind them. Aesthetic value—the perceived quality of the portrait as a skilful, inventive, or beautiful work of art—has only rarely been the primary inspiration in the commissioning, display, and reception of portraits.

Portraits of family members were an important component of art collections from the ancient world, but there are a number of cases of collectors who sought out and gathered portraits as the primary focus of their acquisitiveness. It is notable that some of the earliest art galleries were galleries of portraits. Pliny the Elder mentions that the kings of Alexandria and Pergamon collected portraits of famous poets and philosophers.[3] This legacy was noted when portrait collections of illustrious men became common in both Italy and northern Europe from the fifteenth century. Portraits of eminent men were often displayed in the libraries or studies of Renaissance princes and dukes as objects of inspiration and emulation. Federico da Montefeltro employed Justus of Ghent at Urbino in the 1470s to paint a series of famous men, and Castagno produced a similar series in around 1450. In each of these cases, the portrait formula was the same for each individual represented, and the effect of the whole outweighed the power of any one likeness. One of the earliest and most extensive of these was the collection of the sixteenth-century Bishop of Nocera, Paolo Giovio. In a letter of 28 August 1521 to his friend the secretary of the Duke of Mantua, Giovio claimed that he wanted to bring together 'true portraits of men of letters, the sight of which will stimulate men to virtue'. By the late 1530s, he had collected nearly 400 portraits of famous men, which he displayed in his villa at Lake Como. These portraits were divided into categories representing living and dead men who were known for nobility of spirit, saintly actions, military valour, writing, art, or leadership. The collection was exclusively devoted to men, and

**21 Stefano Gaetano Neri**
*Room of Self-portraits in the Uffizi*, 1753–65

The Uffizi Gallery in Florence was originally designed by Giorgio Vasari in the sixteenth century as an office building for Duke Cosimo I de' Medici, but Cosimo's successors changed its function to that of a gallery housing one of the most important art collections in the world. Among the works collected by the Medici family in the sixteenth and seventeenth centuries were self-portraits by artists such as Domenichino, Guido Reni, and others. By the eighteenth century it had become traditional for artists visiting Italy to offer a self-portrait to the Uffizi collection. Artists such as Joshua Reynolds, Elisabeth Vigée-Lebrun, Jacques-Louis David, and Arnold Böcklin contributed. Today this collection includes nearly 1500 works, but it is not readily accessible to the public.

although Giovio paid some attention to the artistic merit of the chosen works, his primary concern was the identity of the sitters.[4]

A focus on the identity of the sitter, independent of questions of aesthetic value, is a leitmotif in the history of portrait collections. Increasingly, collectors gathered portraits of individuals that fell within particular categories, such as artists, beautiful women, or monarchs. Giovio's Como collection was one of the earliest examples of a tendency that proliferated in Italy, Spain, the German states, and the Low Countries by the end of the sixteenth century. When Cosimo de' Medici decided to start his own portrait collection, he commissioned the artist Crisofano dell'Altissimo to copy Giovio's collection in 1553. In the seventeenth century, Cardinal Leopoldo de' Medici augmented this collection of copies into what eventually became the Uffizi collection of artists' self-portraits [**21**].[5] The fact that many of these portraits were copies, rather than original works, suggests that artistic authenticity was not a major concern. Although portrait collections were displayed as art works, the motivation behind their exhibition was more often dynastic, national, or institutional.

In the sixteenth and seventeenth centuries the dynastic portrait collection was prevalent among the European monarchy and aristocracy. Portrait collections such as that of Ferdinand of Tirol or Maria of Hungary represented royal families usually in a patterned or stylized manner, showing the sitters in poses that visually echoed or complemented each other [**22**].[6] Such portraits could take the form of panel paintings or tapestries and could be introduced into decorative schemes, such as state rooms or long galleries, to create an impression of family continuity. Often such collections would serve as a kind of genealogical tree, to confirm the pedigree of the portraits' owners, or to

establish their relationship with the current monarch. This dynastic portrait collection was further domesticated by the eighteenth century when owners of country houses in Europe displayed portraits of family members and ancestors. Portrait series such as these were produced by a single artist or group of artists who had never met or seen many of the deceased subjects of the portraits.[7]

By the nineteenth century the dynastic emphasis in these early private collections was displaced somewhat by a greater number of portrait collections that represented national, rather than family, interests. One of the earliest of these was the group of portraits amassed by the American artist Charles Willson Peale and exhibited in his 'Gallery of Illustrious Personages', which opened in Philadelphia in the 1770s. Peale's collection included examples of famous Americans, many of whom had signed the Declaration of Independence and been figureheads in the subsequent War of Independence [23]. Peale himself was a republican, and his patriotic impulses lay behind this series of portraits glorifying the American revolution and its heroes, some of which he painted himself.[8] Thus in this case the portrait collection was not a means of emphasizing family heritage but of referring to successes in American history through the faces of worthy individuals who had contributed to national goals. Peale's gallery included both portraits and objects of natural history. His coupling of the faces of American patri-

**23 James Sharples Sr**

*James Madison*, c.1796–7
This is one of a number of
portraits by Sharples of
American heroes of the War of
Independence that formed
part of Charles Willson Peale's
'Gallery of Illustrious
Personages'. Peale originally
opened this gallery in his
home in Philadelphia in the
1770s, and it contained both
portraits and artefacts of
natural history. In the mid-
1790s the museum became
too large for his home and was
moved to the Philosophical
Hall in State House Yard and
later State House
(Independence Hall). Peale's
eclectic collection of artefacts
and portraits was unique, but
the large number of portraits
made it one of the earliest
national portrait galleries.

ots with natural objects links his collections to cabinets of curiosities—
eclectic collections of art and 'wonders' that had dominated European
collecting practices before the advent of specialized museums in the
eighteenth century. Both the natural and the national histories were
thus a kind of taxidermy or preservation of the past, significantly
juxtaposing nature with the nation.

In the 1850s, G. F. Watts in England undertook a similar project by
painting a series of portraits of distinguished living men. While Peale
always anticipated a wide public audience, Watts's project was a private
one; whereas Peale chose to include portraits by a number of different
artists, Watts was solely responsible for painting the portraits in his own
collection. Nevertheless Watts's project had resonances for the founda-
tion of the British National Portrait Gallery in 1856.

THE FUNCTIONS OF PORTRAITURE 47

**24 Anonymous**
'Welcome!' Cartoon from
*Punch*, 11 April 1896
Although founded in 1856,
the English National Portrait
Gallery had no permanent
home until 1896, when it
moved to St Martin's Place in
London. A spate of publicity
appeared on the occasion of
the opening of the new gallery
building. In this example, the
figure of Britannia in the
centre is gesturing to a range
of portraits of British
monarchs and statesmen
come to life. The nationalistic
flavour of this cartoon is
indicative of the rhetoric that
surrounded the portrait
collection from its inception,
when it was seen to be more
important as a repository of
British history than as a gallery
of art.

The debates surrounding the foundation of the National Portrait Gallery in London further indicate the tensions between the perception of the portrait as a work of art and the sense that portraits have a broader function. In the mid-nineteenth century, when discussions were underway about the formation of a gallery of portraits, some argued that only portraits of high aesthetic quality should be allowed in the collection, but the debate was dominated by those who emphasized the historical importance of visages of significant people from British history. The founder of the concept of the National Portrait Gallery, Philip Henry Stanhope, made this clear in a speech to the House of Lords on 4 March 1856, when he indicated that the gallery should include 'those persons who are most honourably commemorated in British history as warriors or as statesmen, or in arts, in literature, or in science' [24].[9] The portrait gallery was thus set up with an ideal of national celebration, and the choice and arrangement of the exhibitions inevitably presented this history with particular biases.

Such debates have been revisited in the formation and display of national portrait collections in other countries. For example, a 1990s publicity leaflet for the National Portrait Gallery in Washington DC stated: 'This is a history museum. By the time you finish with this, you will have seen all of American history.' Portrait collections have often become adjuncts to national histories in other contemporary galleries. For example, American colonial portrait collections are frequently hung next to antique furniture in American museums such as the Rockefeller Museum in Williamsburg, Virginia, and the Wadsworth Atheneum in Hartford, Connecticut. Portraits seem to evoke the feel of an era by providing faces of contemporary people in the midst of period furniture. In European countries as well, portraits are still displayed as dynastic or historical artefacts rather than works of art in their own right. The Schweizerische Landesmuseum in Switzerland includes portraits as part of a display of history, separated from works of other genres displayed in the art galleries in Zurich; Schloss Ambras in Innsbruck houses the Austrian national collection of royal portraits, while other old master works get pride of place in Vienna's principal art gallery, the Kunsthistorisches Museum.[10] The attempt to site portraits as if they are unproblematic reflections of a time, place, and national identity is compounded by the choices made about what sort of subjects should be chosen for display. For example, curators have wrestled with the problems of bringing marginal or oppressed figures into such portrait pantheons, even though portraits of these individuals are more rare than those of their noble, powerful, or famous contemporaries.

The tendency to see portraits as something other than works of art has been reinforced by their centuries-old association with institutions of various kinds. Portraits of company presidents, university vice-chancellors, distinguished scientists, or members of royal families grace

appropriate institutional settings, but these portraits can adhere so
rigidly to conventions that they can be virtually invisible on the walls of
the buildings in which they are hung.[11] As soon as a group of portraits
is put together, the viewer is invited to see them as a collection of
people, rather than a display of art works.

There have been alternative views, however. In the sixteenth cent-
ury, when portrait collections were becoming popular, writers also

began to recognize the quality of the artist above the virtues of the sitter. Bembo, Aretino, and Castiglione wrote poems praising artists such as Giovanni Bellini, Raphael, and Titian for their portraits; in each case, their emphasis was less on the subject of the portrait and more on the skill of the artist.[12] In the nineteenth century, when national portrait galleries were in their formative years, connoisseurs were beginning to collect portraits by eighteenth-century artists such as Gainsborough and Reynolds for their value as beautiful samples of old master painting rather than for the fame of the sitter.

## The portrait as biography

Portraits share affinities with the literary form of biography. Analogies between portrait and biography are certainly common. The eighteenth-century portrait painter and art theorist Jonathan Richardson most famously wrote:

A Portrait is a sort of General History of the Life of the Person it represents, not only to Him who is acquainted with it, but to Many others, who upon Occasion of seeing it are frequently told, of what is most Material concerning Them, or their General Character at least . . . These therefore many times answer the ends of Historical Pictures.[13]

Richardson here hints that the portrait can convey the same sort of information about an individual as a biography can. This was certainly a common assumption from the sixteenth century onwards, as biographies were frequently published with engraved portraits of their subjects. Furthermore, literary portraits, based on a tradition that dated back to Lucian in the second century AD, were a popular means of evoking a picture of an individual through the medium of words. Literary portraits were briefer and sketchier than biographies, and they thus approximated the snapshot moment of visual portraiture. The relationship between biography and portraiture reached a peak in the eighteenth and nineteenth centuries, notably exemplified by James Granger's *Biographical History of England from Egbert the Great to the Revolution* (1760). Although the original publication of Granger's book was in a single volume, subsequent editions were augmented with so many engraved portraits that by 1824, the history consisted of six volumes. However, despite what seem to be clear links between the verbal and visual representation of an individual, the relationship between portrait and biography is not a straightforward one. Although the two modes reinforce each other, they also serve clearly separate functions.[14]

The momentary nature of portraiture—its 'occasionality'—as well as the portrait's paradoxical impression of a timeless or iconic image, is at odds with the more sprawling and developed aspects of character and

action that comprise biographical writing. From the fifteenth century, however, portraitists attempted to deepen the significance of their work by including mottos, emblems, or other clues to the character of the sitter. Pope-Hennessy called this the 'augmented portrait'.[15] Portraits by sixteenth-century Italian artists commonly included verbal mottos, sometimes invented and sometimes taken from classical literature. These mottos, called *imprese*, could appear on scrolls, sleeves, books, or ledges. They could refer generically to the evanescence of life or the inevitability of death, or to the character or moral qualities of the sitter. In works such as these, the portrait veered towards biography's recounting of the characteristics of the subject, but what the portrait could not achieve was a demonstration of that individual's actions or behaviour. As portraits could be tied to conventions of gesture and expression, the presentation of character frequently had to be enhanced by these additional literary tags.

In the sixteenth century, this use of *impresa* and literary tag engaged with contemporary ideas of character. The German artist Lucas Cranach's portraits of Dr Johannes Cuspinian and his wife Anna [25] are examples of the way an artist could use astrological symbols to elucidate the character of the sitters. Sixteenth-century notions of character partook of the ancient idea that an individual's behaviour was determined by the dominance of one of the four humours. In these paired portraits Cranach placed an image of the children of Saturn from an astrological fresco behind Johannes, indicating a saturnine or melancholy character. His wife Anna is accompanied by the attribute of a parrot, which evokes a sanguine personality. However, the poses, gestures, and expressions of the sitters themselves are conventional and unrevealing.

There are more differences between biography and portraiture than simply the medium of representation. Biographies chronicle the lives and achievements of individuals, often deceased. Before the twentieth century, biographies were largely organized on a chronological basis, following conventions of revealing the character, appearance, and actions of the subject from birth to death. The particular moment chosen for a portrait cannot be extended in such a way: it represents the individual's appearance at a specific point, and other aspects of his or her life can only be alluded to. *Imprese* and other forms of verbal device in portraits act as footnotes to the momentary image, but their artificiality can often jar with the illusion that we are looking at a living person at a given moment.

Furthermore, the nature of what constituted a biography gradually changed after the sixteenth century. Early biographies focused on establishing the higher worth of their subjects through carefully selected revelations of action and character. Biographies could also catalogue eccentricities or faults of character, as witnessed by the Italian

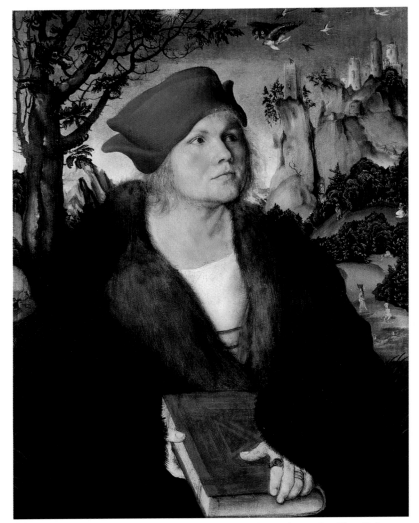

Vasari's *Lives of the Artists* (first published 1550) or the Englishman
Aubrey's *Brief Lives*, which was compiled in the seventeenth century
but not published in full until 1813. However, in these cases, the subject's
faults were also seen to contribute to a picture of his or her character. In
the nineteenth and twentieth centuries, biographies began to offer
more probing considerations of the motivations and personality traits
of the subject, as well as to more intimate aspects of their subject's lives.
During the same period, portraits similarly undergo a transformation
from the representation of generic traits to a greater probing of charac-
ter, but it could be said that this is where the similarity between the two
genres ends. A portrait can take on only the most basic elements of a
biography, while a biography cannot convey the presence of the indi-
vidual with such immediacy and evocative power.

## The portrait as document

The occasionality of portraiture gives it a more prominent relationship with historical documents. Portraits are representations, not documents. Portraiture, however, can have a documentary feel: the depiction of a named individual; the details of dress, setting, and props; and labelling of the sitter's name and age can all evoke the specificity of a particular time and place. However, as with any historical document, it is important to balance what seems to be the presentation of 'facts' with the ways those facts were represented and understood.

Like documents, portraits often contain words. These words can appear on a scroll or piece of paper within the representation, or they can be written on the canvas itself or on the frame. The use of labels to

indicate the age of the sitter, the date the portrait was produced, or other pieces of information was commonplace from the fifteenth century. The dominance of these words in some portraits, such as the anonymous portrait (1616) of the native American Pocahontas [**26**], suggests that they were especially important in establishing the authenticity of the likeness. The use of words to identify Pocahontas confirms the historical placing of the sitter, but in this case the claim for authenticity was misleading, as this portrait was a third-hand image—copied from a print which itself was copied from a drawing.

It might be asked what the use-value of such 'documentary' portraits might have been. In the centuries before photography, portraits were the only way of conveying the appearance of an absent or unknown person, and they were a method of preserving the physical appearance of someone that would remain after their death. Portraits also could act as reminders of particular events, such as marriages, treaties, or diplomatic visitations. For example, an anonymous portrait of a Moorish ambassador from the early seventeenth century [**27**] provides a docu-

ment of the age of the sitter, Abd el-Quahed ben Messaoud Anoun, and the date he visited England and the court of Queen Elizabeth I. However, the format of this work appears formulaic and possibly indicates that it could have been part of a series similar to Giovio's collection of eminent men. Contradictory signals, however, appear in the distinctive physiognomy of the sitter, which gives the work a dramatic quality that prefigures the Moorish stereotypes in Shakespeare's *Othello*, which was first performed four years later. The documentation of the sitter's age and visit are thus in tension with both the formulaic and stereotypical qualities of the portrait.

Although it may be common to look at portraits solely as documents of identities or events, portraits are more complex than this simple

**27 Anonymous**

*Portrait of Abd el-Quahed ben Messaoud Anoun, Moorish Ambassador to the Court of Queen Elizabeth I, 1600*

The origins of this work are not known, but the canvas is clearly dated 1600. The format of this portrait seems to indicate that it might be part of a series. If this is the case, the series possibly commemorates the visitation of other foreign ambassadors to the court of Elizabeth I, although unfortunately no other similar works have yet been located.

analogy allows. One of the clearest demonstrations of this can be seen by examining the art-historical debates about the meaning and purpose of Jan Van Eyck's *The Arnolfini Marriage* [**28**]. Although this work has been subjected to a variety of conflicting interpretations, art historians are compelled to engage with Erwin Panofsky's assertion in 1934 that this work served as a document of a marriage ceremony.[16] As one of the first free-standing whole-length double portraits, this work was an innovation in early fifteenth-century painting. It represents the Lucchese merchant Giovanni Arnolfini and his wife Giovanna Cenami. Their hand gestures and the symbolic accoutrements of the room suggest they are engaged in some sort of ceremony or ritual. What convinced Panofsky of the documentary nature of this work was the presence of an inscription on the back wall, 'Jan Van Eyck fuit hic' ('Jan Van Eyck was here'), and the accompanying appearance of Van Eyck in the room, seen in the mirror on the back wall. Panofsky felt that this combination of elements established the work as a document of the sacrament of marriage, which in this case had been conducted as a private ceremony with Van Eyck as a witness. Panofsky's interpretation has provoked many objections and a number of questions: why would a couple go to the expense and trouble of using a portrait as a document of their marriage, when a simple piece of paper would do? How would such a document be used? To what extent does this bland documentary quality conflict with the highly complex symbolic functions of the objects in the room?[17] Furthermore, the portrait is packed with the kind of religious symbolism normally associated with altarpieces. The 'documentary' quality of the inscription sits uneasily with the moralizing symbolism of the fruit on the table (either innocence or its loss); the burning candle (possibly the eye of God); the dog (fidelity); the image of St Margaret, the patron saint of childbirth, carved on the chair; and the clogs cast aside as a sign of holy ground. The portrait is thus much more complex than the label of 'document' allows. However, though convincingly rebutted, Panofksy's argument raises important issues about how a portrait might serve the function of a historical document and the way the written inscriptions on the portrait contribute to this purpose.

What underlies such uncertainty about the documentary nature of portraiture is the way artistic interpretation and representation always undermine any authenticating information that might be appended to a work of art. However, it is fair to say that portraits are—and have always been—used for documentary purposes. From ancient times, portraits on coins serve both to establish the identity of the current reigning power and to consolidate that authority by making the appearance ubiquitous. Portraits were used to validate identity in the early modern period, when they were employed in lawsuits or in campaigns to track down conspirators. Portraits appeared in early manuscripts, for

instance in the roll of pleas in the court of the King's Bench in England, as authenticating records of individual identity.[18] Artists could employ portraits for utilitarian purposes: Albrecht Dürer, for example, produced a famous portrait drawing of himself (*c*.1512–13) as a means of demonstrating a painful sore to a distant doctor. In eighteenth-century Mexico, families commonly commissioned portraits of daughters who were going into convents, and such portraits are riddled with references to the women's marriage to the church.[19] Portraits have been used effectively by costume and furniture historians as a way of reconstructing the appearance of garments, textiles, or tapestries, for which the actual material evidence is minimal or has been damaged by the ravages of time. Portraits remain an intrinsic part of the legal system in Western countries: passport photographs allow individuals to travel and identi-kit and photo-fit records of suspected criminals have been produced as part of police investigations since the late nineteenth century [**29**].

In the early twenty-first century, the documentary nature of portraiture has been both embraced and rejected. In 2001 the British artist Marc Quinn was commissioned to produce a portrait of the geneticist Sir John Sulston for the National Portrait Gallery in London. He chose to display a DNA culture taken from Sulston. The 'portrait' was there-

**29 Alphonse Bertillon**
*François Bertillon*, 1902
Bertillon worked for the Paris police department in the 1880s, pioneering photographic methods of criminal identification. Bertillon used his relatives as subjects in portraits such as this one. He photographed his sitters full face and showing both profiles, claiming that photographs posed in this way, along with records of height and length of arms and legs, could be used to identify criminals. Bertillon's documentary method of portrait photography is still used in criminal investigations today.

fore both invisible to the naked eye, and it provided the ultimate confirmation of Sulston's distinct identity. Quinn called this the 'most realistic portrait in the gallery', and it could be argued that the use of DNA relegates the portrait to a piece of forensic evidence that confirms Sulston's genetic individuality.[20] However, it could also be argued that Quinn's artistic gesture involves the kinds of choices that all portraitists make about how best to represent their sitters. As Sulston's fame came through his involvement with the human genome project, Quinn's use of DNA parallels the methods of artists who use props or costume to signal the individuality of their sitter. Portraits can appear to provide documentation or authentication of a person's appearance, age, status, or even biological identity. But the imaginative and interpretative aspects of all portraiture make it resistant to documentary reductivism.

## The portrait as proxy and gift

Perhaps one of the major problems with seeing portraits as documents is how the presence of the individual calls upon the viewer to respond to a person rather than a piece of information. So even while portraits were used to identify conspirators or to document the appearance of kings and queens at a given moment, they also had an immediacy and a presence that enabled them to stand in for the real people they represented. Many portraits have this power. Roland Barthes in his *Camera Lucida* has written most eloquently about the effect a portrait photograph of his mother had upon him.[21] Although the photograph recorded his mother as a little girl, long before he was born, the associations he had with her as an older woman were sharpened and awakened by viewing the photograph. The power of the photograph was further enhanced because it documented a moment that was past and could never be recovered. Although Barthes was writing about photography, portraits in other media have long been felt to have this effect. The portrait seems to offer the viewer a magical substitute for the individual depicted by bringing a past moment of that person's life into the present.

The nature of portraits as a proxy or substitute for the sitter was an effective metaphor in Italian Renaissance poetry by writers such as Aretino and Bembo. Poets often addressed portraits as if they were writing to living individuals, and artists exploited the portrait's immediacy and engagement with the viewer by choosing poses, gestures, and expressions that seemed to call the viewer into the picture, rather than excluding them from it.[22] The private engagement with the sitter's visage was reinforced in the sixteenth, seventeenth, and eighteenth centuries with the popularity of miniatures and pastel portraits [30]. Miniatures were small portrait images that could be held in the hand, or placed inside lockets, snuff boxes, or other tiny ornaments. Their minute size functioned to create a seemingly private relationship between the sitter

**30 Nicholas Hilliard**
*Sir Walter Raleigh*, c.1585

Although other types of subject matter were occasionally represented on miniatures, the portrait dominated miniature painting from its inception in the early sixteenth century. Miniatures were originally part of illuminated manuscripts, but in England and France in the 1520s they were devised as separate objects. Portrait miniatures were popular for their intimacy and the skill with which these often tiny likenesses were produced. Hilliard was court miniaturist and goldsmith to Queen Elizabeth I. His interest in the technique of taking portrait likenesses can be seen in his manuscript, *The Arte of Limning*, which was written between 1598 and 1603 but not published until 1912.

and the owner of the image. Similarly intimate was pastel portraiture, which was invented in the early eighteenth century and quickly became a popular method of taking an engaging and lifelike portrait. In the hands of talented artists like Jean-Étienne Liotard the soft tones of pastel could mimic the texture of flesh and enhance the immediacy of the portrait image [31]. Because they rendered the person both lifelike and seemingly touchable, miniatures and pastels potentially had an erotic or fetishistic quality and were collected obsessively.

The talismanic and erotic charge of portraiture may have been one of the reasons that portraits were frequently used in marriage negotiations among European royal families. Families intermarried for the purposes of expanding dynasties and power bases, but potential spouses more often than not lived a prohibitive distance from each other and therefore could not meet before the marriage ceremony took place. It was thus common to use the portrait as a way of undertaking marriage negotiations. The portrait then served the function of validating the age and physical attractiveness of the sitter, as well as their state of health. Henry VIII most famously employed Holbein in his efforts to seek out a wife to succeed Jane Seymour. Holbein was forced to do the travelling, while Henry stayed in England and examined the portraits of potential wives. Holbein's exquisite skill in portraiture played no small part in Henry VIII's decision to wed Anne of Cleves [32], but when he first met her his distress at her real appearance allegedly contributed to their speedy divorce. Whether or not this story is true, it attests to the perceived power of the portrait image and its role in human relationships.

Since portraits could serve as proxies for the individual represented,

they were often exchanged as gifts. Roman consuls commonly presented portraits in the form of ivory, wood, or metal diptychs to friends or to emperors to demonstrate their respect. In the fifteenth and sixteenth centuries the exchange of portraits was a prominent means of affirming friendships, particularly among young men. Individuals would have their likenesses made or copied for the purpose of giving them to a friend or relative. This was particularly the case in educated circles. For example, the humanist Erasmus in Rotterdam commissioned a portrait of himself from Quinton Metsys in 1517 specifically as a gift for Thomas More in London. This acted as an affirmation of common belief and mutual respect. This tradition has had a striking longevity. For example, Van Gogh and Gauguin exchanged portraits shortly before they were due to come together for what turned out to be an ill-fated partnership in the French village of Arles in 1888. The English boarding school Eton College had a long tradition of asking its leavers to donate a portrait of themselves to the school, and something of this tradition remains in scholarly communities. For example, in

**32 Hans Holbein the Younger**
*Anne of Cleves*, 1539
After the death of his third wife, Jane Seymour, Henry VIII's intention to marry a foreigner was partly motivated by his desire to ally himself with other anti-papal powers. However, this decision also had an artistic impact. Because Henry was notoriously covetous of beautiful women, he felt he had to see an image of his wife-to-be before committing himself, despite the underlying political impetus behind the marriage. Holbein was sent to the Low Countries as an envoy, and he produced this three-quarter composition of the daughter of the Duke of Cleves. Anne's frontal pose and direct gaze are unusual in a portrait tradition that placed women in part profile and looking off into the distance.

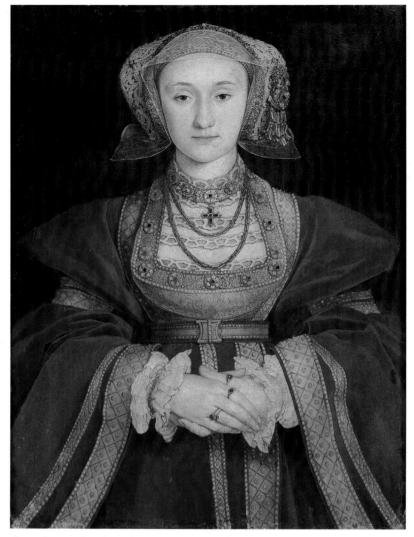

American schools today it is common for children to exchange portrait photographs with their friends.

The portrait thus has a sort of power that allows it to be thought of as a substitute for the individual it represents. The use of portraits for marriage negotiations, gifts, and private contemplation grew from the power of a portrait not only to stand for the represented individual, but also to evoke the individual's presence in the minds of viewers.

## The portrait as commemoration and memorial

Whether portraits serve primarily an aesthetic, biographical, documentary, or proxy function, they are often associated with the past, with memory, and—by extension—with death. Portraiture almost magically

retains the life of individuals who are dead, or the youth of individuals who have aged. Louis Marin has argued that as the portrait seems to bring the dead back to life, or to bring the past into the present, it serves the same kind of function as other types of commemoration—specifically the panegyric and the funerary oration.[23] Portraits offer their sitters a kind of immortality, but they also act as relics, souvenirs, or as a stimulus to memory.

The relationship between portraits and rituals of death and burial is an ancient one. Indeed, it could be argued that portraits were originally invented to serve ritualistic funerary functions. In early Oceanic and South American cultures, the portrait was considered to be a trace of the dead individual. The importance of the trace was also felt in ancient Rome, where it was common practice to take a death mask in order to preserve the likeness of a family member for posterity. In Egypt, realistic portraiture was necessary, given the strongly held belief that dead people needed a body to inhabit when they died.[24] Such a pragmatic use of the likeness was also part of ancient Chinese culture, where identifiable and distinct likenesses enabled families to recognize and worship the correct ancestor.[25] However, early portraits also commemorated the dead (for example, the Fayum portraits from Roman Egypt in the first to second century AD [**33**]) and served to remind the living of an exemplary life (such as classical Greek portraits on tomb stelae). James

**33 Anonymous**

*Portrait of a Woman,*
AD 190–220

One of the most interesting aspects of Roman Egyptian portraiture is its variety of forms. Fayum portraits were painted in either a wax-based (encaustic) or a water-based (tempera) medium, and they appeared on mummy shrouds as well as on wood. This portrait actually forms part of a coffin lid, and includes the sitter's hands as well as details of costume and props such as corn ears and a pomegranate.

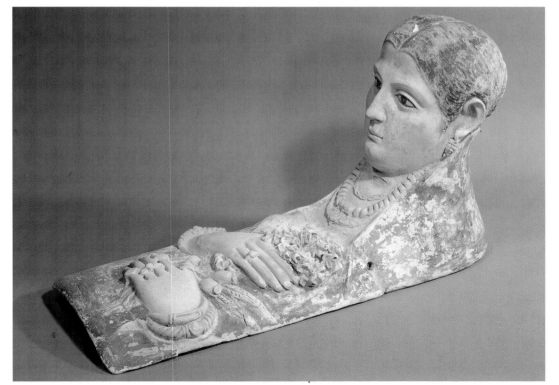

Breckenridge has argued that the majority of ancient portraiture played such a funerary role, but in his view true portraiture privileges the likeness of an individual over any religious or ritual function.[26] Although he makes a solid case for portraiture as distinct from artistic genres associated with death rituals, the relationship between portraiture and death is not one that ends with the ancient world.

From the Middle Ages onwards, portraits have formed a prominent part of tomb sculpture. Originally tombs would include only effigies of the dead individuals, and often these were stylized and interchangeable. But portraits on later medieval tombs begin to show distinctiveness in individual features as it became increasingly important to allude to the person who had died, rather than making only a generic reference to life and death. The direct relationship between portraits and tomb sculpture in these earlier periods may have contributed to an association between portraiture and death that persisted for centuries. As David

Piper eloquently put it: 'the painted portrait may often seem to be but a domesticated tomb-effigy'.[27] Certainly from the fifteenth century onwards, portraits included the presence of dead individuals amidst the living, and references to death in portraits of the living. Given the prevalence of sudden or premature death, it was common for patrons to request that portraits include representations of loved ones who had died. The English portraitist John Souch's representation of *Thomas Aston at the Deathbed of His Wife* [34] commemorates an actual death, but artists were generally less obvious in their references. In the next century, Hogarth included a deceased sibling in his famous portrait of *The Graham Children* [see 81], and in *The Cholmondeley Family* (1731) he represented a wife who had died of consumption in France and whose body had been lost at sea. He included both of these dead people as if they were part of the living scene: in the case of the Graham child, Hogarth began painting him before he died, but he had to resort to copying an old miniature for his portrait of the deceased Mary Cholmondeley. The dead presented as if living was also an attribute of posthumous portraits, which were sometimes produced from death masks.

The inclusion of dead individuals in portraits of living ones was not the only association between death and portraiture. Many seventeenth-century portraits featured a skull as a prop. This was intended to be a *memento mori*, or a reminder of death, which emphasized the ultimate destiny of all the live individuals represented. To show a skull or other symbol of death in a portrait was a way of undercutting the vanity of portraiture by reference to the levelling function of death. This persistent tradition in European portraiture was exploited and used ironically by artists in the nineteenth and twentieth centuries, and it is important to see how the associations between portraiture and death continued, even when death was no longer necessarily associated with religion and elaborate funerary rituals. The Norwegian artist Edvard Munch's *Self-portrait with Skeleton Arm* [35] represents the artist as both living and dead, in a macabre testament to Munch's obsession with the more negative aspects of the cycle of life—a fascination he shared with many *fin de siècle* contemporaries. Revelling in the morbidity of death was more prevalent from the nineteenth century onwards; early modern references to death tended to be reverent, commemorative, or superstitious.

Ironically, because of their apparent vivification of the represented person, portraits had an inextricable relationship with death. A portrait could bring the dead back to life and appear to provide both a trace of a body and a stimulus to memory.

## The portrait as political tool

So far I have shown that although portraits can be seen as aesthetic objects, they also can take on pragmatic and symbolic functions—as

*Self-portrait with Skeleton Arm*, 1895

Munch produced a number of self-portraits that echo the morbid and lugubrious tendencies of his other pictures. This self-portrait also demonstrates Munch's original experimentation with lithography, as he used the effects of the lithograph stone to enhance the gloomy atmosphere of the portrait. Although Munch's work was modern in its introspection and in his novel use of a familiar print technique, he was also exploiting the centuries-old tradition of linking portraiture with death by means of a *memento mori*—in this case, his own skeletal arm rather than the conventional skull.

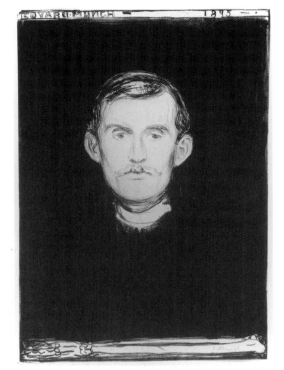

documents, memorials, visual biographies, or as proxies for the sitters. A final function of portraiture that needs to be considered here is the extent to which portraits can and have served as political tools, or as a means of conveying an impression about an individual or individuals that serves some kind of political or power motive.

The use of portraits for political purposes seems at first to suggest propaganda, but there is perhaps a subtle difference between rulers who attempted to coerce or brainwash their subjects by exploiting an image of power, and those whose use of portraiture to convey their authority had a particular social or political function within their specific historical milieu. For example, R. R. R. Smith has argued that in the case of ancient portraiture it is misleading to use the term 'propaganda', which generally has strong negative connotations inappropriate for portraiture that was intended to provide reassuring images of authority.[28] Ancient portraits often depicted their subjects larger than life to stimulate a sense of respect and admiration. The ancient colossal head of the Emperor Constantine I [36] is a good early example of this sort of representation. The physical dimensions of this work are massive, and Constantine is shown with excessively large eyes to stress his wisdom and religious piety as well as his political leadership.

European portraits of monarchs were similarly often envisaged to offer reassuring models of worldly authority, but the authority was signalled in different ways. For example, Holbein's portraits of Henry VIII

represented the monarch as a vast and imposing figure, so laden with expensive clothes and jewels that he nearly bursts out of the canvas. A century later Van Dyck's portraits of Charles I are virtuosic examples of how an artist could take a likeness of the monarch but could also show him in an idealized and ennobled form. Charles I is represented on horseback, or with his horse bowing submissively to him. A king known for his diminutive size was depicted as if he were imposing and inspiring immediate obedience. In the art of the seventeenth century Louis XIV was one of many monarchs who employed portraitists as part of a battery of artists to bolster the image of his absolutist power, but the label of 'propaganda' may not be appropriate for this either.[29]

Portraits were not necessarily propagandist in themselves, but they could be made so through the ways they were copied and displayed in a variety of venues. Copies could not only remind the viewer of a ruler's appearance but also could spread that likeness everywhere and give a sense of omnipresence. This was the case with statues of Alexander the

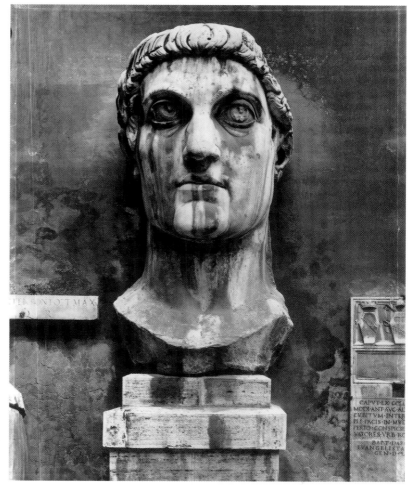

**36 Anonymous**

*Constantine I, c.*AD 315–30
Constantine was the Roman emperor most famous for founding Constantinople, promoting Christianity, and for his patronage of architecture. This large bust portrait of the Emperor resembles representations of Constantine on imperial coinage, and there is speculation that both were meant to be faithful likenesses, despite the idealization present in the enlarged eyes.

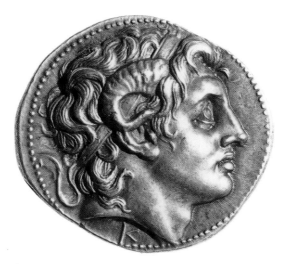

**37 Anonymous**

Coin with the head of Alexander the Great from Pergamum, *c.*297 BC

Coins are one of the earliest sources of portraiture. Coins in the ancient Greek world at first included effigies of gods or heroes. Although stylized portraits of rulers appeared on currency in Lycia and Persia from the early fifth century BC, Alexander the Great was largely responsible for making the ruler portrait a standard feature of coinage. Today we take for granted the convention of including portraits of presidents, kings, and other famous individuals on coins and banknotes.

Great that graced every provincial part of the ancient Greek empire. Replicas of Allan Ramsay's portraits of King George III and Queen Charlotte were not only located in houses of the English aristocracy but also appeared in public offices both in England and in colonial America. Such a method was not only used by monarchs. Martin Luther found printing a useful means of disseminating his own image when his theological arguments became known throughout Europe. The accessibility of Luther's image to disaffected Catholics in many parts of Europe helped fuel the sense of power behind his subversive questioning of Catholic doctrine and played no small part in ensuring his fame. The most obvious example of dissemination through copying is the coin or banknote [**37**], which makes the monarch's image visible to anyone who has money to spend and naturally associates the ruler with the power of currency.

Although portraits served an ideological function by enabling figures of political authority to communicate particular kinds of images of themselves, there were very few who used portraiture systematically to perpetuate a particular image of their leadership. The clearest exception to this was Adolf Hitler, who commissioned many idealized academic portraits of himself delivering the word of National Socialism in Germany during the 1930s. The portraits of Hitler were intended to inspire patriotic and chauvinistic feelings in Germans, as well as to incite hero worship of the dictator, and link him with his own mission of Aryan supremacy. Portraits of Hitler were explicitly promoted by the propaganda ministry headed by Joseph Goebbels.

Although one could certainly question the extent to which the ubiquitous visual presence of a ruler, hero, or controversial individual could constitute propaganda, the attention that rulers played to the creation and dissemination of their portraits suggested that they saw the

political value in the visibility of their likeness. It was common in the ancient and medieval world for portraits to be altered if a ruler was disgraced or deposed, and the portrait in these cases was employed to help rewrite history. Just as portraits could be renamed or altered when the political situation changed, they could also be removed from their visible public spaces and replaced with images of a new leader or hero. This symbolic act of destruction remains prevalent in the twenty-first century. For example, when Iraqi citizens and US soldiers joined together to topple a public statue of Saddam Hussein in Baghdad in April 2003, they were expressing different feelings about the deposition of a dictator but found the destruction of an iconic image the most potent means of signalling their position. The desire to destroy or tamper with likenesses testifies to the political power of portraiture.

# Power and Status

3

Portraits act as signifiers of the status of the individuals they represent. Although it is important not to see portraits as mere reflections of social hierarchies, they can help us understand how specific levels of society were perceived at different periods of history. Through the gestures, dress, props, background, labelling, and other facets of a portrait, we are usually given either clear or oblique signals about whether the subject is rich or poor, powerful or subjugated, and whether they can be associated with a particular profession, class, club, or other group of people. Portraits can also affirm or challenge social hierarchies. These signs of power and status have enhanced the functional value of portraits and decisions about their purchase, display, and exhibition.

Although it is somewhat artificial to separate portraits into categories of status and profession, such a taxonomy may help to reveal the motivations behind the commissioning and reception of portraits in different historical periods. A portrait of a ruler gives different signals and has different functions from a portrait of a famous poet or a beloved family servant. In each case the social role, authority, and power of the individual in their own era helped shape the way he or she was represented in the portrait.

**38 Jean-Auguste-Dominique Ingres**

*Napoleon I on His Imperial Throne*, 1806
This monumental portrait was a product of Ingres's early period and was painted in Paris shortly before he took up the Prix de Rome and moved to Italy in 1806. Although this portrait perpetuates the myth of an invincible Napoleon, it was met with incomprehension by David and visitors to the Salon where it was hung. Ingres's later focus on society portraiture moved him away from the grandiose extremes of this work.

## Portraiture and patronage

Who actually commissioned portraits? There is no simple answer to this question, and the varied functions of portraiture discussed in the last chapter point to a myriad of possibilities. Portraits have been commissioned by individuals and by groups or organizations—nearly always those with wealth and power—to represent themselves or others. The wealthy and powerful have never been the exclusive patrons of portraiture, however. Complaints about portraits of the bourgeoisie, artisans, merchants, and other labouring classes began as early as Lomazzo's art treatise of 1584, which lamented the ubiquity of portraiture:

Merchants and bankers who have never seen a drawn sword and who should properly appear with quill pens behind their ears, their gowns about them and day-books in front of them, have themselves painted in armour holding generals' batons.[1]

Although portraiture has always represented a wide range of classes and professions, monarchs, emperors, popes, presidents, dictators, and members of European court cultures have been the most avid patrons of portraiture. The many portraits that exist of monarchs today—whether their power is honorary or genuine—attest to the strong tradition of rulers commissioning portraits of themselves. However, artists also sought out individuals who were of a lower class, who had little or no prominent public role, or who had distinguished themselves by their creative ability, intellectual acumen, or talent, rather than their power.

## Portraits of rulers

To the ruling elite, portraiture has always had an important function. These individuals were fallible human beings with bodies that aged and died like any others. But they also held highly visible public roles, and, according to ancient ideas of rule, the physical body of the ruler was symbolically overwhelmed by the powerful nature of the office that they assumed. The division between the frail human body and the ideal symbolic body of the monarch is what the historian Ernst Kantorowicz has called 'the king's two bodies'.[2] Portraitists had to engage with the co-existence of both physical and ideal in the body of the monarch; representations of the visages and forms of people who held power needed to signal their authority. This act of negotiation varied in different art-historical periods; with occasional exceptions, however, portraits of rulers continue to emphasize the 'effigy', or social role of the individual, over the likeness or personality. Such depictions have been called 'state portraits', as they serve a largely political function. As Marianna Jenkins put it in her definitive study of state portraiture, 'The primary purpose is not the portrayal of an individual as such, but the evocation through his image of those abstract principles for which he stands.'[3]

This idea of the transcendent authority of the ruler was strongly implicated in religious beliefs, and often the ruler was seen to derive power directly from God. This was particularly true in seventeenth-century Europe, when the theory of the Divine Right of Kings endowed rulers with a God-given authority. However, such a legacy can be traced back to the ancient world, when artists depicted Alexander the Great clad in a panther skin, normally associated with gods, demi-gods, and legendary heroes like Dionysus or Hercules.[4] This symbolism created a visual association between the ruler and the higher order of gods. Medieval and early Renaissance artists made similar connections. One of the clearest ways of doing this was by representing the ruler in a pose normally associated with depictions of Christ. Portraitists have tended to favour poses that put their subjects into some sort of partial profile, breaking up the stark symmetry of a frontal gaze by angling the face and thus preventing the portrait subject from staring too glaringly

out of the canvas. However, in portraits of rulers the frontal pose was used from the third century AD and was associated with Byzantine mosaics of Christ. Frontality was often combined with a seated pose that further reinforced an aura of divinity and command, particularly if the subject of the portrait was seated on a throne. This frontal, seated pose was popular from the fifteenth century when Jan Van Eyck included a monumental figure of God on a throne gazing forward on the inside top panel of his *Ghent Altarpiece* (1432). Echoes of this God-like pose appear in portraits of rulers from Richard II of England to Napoleon [**38**]. Each of these rulers was shown seated, facing the viewer and displaying their authority through both the directness of his gaze and the divine connotations of his pose. Although the stark frontal view was not employed frequently in portraiture, the seated figure was commonly used to represent power.

The poses chosen by portraitists to portray rulers have been remarkably consistent and convey as much about the authority of the subject as the inevitable accompanying symbolic trappings. Other poses used for rulers include the full-length standing position and the equestrian portrait.

The full-length standing figure of the ruler owed its origins to representations of saints, and it is notable that most formal portraits of rulers before the nineteenth century show their whole bodies rather than just a bust or head and shoulders. The many portraits of Queen Elizabeth I of England are examples of this [**39**]. Like her father, Henry VIII, Elizabeth was highly conscious of her royal image, and as she aged and consolidated her power her portraits became increasingly static, stylized, and symbolic. Elizabeth's portraits are a key example of the way the monarchs' symbolic status was more important than their physical likeness. She attempted to control her image by issuing a proclamation in 1563 that allowed only an approved representation, justifying this by suggesting that the 'errors and deformities' of some of her portraits 'grieved' her subjects.[5] This established model showed Elizabeth frozen in an ageless and emotionless beauty, surrounded by symbols of her power and virginity, qualities which were portrayed as interdependent. The portraits were always full length and took on the frontal formula of earlier representations of Christ and the saints.

The full-length portrait of rulers has had a remarkable longevity. It is interesting to note the way some portraits of the first American president, George Washington, employed this European tradition for rather a different purpose [**40**]. Unlike a European monarch, the president of the United States was democratically elected (although the early American practice of democratic election did not mean universal franchise). However, in Gilbert Stuart's 'Lansdowne portrait', Washington is shown standing in a traditional full-length pose that still held lingering associations with saints and divine right. The symbolic

*Elizabeth I* (the 'Ditchley
portrait'), *c.*1592

As she grew older, Elizabeth I
became increasingly
concerned with controlling her
image and having herself
represented as the ageless
Virgin Queen. Later portraits of
her, such as this one, are
replete with complex
symbolism that links her
political power with her
virginity. Unlike the strongly
detailed portraits by artists
such as Holbein favoured by
her father Henry VIII,
Elizabeth preferred a
mannered and decorative
form of portraiture that
underplayed likeness in favour
of themes of regal authority.

**40 Gilbert Stuart**

*George Washington* (the
'Lansdowne portrait'), 1796

Stuart was responsible for
creating an image of George
Washington that has become
one of the most recognized
visages in history. Stuart
painted bust-length portraits
of the American president in
1794 and 1796, and the
second of these became a
model for a series of copies
and reproductions of
Washington's head. The
frequent repetition of
Washington's image—
including its presence on the
dollar bill—has made this face
synonymous with American
political ideals after the War of
Independence.

trappings surrounding him this time are symbols of American freedom
and democracy. Washington stands next to an armchair which is deco-
rated at the top with an oval medallion containing 13 stars and stripes
representing the original colonies of America. The table leg includes
figures of eagles clutching arrows, an emblem borrowed from the Great
Seal of the United States. The books on the floor and table (with titles
such as *Journal of Congress* and *Constitution*) allude to Washington's role
in the political foundations of the American republic. Stuart used this

*Equestrian statue of Peter I,*
1716–44

Rastrelli was part of a family of Italian artists who settled in the court of St Petersburg to work for Peter I. He produced a number of sculpted portraits of the monarch and his family, but his most famous work was this equestrian monument. Taking nearly three decades to complete, the monument was cast after Rastrelli died, and erected over fifty years after his death in front of the Engineers' Castle in St Petersburg.

representation of Washington's face in several portraits, and this particular image became inextricably associated with the idea of the first president. As in the portraits of Queen Elizabeth, Washington's face became a sort of iconic motif even though, unlike Elizabeth, Washington did not issue any proclamations.

The equestrian portrait, however, was almost universally used for male figures of authority. The model for the equestrian portrait was the ancient Roman statue of the emperor Marcus Aurelius, which later became a potent symbol of both leadership and the imperial power of the ancient Roman world. This monument-cum-portrait format was particularly popular in fifteenth-century Italy for commemorations of military heroes, for example. The most notable of these, Donatello's statue of Gattamelata in Padua (1443–53) and Verrocchio's Bartolommeo Colleoni in Venice (begun 1479), adopted the form of the Marcus Aurelius statue for Cinquecento purposes. The monumental equestrian portrait continued to be used for several centuries, not only in western Europe but in other parts of the world as well [41]. The same format

**42 Titian**

*Emperor Charles V at Mühlberg*, 1548
Titian's equestrian portrait of the Holy Roman Emperor Charles V was clearly inspired by the ancient Roman equestrian statue of Marcus Aurelius, but it also alludes to the Christian Knight of Dürer's allegory, *Knight, Death and Devil*. The latter is a particularly appropriate reference as the Battle of Mühlberg established Charles's victory over the Protestants. Titian's portrait is thus both a symbolic portrait and a narrative of victory, and it straddles a fine line between portraiture and history painting.

was also successful in painted portraits, most notably Titian's portrait of Emperor Charles V in the midst of his victory over the united Protestant forces in 1547 [**42**] and Van Dyck's portraits of Charles I of England. In each case, these monumental works expressed the majesty of the leader, his control over nature, his military valour, and his towering stature above ordinary subjects. Whether seated on a throne, standing in a full-length format, or sitting astride a horse, these different types of poses became iconically linked with the power and authority of the leader.

Most of the poses discussed so far represented the ruler's entire body, but a different strategy of projecting leadership focused on the isolated head of the ruler, usually depicted in profile. Coins and medals provided a schematic image of rulers from the fifth century BC onwards, and stamps became the modern equivalent of this form of dissemination. In ancient Greece and Rome, the use of a ruler's profile on coins became a means of establishing his identity throughout his often geographically dispersed empire. The self-conscious revival of the profile portrait in

*Meeting between Ludovico and Francesco Gonzaga*, the Camera degli Sposi, Palazzo Ducale, Mantua, 1465–74

Mantegna was lured by Ludovico, Marquess of Gonzaga, to Mantua, where he came and settled in 1459, working primarily for the Gonzaga court for the rest of his life. Among his commissions for the court Mantegna was asked to decorate the wedding chamber ('Camera degli Sposi') in the Gonzaga palace. The result was a complex composition containing many members of the Gonzaga family, young and old, amidst a landscape and cityscape filled with detail. Although many portraits were included in the composition, the frescoes also served to give a flavour of the daily life of the Mantuan ruling family. This section of the fresco includes Ludovico himself and his second son, Francesco.

fifteenth-century Italy led to its use again on coins and medals, but this time the iconic authority of civic leaders was enhanced by the association of the pose with the power of ancient imperial Rome.

Another common way leadership and power were signified in portraiture was by a blending of portraiture with history painting. History painting—what the Renaissance theorist Leon Battista Alberti called *istoria*—traditionally represented gods and heroes enacting great deeds, or displaying moral virtue or physical valour. As history painting was normally about people in the past, the representations of these people were inevitably imaginary, and the life-likeness of portraiture was contrary in principle to the purpose of history painting. However, artists

were happy to blend the two genres and show living individuals amidst historical or heroic characters. The boundaries between contemporary people and timeless heroes or saints thus became blurred. This was a common practice in Italian Renaissance art, in which the faces of high-born men and women often stood in for saints and martyrs, or appeared as witnesses to significant moments of Christian history. A notable example is Ghirlandaio's frescoes of the life of St Francis in the Sassetti Chapel in Santa Trinità, Florence. Here the life of St Francis is told in a complex iconographic programme, which includes familiar members of the Tornabuoni family, who were patrons of the chapel, witnessing and participating in Francis' life and miracle working. Using a somewhat different tactic, Andrea Mantegna created a history-like representation of the Gonzaga family in his fresco devised for their private chambers in their palace in Mantua [43]. In this fresco Mantegna depicted the interactions between the family members through detailed study of their visages amidst an elaborate landscape setting.

The incursions of portraiture into history painting were consolidated by the theory and practice of the eighteenth-century English artist Sir Joshua Reynolds, who justified the prevalence of portrait practice by claiming that portraits could be raised to the level of history paintings through an appropriate combination of symbolic trappings and painterly technique. Reynolds contended that by devoting attention to the 'general' rather than the 'particular', artists could transcend the mundane mimetic qualities of portraiture and create works of lasting significance.[6] His own means of achieving this was by depicting his subjects in the poses of ancient sculpture or old master paintings, and dressing them in timeless garments that elevated the sitters by association with ancient deities [see 95]. It is notable that many, but not all, of Reynolds's sitters were from the higher echelons of society, although he was never asked to produce a formal portrait of King George III and Queen Charlotte. The blurring of history painting with portraiture was thus another way of signalling the power of the already powerful through visual and historical associations.

Paradoxically, although people without power were slow to appropriate the portrait formats of rulers and aristocrats, by the seventeenth and eighteenth centuries it became increasingly common for monarchs, the aristocracy, and the gentry to commission portraits of themselves in domestic settings or intimate circumstances. In many instances, such portraits still contained vestiges of standard power portraits, such as the standing or seated full-frontal pose, or elaborate symbolic trappings. However, these portraits were domesticated in a number of ways. Portraits were more frequently set in private rooms or other intimate spaces, rather than state rooms or theatrically curtained and columned interiors. These portraits more often included children, or animals shown playing or interacting with the adults and adding an air of

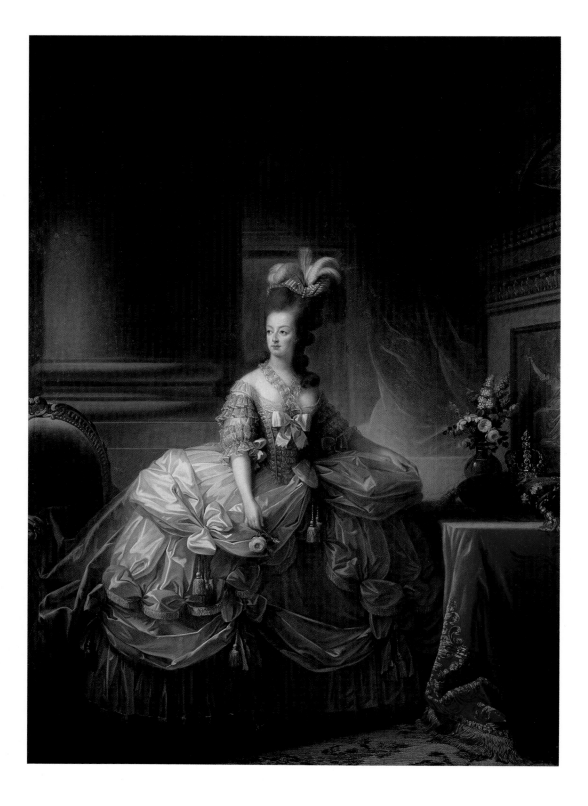

**44 Elisabeth Vigée-Lebrun**
*Portrait of Marie-Antoinette,*
1778–9

The patronage of Queen
Marie-Antoinette was both a
support and an obstacle to the
career of Vigée-Lebrun.
During the 1770s and 1780s
she produced around 30
portraits of the queen and was
in heavy demand among the
French aristocracy even
though she was a woman.
However, when Marie-
Antoinette was disgraced and
executed in 1789, Vigée-
Lebrun's former associations
with the queen and court led
the artist to flee France.

informality. This can be seen in Elisabeth Vigée-Lebrun's portraits of
the late eighteenth-century French queen, Marie-Antoinette. Vigée-
Lebrun did paint conventional formal portraits of her, showing her
standing in a full-length pose in contrived settings with the familiar
accompaniments of column and curtain [**44**]. However, she also repre-
sented Marie-Antoinette with her children. Marie-Antoinette was a
monarch reviled by many of her subjects for her extravagance; through
portraiture, however, Vigée-Lebrun helped her manage her public
image, emphasizing her domestic virtues and maternal occupations in
order to counter her public reputation as the Queen who play-acted the
role of shepherdess while living in the splendour of the Versailles palace.
Vigée-Lebrun's portraits veer between signalling this domestic image
and retaining a decorous formality in the figure of the Queen.

In England, by the eighteenth and nineteenth centuries the royal
portrait in a domestic setting became a common foil for the more
formal portrait. It is important to realize that such informality was as
contrived as the more hierarchic signals of Divine Right. By having
herself represented as interacting with her family in the drawing room,
Queen Victoria for example could seem more familiar to her subjects
and provide a moral exemplum. Such images could also create a
publicly palatable image of a powerful Queen's relationship with her
consort, Prince Albert.[7]

A similar change of direction can be discerned in other sorts of insti-
tutional portraits of powerful people in England. While university
deans or vice-chancellors and captains of industry were once shown
uniformly in sombre suits or black gowns, standing or seated in tradi-
tional leadership roles, nowadays such individuals are represented just
as often in shirt sleeves or private domestic environments. This is partly
a matter of portrait practice, but it also indicates changes in the social
conception of leader from an exalted to an everyday figure. Neverthe-
less, these portraits project an image of a different kind of power and
authority, but one which is no less recognizable to the viewer. So
although portraits of rulers and other powerful figures have tended to
be formal, iconic, symbolic, and imposing, they can also be informal,
domestic, and familiar.

## Portraiture and the formation of bourgeois identity

Although rulers and other powerful individuals characteristically com-
missioned portraits, portraiture was also the province of lower ranks of
society. The middle classes—as we now know them—used portraiture
to help them project a distinct identity; this level of society became
most closely associated with portraiture in the modern period. Scores
of books have been written about the so-called 'rise of the middle class'
and what constitutes a middle-class identity. In this book, it is only

possible to give the most basic summary of this complex area. Historians have variously attributed the formation of a bourgeoisie, or a middle class with its own particular characteristics and attributes, to the seventeenth, eighteenth, and nineteenth centuries. However, it has been debated whether or not we can talk about a middle class before the sixteenth century, and there is some disagreement about what constituted this amorphous social group in any given period. Whatever argument is adopted, it is usually agreed that in America and western European countries by the end of the nineteenth century there was an identifiable middle class or 'bourgeoisie', with a separate sense of identity from both the aristocracy and lower classes such as servants and the poor. By the nineteenth century as well, portraiture was coupled with the projection of this middle-class distinctiveness. As the art critic Théodore Duret put it in 1867, 'The triumph of the art of the bourgeoisie is the portrait.'[8] It is worth investigating how, when, and why portraiture came to have this association.

Portraits of members of the middle ranks of society appear only rarely in the fifteenth and sixteenth centuries, but there are some examples, especially in northern European portraiture. Jan Van Eyck [see **28**] and Holbein [see **1**] are two artists who did not concentrate exclusively on regal or aristocratic sitters, but nearly all portraiture of this time was commissioned by those who could afford it and employed it for purposes of establishing or reinforcing their status. In the following centuries, northern Europe continued to be an important centre for portraits of the middle social ranks. This was especially prevalent during the seventeenth century when a plethora of portraits was produced, many of which were commissioned by citizens who had plenty of worldly wealth and a bevy of excellent artists to choose from. Portraitists in this period usually avoided the large-scale full-frontal, equestrian, and seated formats in favour of more varied and often informal compositions, a greater attention to qualities of expression and gesture, and a more creative approach to the blemishes, foibles, and fallibilities of the human countenance. These tendencies became more widespread by the eighteenth and nineteenth centuries, when portraiture in Europe and America was no longer the province of a few privileged or powerful individuals, but had a much broader class profile, including artisans and other working people. Associations between class of the sitter and the style and emphasis of the portrait could be used effectively. Copley's portrait of Paul Revere, the American hero of the War of Independence [**45**], does not depict him making his famous midnight ride to warn Bostonians that the British were approaching, but in his workshop practising his trade as a silversmith, holding a teapot he has just completed. Copley chose a half-length format to represent Revere in his work clothes and with an evocative gesture of contemplation. Although Revere is not shown in a heroic moment, he

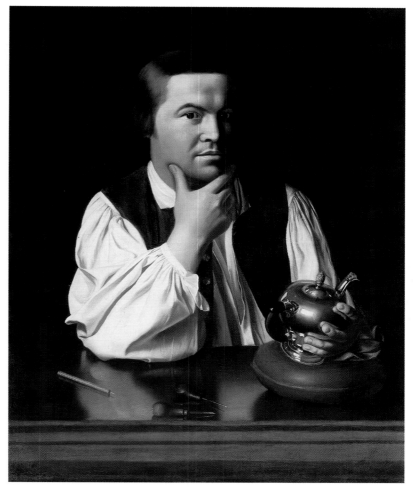

is nevertheless associated with the anti-monarchical rebellion through
a pose and gesture that clearly contrast with the more formal portraiture
of monarchs. Copley's superb handling of the textures of the teapot and
Revere's work clothes give this portrait some affinity with the materials
and emphasis of Holbein's portraits of London merchants [see **1**].
Holbein's paintings were not available for Copley to see in colonial
America, but it is interesting that both artists saw the mode of detailed
observation as most appropriate for their portraits of middle-class
sitters.

There are significant differences between portraits of these middle
ranks of people and those of rulers. If portraits of powerful individuals
had affinities with the moral, elevated qualities of history paintings, so
portraits of the middle classes could be indistinguishable from genre
painting or scenes of everyday life.[9] Such portraits shared with genre
painting an emphasis on communicative, even theatrical, expression
and gesture, and a focus on the trivial, familiar, or ordinary qualities of

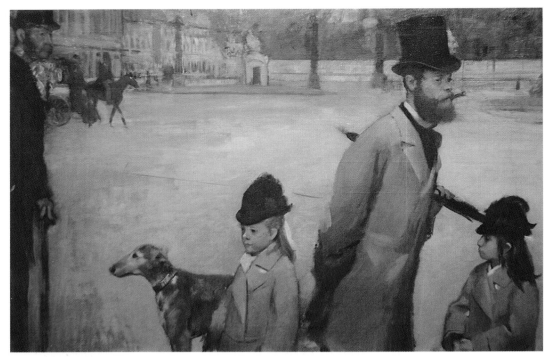

**46 Edgar Degas**

*Place de la Concorde (Vicomte Lepic and His Daughters),* 1875

This very unusual portrait was painted during a period in which Degas was exhibiting with the group that became known as the Impressionists. However, the work is less a reflection of the ethos of Impressionism than it is of Degas's own particular interests. He painted many psychologically penetrating portraits, abandoning conventional portrait poses for unusual and often modern gestures and postures. He was also fascinated by contemporary urban life; by setting this family portrait in a Parisian street, he gives it the air of a genre painting.

the scene. Group compositions especially allow for both a contemporary setting and a communication between the figures in the painting and the viewer that is ordinarily characteristic of genre painting. The light-hearted atmosphere of some portraits also contributes to the effect of making the sitters seem less like symbolic objects and more like real people. Such liberties were less often taken in portraits of rulers, even in more domestic settings. The blurring between portraits of the middling sort and genre painting was practised with finesse by the French Impressionists, who often used the opportunity of painting their friends and acquaintances to experiment with compositional formats and modern-life gestures and expressions. Degas's *Place de la Concorde* [**46**], for example, bears little imprint of portrait traditions. The gestures are indeterminate, and the bodies are cut off at peculiar angles. There is a snapshot quality to this portrait that gives it an impromptu, everyday feel, rather than being composed and regulated. Its outdoor setting seems to relate more to the leafy park scenes of Impressionist urban landscapes than to the typically interior spaces of formal portraiture. Linda Nochlin has suggested that in works such as this, Degas was updating portraiture by introducing the varied and expressive gestures of modern life, which had replaced the limited and conventional language of social gestures of the past.[10]

It was in the period of Degas's *Place de la Concorde* that portraiture became firmly associated with a self-conscious bourgeoisie. This coincided with social and political change in industrialized western Europe,

which led to the middle classes gaining more power and influence, as the roles of monarchs were superseded by the authority of parliaments and ministers.[11] However, although the iconic and talismanic aspects of portraiture could be extolled as appropriate for rulers, portraits of the middle class were frequently disparaged by writers and critics as being empty symbols of vanity [47]. This critical reaction began as early as the sixteenth century with Lomazzo's attack on the debasement of portraits that represented merchants rather than heroes, but by the seventeenth century such attacks were commonplace. For example, the French writer Charles Sorel's *Description de l'île de portraiture* (*Description of the Island of Portraiture*, 1659) creates a futuristic dystopia inhabited by hair-dressers, tailors, and professional portraitists. The idea here is that human vanity has spread to all levels of society to the point where self-image and self-presentation becomes more important than higher values. This denigration of portraiture intensified as the middle classes

**47 Honoré Daumier**

*Le Salon de 1857*, 1857
Although he was also a painter and sculptor, Daumier is best known for his lithography. He produced over 4000 lithographs in his lifetime, many of which were caricatural portraits. His contribution to the weekly newspaper *La Caricature* led to his imprisonment when he represented King Louis-Philippe as Rabelais's Gargantua; this action also led to the legal repression of caricatures in France from 1835. After this, Daumier turned to more generic social caricatures such as this one. Here Daumier uses caricatural exaggeration to mock the vanity of French bourgeois society. The comic figure appears excessively pleased with the faithful but unprepossessing likeness of himself being shown in the exhibition. Daumier's satire points to the prevalence of portraits of such bourgeois subjects at the annual Salon exhibitions.

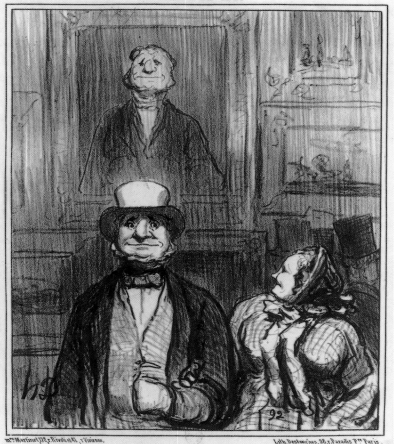

LE SALON DE 1857

_C'est tout d'même flatteur d'avoir son portrait à l'exposition.

gained first greater wealth and power and then a distinct identity and increasing political authority.[12] The eighteenth-century Swiss artist Henry Fuseli expressed most cogently a prevailing distaste for a powerful but vain middle rank of society that felt the need to commission portraits. Speaking in his capacity as Professor of Painting at the English Royal Academy, Fuseli attacked a form of art practised by the majority of his fellow Academicians:

Since liberty and commerce have more levelled the ranks of society, and more equally diffused opulence, private importance has been increased . . . and hence portrait-painting, which formerly was the exclusive property of princes, or a tribute to beauty, prowess, genius, talent, and distinguished character, is now become a kind of family calendar, engrossed by the mutual charities, of parents, children, brothers, nephews, cousins and relatives of all colours.[13]

This separate and identifiable class of sitters often called for a different type or style of portraiture. Portraits of the middle classes could take on the attributes of portraits of rulers, attempting by association to elevate their sitters. Alternatively, sitters could declare their difference by commissioning portraits that stressed their physical imperfections (like stoutness) or showed them in informal or intimate settings (similar to genre).

One of the factors that contributed to the growth of bourgeois portraiture in the nineteenth century was the increasing specialization of professionals in medicine, law, the military, education, and science. Although some women managed to achieve this professional status before the twentieth century, the majority of working professionals were men. Throughout the eighteenth and nineteenth centuries, technological advances and political change gave such professionals an unprecedented amount of public recognition, as well as greater authority. Their public roles were defined by their jobs, but they were also earning an income that classified them as part of the middle classes.

The development of what might be called occupational portraits can be traced back to the associations between middle-class portraiture and human vanity made in the sixteenth century. Lomazzo wrote of the need for decorum in portraiture, by ensuring that soldiers and clerics were depicted in appropriate dress, surrounded by the accoutrements of their position.[14] This was easily achieved by artists who produced portraits of religious or military figures, as they could be shown wearing the uniform of their trade. Although portraits of people who had specific occupations were not new to the eighteenth and nineteenth centuries, it was in these periods that greater specialization in activities such as medicine and law meant that portraits played an increasing role in institutional structures. Portraits were hung in the halls of learned societies, or civic or educational institutions. Through signals that linked their sitters to particular professions, portraits could thus become an affir-

mation of group identity. Frequently they projected a sombre image, and they often included gesture, props, or poses that were redolent of the superior wisdom, intelligence, or gravity attributed to their sitters.[15]

While portraits of middle-class men in the nineteenth century frequently showed them in their public, professional roles, portraits of middle-class women tended to stress their beauty or their sense of fashion. In this period middle-class women were less frequently employed than men or women of the lower classes, and their associations with the domestic environment led them to be placed in these settings more frequently than men. Such portraits often contained evidence of affluence in the furnishings and dress of the sitters. It was this dwelling on the specifics of clothes, furniture, and fashion in portraits of middle-class women that led many to condemn such portraiture as vulgar demonstrations of possessions.

However, portraits of middle-class sitters did not simply reflect a society's hierarchy, they helped give it visual expression. The large number of portraits of professional men, and middle-class women in sumptuous and fashionable domestic interiors, projected a sector of society that was gaining power and influence. The nineteenth century was a key period in the development and dissemination of this kind of portraiture.

## The 'genius'

Portraitists have also depicted people distinguished by their creative work or reputation for intellect. Many of these individuals would have been part of what we would now recognize as the middle class in the sense that they were only infrequently leaders of nations or religions and only occasionally members of the aristocracy or gentry. Portraitists often attempted to express something of their inner spirit or creative power, and thus portraits of writers, philosophers, composers, theologians, and scholars could be different in emphasis from portraits of rulers and other categories of working professionals.

Bust portraits of philosophers and writers were prominent in portrait collections from the ancient world. During the Renaissance, collections of imaginary sculpted portraits of famous writers from antiquity often graced libraries and private studies. Noble families found these individuals worthy of admiration and emulation, and patrons could thus reinforce their own learning and education by possessing such collections of sculpted bust portraits. Such works were frequently part of room or garden decoration, and they could include recent or contemporary thinkers or influential figures. One of the most famous examples of this is the Temple of British Worthies at Stowe in England. This collection of bust portraits of famous contemporaries was exhibited in the grounds of the estate of Viscount Cobham, and his choice of

**48 Joshua Reynolds**

*Dr Samuel Johnson*, 1772/1778

As President of the English Royal Academy, Reynolds is best known for his Grand Manner portraits of the British aristocracy and gentry, but he also produced a series of more intimate portrait studies of his friends, including a series for Hester Thrale's library. Reynolds's painting of Johnson does not attempt to idealize the eccentric author but stresses the genius of his mind, paradoxically through his physical imperfections. Johnson's near-sighted squint in this painting allegedly displeased the writer, who gained the nickname 'Blinking Sam' from his appearance in Reynolds's portrait.

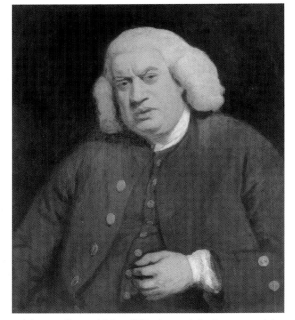

subject reflected his affiliation with the opposition to the corrupt Whig government of Prime Minister Robert Walpole.

Such sculpted portraits of writers, philosophers, and political theorists projected a noble image of superiority, largely through the association of the bust portrait with ancient Roman virtues. By the late eighteenth century, however, artists were producing portraits of scholars and writers that displayed idiosyncrasies as a means of emphasizing the intellectual power of their subjects. Reynolds's famous collection of portraits of men such as the writer Samuel Johnson [**48**] and the musician Charles Burney, painted for his friend Mrs Thrale, are clear examples of this. Following in the tradition of the portrait bust collection, Reynolds painted this intimate circle of writers, musicians, and thinkers for a library, adopting a standard canvas size and half-length format for each painting. However, the similarity between the different portraits ends there. Each one represents something individual about the sitter: Johnson's ungainly figure; the author Giuseppe Baretti's short-sightedness; the musician Charles Burney's manically intense expression. By drawing attention to physical imperfection and eccentricity, Reynolds seems to denigrate rather than exalt his sitters, but the physical fallibility and distractedness of these intellectual men was tied up with contemporary ideas of genius.[16] A genius was felt not only to be above normal human beings in their intellectual or literary powers, but their concentration on higher things was seen to place the qualities of the mind above those of the body. The association of 'genius' with imperfect body and great mind enabled portrait artists to experiment more readily with their mode of representation.

This was particularly true in the late eighteenth and early nineteenth centuries, when Romantic ideas of genius consolidated the notion of an anti-hero whose prowess was intellectual rather than physical. In the late nineteenth century the German philosopher Friedrich Nietzsche fully explored the Romantic idea of the creative 'superman' (*Übermensch*), whom Nietzsche saw as the salvation for the mindless mediocrity of a bourgeois society slavishly obeisant to the rules of church and state. The 'superman' of Nietzsche was this kind of genius, whose power was in the mind rather than the body and who was above ordinary human rules. The idea of genius was frequently coupled with that of insanity, and this further reinforced the idea that geniuses did not behave like ordinary people. The combination of Romantic notions of the anti-hero with Nietzsche's idea of the 'superman' provided an inspiration for portraitists to attempt to convey something of this quality of intellectual superiority bordering on insanity.

It is instructive to look at and compare two different Romantic attempts to produce the portrait of a genius. Rodin's monument to the French novelist Balzac, completed in 1898 [**49**], and Max Klinger's statue of Beethoven, exhibited in 1902 at the Fourteenth Vienna Secession exhibition [**50**], offer parallel but contrasting responses to the representation of creative energy. In Balzac's case, his genius was said to rest in his prolific novel writing and penetrating views of human nature. Beethoven was a cult figure whose dramatic music was apparently enhanced, rather than checked, by the debilitating deafness of his later years. In each of these sculptures the artists have used traditional materials in a non-traditional way. Rodin did several versions of his Balzac as both a carved and a cast figure. The final bronze casts emphasize the irregularities of the material. The imperfections in Balzac's face are stressed rather than hidden, and the body becomes an amorphous mass of robe rather than a carefully composed human figure. Klinger's Beethoven monument is carved rather than cast, employing a variety of different materials to create a polychrome effect. Beethoven emerges like a pale spirit from amidst the rich textured marbles and jewels that make up the throne-like chair on which he sits.

Both monuments display their subjects in unorthodox dress and poses. Balzac is represented in a voluminous cloak that stands for the bathrobe he was known to wear while he was writing. The intimate nature of this garment contrasts with the public forum in which the sculpture was meant to be displayed. The slightly unsteady posture, combined with the high angle of the head, gives a sense of someone in the throes of concentration and creation. Like Balzac, Beethoven is shown in a state of *déshabillé*. He is naked from the waist up, with a loose cloth draped about his lower body. The hint here is that there is a pure creative power in the body of this man, whose musical genius transcended his own deafness. Beethoven's seated position echoes

**49 Auguste Rodin** (next page)
*Monument to Balzac,*
completed in 1898
Rodin was one of the most inventive sculptors of the nineteenth century, but he produced very few works that could be classed as portraits. Most of his sculpture deals with larger themes or is based on literary sources. This monument to Balzac has the universal qualities of other free-standing sculpture by Rodin, such as *The Thinker* and *The Burghers of Calais*, but in this case the very specific features of Balzac's face contribute to the effect of the monument.

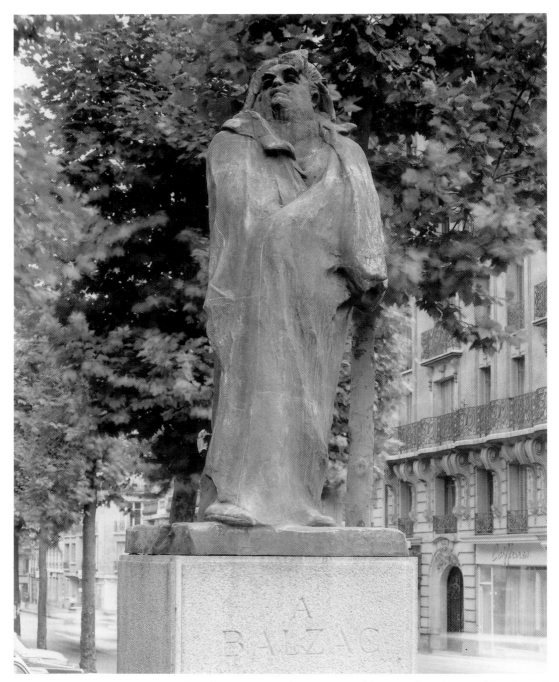

portraits of emperors and popes seated in state, but the combination of semi-nudity with this regal theme undermines the analogy.

Both Rodin and Klinger attempted to use their monumental portrait sculpture as a way of projecting ideas about the creative power and genius of their subjects, and they did so by a mix of signals that was not

**50 Max Klinger**

*Beethoven*, 1902

Although best known as a printmaker, Klinger began producing sculpture in the 1890s. He was fascinated by ancient polychrome sculpture, and he experimented with a variety of materials, from conventional bronze and marble to glass and jewels. His statue of Beethoven demonstrates his versatility with these different materials. This sculpture was part of the Fourteenth Vienna Secession exhibition, which was a joint venture with artists such as Gustav Klimt. The exhibition was dedicated to Beethoven, and Klinger's idealized portrait sculpture was the centrepiece of a bold and innovative display.

necessarily palatable to their audiences. Rodin's monument to Balzac was commissioned in 1891 by the Société des gens de lettres (Literary Society), who proceeded to reject the monument as inappropriate once it was completed. Klinger's Beethoven statue was part of an elaborate homage to Beethoven that comprised the Fourteenth Secession exhibition in Vienna, and the innovative display that framed this statue enabled greater experimentation with the image of genius. In each case, states of mind such as distraction (Balzac) and concentration (Beethoven) are evoked to transcend the impression of mere likeness. In the case of Balzac, as with Reynolds's portrait of Johnson, bodily imperfection is also used as a metaphor for the genius of the mind.

The idea of the imperfect body of the genius also appeared in portraits of talented women, but here there could be different effects. Michele Gordigiani's 1858 portrait of the poet Elizabeth Barrett Browning is a key example [**51**]. In some ways this could be considered a typical bourgeois portrait, as it lavishes attention on the details of Browning's attire, including the lace at her cuff and the silky sheen of her dress. But unlike other portraits of bourgeois women, which stress their beauty and sense of fashion, Browning is depicted with her hair unfashionably down and awry, dark smudges under her eyes, and with a face where the signs of age appear quite prominently. Browning was known for her unorthodox lifestyle and especially for her elopement with the younger poet, Robert Browning. Gordigiani painted this portrait of her in the last years of her life when she was succumbing to a prolonged nervous disorder and opium addiction. The impression

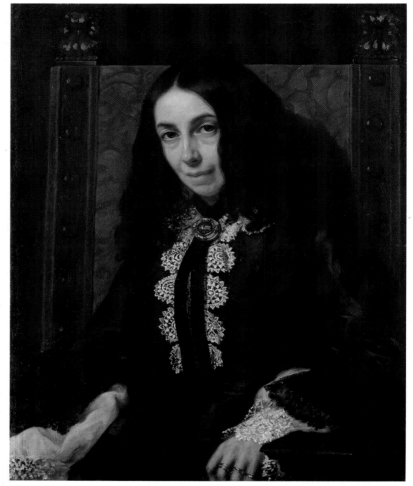

*Elizabeth Barrett Browning*,
1858
Gordigiani was an Italian
portrait painter who benefited
from the presence of artists,
writers, and intellectuals from
America and other parts of
Europe who congregated in
Italy during the second half of
the nineteenth century. The
English poet and intellectual
Elizabeth Barrett Browning
settled with her husband
Robert Browning in Florence
from 1846 until her death in
1861, and Gordigiani painted
this portrait of her in the last
years of her life.

given here is certainly that of an atypical woman, but the means of achieving this effect in the portrait are much more subdued than in those of Rodin and Klinger. The difficulty here was that the Romantic conception of genius, and especially its Nietzschean variant, was specifically connected with men.[17] The social constraints on women's behaviour further hampered the experimentation of portraitists who might have wished to represent talented women in an unusual way.

The notion of genius that made its way into portraits of philosophers, writers, and composers has not disappeared, but in the last decades of the twentieth century the whole idea of genius has been strongly challenged. Genius has come to be conceived as a combination of innate ability and social construction. More recent portraits of men and women, who might once have been thought of as geniuses, sometimes stress their ordinariness. Jane Bown's photographic portrait of the playwright Samuel Beckett [**52**], for example, could easily be mistaken for the portrait of an older man whose leathery face shows signs of years

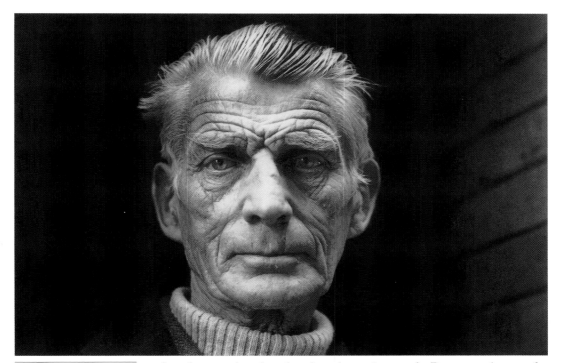

of outdoor work rather than long hours in a study. Bown was known for her 'spontaneous' and unedited photography, and supposedly photographed Beckett in an unplanned meeting. On the other hand, one could argue that portraits like this still couple the notion of physical imperfection with the idea of intellectual superiority. This could therefore be seen as serving a similar function to Reynolds's portrait of Johnson or Gordigiani's portrait of Elizabeth Barrett Browning. The more extravagant signs of genius that characterized late Romantic portraiture have perhaps become somewhat subdued, but there remains a fascination with the 'difference' of famous creative people and how that might be expressed in a portrait.

## Celebrities

If the idea of genius has been somewhat discredited in the late twentieth and early twenty-first century, the notion of celebrity has been in the ascendant. Portraiture has been very important to celebrity, as the cultivation of celebrity depends to an extent upon the familiarity and dissemination of likeness. Portraits of celebrities often focus less on class and social status and more on the uniqueness or star quality of the represented individuals. This is not to suggest that power, authority, class, and status are no longer key components in portraits, but that the fame of the sitter has become a new kind of authority.

A developed notion of 'celebrity'—or the public recognition of an

**53 Walter Richard Sickert**

*Minnie Cunningham at the
Old Bedford*, 1892

After studying with Degas in
Paris in 1883, Sickert
returned to London and spent
the next few years painting
working-class music halls like
this one. In these paintings
Sickert used unusual
viewpoints and included both
audiences and performers.
They were most controversial
at the time for their
representation of popular
performers and lower-class
audiences, but Sickert's
music hall scenes also
included portraits of
performers like this, known for
their comic 'turns' and
raucous singing.

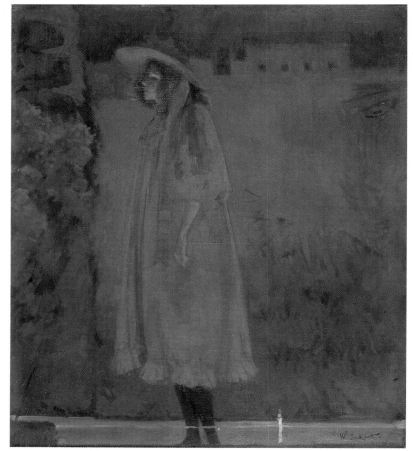

individual's unique qualities or contribution—can be traced to the eighteenth century and is inextricably linked with the growth of western European technology and commercialism. The economic growth of countries such as Britain, France, and Holland was accompanied by a greater circulation of newspapers, pamphlets, and other kinds of publications that paid greater attention to both the lives and personal qualities of public figures such as politicians and actors. The role of portraiture in fuelling the celebrity of individuals also appeared in this period. In Britain, for example, portraits of famous actors, actresses, and politicians became showpieces at Royal Academy exhibitions and were disseminated to a wider audience through sales of engraved versions in print shops. Portraits of performers were particularly useful to artists, as they both drew attention to their work by association and enabled them to experiment with different modes of representation, as performers could be shown in different guises without breaching decorum. In the late nineteenth century, the English artist Walter Richard Sickert built his early reputation on his representations of music halls, including portraits of well-known contemporary performers [**53**]. Gaining inspi-

ration from his French Impressionist contemporaries, Sickert's works drew upon depictions of everyday life, rather than the conventions of portraiture, for their formats. Taking named individuals as his subjects he nevertheless emphasized the painterly qualities of brushwork and surface, using the notoriety of the singers and comedians of working-class music halls as a springboard for artistic experimentation.

The role of the celebrity in portraiture was enhanced by the invention of photography in the nineteenth century, which made the acquisition of images of famous people much easier. Portraits of well-known people were frequently collected and stored in elaborate albums.[18] Although this habit bears some relationship to public display of portrait busts of famous poets and philosophers, or paintings in public institutions, the very fact that such photographic portraits were collected

**54 Lev Bakst**

*Portrait of Sergei Diaghilev with His Nanny*, 1904–6
Although best known for his illustrations and theatre designs, Bakst was also an accomplished portraitist. He worked closely with Diaghilev from the 1890s, when the latter founded the journal *Mir Iskusstva* (*World of Art*); later he assisted Diaghilev in the designs for productions by the Ballets Russes. The two were thus very close, and this portrait has the quality of a work replete with personal symbolism. Bakst has represented Diaghilev as a confident dandy—a role he consciously cultivated—but the presence of his Russian nanny in the background somewhat undercuts the exuberance of Diaghilev's stance. It has been suggested that this portrait may symbolize Diaghilev's rejection of his native Russia, as he made his name outside his home country.

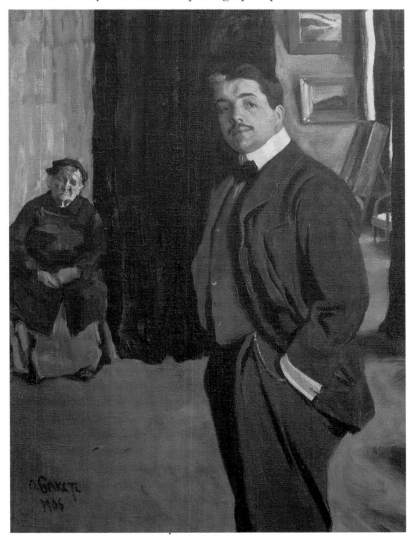

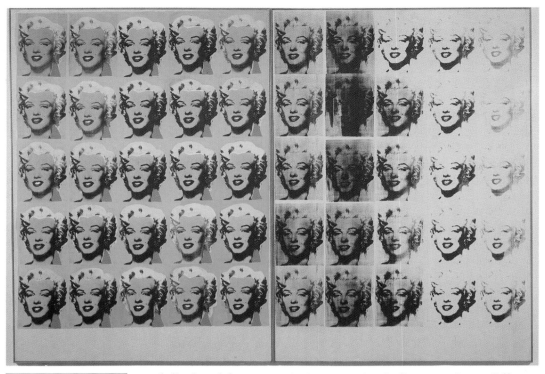

and displayed for a more intimate gazing indicates rather a different purpose. Such collections could make a celebrity seem accessible and stimulate the fascination or fantasies of observers who had perhaps never seen the celebrities they admired.

This combination of accessibility and distance also appears in painted portraits after the invention of photography. The unusual portrait by Lev Bakst of the Russian impresario Diaghilev is an example of a work that blurs the boundaries between public and private [**54**]. The portrait shows Diaghilev with his nanny and appears to give a glimpse into the intimate life of a famous man, but it also links him with his childhood, possibly reinforcing the idea of talent being spawned in infancy. However, unlike Sickert's work, this painting was intended for an intimate circle of friends rather than public consumption. The context and commissioning history of celebrity portraits must be taken into account when assessing their impact and reception.

Portraiture, commercialism, fantasy, and celebrity all came together in the twentieth century with the advent of Pop Art in the 1950s and 1960s. Andy Warhol's silkscreen impressions of contemporary icons such as Elvis Presley, Marilyn Monroe [**55**], and Jackie Onassis are key examples. Like much traditional portraiture, Warhol's work is founded on likeness. The viewer is supposed to be able to identify the famous people they represent. The photographs on which his prints were based, however, were not taken by Warhol himself but were drawn from

newspapers and magazines. Here mechanical reproduction takes over the task of representation, and the repetition of imagery and the consequent dulling of individuality become explicit themes. In the second half of the twentieth century, with the explosion of curiosity about the private lives of stars, these works served the sort of iconic function that portraits of Queen Elizabeth I did in the sixteenth century. Warhol chose his icons from among celebrities whose lives were associated with tragedy: Marilyn Monroe and Elvis Presley both died young, and Jackie Onassis witnessed the assassination of her husband, President John F. Kennedy. But Warhol's repetitious impressions of them neutralizes this sense of tragedy. So although they are portraits, Warhol's works are also a comment on the iconic nature of celebrities and the function of mass media as a means of creating a false sense of accessibility.

## The unknown and the underclass

The portraits discussed so far in this chapter represent people who had authority, power, wealth, talent, or fame. These portraits helped create and perpetuate a public image of leaders, prominent members of society, creative people, and celebrities. But in considering the question of status and power, it is also crucial to look at portraits of those who did not have a high position in society and who may have had momentary notoriety but were relatively unknown even in their own time. Portraits that fall under this category may represent the poor, servants, criminals, and—in certain periods of history—non-Europeans. Such portraits were rarely commissioned by the subjects themselves but could be requested by interested third parties, or produced by the artist as a commercial speculation. Unlike portraits of prominent members of society that were intended to project a message about the power or virtue of their subjects, portraits of the unknown or members of an underclass did not send such signals. In many cases portraits of this underclass breach portrait conventions, and in doing so they give us an insight into how certain societies expressed a fascination with or a disdain for otherness.

Portraits of lower ranks of society were frequently commissioned by the people for whom they worked. Among the most famous examples of such a commission was the series of portraits of court dwarfs painted by Velázquez for Philip IV. Although it was common during the Renaissance for artists to produce portraits of court dwarfs, Velázquez' portraits are unusually striking works. His portrait of Calabacillas [56] demonstrates how works like this abandoned conventions in a way that would have been unacceptable for higher classes of sitter in the Spanish court of the time. Calabacillas is seated in a relaxed and casual cross-legged pose, in contrast to the stiff and formal postures of state portraiture. He is smiling rather than showing the static expression

*Don Juan Calabazas, called Calabacillas*, 1640

As court painter to King Philip IV of Spain Velázquez not only produced formal portraits of the royal family but was also responsible for painting portraits of court fools and dwarfs. These essential members of the court provided entertainment for the king and his entourage. Because of the dwarfs' unique positions at court Velázquez was commissioned to paint their portraits. Their physical disabilities and low status allowed him a liberty in depicting them that was not available to him for portraits of the royal family.

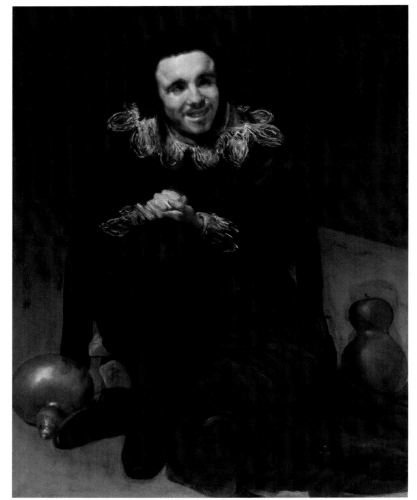

common to most seventeenth-century Spanish court portraiture. He is also represented with a prominent squint, whereas most court artists of that period evaded the natural deformities of higher-born subjects in an attempt to express beauty and grace. Instead of an attribute expressing his virtues, Calabacillas is surrounded by bottles, which possibly hint at indulgence in drink and give an air of carelessness to his surroundings. The portrait is even unconventional in the way it was painted. Velázquez allowed himself more than usually free brushwork on Calabacillas' sleeves, ruff, and face. What results is a powerful and evocative portrait rather than the social mask that was so common among higher ranks of society. But one must question how such portraits would have been seen and understood. It has been argued that Velázquez' portraits of court dwarfs are warm expressions of the humanity of their subjects. The same elements that seem to make Calabacillas a figure of potential derision—his diminutive figure, his squint—could also make him an

object of compassion. Certainly dwarfs were part of the court 'family' in seventeenth-century Spain: they were sought after and celebrated, and were allowed certain liberties within the court that were closed to other working people. It is impossible to recover the responses of contemporaries to this figure and to know whether they would have felt a humane affection for Calabacillas, a sense of superiority to his awkwardness, ugliness, and possible dissipation, or a mix of these and other emotions. What is clear, however, is that Velázquez' portrait emphasized the difference of his subject from the physical demeanour and expression of his royal and aristocratic sitters.

Other portraits of lower-class sitters are perhaps less ambiguous, if also less powerful. By the eighteenth century it was not unknown for country house owners in Britain to commission peripatetic artists to paint pictures of their servants [57]. Such works may have been devised as records of ownership, in much the same way as these same patrons commissioned portraits which included their family estate. The institutional significance of such portraits is attested to by the number of portraits of servants painted for Oxford and Cambridge colleges. For

**57 British School**

*John Mellor's Black Coach Boy, c.*1730

This is one of a series of portraits of servants from Erddig House in Wales. These portraits seem to have been commissioned over a period of time to commemorate faithful family servants. The tendency to commission portraits of servants was common in Britain, but because the subjects of the works were not famous and were quickly forgotten these portraits have tended to be lost or destroyed. The Erddig collection is a notable exception.

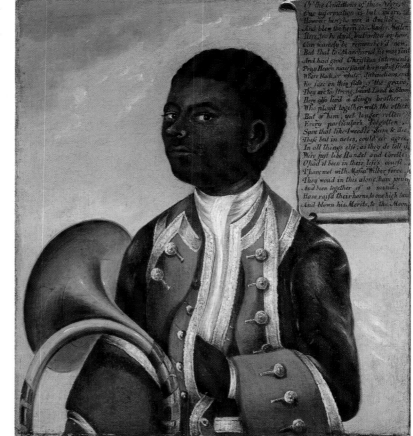

**58 Jan Steen**

*The Baker Arent Oostwaard and His Wife Catharina Keizerswaard*, 1658

Although he painted a few portraits Steen was best known for his low-life genre and 'merry company' scenes. Some of the qualities of the merry company paintings can be seen in this portrait. The sitters are grinning, posed informally, and Oostwaard has ruddy features and a bulbous nose.

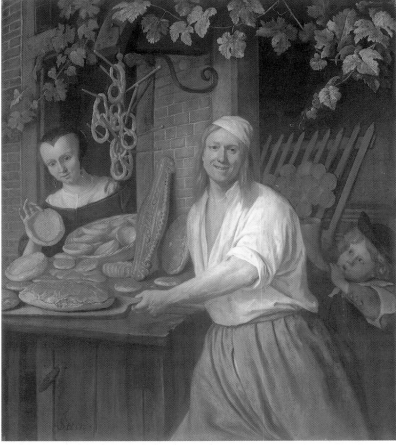

**59 Johann Zoffany**

*John Cuff and His Assistant*, 1772

Zoffany's portrait of King George III's optician is in notable contrast to his portraits of the King, Queen Charlotte, and their children, even though Zoffany's royal family portraits also have some informal elements. Although these portraits are set in domestic interiors and show, for example, the royal children donning fancy dress, he was careful to delineate the features of the royal family in a decorous, flattering way. By contrast, Zoffany subjected Cuff and his assistant to close scrutiny and presented their features in uncompromising detail.

example, an anonymous portrait in New College, Oxford, of 1764 represents Thomas Hodges, the servant to the Chaplain, smiling and with a squint in the manner of Velázquez' Calabacillas, and holding a tankard of ale and an armful of pipes.[19] It is significant to note that in many cases these portraits were painted by relatively unknown and/or itinerant artists. This may have been for reasons of expense or convenience, and servants would not have been likely to have the leisure to visit portrait studios. However, another reason may be the documentary or commemorative quality of many such portraits, as these works were often accompanied by inscriptions, which indicate the identity of the sitter and the sitter's role in the house or institution.

Although portraits of servants do not follow a specific set of conventions, many of them share certain qualities with genre painting, specifically an emphasis on communicative—even theatrical—expression and gesture, and a focus on the everyday qualities of the scene rather than the symbolic ones. Portraits by the seventeenth-century Flemish artist Jan Steen demonstrate how portraits can take on aspects of genre [**58**]. Group compositions especially allowed for both an

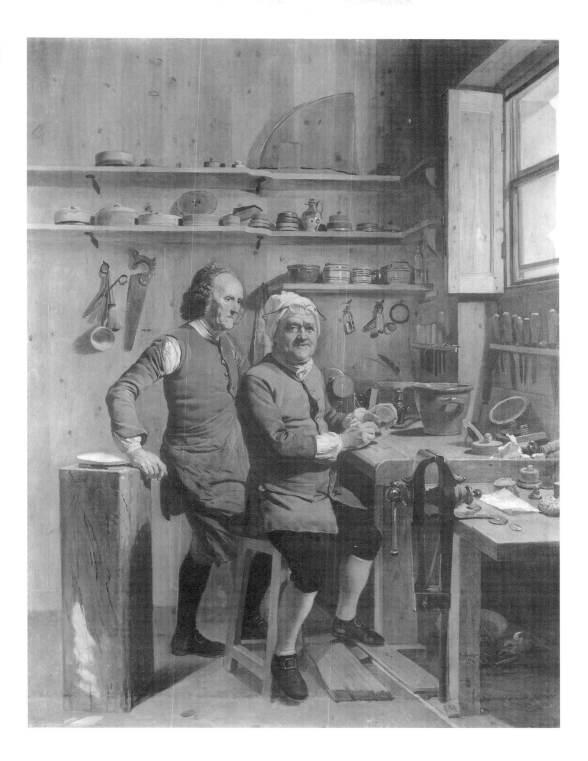

everyday setting and a communication between the figures in the painting and the viewer. The light-hearted atmosphere of such portraits also contributed to making the sitters seem less like symbolic objects and more like people. However, such qualities also make Steen's portraits appear to be indistinguishable from some of his 'merry company' paintings that represent cavorting revellers.

Another example can be found in Johann Zoffany's portrait of the optician John Cuff, who worked for King George III [59]. Compared to the conventions of formal portraiture, the only clear signal that this is a portrait is the way Cuff stares out of the picture, as if posing. Other aspects of the work give it greater affinities with genre painting. For example, Cuff is shown with an assistant, working in his shop at Fleet Street, London. Zoffany has dwelt on the physical qualities of the tools of the trade in the room, and he has emphasized the wrinkled faces and crumpled work clothes of his figures. The fact that Cuff is smiling is also indicative: the display of such an overt expression as smiling was generally avoided in portraiture, as in its frozen state the smile can seem to distort the face of the subject. The use of explicit expression has been seen already in representations of other working people like Steen's baker or Velázquez' Calabacillas, and smiles and laughter were commonly associated with the more comic aspects of genre painting.

The different kinds of poses, gestures, and artistic associations that appear in each of these portraits of servants and other members of the lower classes seem to give them a representational 'otherness' in relation to the people who commissioned their portraits. This perception of otherness is also significant in understanding why portraits of criminals, insane people, and individuals from other nations could be less constrained by conventions than those of leaders, intellectuals, or stars. In the nineteenth century, the French artist Théodore Géricault famously produced a series of portraits of people in the Bicêtre insane asylum that exemplifies this point well. Géricault's portraits represented unknown people with serious mental disturbances, and they were intended to document the diverse forms of madness suffered by the inmates of the asylum. However, they also stand as penetrating portraits, not least because—despite the use of a standard half-length format—Géricault was not constrained by the expressions and gestures associated with portraits of people with a higher standing in society. Because such individuals were considered outsiders, conventions of portraying their faces could also be readily abandoned. But what could produce a startling and fascinating work of art could also be a manifestation of the prejudices or perceived superiority of higher ranks of society.

Thus portraits of different levels of society were commissioned by both the sitters and by those who had reason to commemorate or remember them. The traces of status in the poses, gestures, and accoutrements of portraiture enabled viewers to respond in a way that tested

their own perceived superiority over, inferiority to, or affinity with the subjects of the portraits. Portraits of different classes thus required different kinds of signals to engage with the needs of patrons and the expectations of audiences.

1 René Crevel
2 Philippe Soupault
3 Arp
4 Max Ernst
5 Max Morise
6 Fédor Dostoïewski
7 Rafaele Sanzio
8 Théodore Fraenkel
9 Paul Eluard
10 Jean Paulhan

# Group Portraiture

Nearly all the portraits that have been discussed in this book so far have represented individual sitters. Another important category is group portraiture, which includes two or more individuals who usually have some sort of relationship based on legal contract, blood ties, or professional or personal affiliation. Just as individual identity can be represented in many different ways, so group identities are subject to contemporary conceptions about the purpose and function of families, institutions, and professional circles. However, group portraiture also encompasses elements that distinguish it from portraits of individuals. First of all, the stylistic and technical issues facing artists in producing group portraiture are more complex than those of portraits depicting single sitters. As soon as there is more than one sitter, the conventions of posed formality so common in individual portraits are challenged and the possibilities of how to represent the figures are multiplied. Although sitters can be grouped as if they were a collection of formal, individual portraits, group portraiture can also involve a greater experimentation with composition and the physical relationships between the figures. In this respect group portraiture has often had an affinity with theatrical performance, as figures can be shown interacting with each other as well as posing for the portraitist.

A second and related aspect of group portraiture is the way a portraitist may deal with relationships among the individuals represented. Whether the group is a family, friends, or members of the same institution, their juxtaposition begs questions about what their connection was and how their contemporaries understood it. While an individual portrait projects an idea of identity based on likeness, personality, or social status, group portraits include the additional variable of human interaction. In more formal group portraits such relationships may be shown spatially rather than psychologically. For example, in periods of patriarchal dominance the father of a family may have the most prominent place in a family portrait; or if a club or militia group is represented, the president or leader might take up more space on the canvas than the other figures.

A final key factor in understanding group portraiture is the social context in which the work was commissioned and received. The reasons

Detail of 80

for commissioning and displaying group portraits can include the desire to create or demonstrate a sense of shared identity. A group portrait can say a great deal about the significance of a specific group at a particular time. Just as the gestures, setting, and costume of an individual portrait may provide signals of status or authority, the ways familial or professional identities were shared is often the subtext of group portraiture. How such portraits were used, who commissioned them, and where they were hung all contribute to the issue of how group identity was both conceived and conveyed.

An unusual group portrait by Titian showing Pope Paul III, Cardinal Alessandro Farnese, and Duke Ottavio Farnese [**60**] demonstrates each of these points. On the one hand this is a portrait of members of the powerful Farnese family; on the other it is a hierarchical portrait about status and institutional affiliation in its depiction of important men in the sixteenth-century Catholic Church. Titian had to engage with the stylistic problems of including three known sitters within the same composition, and he had to find a way of demonstrating their relationships with each other, relationships which were both personal and institutional, generational, and hierarchical. Titian indicates the public status of his sitters through costume, gesture, and setting. The Pope sits in a chair in the established position of an authoritative ruler; all three figures wear clothes that indicate their public role. These spatial and gestural signs of their formal relationship are countered by the ambiguous psychological interaction that Titian develops among them. The ambiguities in this portrait are intensified when more information about the sitters is brought to bear on the interpretation. Early in his papacy, Paul III had promoted the career of both of his grandsons—securing the Duchy of Parma and Piacenza for Ottavio's father (which passed to Ottavio), and the position of cardinal for Alessandro. In 1545 Paul III summoned the Council of Trent to initiate reforms within the Catholic Church. His zeal for reform stimulated his own anxieties about accusations of nepotism, and he decided to remove the Duchy of Parma and Piacenza from Ottavio's control. This led Ottavio and Alessandro to negotiate secretly with Emperor Charles V to retain this power. Paul III perceived this as a betrayal, from which he never recovered. Titian's portrait was painted in the early stages of this tense set of familial and political negotiations. The Pope appears aged, wizened, and irritable. The gestures and postures of his grandsons have been interpreted variously as obsequious, conspiratorial, or courtly. Titian's group portrait thus represents a set of relationships that function on more than one level—public, personal, and psychological. To an extent these elements are characteristic of all group portraits.

There are many different kinds of group portraits, but this chapter will focus on three principal types: portraits of families, portraits of civic and institutional groups, and portraits of artistic circles. In each case the

**60 Titian**

*Pope Paul III, Cardinal Alessandro Farnese, and Duke Ottavio Farnese*, 1546
Titian's portrait of the Farnese pope and his two grandsons was probably modelled on Raphael's portrait of Pope Leo X with two cardinals (1518). Although the portrait was unfinished, it is a lively and expressive presentation of complex family and professional relationships.

portraits show the artists' engagements with the aesthetic, psychological, and social problems of representing more than one known sitter within the same compositional format.

## Family and marriage portraits

One of the most common types of group portraiture is that which represents members of the same family. Portraits of families can be traced back to ancient Egypt, and have taken many different forms.[1] Some show an entire extended family together; others single out husbands and wives, or parents and children. In each case the family portrait originates from some conception of why a family is important, and therefore can reveal a great deal about the perceptions of the family at different points in history. A family is a collective body of persons related legally, emotionally, or by blood, but this simple definition belies a range of different conceptions. Ideas of family have varied from the closed 'nuclear family' group of mother, father, and children, to more open extended families, including aunts, uncles, grandparents, and so

on, to a twenty-first century notion of the family, which frequently includes a wider range of emotional and legal relations, such as step-parents, unmarried partners, or adopted children. When artists represented a whole family, or part of it, they were engaging with contemporary expectations and preconceptions about the family as well as with the experience of family life in their own time.

Although ideas of what comprises a family have changed, family portraiture has followed certain trends. Two famous early family portraits by Holbein—his drawing of *Sir Thomas More and His Family* [**61**] and his so-called 'Whitehall portrait' of Tudor monarchs [**62**]—reveal contrasting approaches. Holbein's drawing of More's family was a study for a painting that was later destroyed. The figures are hierarchically posed, with More given a place of prominence in the centre as family patriarch. However, Holbein has also managed to capture an air of informality by using a domestic setting and showing some members of More's family interacting or engaged in reading. Sketches of the work reveal that Holbein originally conceived of the portrait as displaying the family's devotion, with Lady More kneeling and others reading the Bible. The removal of these details in the final version endowed the work with a more secular feel and reinforced the focus on the family itself, rather than on the theme of piety. Despite the formality of the poses there is some sense here of a lived family scene in which the personal relationships among the family members are evoked visually. This is especially important as More's family includes his second wife, as well as both offspring, an adopted daughter, and a daughter-in-law. It is therefore a scene of a large, extended family rather than a closed nuclear family group. The kind of extended family and the relationships represented in this portrait reveal the first glimmerings of an

**62 Remigius van Leemput, after Hans Holbein the Younger**

*Henry VII, Elizabeth of York, Henry VIII, and Jane Seymour* (the 'Whitehall portrait'), 1667

This is one of two existing copies of this dynastic portrait, the original of which was destroyed in the fire of 1698.

interactive informality that was to become a common characteristic of later family portraits.

By contrast, Holbein's Whitehall portrait is a much more deliberately formal work [62]. Like the painting of the More family, the original version was destroyed in a fire, but copies remain. This work was commissioned by Henry VIII for Whitehall Palace in 1537, shortly after his son Edward was born. The mural represents Henry VIII and his father Henry VII on the left side of a plinth inscribed with a homage to the Tudor dynasty. On the right side is Elizabeth of York, wife of Henry VII and mother to Henry VIII, and Jane Seymour, Henry VIII's third wife and the only one to bear him a son. This hierarchic painting therefore serves a dynastic purpose—to glorify the House of Tudor and to hint at the continuation of the line through the representation of two generations of the Tudors. The men standing on the dominant left side are arranged according to their seniority, with Henry VII having the most prominent place at the highest point of the composition.

Both the interpersonal and dynastic aspects of family portraiture have been remarkably tenacious. Whether the family portrait stresses the private aspects of family relationships or the arguably more public representation of lineage and family hierarchy, representations of the family give clues to what was significant about family life in a particular age and country.[2] The importance of family hierarchy, with the father visually representing the dominant patriarch, remained prevalent in European portraiture until the nineteenth century. However, even while hierarchical formal family portraits persisted, much portraiture from the seventeenth century onwards also expressed something about the relationships among family members. In the Low Countries in the seventeenth century and in Britain in the eighteenth century, family groups were frequently depicted interacting with each other in an informal way. Drinking tea or playing music were visual methods frequently used to unify a diverse group of people and to represent them in harmony with each other. Flemish portraitists of the seventeenth century, such as Rubens and Jordaens, employed these techniques in portraits of their own families [63]. In Jordaens's family portrait, the element of formal posing and the elaborate garden setting indicate his status and worldly success, but these are countered by the implication that the family are preparing to make music and sing together—musical harmony was a metaphor for family love and solidarity. Such apparently informal and personal portraits can have formal and public functions.

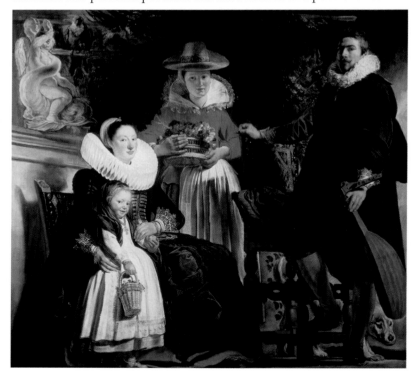

**63 Jacob Jordaens**
*The Artist, His Wife Catharina, and Daughter Elizabeth, c.*1620–2
Jordaens was a prolific Flemish painter who specialized in history and genre scenes. He painted a number of portraits, most of which represent his family and immediate circle.

*The Sargent Family*, 1800
Anonymous portraits of families, possibly by itinerant artists, remained common in America in the nineteenth century after they had gone out of fashion in many parts of Europe. The vast expanse of America, and the concentration of professional artists in a few metropolitan centres such as Boston or Philadelphia, meant that families who wanted portraits had to rely on travelling painters to satisfy their needs. This portrait may be an example of such a work.

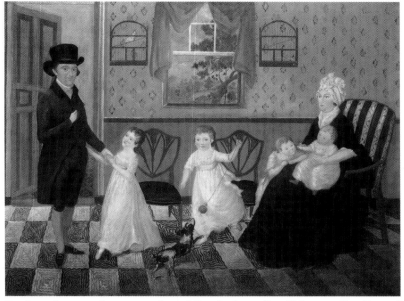

Jordaens's portrait was produced for the benefit of his own family and social circle, but it also was a demonstration of his skill as an artist and a possible means of advertising that skill.

Another public purpose for the representation of family informality can be seen in eighteenth-century Britain, when 'conversation pieces' (informal group portraits) represented members of the aristocracy or gentry who were keen to project an image of family harmony at a time when many families were experiencing dynastic and financial problems.[3] The trope of family interaction could thus be seen as a public way of expressing the continuation of a blood line. Furthermore, seemingly informal portraits were often arranged as hierarchically as Holbein's Whitehall portrait. A typical example of nineteenth-century American portraiture [**64**] shows a family scene set in a simple bourgeois interior, with lively children playing games with each other. Nevertheless, the father has a position of prominence as both the tallest person in the work and the one positioned first, when looking at the painting from left to right. The children are also disposed from left to right according to their age.

The competing, but coexistent, signs of family hierarchy and interaction remained strong in portraiture throughout the nineteenth century. From the later nineteenth and twentieth centuries it is possible to detect a greater focus on the psychological, as well as social, dimensions of family life in portraiture. Degas's *The Bellelli Family* [**65**] is an extreme but useful example of a portrait that represents a family in crisis. This portrait could be placed in the tradition of conversation pieces, with family members interacting in a domestic interior. However, the odd arrangement of figures, with the father spatially separated

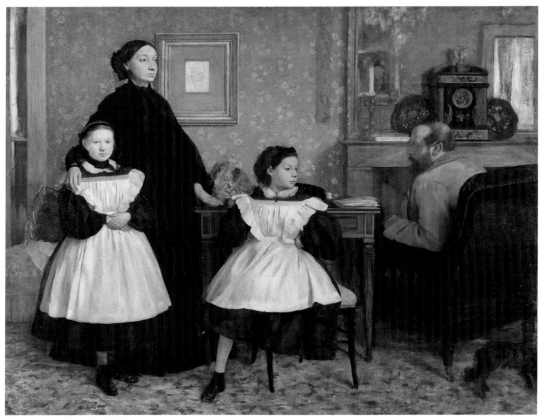

**65 Edgar Degas**

*The Bellelli Family,*
*c.*1858–60

Degas painted the Bellelli
family while he was part of
their household in Florence
between 1858 and 1860.
Although it is an early work,
Degas's psychological
penetration and use of
unconventional poses,
gestures, and disposal of
figures that were
characteristic of his later
portraiture can already be
seen here.

from his children and the mother standing in the usual position of hierarchy assigned to the patriarch of the family, gives this work an unstable and uncomfortable resonance. At the time Degas painted this portrait the Bellelli marriage was strained, and the tensions were affecting the family relationships. Degas, who lodged with the family at the time, attempted to tackle this tension visually rather than subsuming it beneath the artistic conventions of formality and hierarchy. Although most commissioned family portraiture projects a positive expression of family relationships, artists could be challenged by the problem of showing a group that did not necessarily fulfil the contemporary ideals of family life.

Family portraits do not always show a large number of family members. Sometimes specific relationships are singled out for artistic attention. This is especially the case in portraits that represent husbands and wives, and here a distinct tradition can also be identified. Before the nineteenth century it was common for patrons to commission companion marital portraits or portraits of married couples that visually separated the husband and wife. Piero della Francesca's famous double portraits of Battista Sforza and Federico da Montefeltro, the Duke of Urbino [**66** and **67**], are an early example. This unusual work is set in a

diptych format more frequently associated with altarpieces than portraits, and the two noble sitters are presented in a formal profile pose reminiscent of Roman coins. What unifies them is the landscape background that cuts across both portraits, and the cognate processional images on the reverse of the portrait panels. These images represent Montefeltro and Sforza involved in an ancient Roman triumphal procession, riding in carts containing Latin inscriptions that link the sitters

**66 Piero della Francesca**

*Federico da Montefeltro and His Wife Battista Sforza, c.1472*

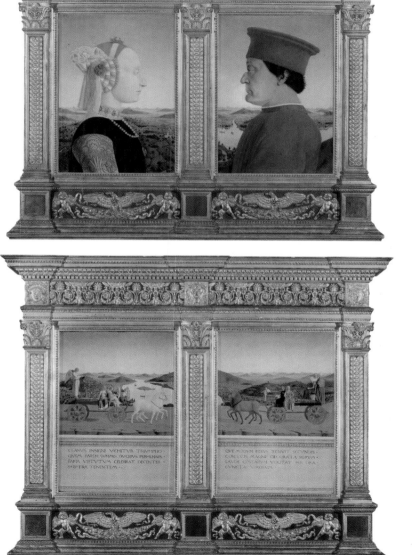

**67 Piero della Francesca**

*The Triumphs of Federico da Montefeltro and Battista Sforza, c.1472*

Federico was best known for his military valour and architectural patronage, which he dispensed from his court in Urbino. Although Piero della Francesca was only in Urbino for a short period of his career, he gained the patronage and respect of Federico and painted this allegorical double portrait of Federico and his wife Battista Sforza. Sforza died suddenly in 1472, and it is possible that her portrait was completed after her death.

with the cardinal and theological virtues. This portrait therefore probes the moral qualities of the sitters within the framework of their official marital association. What it does not do is to explore their personal relationship.

This formal model of marital portraiture prevailed for more than 300 years. Artists typically represented each member of the married couple separately, with the two portraits unified visually or thematically. The use of paired portraits can be traced back to medieval tomb sculpture,

**68 Daniel Mijtens**

*Thomas Howard, 2nd Earl of Arundel and Surrey, c.*1618

Mijtens was one of a Flemish family of painters who worked in both The Hague and England. While in England he was an important court artist for both James I and Charles I, and he produced portraits of other courtiers such as these of the Earl and Countess of Arundel. Mijtens follows a Flemish convention of producing paired portraits of the married couple in a full-length format that were meant to be hung facing each other. The Arundel sculpture gallery and family portrait collection appear in the background of these works, and Mijtens thus represents objects that were located in the couple's London home. Arundel was an important patron of the arts, and he employed Mijtens as an art dealer after the artist moved back to The Hague.

where effigies of both husband and wife would flank the family tombs. Theoretically, both husband and wife were given equal treatment, but the emphasis in the portrait was on their virtues as individuals, or as a pair, rather than their relationship with each other. Such paired portraits were conceived to be hung facing each other—for example, on either side of a mantelpiece—and artists often used the complementary gestures, accoutrements, or background to take account of the setting for which the portraits were ultimately intended [**68, 69**]. It has been

**69 Daniel Mijtens**
*Alathea, Countess of Arundel and Surrey, c.1618*

suggested that, by the seventeenth century, these formal qualities of marriage portraits were softened by a new emphasis on the companionate nature of marriage.[4] Certainly portraits of married couples became less formal, and by the eighteenth century portraits of married couples were more often conceived as visually unified compositions rather than as paired works. However, these are conventions of representation rather than a reflection of behaviour. It is important to understand that portraits mediated social expectation and lived experience, and thus the images of marriage that they projected may be related as much to the way people wished to see themselves as to changes in the behaviour or feelings of married couples.

A similar change in representation can be traced in portraits of parents or grandparents with their children. Given the high death rate among children in Europe in the medieval and early modern period, children were considered a precious but fragile part of family life. Early portraits of parents with their progeny tend to stress the importance of

**70 Anthony Van Dyck**

*Thomas Howard, 2nd Earl of Arundel, with His Grandson, Thomas, later 5th Duke of Norfolk, 1635–6*

Van Dyck produced this portrait after his return to England in 1632, when he accepted a court position from King Charles I. On his first brief visit to England in 1599 Van Dyck had already painted a portrait of the famous art collector, the Earl of Arundel. This portrait contains an effective mix of dynastic and personal imagery. During this period the earl was working to re-establish the Dukedom of Norfolk for his family; his grandson would later reap the benefits of Arundel's efforts. Arundel is also dressed in formal military clothes. However, an air of intimacy is achieved through the gentle gesture of his hand on his grandson's shoulder.

**71 William Hoare**

*Christopher Anstey and His Daughter, c.1779*

**71 William Hoare**

*Christopher Anstey and His Daughter, c.1779*

Hoare spent most of his career in Bath, a lively resort that attracted noble and influential members of society throughout the latter half of the eighteenth century. There was a heavy demand for portraits among Bath society, and Hoare competed with such important fellow artists as Gainsborough. Anstey was a famous Bath figure who was responsible for writing the witty jibe at fashionable society, *The New Bath Guide* (1766). In his portrait of Anstey Hoare has attempted to capture something of Anstey's reputation for good humour.

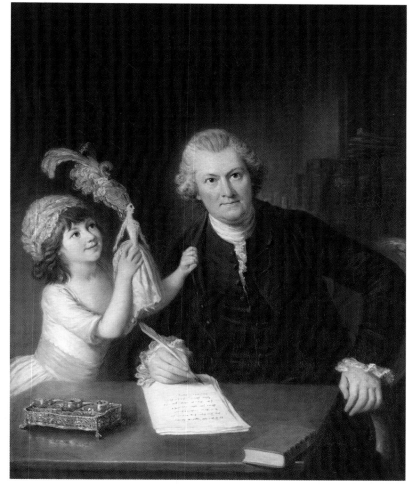

children in carrying on the family line, and therefore the dynastic nature of the parent–child relationship is in the forefront. By the seventeenth century the dynastic emphasis remained, but portraits of parents and children became less formal and concentrated more frequently on social or personal connections between different generations [70]. While continuing to allude to the continuation of a family line, portraits of fathers and sons, for example, could emphasize the son's role in taking on the career of the parent. This frequently applied to high-born families with a military tradition.

What became even more common in portraiture by the end of the eighteenth century was an informal interaction between parents and their children that evoked the idea of a strong personal bond. Portraits of children playing with toys and dolls, teasing their parents, or misbehaving presented a more sentimental side of family life, as can be seen in the English artist William Hoare's portrait of Christopher Anstey and his daughter [71]. The spirited play of Anstey's daughter pulls away

from the dynastic and hierarchical conventions of the family portraiture of the previous century. It has been argued that this kind of portraiture reflected changes in the real behaviour and relationships of families, parents, and children.[5] However, there have been a number of justifiable criticisms of this reading of portraiture as a transparent reflection of family interaction. Hoare's portrait of Anstey, for example, might give a flavour of a warm relationship with his daughter, but the informality of a portrait like this may also have been a means of drawing attention to the work at a public exhibition, or it may relate to a contemporary belief, inspired by the theories of Jean-Jacques Rousseau, in the importance of childhood. Portraits have thus contributed to a changing public image of family life, affecting the way families were represented, discussed, and understood, rather than reflecting a change in the lived experience of husbands and wives, parents, and children.

## Civic and institutional portraits

Just as families may have felt the need to express their personal, dynastic, and hierarchical relationships through portraiture, so various public organizations also have commissioned portraits of groups, as well as individuals. Civic societies such as guilds, militia groups, confraternities, and charities have commissioned often quite imaginative portraits representing large numbers of their membership. These civic group portraits are significant in a number of ways. First of all they needed to express something about the common identity of the group, perhaps through costume, insignia, pose, or gender. Secondly, although guilds and other civic groups had hierarchical structures, artists who produced civic group portraits had to be sensitive to an ideology of equality and solidarity voiced in the rhetoric of some civic groups. Unlike family portraiture, many civic group portraits express democratic rather than hierarchic relationships. Thirdly, individual members of such group portraits had to be distinguishable by their carefully crafted likenesses. Thus, even though a group ethos is being represented, the individuality of each group member must also be apparent. Finally, as with family portraits, artists who produced civic or institutional portraits had to find ways of knitting a collective of individuals into a visually and psychologically coherent group.

The idea that a civic organization could or should commission portraits can be traced back to the late fifteenth century, when Venetian confraternities commissioned works that included portraits of individual members. Confraternities were groups of lay people who dedicated themselves to a particular saint. These organizations often became wealthy due to the income from both subscriptions and endowments, and they competed with each other to demonstrate the greatest homage to their patron saint. The larger confraternities built elaborate meeting

**72 Gentile Bellini**

*Procession in Piazza San Marco*, 1496

This was one of eight canvases commissioned by the confraternity of the Scuola Grande di San Giovanni Evangelista in Venice. This confraternity claimed possession of a relic of the Holy Cross; the series of paintings told the story of how it came into their ownership. This contribution to the scheme by Bellini commemorates an event of 1444 when a Brescian merchant saved his dying son by kneeling before a relic of the Holy Cross carried by the confraternity. The narrative nearly disappears within Bellini's painstaking reproduction of the architecture of the St Mark's Square and the rich detail of the procession. In the foreground, living members of the confraternity participate in the procession wearing their white robes. The inclusion of their portraits in such a historical narrative was important in linking the living members with the historical and religious history of their group.

houses and commissioned the best local artists to decorate them. They also participated in public spectacles in honour of their saint. Because of the public visibility of confraternities, they became a source of civic pride as well as religious piety. Portraiture became one of the many ways in which a confraternity could demonstrate its importance. However, works such as Gentile Bellini's *Procession in Piazza San Marco* [72] are set in a processional, ritualistic context, and the individual members of the group become part of a ceremonial event. The portrait aspects of the work are thereby overwhelmed by the sense of ceremony and occasion. Because of the close rivalry among confraternities, the desire to project a corporate image was strong within these institutions, and that image was felt to reside in both the group ethos and the significance of individual members. The inclusion of portraits in ceremonial compositions therefore served both purposes.[6]

Such group portraits were thus especially common in cities with a strong sense of civic responsibility and enough local wealth and power to encourage rivalry among competing organizations. It is thus no surprise that the heyday of the civic group portrait was the seventeenth century, during which time the Low Countries led the way in promoting this sub-genre.[7] Not only were there militia groups in every major city but also charitable organizations with a prominent local profile. The militia groups were such avid patrons of portraiture that their portraits were given a separate nomenclature, the *doelenstuk*. These portraits were commissioned from many of the major Flemish artists of the seventeenth century, including Hals and Rembrandt. Hals was particularly adept at meeting the complex requirements of civic portraiture: his works demonstrate a group ethos through costume, props, and unifying gesture, but they also give equal attention to each member of the

group and properly distinguish the likenesses of individuals [**73**]. Hals's group portraits can be quite formally arranged, but he undermined this formality by including interaction among the members.

The problems of balancing group solidarity, equality, and individuality were confronted more dramatically by Rembrandt in his famous *The Night Watch* (1642) [**74**]. Originally entitled *The Company of Francis Banning Cocq Readying to March*, this painting shows members of Amsterdam's civic guards preparing for parade. Unlike Hals's more orderly portraits, *The Night Watch* is a dramatic composition that focuses on the action itself rather than on the likenesses of individuals, although these are rendered effectively. Here a sense of hierarchy replaces the illusion of equality apparent in Hals's work, as members of the guard are given varying degrees of prominence. In fact each sitter contributed a different amount to the cost of the group painting, depending on how prominently he was represented. The distinctions between Hals's and Rembrandt's works show the two extremes of civic group portraiture. On the one hand the portrait can be formal, with careful attention to each member of the group; on the other the dramatic qualities of the composition can take precedence, and the artist can manipulate his or her subjects as if they are figures on a stage. Similar qualities are also present in family portraits, but the purposes behind the commissioning of the portraits, and the ways the relationships are conceived and understood, give a somewhat different meaning to the militia portraits.

A clear distinction between family and civic group portraits lies in the gender and age balance and divisions of each kind of work. Family portraits frequently include both children and adults, both men and women. Institutional portraits are more often representative of individ-

**74 Rembrandt Harmenszoon van Rijn**

*The Militia Company of Captain Frans Banning Cocq ('The Night Watch')*, 1642
This group portrait was given the erroneous title *The Night Watch* in the nineteenth century, as the combination of chiaroscuro and heavy varnish made it appear to have a nocturnal setting. Subsequent research proved that this was a civic guard portrait, albeit an unusual one. Rembrandt shows Cocq, the captain of the guard, ordering his lieutenant to prepare the company to march. The sense of bustle and movement here turns a portrait into a kind of narrative scene.

uals born roughly in the same generation and who are of the same gender. Men certainly dominate civic group portraits, largely because of their traditionally prominent role in public organizations. However, in the seventeenth century there were also a significant number of group portraits representing women, especially those who had been involved in charities, hospitals, or other philanthropic activities. Such portraits [75] are similar to the *doelenstuk* genre in that they show a collection of individuals, sharing common dress or attributes and given equal visual prominence. However, it is also interesting to look at the generational aspects of such portraiture. Militia portraits usually represent men in the prime of their life, between 20 and 40 years old. Group portraits of women who have public responsibilities tend to concentrate on the elderly, as those without immediate family responsibilities could devote themselves to such occupations.

The recurring tropes of solidarity, equality, and individuality characteristic of seventeenth-century civic portraits can also be seen in different kinds of institutional group portraiture to the present day. These qualities were cleverly and ironically expressed in a twenty-first-century portrait by Stuart Pearson Wright showing *Six Presidents of the*

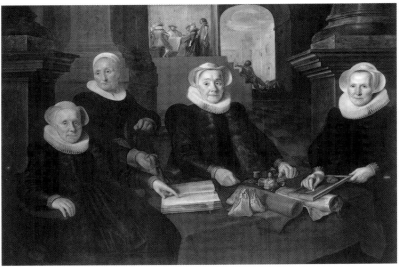

*British Academy*, which won the BP Portrait Award at the London National Portrait Gallery in 2001 [**76**]. Like the seventeenth-century militia, the British Academy is an elite organization, but it is one that stresses academic rather than civic or martial accomplishments. Largely male dominated, the British Academy has had a number of distinguished presidents whose portraits Wright painted separately and then brought together in his fascinating portrait. The issues of solidarity, equality, and individuality that underlay seventeenth-century civic portraiture are translated here into a twenty-first-century context. Solidarity is shown through the identical dark suits worn by all except Sir Kenneth Dover on the far right, who characteristically sports a tattered jumper. Anonymous suits constitute the uniform of this group. Equality is conveyed by the balanced attention given to each figure; Wright has even tilted the perspective of the table so that each one is equidistant from the picture plane. Individuality is achieved in the careful delineation of facial expression and configuration. The stark setting of the room is given geographical fixity by the view of the London Eye Ferris wheel through the back window. The serious expressions of the sitters are challenged by the incongruous presence of a dead chicken—possibly a modern-day *memento mori*—on the tea table. The fact that the group of presidents is drinking tea may allude to the prominence of tea drinking as a unifying activity in family conversation pieces of the past, but here the ritual deliberation of the tea drinking serves to undermine, rather than enhance, the informal nature of this interaction. The presidents of the British Academy are all posing, just as Hals's militia were, but unlike Hals, Wright makes no attempt to create an interaction among the sitters, who all appear rather glumly uncomfortable in this group composition.

Civic and institutional portraiture thus consists of a set of visual

and/or psychological relationships among the sitters that can express something about both group identity and individuality. Such portraits give artists the problem of balancing the needs of an organization with those of each of the individuals within it.

## Artist groups

Family and institutional portraits comprise the vast majority of group portraiture, but another notable type of group portraiture emerged in

the eighteenth and nineteenth centuries: portraits of groups of artists. Previously rare, such works eventually become crucial signals for changes in the self-image of the artist. How artists decided to represent both their fellow practitioners and the nature of their group identity is not only important to the history of portraiture but also reveals a great deal about the growing professionalization of the art world and changing self-perceptions of the artist.

Johann Zoffany's portrait of the first Academicians at the English Royal Academy of 1771–2 is an early example of this type of group portraiture [78]. Zoffany's work represents all of the male members of the recently formed Royal Academy. The group of artists is shown in the life class, which was the foundation of artistic learning at the Royal Academy schools. The interactions among the different artists, and their visible expressions of interest, curiosity, engagement, or distraction enliven the scene. At first glance Zoffany appears to have given relatively equal prominence to each of the sitters, but a closer study reveals the kinds of hierarchies common in family portraits. The major officers of the Academy, such as the President Joshua Reynolds and the Professor of Anatomy William Hunter, stand in the centre background—Reynolds with his ear trumpet and Hunter stroking his chin and considering the position of the life model. By contrast, some of the lesser-known Academicians are tucked away in the far corners. The two female members, Angelica Kauffmann and Mary Moser, would have been excluded from life drawing classes, so they are represented through portraits on the back wall. At a period in British history when artists for the first time had their own professional academy, it was important for them to justify the authority of their new institution. The presence of both antique casts and the life models in this portrait represent the ideals of the Academy schools. Such group portraits of artists have been creatively compared to the so-called *sacra conversazione*—a late fifteenth-century innovation showing the Madonna and Child surrounded by saints who appear to be interacting.[8] Such a comparison gives a hint of the sense of higher purpose behind the production of group portraits of artists.

The combination of informality, institutional pride, and artistic idealism that underlay Zoffany's portrait was not the only model for group portraits of artists. By the late nineteenth century artists were beginning to develop different sorts of collective identities outside the official institutional structures. The notion of the avant-garde signalled artistic rebellion, but much of what was taken to be avant-garde in the last decades of the nineteenth century grew from the interactions of groups of artists rather than from single individuals. The new groupings of artists found different ways of asserting their artistic identity, using the agency of art dealers, the publication of manifestos, and the production of portraits expressing their group ideals.

**77 Henri Fantin-Latour**

*Studio in the Batignolles*, 1870
Fantin-Latour mixed with avant-garde artists but his style often had more in common with old masters. He was especially well known for his still lifes, but he painted a range of group portraits like this one that paid homage to important creative individuals such as Delacroix (1864) and Wagner (1885). In each case he created a modern-dress group composition, with well-known artists, writers, and musicians clustering around the figure of homage.

**78 Johann Zoffany** (next page)

*Academicians of the Royal Academy*, 1771–2
The founding of the English Royal Academy by George III in 1768 was a significant moment for London artists. As with many such pivotal events, a portrait was commissioned to commemorate it. Zoffany himself and several other foreign artists were among the king's specially selected founder members of the Royal Academy. Zoffany was adept at producing crowded group portraits like this one that nevertheless retained a sense of coherence and visual variety.

Among the most famous of these group portraits is Henri Fantin-Latour's *Studio in the Batignolles* [**77**]. This is a much more formal portrait than Zoffany's Royal Academicians, as the interaction among the sitters appears as sombre as the dark clothes they all wear. To signal that this is a portrait about artists, Fantin-Latour has represented the central figure Édouard Manet painting while others cluster around him. Among this group are Renoir and Monet, as well as the novelist Émile Zola. This circle of artists includes some, such as Manet himself, who had been trained in the official Paris art school, the École des Beaux-Arts, but this group was also known for its daring experimentation with both style and subject matter, and some members of the group would later appear together at the 'Impressionist' exhibitions. This is therefore a portrait of men who saw themselves in the vanguard of artistic experimentation. Although we see no evidence of the style or methods advocated by this group, their solidarity suggests a proclamation of collective identity based on their avant-garde ideals.

The Impressionists and their circle were perhaps responsible for shifting the emphasis of artist group portraits away from an institutional ethos and towards a goal of idealism cemented by private friendships. The deliberate formality of Fantin-Latour's portrait is complemented by a much more casually composed group portrait painted by Bazille in the same year [**79**]. Entitled *The Studio in the rue La Condamine*, this unusual work represents Bazille's friends congregating in his studio. At first glance the distance of the figures and the excess of empty space seem to make this an inappropriate composition for a portrait, and the work has the feel of a genre scene. However, each of the figures in the painting has been identified—they include Manet, Monet, Zola, Renoir, and others—some of whom had also been

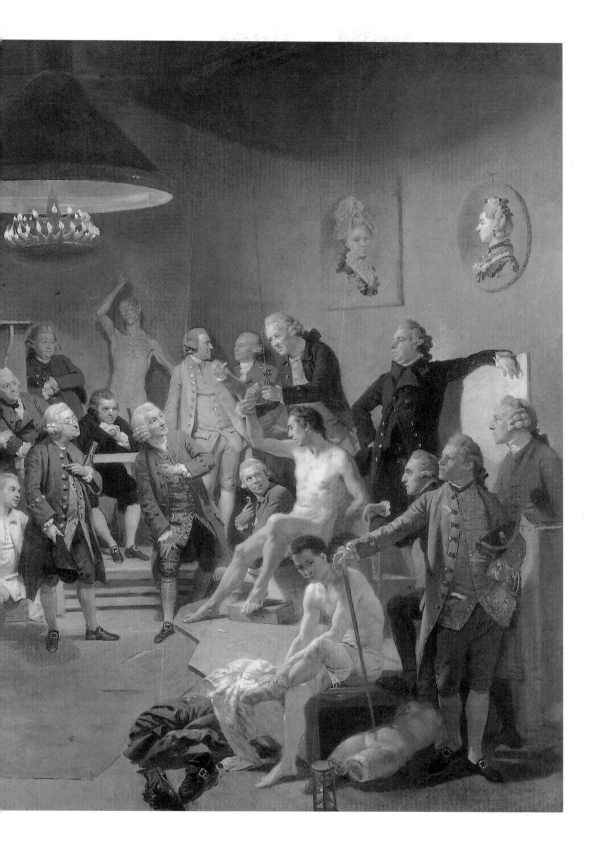

*The Studio in the rue La Condamine*, 1870
Bazille used the group portrait to commemorate his personal friendships with artists and musicians. Although not a key member of the French Impressionist group, Bazille travelled and painted with Monet, and counted Renoir and Sisley among his friends. This is one of several informal group portraits of Bazille's circle set in a studio.

80 Max Ernst

*Au Rendez-vous des amis*, 1922
Ernst painted this group portrait during a transitional period between his involvement with the Cologne Dada circle and his affiliation with the Paris Surrealists from the mid-1920s. Ernst moved to Paris in 1922 after becoming friends with the poet Paul Éluard; this portrait, with its echoes of Dada iconoclasm, commemorates the new set of friendships that would later flourish within the Surrealist movement.

included in Fantin-Latour's portrait. Rather than posing formally, each person is engaged in activity or conversation, and the work exudes an air of cheerful bustle and creative energy. Bazille himself is there in the background, painting at his easel. His figure was added by Manet, which gives the work an even greater sense of communal exchange. This is less of an artistic manifesto and more of a declaration of artistic friendship and common purpose. Such close associations between artists were the impetus for much avant-garde activity in the late nineteenth and early twentieth centuries, and it is perhaps not surprising that portraiture became a method by which artists could declare their solidarity and sense of purpose.

Group portraits of artists could also take the form of a kind of visual manifesto, especially when they were used for stylistic experimentation. This was commonly practised by avant-garde groups in the early twentieth century. Max Ernst's *Au Rendez-vous des amis* [80] thus seems to be more about the rebellious stance of an artist associated with the iconoclastic Dada movement than a declaration of artistic friendship or idealism, although the group he chose to represent was a particularly close-knit one. Ernst played with the style and the subject of this work, as well as experimenting with the genre of portraiture itself, by labelling each of the individuals included and painting the key identifying the sitters. What pretends to be a document thus becomes an ironic representation of a group of artists and writers who challenged the norms of bourgeois society.

Portraits of artist groups could thus serve diverse purposes. They could signal the professional standing of artists. They could reflect artistic friendships. They could be devised as visual manifestos or as public declarations of avant-garde intentions. Group portraits exemplify both visual and psychological relationships, and despite conventionality or formality, they can be more varied in composition, approach, and effect than portraits of single individuals.

# The Stages of Life

5

Age is a significant factor in all portraiture, but it is one that too often gets taken for granted. Portraits are frequently produced at significant moments in the sitter's life, such as childhood, important occasions in young adulthood (for example marriage), and old age. The representations of age could be a great challenge for portraitists, who were often hampered by the competing demands of likeness and flattery. Just as artists could display their abilities through the manipulation of many figures in group portraits, so they could also demonstrate their skills by close attention to the signs of age in their sitters. Artists could concentrate on delineating the signs of age as faithfully as possible, or they could show children as young adults or divest the elderly of wrinkles and blemishes. Such decisions about how to deal with the age of their sitters varied in different times and places.

The problem for the historian of portraiture is determining the age of the sitter. With documentary evidence of birth and death dates, and dates of sittings, it is sometimes possible to infer the age of the sitter, but it is difficult to recognize what age the sitter was *intended* to be; this could be at variance with such documentation, as with portraits of Elizabeth I. Preconceptions about age would have governed the decision-making processes of artists, patrons, and sitters, and they also colour our own interpretations—which may be different to those of the past.

The inextricable relationship between portraiture and mortality is also an issue. As I have argued, portraits can be mementos of a living moment that has gone forever. The age of the sitter is a further intimation of that lost moment. Thus portraits of children can often contain symbolism of life's transience; portraits of young adults can exhibit an ideal but ultimately artificial perfection; and portraits of the elderly can become essays on the proximity of death.

## Children

Ideas of childhood, its limits, and its meanings are historically specific. Nearly all civilizations value children but their concerns can be very different. Some focus on children as carrying on the family line; others have a more sentimental view of the significance of childhood. Children

have been seen as both economic necessities and emotional binds. Childhood has also been subject to different temporal limits. While some societies believe that childhood ends well before puberty, others conceive of it as extending to the teenage years. Although conceptions of childhood are unstable and historically contingent, it can also be argued that there are certain constants. Most cultures have not only valued children as a social necessity but have recognized the emotional attachment felt for them by their parents and guardians. Whatever the conception or limits of childhood, its significance has meant that children have been important subjects of portraiture. Portraits of children were inevitably commissioned by adults, whose views of the children, and of childhood in general, often influenced the choices made in these representations.[1]

In some periods of history children are understood to be adults in miniature, and it is therefore their adult qualities that are emphasized in portraiture. Such works will show a child wearing adult clothes or mimicking a conventional pose. At other times the state of childhood itself has been romanticized or sentimentalized, and portraitists have engaged with the distinctive qualities attributed to children, such as playfulness or innocence. Works in this category will show children playing, exhibiting facial expressions not normally used in adult portraiture, or lounging in casual postures that would be inappropriate for formal portraits. Many portraits represent a tension between the innocent child and the adult-to-be. In each case the general state of childhood becomes a subtext of the specific portrait.

Portraits of children can be traced back to Roman Egypt, where mummy effigies commemorated people who died in infancy. The extant Fayum portraits represent individuals of all ages, as they appeared at the point of their death. Such portraits served a ritual and religious function in Roman Egypt, so the very existence of the effigy of the deceased individual (whether child or adult) was more important than their age.

Death was also a theme in secular portraits of children in later periods. Until the twentieth century witnessed major advances in medicine, nutrition, and sanitation in the developed world, death at birth or in infancy was common at all levels of society. Parents therefore had to accept the possibility that none of their children would survive. Portraits of children before the twentieth century frequently engaged with the issue of death, often in a symbolic way, even while they showed living and healthy children. *The Graham Children* [**81**], by the English artist William Hogarth, offers an eloquent demonstration. Four seemingly healthy and happy children are shown posing cheerfully, smiling, playing with their toys, and holding hands while symbols of death and the loss of innocence abound. The predatory cat threatening the canary in the cage and the figure of Time with his scythe on top of the clock are

**81 William Hogarth**

*The Graham Children*, 1742
Hogarth is best known for his
satirical engravings such as *A
Rake's Progress*, but he was
also one of the most talented
and imaginative portrait
painters in early eighteenth-
century England. Some of his
patronage came from middle-
class families such as that of
Daniel Graham, King George
III's apothecary, who
commissioned this portrait of
his children.

only two of the symbolic references to the loss of childhood through experience and/or death. The death of the youngest of the children here while Hogarth was completing the portrait did not stop the artist from including him as if he were alive.

Throughout the history of portraiture, however, there has also been a tendency to show children as miniature adults. The contrast between adult postures and clothes and childlike faces is apparent in works such as Velázquez' various portraits of children [82]. For example, Velázquez represents Philip IV's daughter, the Infanta Margarita, standing in a conventional portrait posture with a characteristically adult frozen facial expression. But while we seem to see here a miniaturized adult, we also get a strong sense of the smallness of the child through the vast garments that encompass her frame, her tiny hands, and pouting mouth. Portraits such as these were meant to represent the child in their official state role. While such portraits often served a public or ceremonial purpose, the impression they conveyed of childhood could be ambiguous. Children represented as miniature adults may appear to be

82 Diego Rodríguez de Silva y
Velázquez

*Infanta Margarita in a Blue
Dress*, 1659
Velázquez painted Philip IV's
young daughter several times
in his late career, and she was
also the central figure in *Las
Meninas* [see **20**]. Margarita is
usually shown in a formal pose
but wearing different
garments, allowing Velázquez
to demonstrate his skill at
portraying drapery. After
Velázquez' death Margarita
became the wife of the
Emperor of Austria,
Leopoldo I, at the age of
only 15.

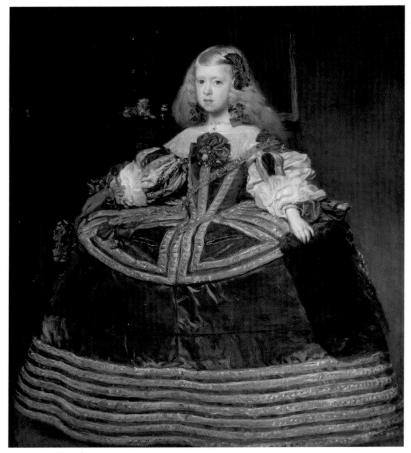

masquerading, but underlying such representations are the discordant tropes of childhood innocence and adult sexuality. The fact that royal children such as the infanta were being groomed for marriage from a very early age reinforces our dual vision of the child/adult.

Velázquez' Flemish contemporary Gerrit Dou used a different tactic in his portrait of Prince Rupert of the Palatinate [**83**]. Dou plays with the contrast of youth and age characteristic of some family portraiture, but the emphasis here is on the child being educated for his public role. The fact that both tutor and pupil are in fancy dress gives a deliberate air of masquerade. A portrait such as *The Graham Children* symbolically represents death and the loss of innocence; by contrast, this portrait is a metaphor for the process of passing the wisdom of age on to the ignorance of youth. Here Prince Rupert is shown acquiring the tools he will need for his later public role, but Dou gives us no sense that the prince is anything but a child. While Velázquez' Margarita appears as a sort of iconic figure, Dou's narrative calls attention to the link between Rupert's education and his future responsibilities.

From the seventeenth century onwards it was increasingly common

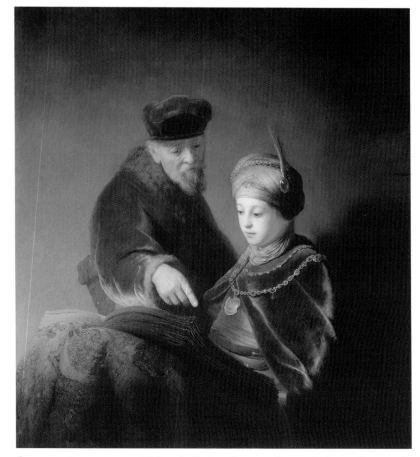

for portraits to stress children's distinctiveness from adults and to sentimentalize this difference. Part of this change was the result of a greater social and psychological attention to the state of childhood itself. By the early nineteenth century the innocence and beauty of childhood became the subject of Romantic poetry extolling the unblemished innocence of the child, even while it recognized the poignancy of loss that came with the growth to adulthood and old age. Portraits of children lost their adult-in-miniature quality, and even when they seemed to foreshadow the adult hiding in the child, this was done in such a way as to emphasize the childishness of the sitter. The Symbolist movement that flourished throughout Europe and in America in the late nineteenth century took on Romanticism's fascination with the poignant and nostalgic qualities of childhood. In the portrait of Jeanne Kefer by the Belgian Symbolist Fernand Khnopff [**84**], the sitter gazes shyly but directly out of the frame and appears uncomfortably overdressed. Her pose is not unlike that of the Infanta Margarita, but the effect of her gesture, expression, and costume is redolent of childish timidity rather than monumentality. This portrait seems to hint at a deeper meaning,

**84 Fernand Khnopff**

*Jeanne Kefer*, 1885

Khnopff was one of the best-known Belgian Symbolist painters in the late nineteenth century. Many of his subjects use devices of European symbolism such as obscure yet richly evocative subject matter and a propensity for androgynous figures. However, Khnopff was also a fashionable portraitist who produced over 30 portraits of elite members of Brussels society. Many of Khnopff's portraits, such as this one, seem to draw their effect from his Symbolist tendencies.

but like Khnopff's other Symbolist work these potential themes remain implied and indeterminate.

In each of these cases, the portraitist had a number of decisions and choices to make. Social expectations would have dictated whether a child needed to be seen as presaging a future adult role, or whether the otherness, innocence, or playfulness of childhood was to be emphasized. The artist had to work with the physiognomy of the child, whose facial character was not fully formed, and would thus often experiment instead with pose, dress, posture, and gesture. Portraits of children also gave artists the possibility of evoking larger themes, such as death or loss of innocence. In each case it is important to remember that portraits of children were commissioned by adults, who had a range of motivations from affection to an assertion of the child's social role.

## Young adulthood

Many portraits represent individuals at the prime of their lives, in the years of young adulthood. There are abundant portraits from this period in the life-cycle because in many countries and periods, adults in their late teens, twenties, and thirties are going through possibly the most significant phase in their lives. These are the years of independence, marriage, and inheritance of parental property. Although marriage

is almost universally considered a highly significant moment in any individual's life, it is also a social phenomenon, bringing with it the possibility of dynastic succession, the maintenance or creation of new family allegiances, or economic power. The period of young adulthood is also a time when elders die, leaving money, estates, or titles to their children. Given the status of portraiture before the modern period as a primarily elite art form, it is no surprise that these significant life moments were the subject of representation. Portraits were frequently commissioned at the time of marriage or title inheritance. Such portraits do not necessarily refer to these moments, but there is often a direct relationship between marriage, inheritance, and so on, and the commissioning of portraits.

However, there is another significant reason why portraits are often commissioned in the years of young adulthood. This is a time when the face is fully formed but has not lost its freshness. Flattery has often been an important consideration for portrait sitters, and the desire to be portrayed at the best moments of one's life is not a surprising human reaction. For example, the beauty of youth was a characteristic of much Renaissance portraiture. Italian artists in the fifteenth and sixteenth centuries stressed the ideal qualities of the sitter's face, even while they paid careful attention to the depiction of likeness. This is true not only for women but also for men. Botticelli's *Portrait of a Young Man with a Medal of Cosimo de' Medici* (*c.*1465) is one such work [**85**]. The identity of the portrait sitter is no longer known, nor can his relationship with Cosimo de' Medici be discerned from the image. The very anonymity of the sitter makes the work as much an essay in youthful male beauty as a portrait. The poetic and philosophical basis of Italian portraiture in the fifteenth and sixteenth centuries made the ideal beauty of youth take precedence over notions of specific likeness. As Cathy Santore has shown, it was only at the end of the sixteenth century that Venetian paintings of beautiful women were labelled portraits (*ritratti*) in inventories; previously they had been referred to as pictures (*quadri*), which suggests a rather different function.[2] Generic portraits by Titian, Giorgione, and Palma Vecchio in the sixteenth century move even further in the direction of blurring the distinction between portraits and ideal representations of young men and women [see **94**]. This slippage between the portrait function and the theme of ideal beauty gives such works a poetic quality, and much of this rests on the representation of youth they convey. This Renaissance concentration on the sitter in the years of young adulthood thus served the purpose of allowing the artist to achieve most satisfactorily a balance between likeness and ideal.

There are also symbolic reasons why portraits might concentrate on the young adulthood of their sitters. Hellenistic royal portraits from the third century BC, for instance, always represented kings as youthful—a state that was signalled by the lack of a beard.[3] The image of a young

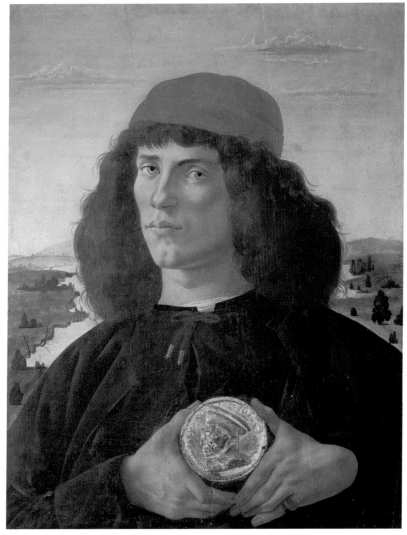

beardless king was not unlike that of a god, and this analogy between royalty and divinity was one that was also explicitly made in cult statuary. In early modern Europe, images of youthful regality had fewer religious connotations but were no less symbolically significant. Queen Elizabeth I's portraits were attempts to endow her with an iconic presence (see Chapter 3), but they also preserved her face at the stage of young adulthood.

## Old age

What is considered old age differs dramatically in place and time. Shakespeare's reference to the seven ages of man in *As You Like It* has a universal resonance in its image of enfeeblement and 'second child-

hood', but the actual age at which this decrepitude occurs is not speci-fied. Whereas Shakespeare describes old age in terms of dress and behaviour, old age in portraiture is expressed by wrinkled skin, faded or mottled complexion, or white hair. It is thus the signs of ageing, rather than the actual age of the sitter, that we can identify. Some of the most powerful portraits are those that show their sitters in old age. While the reasons for choosing to concentrate on youth may be the significance of this period of life, the issue of flattery, or the iconic nature of the por-trait, old age equally carries with it a series of important associations. In different periods of history portraitists have prized or reviled the elderly according to contemporary attitudes. Concern about an unflattering image has prevented many potential sitters from commissioning portraits at a later stage in their life, but artists and sitters have also found the signs of age and experience a stamp of character, wisdom, and experience, and thus potent material for expressive portraiture.

Several countries and periods in the history of art have favoured por-traits of the elderly, and it is worth examining the social and historical reasons why this is so. In ancient Rome, for example, old age was a common subject in portrait sculpture. The wrinkled and lined skin and sunken flesh of Roman portrait busts have been interpreted as evidence of likeness, but it is equally possible that these signs of age were prod-ucts of a culture that valued age as an indication of experience and authority. Those cultures that revived Roman examples, such as the Italian Renaissance, favoured similar stylistic effects for representing the signs of age.[4] Cardinals and popes, for instance, were frequently represented with the signs of ageing showing in their faces [see **60**]. One of the earliest free-standing northern European portraits repre-sents a cardinal: Van Eyck's portrait of Cardinal Niccolò Albergati [**86**] picks out the crow's feet around Albergati's eyes, the chicken-like neck, and the receding hairline.

Another significant era for the representation of old age was the so-called 'Romantic' period at the end of the eighteenth century and the beginning of the nineteenth century. In Europe during this time much attention was paid to the stages of life and to the extremes of both child-hood and old age. The publication of Lavater's essays on physiognomy in 1775–8 helped popularize the idea that facial features could be a sign of personality traits, and this contributed to the Romantic interest in individuality and character (see Chapter 1). This fascination found its way into portraits that concentrated on the imperfections of the sitters, rather than on idealized qualities.

In the twentieth century, especially after the Second World War, the privileging of formal experimentation associated with avant-garde artists meant that sitters could be willing to choose a portraitist whose representation of them highlighted, rather than concealed, the signs of age. With the growth of photographic portraiture and photorealism the

blemishes and wrinkles of age have become a common theme in works by artists as diverse as Chuck Close [see **135**] and Jo Spence [see **137**].[5] Perhaps the representation of age in portraiture has become so widespread because the average age of the population of the Western world has risen dramatically, owing to advances in medicine and sanitation. More people live longer, and age has become a powerful political and social issue in many countries. Accompanying this demographic pattern are mixed feelings about the ageing population, due to a strong popular culture of youth, health, and vigour.

In all periods of history, however, portraits of elderly sitters have certain resonances in common. First of all, age is frequently represented in portraiture as a sign of authority, wisdom, and experience. In premodern periods these qualities are frequently reserved for the representation of age in male sitters only, as the more positive connotations

**86 Jan Van Eyck**

*Cardinal Niccolò Albergati, c.1432*

In preparation for this portrait of the Bolognese cardinal, Van Eyck produced a silverpoint drawing, which was accompanied by handwritten notes detailing the colour scheme he intended to adopt in the final oil painting. This suggests that the artist's working method consisted of capturing the essential features of his sitter before he heightened the verisimilitude of his representation with colour. The recently discovered technique of oil painting served Van Eyck particularly well in contributing to his desired effect, as it allowed greater nuance of light and shade. This can be seen especially in the way Van Eyck has strongly lit the left side of Albergati's face, the interplay of light and shadow revealingly picking out the sitter's distinctive features.

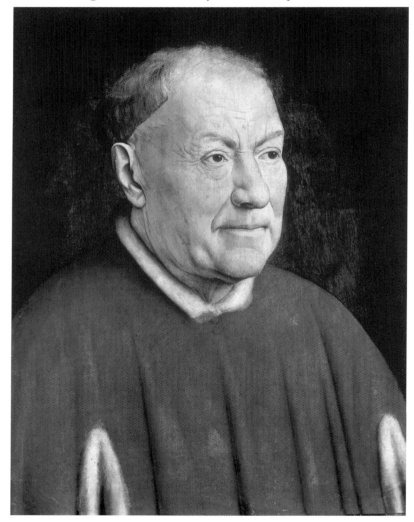

of ageing—such as wisdom and authority—were generally considered to be public virtues that were simply unavailable to women, whose lives were lived almost solely in the domestic sphere.[6] When ageing was associated with women, the connotations could be different. Portraits of artists' mothers, such as those by Rembrandt and Whistler [see **121**], associate ageing with matriarchal authority and domestic stability. Conversely, some contemporary women artists have recognized the social stigma of ageing for women, and have chosen to draw attention to society's hypocrisy about ageing. Alice Neel demonstrates this most effectively in her provocative self-portrait [**87**]. Here she plays with taboos of old age and nudity, but satirically exaggerates her sagging breasts and stomach in a work that otherwise shows her in a conventional seated portrait pose.

There are exceptions to this gender-specific representation of ageing

**87 Alice Neel**

*Self-portrait*, 1980

Neel was an American artist who maintained a commitment to figure painting during periods in the twentieth century in which abstraction was more fashionable. Most of her portraits were uncommissioned works, and she took advantage of the freedom this gave her to present unflattering, highly characterized impressions of her sitters. She was no less harsh on herself, as can be seen in this self-portrait of her aged and sagging body and jowly face.

**88 Sofonisba Anguissola**

*Self-portrait, c.*1610

This portrait of the highly successful Italian artist is one of 12 surviving self-portraits that Anguissola painted at different points in her life. As she lived to be over 90, the portraits catalogue her ageing face. These portraits represent Anguissola's diverse accomplishments, from painting to music. She ended her career with her artist/husband at the court of King Philip II in Madrid.

in portraiture. Portraits of charitable societies in the Low Countries in the seventeenth century show elderly women as distinguished and wise by virtue of their age. Women artists also painted self-portraits in which they studied their own ageing with a seemingly detached eye. This was the case for the seventeenth-century Italian artist Sofonisba Anguissola, who painted portraits of herself at many different stages of her life, and provides a dispassionate but by no means harsh view of herself in old age [**88**]. Here the signs of ageing—thin lips, leathery complexion, and greying hair—accompany a sombre expression that is both dignified and moving.

A second reason for showing age in portraiture is the challenge to the artist of the expressive possibilities in representing the complexity of ageing facial features. Most notably Rembrandt played with this expressive power in his own late self-portraits, where he is uncompromisingly severe in his treatment of his ageing. The German twentieth-century printmaker Käthe Kollwitz also produced numerous self-portraits highlighting her ageing features. She deliberately represented herself as ugly, even ape-like, and stressed the square masculinity of her face in a sometimes brutal way. It is notable that such expressive portraits of ageing are most frequently self-portraits, as artists found opportunities to experiment with their representation of the human countenance in a way that may not have been tenable in commissioned portraits.

Perhaps some of the most powerful self-portraits representing the ageing face are those of the Finnish artist Helene Schjerfbeck. Schjerfbeck painted over 20 self-portraits between the ages of 77 and 83 [**89**].

**89 Helene Schjerfbeck**

*Self-portrait with Red Spot,*
1944

Schjerfbeck was one of the most distinctive artists working in Finland at the end of the nineteenth century. Her career extended to the 1940s, when she was still producing self-portraits. Although in the 1890s Schjerfbeck was heavily involved with the art community in Helsinki, she withdrew to the country in 1902 and joined with like-minded artists in the 1920s who rejected modern metropolitan art culture. Schjerfbeck was influenced by old master artists throughout her career, and it may be that her many self-portraits owe some debt to serial self-portraits by artists such as Rembrandt. However, they have also been read as eerie catalogues of her own physical decay and signals of approaching death.

These portraits serve a parallel purpose to earlier portraits of anonymous youths by Titian and Giorgione in that they defy easy categorization and seem to be as representative of a stage of life as they are of Schjerfbeck as an individual. As she aged, Schjerfbeck gradually distorted and masked her own features in her portraits. By the end of the series the bony visage and thin hair of an old woman becomes an eyeless and empty skull-like mask. Schjerfbeck alludes to her own closeness to death in these works.

The motivations for producing portraits representing sitters at the stages of youth, maturity, and old age have thus varied enormously. Children could be depicted as a result of affection, pride, or grief; young adults could be represented as exemplary of ideal states or as reminders of important life events; and portraits of the elderly could encapsulate prevailing ideas about the wisdom of experience, or show the skill of the artist. Whatever the combination of motivations and effects, portraits show how both artists and sitters engaged with prevalent ideas of youth and age in their own times.

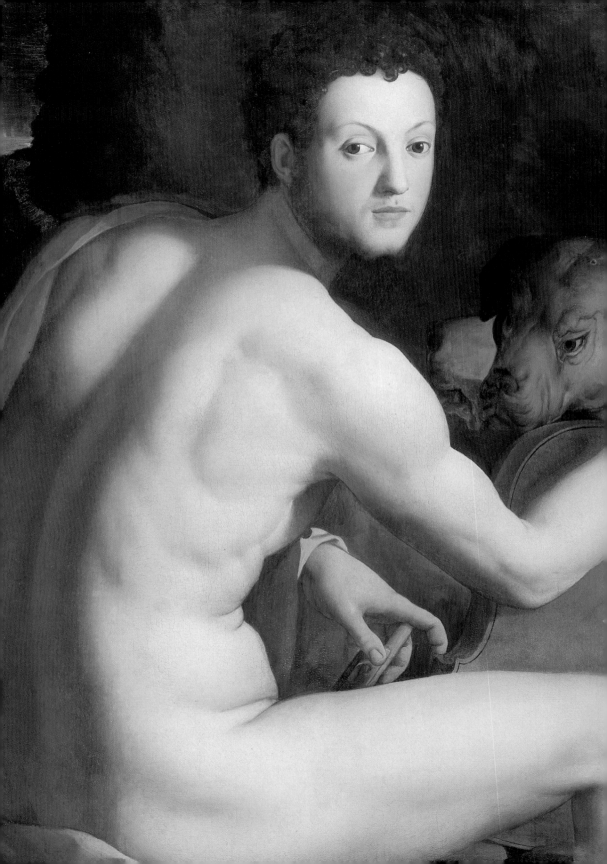

# Gender and Portraiture

6

Like age, the sitter's gender is a key factor in understanding the ways portraits represent their subjects in different places and times. 'Gender' refers to those qualities of masculinity and femininity that are both physical and social. In different historical periods there have been variations in what was considered appropriate for male and female behaviour, although some believe differences between men and women are universal because they are biologically determined rather than socially constructed. Individual portraitists have chosen to focus on different aspects of men's and women's social roles, physical features, or character, depending on many variables, including the gender politics of their time.[1]

In considering the history of portraiture in relation to the subject of gender, the gender of both artist and sitter needs to be taken into account. In terms of the gender of the artist, it is important to note that many women artists who made a living from their work before the twentieth century were portraitists. There are a number of social and historical reasons for this. Self-portraits or portraits of close family or friends could be produced in the home: in periods in which middle-class women were expected to spend most of their time in a domestic environment, they could thus practise portraiture without breaching the rules of social decorum. However, portraits were also considered a low and mechanical genre of art for many centuries, and women were traditionally viewed as creatively limited and best at arts that required imitation rather than creation. Thus portraiture could be justified as an acceptable practice for women artists, even before the twentieth century when women began to have a more prominent role in the professional art world. There are, therefore, many examples of portraits produced by women, as well as by men.

The gender of the artist is one fact; the gender of the sitter another. The ways male and female artists interact with and represent male and female sitters further complicate the role of gender in portraiture. In certain contexts, a male portraitist may have a different approach to his subject than a woman contemporary, and men and women artists may respond differently to male and female sitters. Such differences can relate to both social expectations and artistic practice. Arguably it is

**90 Agnolo Bronzino**

*Cosimo I de' Medici, c.1538–40*

Bronzino was court artist to Duke Cosimo I de' Medici, and completed a number of religious and decorative schemes for his patron. However, he was best known for his stylized court portraits. To all of his works Bronzino brought the fruits of a developed intellect that had been cultivated through his membership of an academy of writers and intellectuals in Rome. Although it was common for Renaissance court painters to produce portraits of noble men and women in religious and mythological characters, this portrait of Cosimo is unconventional in its use of nudity.

**91 Lotte Laserstein**
*Self-portrait with Cat*, 1928
Laserstein's sober view of her
own androgynous features is a
good example of the aesthetic
of 'New Objectivity' that was
adopted by many artists
throughout Weimar Germany.
These artists rejected the
stylistic tendencies of
Expressionism, and they also
turned their back on some of
the Expressionists' more
spiritual themes in favour of
everyday reality. The portrait
was highly valued by German
artists of the 1920s as a
putatively 'objective' form of
representation that was thus
distanced from the
imaginative extremes of
Expressionism.

dangerous to make a sweeping claim that there is always a fundamental
difference between portraits that represent men and those that repre-
sent women, although it is often possible to discern differences that can
be attributed to the gender expectations of the time when the works
were produced. A specific comparison between the way a male and a
female artist produce portraits within the same artistic milieu opens up
the issues at stake here. The German artists Otto Dix and Lotte Laser-
stein both painted portraits of women in the mid-1920s, and both
artists practised the ostensibly detached observation of nature that
characterized the 'New Objectivity' art movement of Weimar Ger-
many [**91** and **92**]. Both portraits represent professional women who
adopted the androgynous fashion of the time: Dix depicted the
Bohemian journalist Sylvia von Harden, and Laserstein represented
herself painting in her studio. Here the similarities end. Laserstein's
self-portrait presents her as a startlingly masculine woman, attired in a
painter's smock that could be a man's shirt. The addition of her cat as a

prop serves both to humanize and domesticate the image, and her stare into the mirror but also out at the viewer is engaging in its concentration and purpose. Dix in portraying Sylvia von Harden expresses her androgyny in a different way: the *bubikopf* haircut contrasts with von Harden's excessive lipstick and manicured nails. Dix elongated her hands to give her a monstrous quality, and she is shown in disarray, with a crumpled stocking and an awkward pose. Dix's portrait strays into the realm of stereotype, even caricature. Partly there is a difference between the 'objective' view of the male artist and the subjective self-image of the woman artist; the two works also express the divergent roles these artists assumed within their social and artistic worlds. Dix's particular approach to representation consisted of many vicious satires on men as well as women, which reflected a bitter engagement with what he saw

**92 Otto Dix**

*Portrait of the Journalist Sylvia von Harden*, 1926
Dix painted several portraits of popular characters from the cultural milieu of Weimar Germany. Apart from this portrait of von Harden, he also produced portraits of the infamous dancer Anita Berber and the Francophile art dealer Alfred Flechtheim.

to be the evils of post-First World War Germany. Laserstein, on the other hand, was one of Weimar Germany's many 'new women', who advocated equality with men in terms of pay and lifestyle. Such distinctions elucidate the ways gender can enter portraiture on many different levels: these include the concerns of particular artists, the ways they represent themselves and others, the gender politics of their time and place, and fashions of male and female dress and behaviour.

The question of gender in portraiture needs to encompass portraits of both men and women by both men and women, and it is therefore of relevance to all portraiture. The ways portraitists negotiate dominant and subordinate ideas of gender in their own time is present in every portrait, but there are portraits in which the gender of the sitter is a more obvious or intrusive element of production, representation, or reception, as in the portraits by Laserstein and Dix. Although in this chapter gender is being considered as a separate theme, the issues it raises are relevant to all portraits at all times, and constructions of gender therefore need to be noted whenever a portrait is viewed or studied.

## Women, beauty, and allegory

Many portraits of women represent them in roles: goddesses such as Juno or Hebe, historical or religious figures like Mary Magdalene, Muses such as Euterpe (Music) or Thalia (Comedy), or allegorical embodiments such as 'Painting' or 'Beauty'. Such slippages between the portrayal of women and the embodiment of abstractions has been interpreted as denying women the kind of character and public roles emphasized so often in portraits of men.[2] This is the argument of Felicity Edholm, for example, who sees the roles of women in portraiture as a negative sign of their social repression in the past:

Behind many portraits . . . is an assumption of a biography, a known or knowable story, for men in particular a story of potential when young and achievement when middle-aged. Women's lives and faces cannot tell the same story . . . in terms of representation, it is beauty—or if not that, due modesty and gracefulness—when young, and the loss of beauty when old.[3]

However, the sheer variety of these allegorical representations and their imaginative employment by both male and female artists can also open up the possibilities of seeing women outside the constraints of their domestic and social roles. Although the qualities of women that are valued have changed significantly, given the checks on women's public roles before the modern period, portraitists often chose to represent women in terms of these more abstract qualities.

The origins of the tendency to view women allegorically can be traced to fifteenth- and sixteenth-century Italy. Here several factors

**93 Dominico Ghirlandaio**

*Giovanna Tornabuoni*, 1488
This portrait represents the
wife of Lorenzo Tornabuoni,
who was Ghirlandaio's patron
for the major commission to
decorate their chapel in Santa
Maria Novella, Florence.

ARS VTINAM MORES
ANIMVM QVE EFFINGERE
POSSES PVLCHRIOR IN TER
RIS NVLLA TABELLA FORET
MCCCCLXXXVIII

combined to inspire portraits of women that related them to abstract
ideas of beauty rather than status or character. The use of profile por-
traits, the proliferation of paintings that veer between allegory and
portraiture, poetic portraiture, and the growth of portrait collections of

beautiful women were all facets of this imaginative tendency in portraits of women.

To take the first of these points, in fifteenth-century Italy, profile portraits of women were particularly common [**93**]. On one level, the stark sidelong view of a woman's head, such as in Ghirlandaio's portrait of Giovanna Tornabuoni, alluded to the profiles on Roman coins. This reference implicitly related the sitter's qualities to the virtues of the Roman world that were valued in the fifteenth century, but these virtues included military prowess and imperial power—qualities not normally associated with women at the time. The profile thus serves other purposes. Ghirlandaio's portrait eschewed the clues of expression and character that would have been given by a frontal portrait, emphasizing instead the beautiful lines of the physiognomy. The elegance of the aquiline nose and overly long neck, the firmness of the chin, and the smoothness of the forehead became the subject. The Latin inscription on Tornabuoni's portrait translates: 'Art, if you could portray manners and spirit, there would be no more beautiful picture on earth.' The inscription indicates that beauty is not simply contained in the sitter's physical perfection but in her character as well; the two are, by implication, inextricably linked. Although profile portraits also existed of men, these representations were more often confined to coins and commemorative medals that stressed their public role.

By the sixteenth century the profile view was superseded by half- or three-quarter-length portraits of women with most of their face visible. Such portraits were particularly common in the work of Venetian artists such as Titian, Giorgione, and Palma Vecchio. Portraits of women by these artists tend to be less individualized than those of men by the same artists.[4] We can no longer identify the sitters of many of these works, which now have vague titles such as *La Bella* ('Beauty') [**94**]. The anonymity of the sitter and the stress on generalized beauty give these works affinities with allegorical painting, as the sitters seem to be models rather than identifiable individuals.[5] The gender implications of such an emphasis are that these works were intended to represent ideal beauty rather than the likeness of any individual woman. However, Lomazzo's treatise on art reduced decorum in female portraiture to beauty, which suggests that these artists were working within the accepted conventions of contemporary portraiture. It is also worth noting that ideal beauty combined with erotic allure in many of these portraits, which has led some historians to claim that they are representations of courtesans.[6]

Contemporary conventions of literary portraiture offer further evidence on this point. In Italy during the sixteenth century, treatises written on the beauty of women included literary portraits of particular individuals, such as *I ritratti* ('Portraits'), a poem written for Isabella d'Este by the Vicenza humanist Gian Giorgio Trissino.[7] Many of these

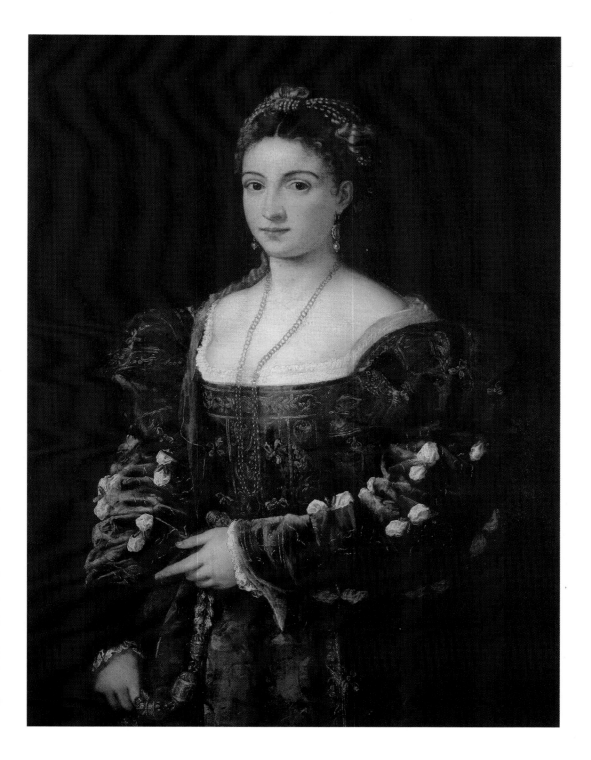

poems link the physical beauty of women to virtues such as chastity and modesty, as Aretino did in a poetic portrait of Eleanora Gonzaga. In such poems and literary portraits, conventional characteristics of beauty were repeated formulaically, regardless of the real physical attributes of the women they purported to describe.[8] These series of relationships between ideal beauty, poetry, and portraits of women set up a strong tradition of idealization in portraits of women that spread beyond Italy to other European countries affected by Italian Renaissance aesthetics.

One of the effects of these associations between women, ideal beauty, and poetry was a tendency to collect portraits of 'beauties'— which also can be traced to early modern Italy. In 1473 Duke Galeazzo Maria Sforza began amassing portraits of beautiful women that he displayed in a similar way to Paolo Giovio's collection of famous men in Como. Other Italian aristocrats, such as the Duke of Mantua in 1604, followed Sforza's lead and created portrait galleries of beautiful women. This collecting practice was adopted throughout Europe and was particularly strong in late seventeenth- and early eighteenth-century court cultures. There were collections of beauties in the courts of Denmark and France, as well as in Electoral collections throughout Germany and in central Europe. Notable examples of these collections of beauties were in England and consisted of groups of portraits by Peter Lely at Hampton Court and, in the next generation, by Godfrey Kneller at Windsor Castle. Lely, for example, painted portraits of aristocratic women who were prominent in the Stuart court. The portraits were produced in a standard size and format, and Lely stressed the similarities between the women rather than their differences. The emphasis on ideal beauty was a legacy from the poetic portraits of the early sixteenth century, and as with those portraits, the likenesses of the individual women were minimized in favour of the qualities for which they stood.[9]

Although portrait collections of beauties became less common by the second half of the eighteenth century, in both eighteenth-century France and England there was a vogue for portraits of women wearing antique dress or in character roles, usually from classical mythology, especially goddesses, famous mistresses from classical literature, or one of the Three Graces.[10] Such portraits could be highly theatrical, and role play and allegory could blend together. Artists such as Jean-Marc Nattier and Nicolas de Largillière in France and Reynolds [95] and George Romney in England posed their women sitters in such classical roles, ostensibly as a way of elevating the portrait by linking it explicitly with the subject matter of history painting. Such portraits were in many ways transgressive because they represented aristocrats posing in the guise of characters from classical literature not renowned for their moral virtues. While the fantasy quality of these portraits enabled women to

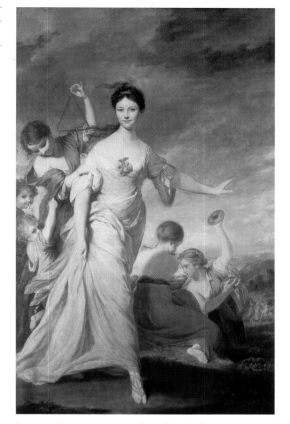

**95 Joshua Reynolds**

*Mrs Hale as Euphrosyne,* 1766

One of many Grand Manner paintings by Reynolds, this allegorical portrait of Mrs Hale as the Goddess of Mirth transports her into an imaginary classical scene, surrounded by frolicking figures dancing and making music. Portraits such as this one were major sensations at Royal Academy exhibitions in London, as they were large and portrayed familiar members of society in ways that stimulated the imagination of their audiences.

be seen in more varied and imaginative roles than those prescribed by their society, they also represented women as erotic objects and could objectify them by stressing the role itself, rather than the individuality of the women depicted.[11]

The tendency to represent women ideally, allegorically, or theatrically in portraits persisted into the nineteenth century. By the mid-nineteenth century, the variety of roles in which women were cast in portraits became much larger, encompassing not only allegorical figures but heroines from literature and history. Notable examples can be seen in the work of the Pre-Raphaelite circle in England. The Pre-Raphaelites used a number of models in their pictures. As many of these models were women who had been lovers of the male artists in the group, the relationship between the artist and the model becomes an important factor in understanding their work. For example, several artists of the Pre-Raphaelite circle, such as Dante Gabriel Rossetti, John Everett Millais, and Walter Deverell, employed the millinery shop assistant Elizabeth Siddal as a model in their representation of scenes from Shakespeare, Dante, Tennyson, and other writers. When Rossetti became Siddal's lover, he produced pencil portraits that represented her in poses of longing and languor—overlaying the 'real'

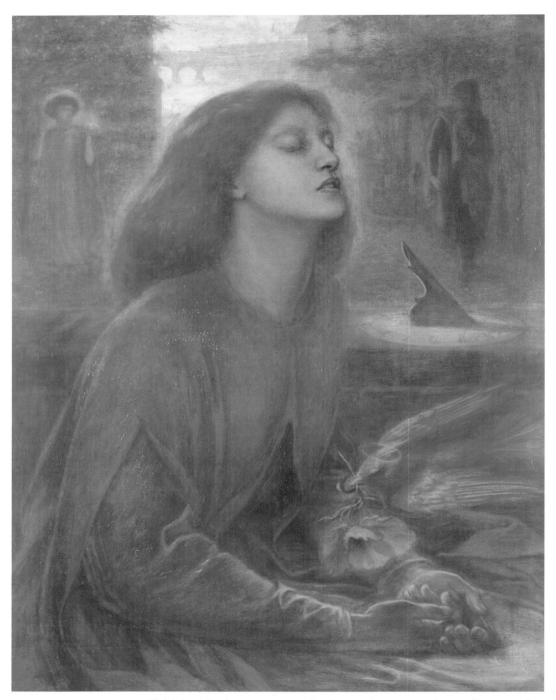

Siddal with the trappings of a fictional or tragic figure. Rossetti frequently cast Siddal in the character of Beatrice from Dante's love poem, *La Vita nuova* ('The New Life'), alluding to his intimate relationship with her by taking on the metaphorical role of his namesake. For

example, Siddal appeared in a commemorative portrait painted after her death, the *Beata Beatrix*, which represents her tragic suicide as a kind of Dantesque apotheosis [**96**]. We can see Rossetti transferring the ideal qualities of Dante's Beatrice into the real portrait of his erstwhile lover, Siddal. However, Siddal was an artist as well, and her own self-portrait reveals not a languorous and anorexic beauty but a tired and anxious woman. Siddal's ostensibly down-to-earth portrayal of herself is another kind of partial truth—a portrait of fatigue and unhappiness rather than beauty and transcendence. But it serves as a foil for imaginative extremes of Rossetti's representations, and the way he subsumed the portrait of his lover into an ideal vision.

So far the discussion of women, beauty, and allegory in portraiture has been confined to the productions of male artists, but women artists also idealized and allegorized other women—and even themselves—in their portraiture. The most famous example of this is the *Self-portrait as 'La Pittura'* [**97**] by the Italian seventeenth-century artist Artemisia Gentileschi. Here Gentileschi engaged with the allegorical tradition of female portraiture in several striking ways. First of all, she showed herself in the act of painting, thus occupied in her professional activity. Furthermore, she did not present herself in an idealized way, but portrayed the act of painting as something that is hard work, distracting, and requiring great energy. She stressed the qualities of concentration and distraction by painting her hair in a disorderly state. In opposition

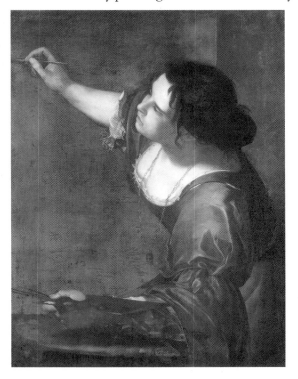

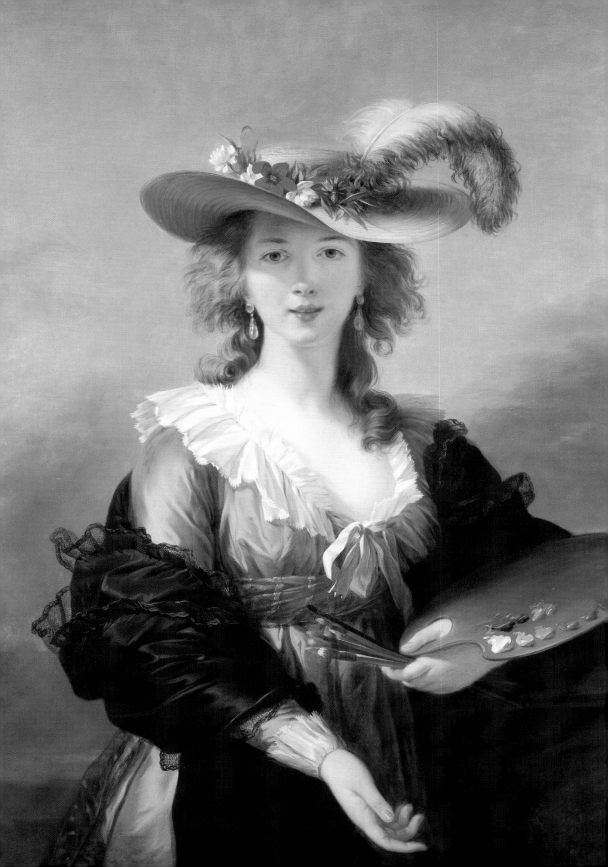

*Self-portrait in a Straw Hat,*
after 1782
Vigée-Lebrun made her career
and reputation producing
portraits of members of the
French court, but she also
painted a number of self-
portraits, such as this one. The
vitality and loose brushwork
here recalls the work of
Rubens, whom she admired.

to this evidence of absorption, Gentileschi is wearing a garment that would have perhaps been inappropriate for the mess of a painting room. However, while she represented herself both as an artist and as a fashionable woman, she also portrayed herself allegorically, as Mary Garrard has shown.[12] Engaging with iconography manuals such as Cesare Ripa's *Iconologia*, Gentileschi embodied herself as the allegory of 'La Pittura' or 'Painting'. Thus it could be said that in this very unusual self-portrait Gentileschi is complicit in the tendency of portraitists to generalize their women subjects. However, she is also self-consciously manipulating a set of conventions, and the very fact that she portrayed herself in this way offers a unique contribution to the corpus of women's self-portraiture.

Other women artists also used different tactics of generalization or idealization in their self-portraits. The eighteenth-century artists Elisabeth Vigée-Lebrun and Angelica Kauffmann both portrayed themselves as beautiful, even though in Kauffmann's case some of the self-portraits were done when she was over 50 years old. Vigée-Lebrun's *Self-portrait in a Straw Hat* [98] is one such work. Like Gentileschi, Vigée-Lebrun represented herself fashionably dressed. Although she is holding a palette, the effect of her dress and straw hat suggests that she is attired for one of her famous conversation 'salons' rather than for the artist's studio. However, Vigée-Lebrun modelled this virtuosic self-portrait on Rubens's painting *Susannah Fourment* (1622–5) that Vigée-Lebrun had seen in Antwerp. The homage to Rubens is partly a comment on the artistic inspiration his work provided, as Vigée-Lebrun allied herself with Rubens's skill as a colourist. However, the allusion to Rubens also places the artist in the tradition of old master portraiture, and Vigée-Lebrun thus confidently asserts her artistic integrity and prominent place in the history of art. As with other forms of elevation, idealization, and allegory, Vigée-Lebrun's self-portrait is thus both a limiting and enabling image.

Women artists did not confine such allegorization or idealization to self-portraiture. For example the nineteenth-century English photographer Julia Margaret Cameron created a clear distinction between photographic portraits of men like Tennyson and Carlyle, who were shown as themselves, and women models such as Maria Spartali and Alice Liddell, who were represented playing fanciful roles such as Circe and Pomona [99].[13]

There are many ways of interpreting the allegorical or idealized nature of portraits of women. It could be argued that such portraits denied women the individuality assigned to men by confining their representations to generic physical or moral qualities rather than their distinct personalities or physical appearances. However, in ages when many women's positions in society were constrained, such portraits allowed them to break out of their conventional roles and assume the

**99 Julia Margaret Cameron**

*The Mountain Nymph Sweet
Liberty (Cyllene Wilson),*
1866

Cameron was strongly
opposed to the new
photographic market that was
dominated by cheap *carte-de-
visite* portrait photographs in
mid-Victorian England. In
opposition to what she felt was
the low technical quality of
contemporary photography
she produced photographs
like this one, the subject
matter of which was directly
related to contemporary
painting. Unlike commercial
photographers who 'touched
up' their images, Cameron left
some of the imperfections on
the negative, giving her works
an evocative soft-focus effect.
She used a limited range of
sitters for her subject
photographs, which have the
same poetic quality as her
portraits of eminent Victorians
such as Tennyson.

guises of mythological or allegorical figures, or to be shown in ways that
might be construed as playful or transgressive.

## Changing notions of masculinity in portraiture

Portraits of women frequently stress the beauty or ideal quality of their
subjects, and it has been argued that this is a recurrent motif in the
history of portraiture. Portraits of men vary rather more in the ways they
represent aspects of gender, although here too there are certain histori-
cal continuities. Before the modern period men dominated political and
public spheres, and their social roles were often seen as inextricably
bound up with their public position. Thus portraits of men in the past
more frequently alluded to their social, professional, or political role
than did portraits of women. This could be expressed in terms of
costume, setting, or other symbolic accoutrements extraneous to the
physical body of the sitter. These signals of status, position, and public
role could accompany other elements in portraiture to project qualities
of masculinity and male virtue that were valued in specific periods
among particular classes of society. For example, the kind of male
behaviour, dress, and social interaction valued in a court might be dia-
metrically opposed to the milieu of the servant class in that same society.

Many portraits of men appear at first glance to express the mas-
culinity of their subjects in a way that we could recognize today as
stereotyped. Equestrian portraits, for example, show men as powerful
and indomitable, possessing both physical and moral strength [see **41**].
Portraits of male leaders often present them in a commanding position,

surrounded by symbols of military or political achievement, or exhibiting other signs of power or authority.

However, at times when courtly manners were considered to be a prerequisite for a gentleman, men could be shown as graceful or elegant, as this could be considered a desirable quality, especially for upper-class men. The attributes of physical beauty were often assigned to women, but in the sixteenth century these same qualities could distinguish men of a higher class. This can be seen, for example, in early sixteenth-century Italian portraits by court artists such as Bronzino who represented courtiers as graceful in the deportment of their bodies.[14] It was perhaps this approach to the qualities of masculinity that made it possible for Bronzino to paint the nude portrait of *Cosimo I de' Medici* in the character of Orpheus [**90**]. Cosimo is here shown not as an authoritative political figure but as the mythological character who was able to control the beasts through music. The reference to Orpheus may allude to Cosimo's patronage of the arts or to his power at a time when the Medici were regaining their political ascendancy in Florence, but it is significant that he could be shown with a body that is masculine in its musculature, but androgynous in its curving elegance. Ideas of effeminacy are always culturally specific, and although Bronzino's portraits may appear effeminate to a twenty-first-century eye, elite viewers in sixteenth-century Italy would have discerned familiar qualities of deportment and elegance that were seen as desirable in male public behaviour.[15]

What today may seem to be effeminacy in portraits of men has recurred in different periods in the history of portraiture, but the reasons it became popular could vary greatly. A famous eighteenth-century portrait of the English poet Brooke Boothby [**100**] painted by Joseph

**100 Joseph Wright of Derby**
*Brooke Boothby*, 1781
Wright was one of the most skilled portrait painters of late eighteenth-century Britain, but many of his commissions came from outside the tight society circles of London, who tended to flock to Reynolds, Gainsborough, and Romney. Boothby was a somewhat unconventional poet, and Wright's representation of him takes liberties with his pose and setting.

Wright of Derby is another example of an elision between masculinity and femininity in a male portrait. Boothby is shown lying in a posture that was traditionally associated with women, especially courtesans, in Renaissance painting. Wright stresses the S-curve of Boothby's body and his relaxation, in direct contrast to contemporary male portraits that characteristically represented the subject standing. The meaning of this portrait can be discerned by examining the clues Wright provides in the setting. Boothby is in a forest, reading the works of Jean-Jacques Rousseau, whose ideas of the purity of rural life and the nobility of the countryside were well known to him. Rousseau's encouragement of the natural qualities of human beings started a Europe-wide tendency to value the public expression of emotions; for a time it was considered acceptable, even desirable, for men as well as women to show their

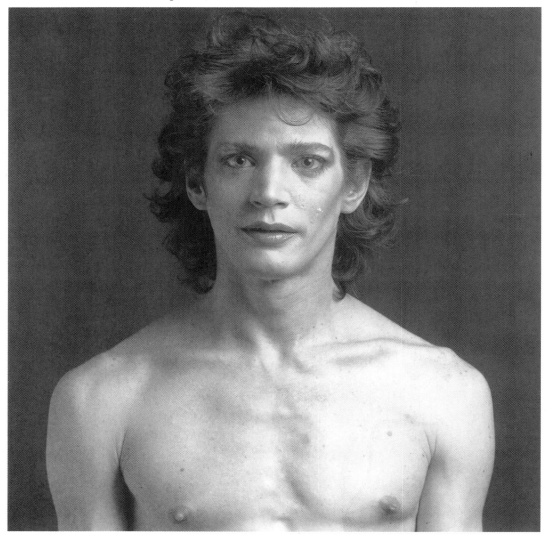

feelings openly in public. In contrast with what might be considered traces of femininity, Wright's portrait also recalls poses commonly used in Elizabethan miniature painting, in which a reclining figure was seen to be beset by melancholy humours. Melancholy had a long association with masculine creativity, and thus the gender signals in Brooke Boothby's portrait are complex and paradoxical.[16]

The representation of masculinity and its manifestations has become much more self-conscious in recent portraiture. This is particularly the case for some gay artists, who have openly explored the relationship between their male and sexual identities. The American photographer Robert Mapplethorpe most notably engaged with this relationship in his various photographic portraits and self-portraits [**101**]. Mapplethorpe photographed himself in a number of different roles—with made-up face, or with leather jacket and cigarette, or nude in a state of bondage. His portraits of other men are frequently sexually explicit, even while they are oddly detached in their concentration on the aesthetic qualities of the male body rather than the sexual act being performed. Many of Mapplethorpe's photographs objectify the body in this way and force the viewer to see it as an abstract pattern rather than a depiction of flesh. In this respect, Mapplethorpe's smooth expanses of male flesh are not unlike those of Bronzino in his portrait of Cosimo de' Medici. What has changed in the representation of masculinity between the sixteenth and the late twentieth century is the degree of self-consciousness in the treatment of issues of masculinity and male identity.

Whether portraitists engage with masculinity self-consciously or accept certain normative yet variable cultural stereotypes, these specific examples belie the fact that there are many models of masculinity, as well as femininity, at any particular time and place. The choices made by portraitists and their sitters about how such qualities should be expressed have been both unconscious and explicit, responsive to social expectations, and sensitive to the changing perceptions of audiences about those qualities of masculinity and femininity that have been expected or valued.

**101 Robert Mapplethorpe**
*Self-portrait*, 1980
Portraits and still lifes were the two staples of the American Mapplethorpe's work. His photographic portraits represented both well-known figures, such as actors and music idols, and gay men in his immediate circle. Mapplethorpe was most notorious for his homoerotic photography, but all of his photographs are characterized by a sense of tonality and surface effect. He produced self-portrait photographs throughout his career, including representations that showed him succumbing to AIDS, which caused his early death in 1984.

# Self-portraiture

7

The history of self-portraiture is one of the most fascinating and complex of the whole genre. Because self-portraits merge the artist and the sitter into one, they have the allure of a private diary, in that they seem to give us an artist's insight into his or her own personality. However, interpreting self-portraiture as a transparent account of artistic personality is to ignore the many other factors that have an impact on both its creation and reception. While the representational qualities of self-portraits allow them to be used as a means of self-examination, they have also functioned, for example, as signatures, as advertisements for an artist's skill, and as experiments in technique or expression.

## The self-portrait as signature, experiment, and publicity

There are few self-portraits before the sixteenth century, and many of these exist only as manuscript marginalia. This early absence could be attributed to a piety that prevented artists from glorifying themselves. In addition, most artists before the Renaissance were considered to be craftspeople or mechanics whose primary occupation was to be responsive to the needs of their workshop and patrons. When artists began producing portraits of themselves in the fifteenth century, it was initially as a footnote or signature to another commission. In Flanders, Jan Van Eyck famously included his self-portrait in the convex mirror of *The Arnolfini Marriage* [see **28**], and his reflection can just be detected in the helmet of St George in his altarpiece representing the Madonna with the donor Canon van der Paele (1436). Van Eyck's Italian contemporary, the sculptor Ghiberti, produced two self-portraits as part of his commission for the doors of the Baptistery in Florence. The first of these was possibly as early as 1401, but the more famous self-portrait appears as a roundel on the so-called 'Gates of Paradise' (1425–52) amidst the heads of prophets. Ghiberti's inclusion of his self-portrait on this highly prestigious commission thus acted as a form of signature that associated him with his masterpiece. Although Ghiberti's is one of the earliest Italian examples of this practice, according to the sixteenth-century biographer Giorgio Vasari a number of Renaissance artists represented themselves as witnesses or spectators in religious commissions. It is

significant that the appearance of free-standing self-portrait painting appeared shortly after the advent of free-standing portraiture in the late years of the fifteenth century, with notable examples by Albrecht Dürer (see below) and Raphael.

There are a number of technical and social reasons why autonomous self-portraiture appeared in Europe when it did. First of all, mimetic self-portraiture relied on the existence of flat mirrors, which were not readily available outside Venice (where they were invented) until the fifteenth century.[1] Secondly, in fifteenth- and sixteenth-century Europe, there was an increasing self-consciousness about identity, and a corresponding growth in the production of autobiography and other forms of self-narrative. Finally, and perhaps most importantly for portraiture, there were significant changes in the status of the artist in the fifteenth and sixteenth centuries, inspired by the advent of academies and art theory that emphasized the intellectual qualities of artistic production over the mechanical ones. At a time when conceptions of the artist's role were changing, the self-portrait proved one means for an artist to reinforce and enhance this new idea of his or her worth.

The assertion of status was only one of the reasons artists produced self-portraits. Self-portraits often originated as opportunities for technical or thematic experimentation. Artists who could not afford models were able to use themselves as subjects, and they were not constrained by issues of contract, decorum, or sitter expectation. This freedom enabled Rembrandt, for example, to use self-portraits to explore the effects of chiaroscuro (light and dark) on his work—a method he transferred to his various history paintings. Likewise, Van Gogh and Käthe Kollwitz used self-portraits to experiment with different techniques: in Kollwitz's case, etching and lithography; in Van Gogh's, the brushwork of Impressionism and neo-Impressionism. Experimentation also took the form of using different dress, poses, gestures, and contexts. This can be seen most notably in the self-portraits by Egon Schiele (who represented his body as amputated and contorted) or Frida Kahlo (who showed herself both as disabled and in Mexican national costume). Experimental self-portraits can also document the artist's age and appearance at a particular period in their life. From the fifteenth century onwards, artists have produced series of self-portraits over short or long periods of time. Dürer, Rembrandt, Sofonisba Anguissola, Van Gogh, Kollwitz, and Schiele are only a few examples of artists who returned to themselves as subjects again and again. In these cases the portraits could serve many functions: as a mapping of ageing, an exploration of psychological change, or an expression of varying moods.

In the sixteenth and seventeenth centuries, self-portraits also served as a useful publicity tool for artists, who would send them to courts in order to advertise their artistic skill to potential patrons.[2] Self-portraits became important records of artists who were associated with Euro-

pean academies, as institutions such as the English Royal Academy and the French Académie Royale traditionally required members to deposit their self-portraits in their collections. The famous collection of self-portraits in the Uffizi in Florence similarly served as a record of notable artists who lived in or visited Italy, or were honoured by one of the Italian academies. The idea that a self-portrait was a tool that enabled artists to explore their own psychological states was very much a twentieth-century phenomenon, although even then, self-portraits continued to be strongly implicated in the artist's notion of their own social identity.

Like all portraiture, self-portraiture has served variant purposes and has appeared in many different manifestations. But underlying all self-portraiture is the mystery of how an individual sees himself or herself as other. A self-portrait involves an artist objectifying their own body and creating a 'double' of themselves. Artists could use the self-portrait as a means of drawing attention to the medium and the process of production of the work, to show off their skill, or to experiment with technique or style. The viewer of a self-portrait also occupies a strange position of looking at a metaphorical mirror that reflects back not themselves but the artist who produced the portrait. Viewing a self-portrait can therefore involve the sense of stepping into the artist's shoes.[3] These qualities make self-portraits both compelling and elusive.

## Self-portraiture, gender, and artistic identity

Self-portraiture by its very nature engages in some way with artistic identity, but how that identity is represented and perceived is heavily influenced by the status and gender of the artist at different periods in history. Because a self-portrait can be a reminder of the artist's profession, artists have used them as visual manifestos, demonstrating their artistic role or sense of place in their society. To give a flavour of the range of these concerns a starting point will be a comparison of self-portraits produced by a male and female artist at different historical periods.

The Italian artist Parmigianino's sixteenth-century painting of himself looking into a convex mirror [102] and the German sculptor Renée Sintenis's 1917 drawing of herself in the nude [103] convey a range of different impressions about the artist and the self-portrait. Both works appear, at first glance, to be technical studies. Parmigianino has represented himself in the act of painting, but by distorting his own form and that of the room behind him he has skilfully drawn attention to the convex mirror in which he is looking. Parmigianino is thus referring to the tradition of artist as craftsman as well as engaging in a kind of visual game which forces the viewer to look in a mirror and see the artist looking back. The reason for this display of virtuosic technical ability becomes clear when we understand that Parmigianino produced this self-portrait in order to gain the patronage of Pope Clement VII.

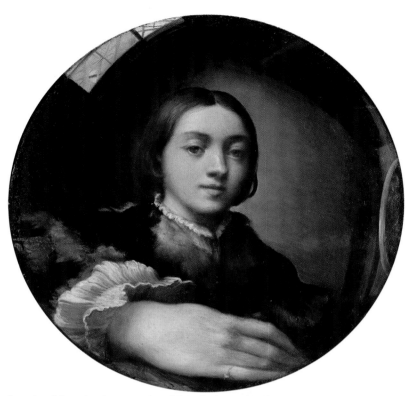

Inspired by the late work of Michelangelo, Italian mannerist artists such as Parmigianino favoured attenuated or exaggerated form and complex, sometimes deliberately arcane, subject matter. In contrast to this mannerist complexity, Sintenis's work seems to serve the more prosaic purpose of a life drawing—a kind of technical study essential to the artist's practice. However, the fact that the nude model she uses is herself gives the work an additional resonance.

These two self-portraits reveal a great deal about gender and status categories in the periods in which they were produced. In the early sixteenth century European artists were battling against the tradition that labelled them as mere mechanics and were striving to obtain a higher status than their fellow craftspeople. Parmigianino's emphasis on his own hand and the technical qualities of the work alludes to this tradition of manual labour, but the dominance of his head also stresses the new significance of artistic learnedness. The technical skill with which Parmigianino represented his image splayed unevenly on the face of the convex mirror is complemented by the inventiveness that underlay this unusual choice of composition.

The self-conscious examination of the technologies and philosophies of artistic creativity that can be seen in Parmigianino's self-portrait was embedded in male self-portraiture from its inception. Some of Dürer's earliest painted self-portraits of the sixteenth century

**103 Renée Sintenis**

*Nude Self-portrait,* 1917
Sintenis is best known for her sculptures of animals, nudes, and athletes. As part of her study of the body she sketched herself naked, as in this self-portrait.

already had begun to play with ideas of artistic and social identity. Dürer returned to his own self-image in a number of different contexts: he produced self-portrait drawings as technical studies or as documents of his state of health; he included self-portraits in religious commissions, just as fifteenth-century Italian artists had done; and he painted free-standing self-portraits. In the latter category are three notable portraits from the turn of the fifteenth century. In the first (1493) Dürer painted a self-portrait that was intended as a betrothal gift to his fiancée, Agnes, showing himself holding a sprig of holly, representative of happiness in love. The second (1498) was painted after his return from a trip to northern Italy, and here he dressed himself as a Venetian nobleman, deliberately elevating his status and eschewing any references to his artistic practice.

The most controversial of his self-portraits is the last one (1500) [**104**]. In this painting Dürer's frontal pose seems to make a direct reference to images of Christ, or the holy face, as seen on Veronica's head-cloth in contemporary religious paintings.[4] Whether or not Dürer intended this deliberate Christ-like reference to be seen as a sign of his status as an artist/creator and whether such an allusion could be read as blasphemous have been the subject of much art-historical controversy and remain unresolved. However, it is difficult to deny that Dürer was representing himself in a way that had clear echoes of contemporary images of Christ, and that his self-portrait avoids any reference to the act of painting itself. The fine detail seen in the curling strands of hair and in the fur of his sleeve, which he seems to caress with

**104 Albrecht Dürer**

*Self-portrait*, 1500

Dürer's exceptional skill as a painter and engraver eventually earned him the position of court painter to two Holy Roman Emperors, Maximilian I and Charles V. However, this portrait was produced early in his career as a master painter. Dürer was committed to raising the status of the artist, and his attention to his own portrait was part of this exploration of artistic identity.

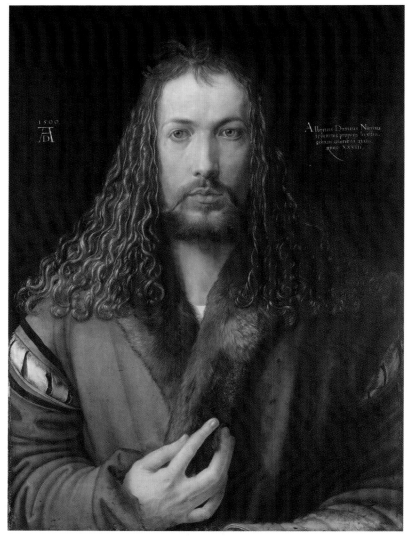

his fingers, demonstrates the skill and attention he devoted to the production of this panel. However, the processes of labour are concealed rather than declared. Dürer is not showing himself as an artist: this was significant in a period in which the status of the artist was subject to scrutiny and change. Dürer himself was dedicated to raising the artist's status in Germany, and his enterprise was acknowledged by his later biographers such as Karel van Mander, whose *Het Schilderboek* of 1604 stressed the deference paid to Dürer by noble patrons. In the early years of self-portraiture artists often used this mode of representation to provide themselves with the more elevated roles normally associated with sitters of a higher social status.

This conception of the male artist as a superior being has remained prominent in the visual rhetoric of self-portraiture, but different kinds

of roles have been assumed to demonstrate it. In the late nineteenth and early twentieth centuries, artists cultivated a notion of themselves as free spirits, whose liberation was manifested in sexual promiscuity, cultivation of lower- or working-class attributes, and asocial behaviour. This was a new way of elevating the male artist by placing him outside the norms and morals of bourgeois society. The number of self-portraits of artists with nude models, who were also their lovers, multiplied in the early twentieth century as the conception of sexual prowess and artistic creativity became conjoined.[5] The German artist Lovis Corinth painted several self-portraits in this sexually dominant mode. In one he represented himself indulging in drink and sexual fore-play with his nude model, Charlotte Berend, who later became his wife. In Corinth's work his artistic identity is inextricably linked to his sexual prowess. By avoiding any indicators of the act of painting his work implicitly linked painting and sexuality. It is this image of the sexually active male Bohemian artist and the coupling of sexuality and creativity that was held to be fundamental to the male modernist artist.[6]

By the late twentieth century, male artists played variously on the tropes of the artist as gentleman, Christ, Bohemian, or technician, while others returned to the technical playfulness of an artist like Parmigianino. Photography has made this latter aspect of self-portraiture even more varied, as can be seen in the work of the photographer Alfredo Dino Pedriali [105]. Pedriali portrays himself in the nude, just as Sintenis had done; like her, he shows himself engaged in his craft by snapping his photograph in a mirror. Here his artistic apparatus serves

**105 Alfredo Dino Pedriali**
*Self-portrait with Camera,* 1979
This is one of a number of self-portrait photographs by Pedriali, who specialized in black and white images of the male nude. Pedriali was based in Rome, and his works recall the classical and baroque traditions of Roman art. This can be seen in his use of chiaroscuro (light and dark), which was practised by Caravaggio and his followers in the seventeenth century, as well as in his allusion to fragments of classical sculpture in photographs in which the nude body can only partially be seen.

to obliterate his face—a primary indicator of his identity—and focus attention on a naked body seen in the context of a bathroom, which he shares with a nude male friend. Like many male twentieth-century artists, Pedriali collapses his sexual identity into his artistic identity, but his self-portraiture also involves playful reference to his technical skills as an artist.

The self-conceptions of the male artists discussed here are thus tied

**106 Laura Knight**

*Self-portrait*, 1913

Knight presented this work to the English Royal Academy upon her election as Royal Academician in 1913. The bold colourism of this portrait is commensurate with the colour experimentation of her avant-garde contemporaries, but the subject matter of an artist painting a model aligns Knight to the conventional academic training method of painting from the nude life model.

up with their technical ability, social identity, and their gender. These are also issues at stake in self-portraits of women artists. Returning to the portrait drawing of Sintenis, here we see a woman artist following in a male academic tradition of using the nude female model as a subject of study. Her study of herself serves to problematize the idea of the woman as artist, as she presented herself as both nude model and working woman.[7] In German art schools of her time, nude models were generally used in life drawing classes as part of artistic training; self-portraiture was alien to this practice. Furthermore, women were employed as nude models in academies and art schools for centuries before they were officially allowed—towards the end of the nineteenth century—to draw 'from the life'. By placing herself as the subject of such a technical study, Sintenis undermined the convention of the objectified female life model. Sintenis's focus on her identity as both an artist and a woman is highlighted by comparing her self-portrait to another painted only four years before by the English artist Laura Knight [**106**]. Knight portrayed herself in a way that referred more explicitly to the conventions of academic life drawing—the clothed artist painting the nude female model. But Knight's relationship with her model is visually harmonious rather than sexually charged. She shows both herself and her model with their backs turned; there is thus a rhyming pattern to the positioning of their bodies, but Knight's choice of pose also provides a clear view of the painting she is making. Like Parmigianino's work, this painting involves a clever play with ideas of mirrors and doubling. It would have been logistically difficult for Knight to view herself from that particular angle, but the work creates the illusion of reality. Unlike some of the role-playing portraits by male artists discussed earlier, Knight foregrounds her artistic identity. The fact that she chose to present this work to the Royal Academy in London upon her election to that institution makes the choice of subject even more significant. As women had been excluded from Academy membership for most of the nineteenth century, Knight's painting stands as a manifesto of her skill and a declaration of her achievement as a woman artist, but it also adheres to the principles of an academic training based on study of the life model.

The earliest self-portraits by women artists also emphasized their professional role. The sixteenth-century Flemish artist Katharina van Hemessen depicted herself with brushes, palette, and canvas [**107**]; this painting became a prototype for other self-portraits by women who employed a similar three-quarter-length format with a partial profile angle.[8] At a time when male artists such as Dürer were attempting to raise their status and disassociate themselves from the mechanical aspects of their trade, women were only just beginning to gain recognition as artists. Representing themselves in their professional role may have seemed necessary as a statement of purpose or a document of

**107 Katharina van Hemessen**

*Self-portrait*, 1548

Hemessen was only 20 years old when she produced this self-portrait. Although this particular work is restrained and somewhat formal, women artists in self-portraits of later generations repeatedly used Hemessen's iconography of the woman artist before the easel.

achievement. It is important to note that self-portraits by women were not exclusively of this nature. It was also common for women artists to show themselves playing music or with their families, as exemplified by the works of the Italian sixteenth-century painter Sofonisba Anguissola, for example.[9]

The self-portraits discussed in this section reveal some of the complexities of gender and status underlying artistic identity in self-portraiture. If a self-portrait was mimetic, it needed to show the artist in the act of producing the portrait, but this also drew attention to the mechanical processes of painting. Those mechanical processes were not always valued; indeed, artists in some periods avoided associations of their work with what they saw as mere craft. On the other hand, if a self-portrait avoided the trappings of the artist's studio, it could present other aspects of the artist's identity, such as the links between sexuality and creativity often associated with the modern Bohemian male artist. In many instances the gender of the artist had an impact on the way in

which he or she chose to portray themselves, with some roles being more commonly assigned to women than to men, and vice versa. Because the self-portrait is both an object of artistic creation and a self-exploration, ideas of gender and status are never far beneath the surface.

## Self-fashioning and self-presentation

In self-portraits artists did not simply present their status and gender identities in an unthinking or un-selfconscious way. From an early stage in the history of self-portraiture artists realized they could project particular ideas about themselves. This deliberate 'self-fashioning'[10] has been rarely absent. Artists have used self-portraiture as a means to perpetuate a view of themselves as wealthy, poor, sad, insane, or as a genius, iconoclast, exemplar, outsider. Such roles were frequently contrived and served to elevate the self-portrait to a statement about the artist's private life or his or her place in society. The idea that different public roles could be crafted, assumed, and represented was articulated in conduct books from the Renaissance onwards. Castiglione's *The Courtier* (1528) was one of the first substantial texts that suggested that a particular kind of character, physical appearance, and behaviour could—and indeed should—be cultivated by the higher classes of society. This perpetuated an assumption that public behaviour could be learned and that certain character traits could be fostered, so that the individual became like an actor performing before an audience, rather than behaving spontaneously.[11] Such ideas are significant for our understanding of self-portraiture. Because artists were conscious about their own status and where this placed them in the social hierarchy, they could use the tool of self-portraiture to enact roles that declared their aspirations, as Dürer had done.

The social functions of 'self-fashioning' have been complemented in portraiture by a kind of self-presentation and role-playing that has a less obvious public purpose. Rather than focusing on a single declaratory image of themselves, or using the self-portrait as a kind of manifesto of their social position, a number of artists represented themselves in a variety of roles and guises over a period of time. Such self-presentation could be probing, revealing, theatrical, experimental, or arbitrary. These works could be intended only for the artist and his or her immediate circle, and they could be less determinate or instrumental than the roles artists assumed to perpetuate a particular kind of public image.

Perhaps the first artist to use self-portraits systematically in this way was Rembrandt in the seventeenth century. Rembrandt produced over 50 self-portraits in many different media: painting, drawing, and etching [**108** and **109**]. The purpose of these fascinating and enigmatic works has been the subject of heated art-historical debate and controversy that, in the absence of full documentary evidence, has by no

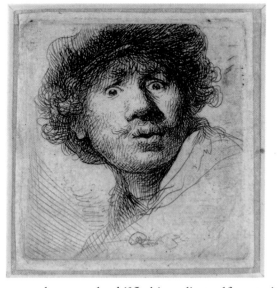

**108 Rembrandt Harmenszoon van Rijn**

*Self-portrait in a Cap, Open-mouthed, c.1630*

This is one of four self-portrait etchings that Rembrandt produced in 1630, each of which was a study in a different facial expression. In addition to this work showing him with a bewildered look, he also depicted himself laughing and shouting.

means been resolved.[12] In his earliest self-portraits, many of which were etchings, Rembrandt employed the self-portrait to conduct experiments in artistic technique, using himself as the cheapest and most accessible model available. These self-portraits appeared to be exercises in facial expression and chiaroscuro, and they may consequently have functioned as studies for history paintings. If they were experimental, this could explain why he returned to this mode of representation again and again throughout his life. From the 1640s onwards, when Rembrandt practised in Amsterdam, he produced painted self-portraits which showed him in a variety of elaborate costumes and with carefully rendered facial expressions. These works appear to be more than technical experiments or studies for history paintings. Some art historians have interpreted these portraits as Rembrandt's map of his moods and changed status at significant high and low points of his life. This has led to a tendency to retell Rembrandt's life through his art. Thus his final self-portrait (*c.*1669) [**109**] represents a doddery old man verging on senility, who has recognized the vanity of his earlier optimism. The labelling of this self-portrait relates him both to Democritus, the so-called 'laughing philosopher', and to the ancient Greek artist Zeuxis, who was said to have died laughing at a picture of an ugly old woman. This is a powerful work in which Rembrandt's heightened expression contrasts with absence of visible emotions that characterize much portraiture. By including such an expression he seems to provoke the viewer to see his life reflected through the painting. However, in this work, as in earlier paintings in which he shows himself dressed in elaborate robes or scowling experimentally through a heavy haze of chiaroscuro, we get a sense of an artist playing roles.

The afterlife of Rembrandt's self-portraiture has perpetuated the

**109 Rembrandt Harmenszoon van Rijn**

*Self-portrait as the Laughing Philosopher, c.*1669

In this late self-portrait, Rembrandt represented himself laughing, just as he had done in etchings early in his career. However, here the laughter of an old man seems less of an experiment in facial expression and more of an embodiment of Rembrandt's own view of himself.

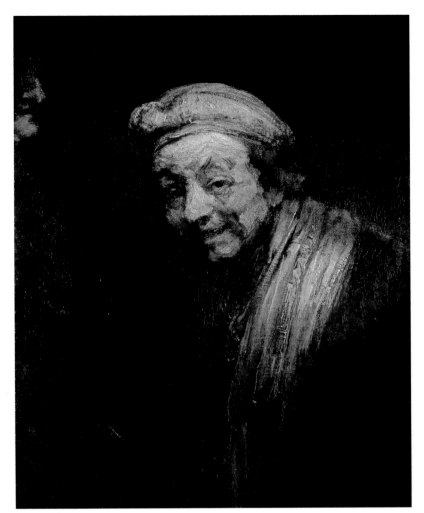

idea that it was desirable or beneficial for artists to represent themselves in such exploratory or experimental ways. Whether the artist used role playing as a means of technical experimentation, exploring the deeper inner workings of his or her psyche, or simply playing dressing-up games is something which is not easily resolvable. In the case of Rembrandt, whatever the artist's intention was, the viewer's idea of Rembrandt as an artist has been affected by his role-playing self-portraits.

Rembrandt may or may not have been adopting different guises as a way of expressing his own view of himself at key moments of his life, but series of self-portraits were often used to display personal symbolism or as a means of psychological experimentation, especially by the end of the nineteenth century. A number of late nineteenth- and early twentieth-century self-portraits appear to exhibit the artist's imaginary projection of himself or herself into different kinds of roles. One of

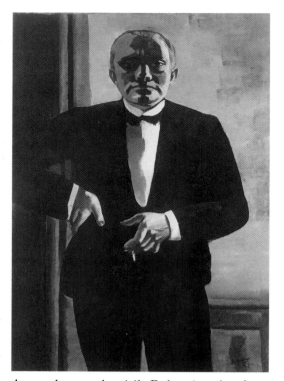

these roles was the virile Bohemian already mentioned, but modernist artists played on other motifs, such as clowns, dandies, or classical gods. Picasso and Georges Rouault chose the persona of a clown to evoke the tragicomic aspects of human existence; Otto Dix glorified himself as Mars, the God of War; and Max Beckmann expressed his pessimism about the artificiality and inescapable tedium of modern life by dressing up in modish fashions and affecting a series of bored or cynical expressions [110].

Although they could be imaginary, the guises assumed by early twentieth-century artists in their portraits could also be plausible and relevant. For example, the unprecedented number of artists who were conscripted during the First World War forced them into the unfamiliar role of soldier—an occupation that many neither expected nor desired. One artist who served only briefly during wartime was the German Ernst Ludwig Kirchner, whose nervous breakdown quickly led to his removal from active service and exile into a Swiss sanatorium. Despite his very limited experience of action, Kirchner represented himself in his military role in *Self-portrait as a Soldier* (1915) [111] in order to convey his sense of despair and identity crisis at the time. Although he suffered no major war wounds, Kirchner depicted himself with an amputated hand, which is significantly his right—painting—hand. Kirchner shows himself with a disability that metaphorically emasculates him and prevents him from practising his art. This image

of emasculation is enhanced if this self-portrait is compared to another one Kirchner produced before the war (1910), showing himself wearing a garish bathrobe sporting a phallic paintbrush and pipe and exuding an air of bold self-confidence. The presence of a semi-clad female model completes the effect of masculine sexual and artistic creativity. This work was produced at a time when Kirchner shared a studio with the Brücke (Bridge) group of artists, who cultivated a free love ethos, and maintained a Nietzschean belief in the links between virility and creative energy. In his self-portrait as a soldier, though, Kirchner's

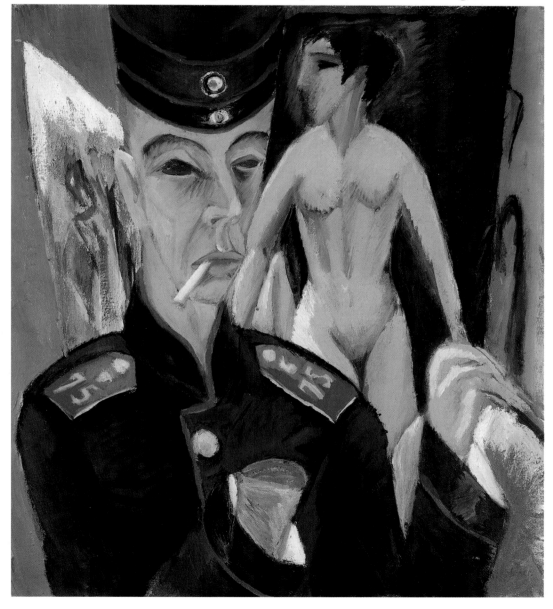

amputation becomes a symbolic castration, emphasized by the presence of a nude female model whom he is now unable to paint. Kirchner's self-portraits explore his psychological state as well as his position as an artist, but there is also an aspect of 'self-fashioning' in the cultivation of a role that was not just a personal statement of anxiety but an image that would have communicated to a wider audience.

## Self-portraiture and autobiography

Self-portraits can be playful, experimental, theatrical, and many other things, but there is a question about the extent to which they bear any relationship with the narrative and revelatory qualities of autobiography. When looking at a self-portrait viewers can be tempted to test the artist's view of himself or herself against what is known about their life, and to see the artist's self-representation as somehow indicative of their feelings or appearance at the time the work was produced. However, as with biography's connection with portraiture, comparisons of *self*-portraiture with autobiography offer both analogies and important differences.

In his essay 'Autobiography as De-facement' Paul de Man pointed out the inherent limitations of autobiography as a record of an individual's life:

We assume that life *produces* the autobiography as an act produces its consequences, but can we not suggest, with equal justice, that the autobiographical project may itself produce and determine the life and that whatever the writer *does* is in fact governed by the technical demands of self-portraiture.[13]

De Man was referring specifically to autobiographical literature and to the way the genre had its own conventions and techniques, which artfully constructed the subject of its narrative. Although a human being is a fragmented array of emotions, experiences, behaviour, and knowledge, the autobiographical narrative seems to erase these discontinuities and create a unified self that can be conveyed through a genre. What de Man calls 'the technical demands of self-portraiture' can be seen as the limitations and possibilities of the medium in which the life story is conveyed. Rembrandt's self-portraits, for example, may seem to give us a snapshot of himself wearing particular clothes and expressing particular emotions at an identifiable moment in time, but the conventions of portraiture convert this apparent life moment into an art form. Furthermore, while a written autobiography will be constrained by those parts of the life selected by the author, a work of art is even more shackled by technical limitations, as—apart from time-based media like video—art works can present only a series of frozen moments.

Although a self-portrait can convey little but traces or vestiges of an actual life, filtered through a medium with its own conventions and limitations, it is significant that the flourishing of self-portraiture in

Europe coincided with the advent of autobiography as a genre.[14] As early as the fifteenth century artists began telling the story of their lives. The sculptor Ghiberti published a *comentarii*, which was a form of autobiography. By the late sixteenth century, when the genre of auto-biography was well established, the Tuscan goldsmith Benvenuto Cellini wrote a lively story of his own life, which was enriched by many details of his fellow artists and patrons (written 1558–62, first published 1728). In the same centuries both Catholic and Protestant theology emphasized the importance of self-examination and self-awareness. Although early autobiographies existed, the use of the term to charac-terize the genre of narrating your own life did not become common until the end of the eighteenth century. Autobiographies could take the form of memoirs or diaries and were frequently published after the author's death. These generic developments were complemented by a public interest in the lives of artists that flourished especially in the eighteenth, nineteenth, and twentieth centuries. By the twentieth century, a prurient fascination with the private lives of famous artists increased the tendency of artists to write their own memoirs and to express their view of themselves in self-portraits. Some artists, like the Viennese Oskar Kokoschka, did both.

David Hockney is one example of a late twentieth-century artist whose work has an autobiographical flavour. In his early career he fre-quently made visual reference to the vicissitudes of his life as an art student and as a young man struggling to come to terms with his sexual identity. Hockney's self-portraits signal specific moments of his life, which may have been private or meaningful only to him. However, the fame he achieved at a relatively young age means that the audience for his private view of himself is vast, and it is an audience that knows enough about Hockney's life to be able to relate his work to his private circumstances. In a self-portrait such as *The Student: Homage to Picasso* [112] Hockney shows himself dressed as a trendy art student observing an oversized bust of Picasso as if he is viewing an object in an art gallery or the effigy of a god in a temple. The self-portrait is a fantasy of Hockney's first definitive encounter with Picasso's work at a retrospec-tive exhibition held at the Tate Gallery, London, in 1960. The homage here is both public and private, and the autobiographical reference to a moment in his formative years is thus overwhelmed by an image that carries greater symbolic, as well as personal, resonance. This is one of Hockney's less intimate views of his own life. He produced other works which refer to his initially secret homosexuality, but interestingly many of these were not conceived as self-portraits.

Hockney's work offers a view of a definitive moment in his life, but the way he imagines that moment, as well as the iconic nature of self-portraiture, eludes easy conversion into self-narrative. So, unlike written autobiography, which can appear to convey a life story through

time, self-portraiture relies on the presentation of frozen moments, which, as de Man says, 'produce . . . the life' of the subject, rather than offer reflections of it.

## Self-exploration and psychoanalysis

Rightly or wrongly, self-portraits can convey to the twenty-first-century viewer the idea that an artist is investigating their inner life rather than playing out social or artistic roles, or referring to specific events or moments. Self-portraits seem to suggest a form of self-exploration. Although the idea that an artist would choose deliberately to explore their states of mind through self-portraiture is a modern one, such an interpretation is often read back on to self-portraits in the past.

This view of self-portraiture is epitomized by responses to and interpretations of Van Gogh's self-portraits. Van Gogh struggled throughout his life with his intense desire to be recognized as an artist and the concomitant frustration of being unacknowledged while he was living. His manic approach to his art—which led to bouts of prolific production—and his well-documented lapses into insanity have coloured subsequent interpretations of his work. Our knowledge of these obstacles and frustrations is enhanced by the evidence of his many letters to his brother, Theo, which were published posthumously, and by the sequence of self-portraits he produced throughout his working life. Van Gogh's work is an example of how subsequent generations could use self-portraiture as a means of exploring the life of an artist.

However, the difference between retrospective interpretations of Van Gogh and those of Rembrandt is that Rembrandt's self-portraits are seen as rather more self-conscious presentations of his successes and failures, while Van Gogh's self-portraits are more often read as catalogues of his unstable state of mind. His self-portraits show artistic innovation and skill, but they also seem to reveal an artist who is intent on a documentary observation of his own psychological vicissitudes.

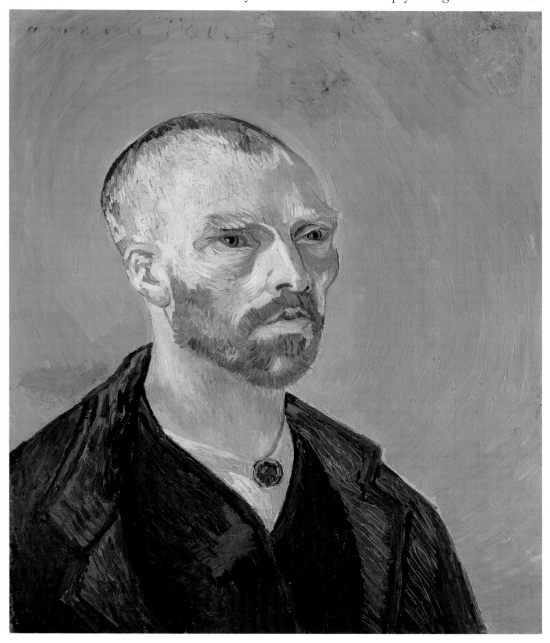

Many of these portraits appear to represent the artist as melancholy, brooding, intense, or threatening [113]. Although artistic intention is always a problematic concept, it is possible to speculate that Van Gogh's own motivations in producing these self-portraits could conceivably have been no different than Rembrandt's. It is notable that Van Gogh had perpetual money worries, and models were an expense he could ill afford, which made self-portraiture a practical choice for the artist. However, shortly after Van Gogh's death, and with the posthumous publication of his letters in 1914, art historians and critics developed an idea of the artist as an insane genius. The retrospective interpretations of his self-portraits were based largely on this view of his life.

The historical point of focus here is the late nineteenth and early twentieth centuries, which witnessed changes in the scientific understanding of psychology. Notable investigations during this period included Jean-Martin Charcot's studies of hysteria in France and Sigmund Freud's focus on sexuality and the unconscious in Vienna, which eventually resulted in his development of psychoanalysis. Explorations such as these led to unique perspectives on the relationships between human behaviour and such issues as insanity and sexual development. The popularization and dissemination of this psychological knowledge affected both how artists approached self-portraiture and the ways it was interpreted by contemporary viewers. Using Freud's terminology, Erika Billeter has pointed out that 'Every self-portrait is a dialogue with the ego'.[15] Here she refers to Freud's idea that the human psyche is based on a constant negotiation between the id (instinctual drives), the superego (the conscience), and the ego (the sense of self). In the early twentieth century artists played self-consciously on the idea of a self-portrait as a dialogue with the ego. The notion of the artist as an outsider, whose mental instability was a sign of his creativity, inspired artists to use self-portraiture as a means of exploring the tensions between their drives and their ego-states. Such self-exploration became embedded in art movements that privileged the inner life above formal experimentation, such as Expressionism and Surrealism, both of which drew self-consciously on Freud's theories of the functioning of the unconscious and the role of sexual drives in human behaviour.

An examination of self-portraits by artists who were associated with these two tendencies in twentieth-century art reveals the ways exploration of psychological states could become the focus of the work. In Austrian Expressionism the inner life was a major concern of portraitists such as Oskar Kokoschka and Egon Schiele. Late in his life, Kokoschka expressed what he thought was the primary function of his portraits:

When I paint a portrait, I am not concerned with the externals of a person— the signs of his clerical or secular eminence, or his social origins. It is the business of history to transmit documents on such matters to posterity. What used to shock people in my portraits was that I tried to intuit from the face,

from its play of expressions, and from gestures, the truth about a particular person, and to recreate in my own pictorial language the distillation of a living being that would survive in memory.[16]

Kokoschka's older contemporary, Schiele, produced around a hundred self-portrait paintings, drawings, and watercolours [**114**] in order to explore the relation between inner and outer life in a similarly probing way. Schiele's self-representations are inevitably disturbing. He showed himself naked, with distorted or amputated limbs, and an emaciated or

**114 Egon Schiele**

*Self-portrait Nude Facing Front*, 1910

Schiele was an Austrian artist best known for his numerous self-portraits that show him in an uncompromising way, with an emaciated, distorted, or disabled face and body. His brutal treatment of his own body and physiognomy explored the animalistic extremes of the human condition, but he also engaged directly with sexuality in a way that was shocking in early twentieth-century Vienna. Some of Schiele's self-portrait drawings and watercolours were based on photographs of himself making faces and posing awkwardly in front of a mirror.

flayed body. He subjected his face to the same sort of brutal treatment, and many of these works represent him scowling or grimacing. Some of Schiele's more extreme works were not intended to be purchased or exhibited; to a certain extent they represent the kinds of experiments with expression characteristic of Rembrandt's early self-portrait etchings. However, Schiele was working in Vienna at a time when Freud's ideas were becoming widely discussed. The overtly sexual subtexts of Schiele's self-portraits appear to tie in with Freud's theories of sexual deviation—ideas that were also explored in the work of other Viennese psychologists, such as Richard von Krafft-Ebing's *Psychopathia Sexualis* (1886) and Otto Weininger's *Sex and Character* (1903).[17] Thus Schiele used these portraits as a means of self-analysis, drawing upon contemporary psychoanalytic ideas. This is a historically plausible way of understanding Schiele's still disturbing project.

**115 Frida Kahlo**

*Broken Column*, 1944

The vast majority of Kahlo's work is self-portraiture, and she used a Surrealist idiom to explore the physical and mental pain that dogged her throughout her life. In the years after a bus accident in 1925 she had more than 32 operations, which left her in constant physical agony. Works such as this one graphically express her suffering. In other works Kahlo also used self-portraiture more positively as a means of exploring her Mexican identity.

Psychoanalysis was used rather differently by the Surrealists, who latched upon Freud's ideas of sexual repression rather than concentrating on his study of sexual deviance. As part of their wholesale attack on bourgeois society, the Surrealists emphasized the by-products of sexual repression, as revealed through the imagery of dreams, wishes, and fantasies. European Surrealism was largely a male movement, but there were also a number of women artists associated with Surrealist tendencies in other countries, including the German/Mexican artist Frida Kahlo. Kahlo produced a number of extraordinarily original self-portraits that drew upon Surrealist ideas of displacement and repression but minimized their emphasis on sexuality [115]. Kahlo's self-portraits had elements of both autobiography and psychoanalytic self-exploration. She frequently alluded to her adoptive Mexican heritage, and she also referred explicitly to a series of back operations that left her in constant pain, and to the miscarriages that prevented her from bearing a child she wanted. Her deeply personal self-portraits turn these real life events into metaphorical and fantastical realizations of her own physical and psychological pain.

Artists like Schiele and Kahlo saw self-portraiture as a way of exploring their own psychological states imaginatively as well as therapeutically. However, it could be said that all self-portraiture involves the kind of othering of the self that Schiele and Kahlo played with so overtly. One of Freud's more notable successors, Jacques Lacan, discussed the phases of life in terms of the development of the human ego.[18] The earliest stages of childhood, in which the baby sees itself as one with the mother ends at the point when the child recognizes its own image in a mirror and realizes that it is a separate being. The implicit or explicit presence of a mirror in self-portraiture recalls Lacan's theory of the development of the self, but it was only in the twentieth century that artists began to adopt this approach self-consciously.

# Portraiture and Modernism

From the fifteenth to the nineteenth centuries, certain continuities characterize the history of portraiture in western Europe and America. Portraits were expected to provide both likeness and some kind of revelation of the sitter's character, status, or position, although how they did so could vary greatly. Although such expectations were not abandoned, some fundamental changes in the conception and appearance of portraiture can be seen in the nineteenth and twentieth centuries. 'Modernism' is the name usually given to the cultural and aesthetic responses to the period of technological modernization that accompanied the Industrial Revolution.[1] These changes appeared in different countries gradually over a long period of time, with Britain showing the impact as early as the late eighteenth century, while Italy, for example, did not undergo a comparable experience of modernization until nearly a hundred years later. In terms of portraiture, modernism brought with it some catalysts for change. The first of these was the invention of photography, which offered both a challenge and an opportunity for portraitists. A second related factor was the rejection of mimesis that characterized many art movements of the late nineteenth and early twentieth centuries. Artists who saw themselves as part of the avant-garde declared their rejection of portraiture's associations with the representational traditions of the past. Thirdly, the major social changes that accompanied modernization also inspired new ways of seeing the roles of individuals in society, and this too had an impact on the way artists used portraiture to represent the people in their world.[2]

It is a common critical trope to reject the importance of portraiture to modernist art.[3] At first glance portraits appear to have little place in the evolution of modernism, as their mimetic associations could not easily be reconciled with the creative freedom assigned to the avant-garde. The modernist ethos of universality and abstraction has been said to be alien to the specificity of the portrait. A disparagement of portraiture was entrenched in much modernist critical theory. For example, the English artist and writer Clive Bell coined the phrase 'aesthetic emotion', which he defined as a feeling that was stimulated by what he called 'significant form'. Significant form was the basis of Bell's formalist theory, and he saw it as the defining characteristic of art.

Although he did not reject representational art entirely, subject matter was irrelevant to him. Because portraiture was felt to be dominated by the likeness of the subject rather than purely formal qualities, Bell conceived of portraits as alien to his definition of 'significant form':

Portraits of psychological and historical value, topographical works, pictures that tell stories and suggest situations . . . belong to this class [of descriptive painting] . . . According to my hypothesis they are not works of art. They leave untouched our aesthetic emotions because it is not their forms but the ideas or information suggested or conveyed by their forms that affect us.[4]

Although several artists in Bell's circle painted portraits, his rejection of portraiture as too intrinsically mimetic for modernism was shared by other early twentieth-century artists, such as the Russian Vassily Kandinsky, who increasingly adhered to an ethos of total abstraction, or 'non-objectivity'. Portraits, which had been low down the academic hierarchies in the early modern period because of their putative lack of inventiveness and idealization, were equally low in the hierarchies of modernism, but this time because of their association with likeness. Even those modernist artists who produced many portraits could be somewhat coy in their references to portraiture. For example, Picasso's sporadic and inconsistent use of the term 'portrait' was belied by a massive exhibition of his portraiture held in 1996, which comprised every remotely identifiable image he painted of all his various lovers throughout his career.[5]

Despite attempts by both artists and critics to place portraits outside the mainstream of modernism, portraiture played a fundamental part in rethinking the kinds of issues surrounding representation and artistic interpretation that preoccupied artists of the avant-garde. Although few modernist artists were exclusively portraitists in the conventional sense, most of them turned to portraiture at some point in their careers. The place of portraiture in the twentieth century is complicated by its diversity: while some artists of the avant-garde attempted totally abstract 'portraits' (see below), others continued a tradition of institutional and private portrait commissions. This resulted in the extremes either of stylistically experimental works or of portraits that were firmly tied to existing conventions of representation, with many examples somewhere in the middle. The plurality of functions and stylistic qualities apparent in portraits of this period makes it worth addressing separately the modernist dimension to portraiture.

## Portraiture and photography

Photography's origins can be traced back to optical devices, such as the camera obscura, that were employed as artistic aids from the seventeenth century. The invention of photography as we know it is usually

dated to the 1820s, when Henry Fox Talbot in England and Joseph-Nicéphore Niepce and Louis-Jacques-Mandé Daguerre in France simultaneously developed methods of mechanically reproducing the image of an inanimate object. The invention of photography was of major significance for the development of portraiture. Although early photography was used for many different purposes, portraiture quickly became one of the most popular practices of professional photographers. There are a number of reasons for this, but one of the most important was that photography appeared to provide a foolproof means of conveying likeness. The conception that a photograph reveals truth initially seemed to offer the model of mimesis required for portraiture. However, from an early stage portrait photographers adopted poses and conventions from painting, while artists used photography for a variety of purposes, many of which offered them new creative approaches to portraiture. Although in its early years photography threatened to replace painted portraiture, the relationship between the two arts was ultimately enriching rather than destructive. Photography provided new methods of producing likenesses; it served to liberate painters from the goal of mimesis; and it offered a new tool for portrait painters as part of their working processes. A consideration of each of these points will help explain how photography both drew upon and challenged the centuries-old conventions of portraiture.

Once photography had been invented, it was soon adopted for portraits. Early professional photographers quickly realized that they could have a lucrative trade in setting up portrait studios providing affordable likenesses that could be produced relatively quickly, with a minimum of fuss. Portraits no longer required the inconvenience of many sittings, and the final product could be presented to the sitter within a reasonable time. The reduction of both time and, eventually, cost was attractive for many sitters who might never have considered having their portraits painted but were less reluctant to have themselves photographed. The early photograph portrait quickly developed a new category of its own—the so-called *carte-de-visite* [**116**]. These were calling cards which included not just the name and address of the subject but their photograph as well.[6] The *carte-de-visite* became the accepted means of social exchange among the increasingly prevalent bourgeoisie in mid-nineteenth-century western Europe and America. The format also provided a portable image that could be kept in pockets, drawers, or albums as mementos of friends or loved ones: thus photographs soon superseded the art of miniature painting.

The technical limitations and long exposure time of early photography meant that sitters had to remain stationary sometimes for several minutes, and this led to a certain stiltedness in the posing. However, even once these technical problems were overcome, photographs appeared no more spontaneous than painted portraits, and indeed often

seemed to be governed by the same conventions. In early photographs sitters adopt neutral expressions, stand, or sit stiffly, and occupy anonymous spaces, which include such artificial elements as columns and curtains—the established props of portraiture. The ubiquity of portrait photographs did not prevent sitters from wanting an image of themselves that had been touched up, and there appears to have been a common expectation that portrait photographs should serve the same kind of purpose as painted portraits. The mimetic potential of early portrait photography was thus undermined by the prevalence of the traditions of painting and the expectations of the sitters.

Although the visual qualities of early portrait photography may have been drawn from painted portraiture, the potential of early photographs to be reproduced and widely circulated meant that they could function more like prints than paintings. For example, portrait photographs of famous actors, musicians, and writers were distributed in the form of *cartes-de-visite*, or as part of albums, in magazines, or as individually sold cards. Theatre managers employed photography as a means of promoting their most popular actors, and the practice of portrait photography helped fuel nineteenth-century celebrity cults, for example of actors such as Sarah Bernhardt in France or Henry Irving in England.[7]

So, in its own right photography had a decisive impact on the

history of portraiture. However, the popularity of portrait photography also inspired changes in the practice of portraiture in other media, such as painting, and these changes were no less far-reaching than the innovations of photography itself. Although there were some gloomy predictions about the death of painting after photography's invention, it did not take artists long to try to find different approaches to portraiture that would distinguish their art from that of the photographer. Although many portraits still retained the customary conventions, artists were also self-consciously experimental, making portraits a starting point for a work that used space, props, and gesture in new ways.

Another way that photography contributed to an alteration in the conventions of portraiture was through its employment by painters as part of their working methods. Before the invention of photography painters often relied on long sittings in their studio; subsequently a painted portrait could be produced wholly or partly from a photograph rather than from a sitting. For those sitters who still wanted their portraits painted, photography offered a way to liberate their time while providing the photographer with a means of studying their faces without having them there. Photography also offered a new tool for self-portraiture, as it enabled artists, if they wished, to dispense with the mirror. Among the late nineteenth- and early twentieth-century artists who had themselves photographed for self-portraits were Munch, Kirchner, Schiele, and the German society portraitist Franz von Lenbach.

As John Gage has shown, the irony about the invention of photography was that it, like portraiture, was devalued as a mechanical taking of likenesses, rather than praised as a significant creative tool for the artist.[8] The idea that the camera could be objective implied that the person operating it was a mere technician—a label that had also been associated with the mimetic nature of painted portraiture. However, photography itself was not used mechanistically, but was employed for creative purposes. Photography did not make portraiture obsolete, but expanded its potential.

## Portraiture and modernist aesthetics

Although officially commissioned and conventionally posed portrait painting continued to flourish, by the end of the nineteenth century some portraitists were attempting to offer something different to their patrons and clients. Often the conventional coexisted with the experimental. This can be seen in the work of the late nineteenth-century fashionable portraitists such as Giovanni Boldini in Italy, France, and England, Jacques-Émile Blanche in France and John Singer Sargent in England and America. These portraitists flattered their sitters through

**117 John Singer Sargent**

*Daughters of Edward Darley Boit*, 1882

Sargent painted this portrait of the daughters of Boit while both the artist and the sitters were in Paris in 1882. Although this was still an early point in Sargent's career, the dramatic use of space and the deep colour tones, reminiscent of Velázquez and Hals, were to become trademarks of Sargent's society portraiture during the succeeding decades.

exaggerated attention to their beauty, the lavishness of their garments, or the elegance of the settings. They also alluded to the status, wealth, or profession of their sitters in a way fully commensurate with portraiture's traditional functions. Sargent's portrait of the daughters of Edward Darley Boit [**117**] achieves some of these effects, and it draws authority from Sargent's use of murky colour tones and painterly brushwork reminiscent of old masters such as Velázquez and Hals. Sargent thus places his portrait firmly within the tradition of seventeenth-century portrait painting—albeit from two different national tendencies. However, Sargent's brushwork here relates not only to the works of seventeenth-century masters but also to the stylistic character of contemporary Impressionist painting. Sargent's technique blurs his sitters' features much more forcefully than, for example, Hals had done. Sargent also experimented here with the disposition of space. He used such tactics as adopting a view from the distance, as with the Boit

**118 Gustav Klimt**

*Adele Bloch-Bauer I*, 1907
Although Klimt's early reputation rested on his founding of the Secession group in Vienna and on his richly decorative subject pictures of *femmes fatales* such as Salome and Judith, towards the end of his career portraiture was a mainstay of his profession. His reputation for rebellion was superseded by acceptance from the Viennese bourgeoisie, especially the Jewish community, who welcomed his trademark style in portraits such as these.

children, or from above, or arranging groups of figures obliquely or in apparently haphazard relation to each other. Portraits such as Sargent's drew on both the past and the present in a way that was commercially successful and artistically complex.

These 'society' portraits remained a sufficient compromise for many elite sitters until the Second World War. However, some artists stripped away references to status, wealth, and beauty that existed in the society portraits of Sargent and his contemporaries and focused instead on the formal properties of their portraits. One who did this successfully was the Austrian painter at the end of the nineteenth and beginning of the twentieth centuries, Gustav Klimt, whose portraits were both flattering likenesses of aristocratic beauties and wild experiments with flat decorative areas of costume [**118**]. Klimt's portrait of Adele Bloch-Bauer

was one of several that he painted of wealthy members of the Viennese Jewish community. The care with which he has delineated Bloch-Bauer's features gives a dimensionality that contrasts strikingly with the flat pattern of her garment. The pattern here recalls medieval mosaics, such as that of Justinian and Theodora [see **4**] that Klimt had seen on a trip to Ravenna. The portrait thus evinces a representational tension: it addresses likeness, but contains elements that have more associations with the artist's technical interests than with the sitter's status or character.

This kind of tension is apparent in much avant-garde portraiture—despite a critical tendency to highlight modernism's complete break with tradition. Among the few early twentieth-century portraits discussed in standard histories of modernism are Picasso's representation of Gertrude Stein [**119**] and Matisse's portrayal of his wife, Amélie, with a green line painted down her nose [**120**]. These works are often presented in terms of their contribution to the development of avant-garde art movements, and for their disruption of traditional ideas of form and colour. Their status as portraits can be ignored or seen as secondary to their stylistic experimentation. However, both works allude to, as well as disrupt, the representational conventions of portraiture. Picasso depicted Stein in a way that captured her distinctive features, overlaying them with the characteristics of Iberian sculpture that Picasso had discovered while on holiday in Gosol, Spain, during 1906. Stein herself was known for her non-representational literary portraiture which later drew on Cubism for its fragmented format.[9] Matisse's portrait of his wife is also a recognizable likeness, following a conven-

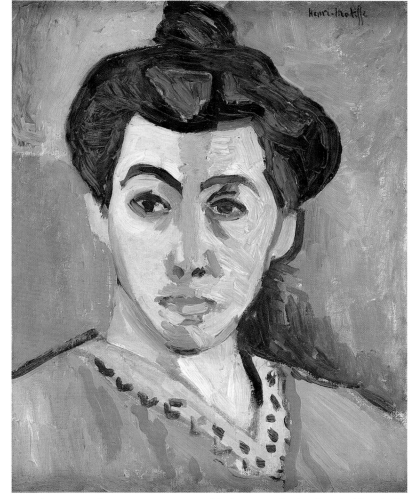

tional portrait format—a part-profile bust, with the face half in light and half in shadow. But instead of using nuances of colour to create an effect of dimensionality in the face, Matisse chose a sickly green that rather violently bisects Amélie's nose. The shock of Matisse's work to contemporary audiences was this apparently cavalier treatment of a genre known for its mimetic qualities.

Given that the notion of portraiture as likeness rests on this mimesis, portraiture as a genre would seem to resist the pull of modernist abstraction towards a non-mimetic and even non-objective mode of representation. However, there are a number of modernist 'portraits' which are partially, or fully, abstracted, or totally non-representational. This tendency began to develop in the late nineteenth century, when Whistler categorized his portraits in terms of their colour tones, rather than the name of the sitter. His famous portrait of his mother was originally entitled *Arrangement in Grey and Black: Portrait of the Painter's*

**121 James McNeill Whistler**

*Arrangement in Grey and Black: Portrait of the Painter's Mother*, 1871

Whistler painted this portrait of his mother at a tense period in his private life. He had been living in London with one of his models, Joanna Heffernan, but in 1871 Joanna moved out when his mother moved in. Whistler used his mother as a model for this portrait, which was exhibited at the Royal Academy in London in 1872. Although it could be said that by painting a portrait of his mother Whistler was catering to Victorian sentimentality, he vehemently denied the relevance of the subject matter. In an article of 1878 he wrote: 'What can or ought the public to care about the identity of the portrait?'

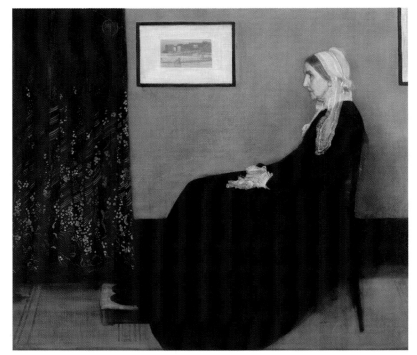

**122 Alberto Giacometti**

*Portrait of Annette*, 1964

Giacometti's Surrealist objects and attenuated sculptures of standing and walking figures were only one part of his vast output. He also produced a large number of portraits, painted and drawn in various media, and representing a limited number of sitters. Giacometti's foray into portraiture was most intensive from the 1940s, when he attempted to use likeness as a means of representing what is visible to the eye. His obsessive reproduction of the image of his sitters—his brother Diego, a Japanese philosophy professor Yanaïhara, and wife Annette, shown here represent his attempts to achieve a state of pure perception. His idealistic endeavour led to increasing frustration, to which the many unfinished portraits of this period attest.

*Mother* [**121**]. Whistler portrayed a personal subject, but underplayed the sentimental qualities of the work in favour of the formal ones. In his portraits, as in his landscapes, he used titles that had musical associations—harmonies, nocturnes, arrangements—suggesting the prevalence of tone or mood over subject matter.

Whereas Whistler used musical analogy as a strategy for undermining the mimetic qualities of his portraits, others attempted to erase these aspects in a different way by using patterns and treating their sitters as 'motifs' rather than as individuals. This is particularly evident with artists who painted a series representing the same sitter. Matisse's busts of Jeannette, Giacometti's portraits of Annette [**122**] or Yanaïhara, and Modigliani's various female models are repetitions of the physical form of their subjects rather than explorations of individual identity. Giacometti subjected his handful of sitters to endless sessions while he worked and reworked his representations. Paradoxically, instead of intensifying the verisimilitude of his portraits, Giacometti's close studies give his works a disturbing, alien quality that makes the sitter's character and likeness elusive. Nevertheless such stylistic posturing does not disguise the fact that these are portraits of actual people. In each case the tensions between stylistic experiment and revelation of the individual cannot be denied. The descriptive and referential qualities of twentieth-century portraiture subsume even the most radical stylistic departures within portraiture's traditional revelatory, celebratory, and mimetic traditions.

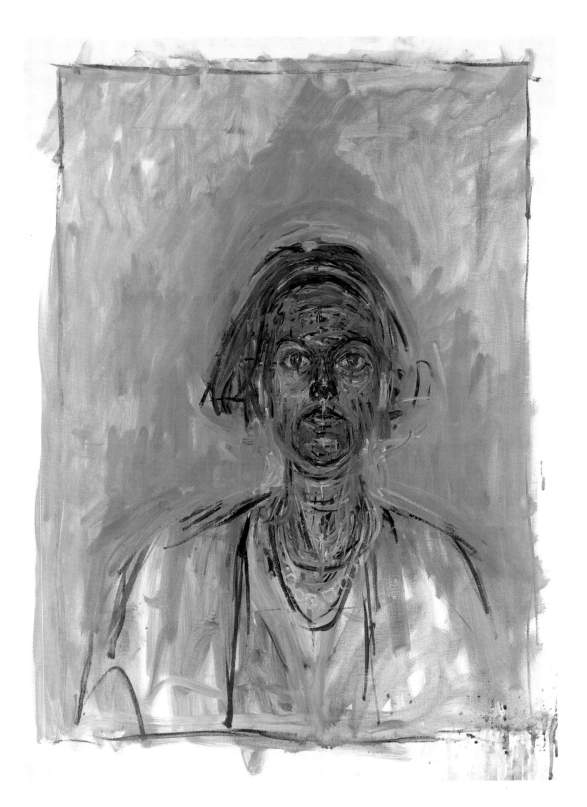

## Abstract and non-representational portraits

Whistler's and Giacometti's portraits, like those of Matisse and Picasso, still have a representational function in that they are recognizable likenesses of the individuals they depict. However, a number of avant-garde artists produced portraits that did not convey a likeness of their sitter in the usual sense. Among these are the portraits of and by the

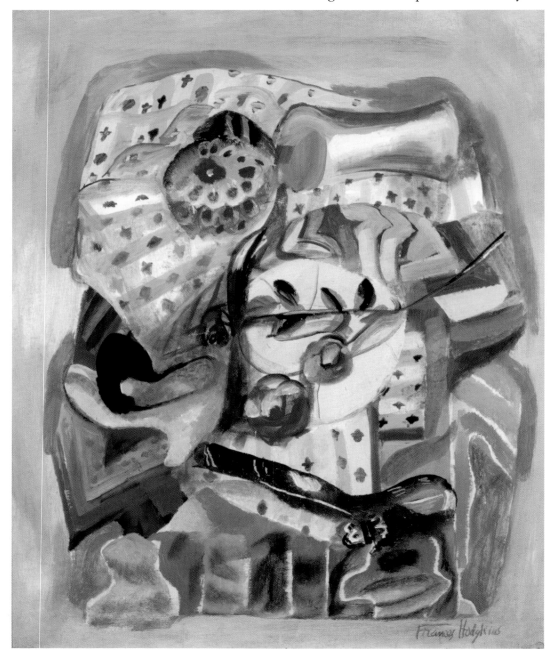

New Zealand artist Frances Hodgkins, who employed a collection of objects, such as mirrors and flowers, to evoke her subjectivity [123]. Hodgkins's works could be labelled still lifes, but she chose to call them 'self-portraits' and used the still-life elements as a means of referring to her own personality, obsessions, and interests.[10] A different approach to non-representational portraiture was taken by the American artist Charles Demuth, whose 'poster portraits' include his homage to the poet William Carlos Williams, *I Saw the Figure 5 in Gold* [124]. Here Demuth conveys the impression of an urban street as seen through the imagery of Williams's poem, *The Great Figure*. Although containing abstract components, Demuth's work also depicts recognizable elements, such as the number 5 itself.

The radical simplifications in some modernist portraits bear a conceptual relationship with the methods of caricature. The German artist Gabriele Münter reduced the features of her sitters to a schematic series of lines and colours, in a manner that could be both evocative and amusing [125]. Although her work drew on the inspiration of French

**123 Frances Hodgkins**

*Self-portrait: Still Life*, 1941
A New Zealander by birth, Hodgkins spent most of her career in England, and from the First World War she was involved with various avant-garde groups in St Ives and London, and was best known for her watercolours and landscapes. Her self-portrait still lifes are unique attempts to convey something about herself through an array of inanimate objects.

**124 Charles Demuth**

*I Saw the Figure 5 in Gold: Portrait of William Carlos Williams*, 1929
This is one example of Demuth's series of 'poster portraits' produced from the mid-1920s to represent artists and writers who were part of his immediate circle in New York. Among his subjects were the artist Georgia O'Keeffe and the writer Gertrude Stein. Demuth's poster portraits reveal a strong influence of Cubism in his use of fragmented space, but there is also evidence of futurist inspiration in the evocation of movement and 'states of mind'.

*Listening (Portrait of Jawlensky)*, 1909

Although her contemporary reputation was eclipsed by that of her lover and teacher, Kandinsky, Münter made a distinct contribution to the Blaue Reiter (Blue Rider) group, and to German Expressionism generally. While Kandinsky concentrated on conveying his colour symbolism through imaginary landscapes, Münter focused on portraiture and still life. The idea of portraiture as mimesis was in many ways antithetical to the spiritual ethos of Expressionism, but Münter's reduction of her portraits to essentials attempted to convey the essence of the sitter's spirit and character, rather than a likeness.

Impressionism and post-Impressionism, her combination of simplified portraiture and humorous portrayal of character gives her work a relationship with caricatural portraits in popular German comic magazines such as *Simplicissimus*. To Münter, these simplified forms also bore aesthetic affinities with the folk art and children's art that she and her lover Kandinsky collected. In the later decades of the twentieth century, the French artist Jean Dubuffet used caricatural forms in his portraits much more deliberately. But in Dubuffet's portraits—unlike those of caricaturists—the likeness seems less important to him than the association with a raw, or radically simplified, form of representation.

It is notable that although many modernist portraits are non-representational in that they do not convey a likeness, very few of them are purely 'non-objective', that is, constructions of pure line and colour without any representational qualities. However, there are examples. One of the few justifications for approaching portraiture in this way came from the early twentieth-century American artist Katherine Dreier, who described her abstract portrait of Marcel Duchamp as follows:

Through the balance of curves, angles, and squares, through broken or straight lines, or harmoniously flowing ones, through colour harmony or discord, through vibrant or subdued tones, cold or warm, there arises a representation of the character which suggests clearly the person in question, and brings more pleasure to those who understand, than would an ordinary portrait representing only the figure and face.[11]

Dreier suggests that mimetic representation is an imperfect way of conveying the essence of a person; instead portraitists should use form and colour as a means to evoke, rather than describe, the sitter's qualities.

However, as with all 'non-objective' art, the relationship between the artist's representation and the viewer's perception is often a tenuous one, and such portraiture may fail to convey anything about the subject to someone who does not actually know them.

## Portrait tradition and the avant-garde

As I have shown, modernist portraiture—even by artists with avant-garde affiliations—did not always privilege stylistic experimentation. There were also many twentieth-century portraits that were conceived in mimetic terms and included the sort of props, expressions, and gestures, as well as signs of status and profession, that had been common in portraiture from the fifteenth century onwards. This tendency in portraiture has sometimes been related to an anti-modernist conventionalism. Certainly, one of the most stylistically restrained eras in twentieth-century art—the interwar period—was dominated by portraiture. It was during this time, for example, that Otto Dix self-consciously adopted a realist visual rhetoric that recalled such old

**126 Stanley Spencer**

*Portrait of Patricia Preece,* 1933

One of Spencer's main themes in his subject pictures was the importance of sexuality and eroticism. This obsession also found its way into Spencer's portraiture—both his own self-portraits and those of his second wife, Patricia Preece. Spencer married Preece in 1937 after divorcing his wife of 12 years, Hilda Carline, though his second marriage was never consummated. This portrait was one of a series Spencer painted at a time when they lived together in a chastity enforced by Preece. There is an uncomfortable quality to the intimacy of a portrait that is invested with Spencer's own sexual desire and frustration.

masters as Lucas Cranach [see **25**] and Hans Holbein [see **1**], and included clues to his sitter's status and character, as in his portraits of the journalist Sylvia von Harden with her monocle and spritzer [see **92**], and the photographer Hugo Erfurth sharing a canvas with his Alsatian dog. Other skilled portraitists, such as Giorgio de Chirico and Max Beckmann, were vehemently opposed to modernist tendencies in art.

Although portraits by artists such as Dix may not be as stylistically radical as those of other avant-garde artists, they did challenge traditions of portraiture in other ways. For example, some twentieth-century portraitists stressed the ugliness or physical imperfections of their sitter in an exaggerated manner that was uncommon in the past. Schiele extended his studies of his emaciated and attenuated body [see **114**] to his face, which he depicted scowling, grinning, and screaming. The distortions of expression here have resonances with the work of Rembrandt or Schiele's fellow Austrian, the eighteenth-century sculptor Messerschmidt [see **16**], but Schiele's prolific reproduction of variations on the 'ugly' face and body suggests a different degree of obsession. Both Stanley Spencer [**126**] and Lucian Freud borrowed Schiele's method of representing the body with purple veins and swollen genitals, and they added to this the wrinkles of age and the sagging, pendulous swells of fat that are all-too common but do not represent the side of humanity that most sitters wished to see. Portraiture has always included sitters who have physical imperfections. What is different in these works is the excessive emphasis on the corporeality of the human body—on muscles, veins, and fat.

In the work of the Irish artist Francis Bacon, physical distortion in portraiture became a disturbing reference to the negative sides of the human condition. Bacon repeatedly represented his close friends George Dyer [**127**] and Isabel Rawsthorne with bulbous noses, hooded eyes, crooked heads, and monster mouths. In such works he was not only revealing the evanescence of the corporeal self but was using his portraits to convey visually the violence of human suffering and

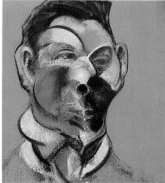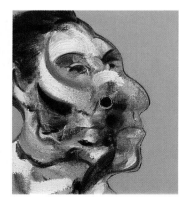

unhappiness. Bacon engaged with the history of portraiture from early in his career, when he copied Velázquez' portrait of Pope Innocent X but replaced the sombre countenance of the sitter with a screaming mask. Bacon used portraiture to draw attention to the very things about human existence that portraiture of the past did not so readily show.

From these examples, it becomes clear that modernist portraiture both draws from tradition and contests it; it both contributes to the modernist paradigm and has characteristics which cannot be confined to the development of modernism alone.

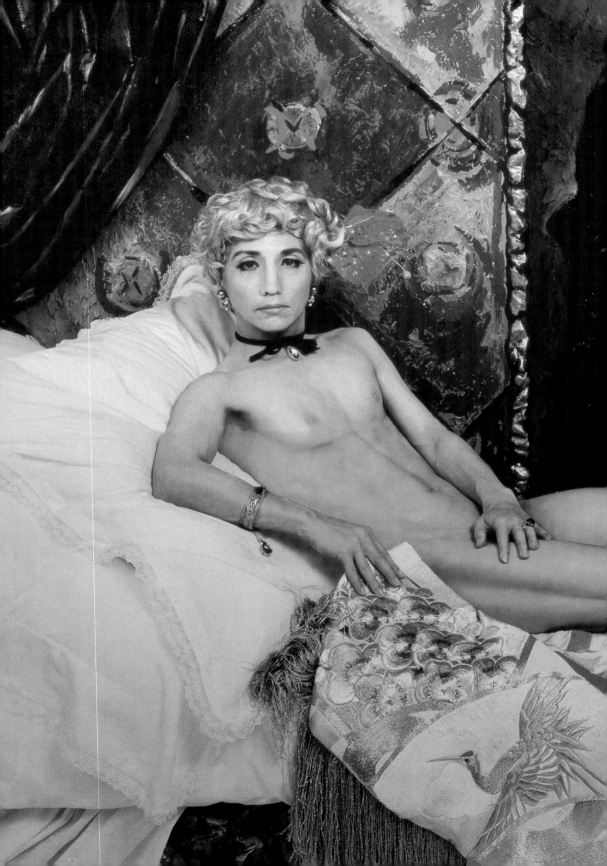

# Identities

During the last three decades of the twentieth century—the so-called 'postmodern' era—issues of personal identity and how that identity is constructed and understood came to the forefront of cultural commentary and aesthetic practice. Postmodern visual culture has explored the relationships between individuality, social role, and cultural, sexual, and gender stereotypes, but artists deal with these concepts as unstable, fluctuating, and indeterminate. In terms of portraiture, there has been a greater self-consciousness on the part of artists about the implications of the age, gender, ethnicity, nationality, and other signs of their sitters' identity. The exploration of these aspects of identity is fundamental to the postmodern project.

Since the 1970s many artists have found that the best way to tackle identity issues is to return to a form of mimetic portraiture. Artists have found it useful to harness the evocative power of the face and body, but instead of adopting standard conventions of posing, expression, and setting, they treat these conventions playfully, ironically, or parodically. Another key aspect of portraiture since the 1970s is the choice of medium, and the camera has proven to be the most effective tool for many portraitists. The explosion of media after the Second World War has also meant that portraiture has appeared in many different forms, including performance art, where individuals use their own bodies to convey their ideas. It could be said, for instance, that the 'living sculpture' of the English artistic team Gilbert and George is a kind of self-portraiture. These artists painted their bodies, dressed up in formal clothes, posed, sang, and danced mechanistically. This form of self-expression was tied up for them with explicit role-play, in which they fashioned themselves as prim and respectable English gentlemen (although Gilbert was a German-speaking Italian), countering some of their more outrageous imagery of bodily fluids and gay sexuality that dominated their paintings and prints.

In attempting to investigate the complexities of portraiture since the Second World War, it is worth considering several key areas of artistic exploration: a renewed interest in this tradition of social role-playing and masquerade; the significance of self-portraiture as a means of exploring sexuality, gender, and ethnicity; and a shift of attention from

Detail of 131

the face to the body. Although these themes are by no means exhaustive, they provide a framework for appreciating the importance of portraiture in our own time.

## Masks and roles

Both the presentation of social roles and a tendency to fashion the self were apparent in portraiture from the fifteenth century onwards, and artists frequently and self-consciously portrayed their sitters and themselves in different roles for a variety of social and artistic reasons. During the last decades of the twentieth century this aspect of portraiture became prevalent and even more self-conscious. Role-playing has become a method of exploring fluctuating aspects of identity in portraiture, but it has also been used ironically, as a means of undermining the idea that identity can be encapsulated in representation.

These aspects of role-playing portraiture owe a great deal to the work of the early twentieth-century artist Marcel Duchamp. Duchamp's use of art for playful, ironic, or subversive purposes derived from the iconoclastic nature of the Dada movement in the 1910s and 1920s, with portraiture playing a crucial part in his oeuvre. Duchamp worked with fellow artist Man Ray to produce a series of portrait photographs that represented Duchamp dressed up as an invented woman whose name, Rrose Sélavy, was a pun on the French 'Eros, c'est la vie' ('Love, that's life'). In these photographs Duchamp wore fashionable clothes and make-up and performed the role of a woman, thus altering his own gender identity in a way that was both ironic and unsettling. Duchamp's work also mocked the very foundations of art and of portraiture. He defaced the image of one of the most famous portraits in history, Leonardo's *Mona Lisa* [128], by marking up a reproduction of the image with a moustache, a goatee beard, and the punning initials *L.H.O.O.Q.* ('Elle a chaud au cul'), which becomes 'she has a hot ass' when translated into English. Duchamp's use of graffiti to transform a famous picture into an image from a girlie calendar humorously undermined the authority of the old master portrait. Duchamp's works were thus not portraits in any traditional sense: they were not commissioned by the sitter as a means of retaining a likeness for posterity. They did not provide signs of the status, character, and profession of their sitter; nor did they probe the inner life of their subjects. However, Duchamp's adoption of masquerade to challenge the fixity of gender roles, his use of photography, his collaborative methods, and his subversive and playful treatment of the work of old masters were all elements that were valued by portraitists in the late twentieth century.

Like Duchamp's early experiments, much postmodern portraiture deals with the way roles and identities can be assumed and then discarded. The photographers Robert Mapplethorpe and Cindy Sherman

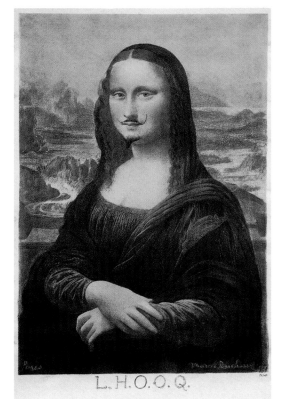

**128 Marcel Duchamp**

Replica of *L.H.O.O.Q.* from *Boite-en-Valise*, 1919

This work is not a portrait as such but represents Duchamp's comment on one of the most famous portraits in history. Leonardo da Vinci's depiction of the enigmatic *Mona Lisa* (1503–6) was a canonic masterpiece that hung in the major French public art collection in the Louvre and was a clear target for Duchamp's irreverent approach to art. By poking fun at this work of art Duchamp raises questions about the status of old master art and the value of portraiture as a genre. He produced this defaced print of the *Mona Lisa* while in Paris in 1919, when he was involved with a circle of Dada artists congregating around the poet Paul Éluard.

L.H.O.O.Q.

most notably examined the issue of fluctuating identity in their work of the 1970s, 1980s, and 1990s. Mapplethorpe's portraits are aesthetically pleasing studies of blank faces and smooth bodies that stress the cosmetic aspects of their sitters' appearance, without delving into character, status, or personality.[1] Mapplethorpe was interested in the way his sitters looked, rather than who they were, and his many portraits of famous actors, models, and singers are treated as the same sort of aesthetic exercises as his photographic portraits of himself and his many, mostly anonymous, friends and lovers. Mapplethorpe stripped his portraits down to an attractive-looking physical likeness, but in doing so he seemed to play up the artificial or cosmetic aspects of modern life.

Cindy Sherman's photographs play with issues of identity in different ways. From the 1970s onwards she photographed herself as if she were a film character or a figure in an old master painting [**129**]. Very few of Sherman's images relate to actual films and paintings; rather, they recall the film or painting type. For example, she portrays the baby doll or slattern from Hollywood melodramas of the 1950s, or the threatened beauty from Hitchcockian thrillers, or the Madonna from a baroque altarpiece. Each of these roles represents a recognizable stereotype about women. Sherman shows women as they are often portrayed in visual media: for example, as sexy, dutiful, stupid, or vulnerable. In each case she

## 129 Cindy Sherman
### Untitled #216

Sherman is perhaps best known for the untitled 'film stills' she produced in the late 1970s and 1980s. In these works she photographed herself in stereotypical women characters from 'B' movies. However, in 1989–90 she took a rather different approach and photographed herself in the costumes of women from famous old master paintings. Among the works she alluded to were Caravaggio's *Bacchus*, Ingres's *Odalisque*, and generic paintings of the Madonna and Child. This represents one example of a Madonna painting that shows Sherman as the Virgin Mary, holding out her breast to the viewer as a metaphor for her intercessory role in Catholic theology.

photographed herself in the stereotypical role. Some commentators have claimed that Sherman's work is self-portraiture, and that she is examining herself as much as she is making a comment about the restrictive nature of women's assigned social roles. Sherman herself has denied this, claiming that her works were explorations of gender, rather than self.[2] Although Sherman is less concerned with cosmetic appearance than Robert Mapplethorpe, it could be argued that her film stills and other photographs both represent and play out gender as a performance.[3]

Both Sherman's and Mapplethorpe's work concentrates on the surface or superficial expectations of their world. Both artists deal with social masks and the ways individual identity can be submerged or obliterated by surface or stereotype. In this sense their work reinforces a view of contemporary society held by the French philosophers Gilles Deleuze and Félix Guattari, whose complex social theory categorized the veneer of modern existence as *visagéité* ('faciality'). Deleuze and Guattari contrast the use of the mask in 'primitive' societies with the role of the mask within hyper-civilized modern global capitalism:

Either the mask assures the head's belonging to the body, its becoming-animal, as was the case in primitive societies. Or, as is the case now, the mask assures the erection, the construction of the face, the facialization of the head and body; the mask is now the face itself, the abstraction or operation of the face, the inhumanity of the face.[4]

In their different ways both Sherman and Mapplethorpe explore the implications of the modern mask/face, and they both use portraiture as the most suitable form for such an exploration.

Another characteristic of postmodern portraiture is the extent to which film stars, pop idols, and other public figures have become its primary subjects. This focus on the popular icon has replaced the traditional use of portraits to portray monarchs, religious leaders, and other powerful individuals. Popular journalism has exposed the most intimate details of the private lives of public figures, as well as making their likenesses accessible to a worldwide population. This means that certain subjects are so universally known that a portrait will be globally recognizable. This is true of the portraits of the Singh twins, who use the technique of Indian miniature painting to produce portraits of

**130 Rabindra K. D. Kaur Singh**

*From Zero to Hero* (from the 'SPOrTLIGHT' series), 2002
Using the format of Indian miniature painting from the eighteenth century, the Singh twins here employ a hierarchical structure and a range of symbolism to present the portraits of the twenty-first-century celebrities—the footballer David Beckham and his wife, former pop star Victoria, with their son Brooklyn. The technique of the miniature allows for the presentation of the couple as contemporary icons, and they are both given the regalia of royalty, with Beckham dressed as Richard the Lionheart. However, there are also references to them as an ordinary family, seen in their physical intimacy and the presence of nappies and snacks beside Victoria. A series of tempters hold out commercial merchandise on golden trays at the bottom of the painting, and the media are represented at the top by a cat and dog clad in banknotes. This unusual portrait stresses both the extraordinary and everyday aspects of modern celebrity.

contemporary female icons such as the singer Madonna, Diana, Princess of Wales, or Victoria and David Beckham [**130**]. The closely studied miniature technique give these works the appearance of icons to be worshipped, and while the mimetic quality of the representation leaves us in no room to doubt the subject of the portrait, the works also project an otherworldliness that matches the legendary status of the sitters.

Mapplethorpe, Sherman, and the Singh twins all share a fascination with the effect on public perception of mass media such as film and journalism. All of them deal with the public or social mask and the way it has become inseparable from a sense of an individual's identity. The social mask, the inescapability of social stereotypes, and the notion that even the identity of a single individual can be multifaceted and subject to fluctuating interpretations are all elements common to much portraiture that has been labelled 'postmodern'.[5] Each of these artists, and many others, has found portraiture an appropriate medium to convey the sense that, in the late twentieth century, no individual has a single, definable identity. Richard Brilliant has summed it up succinctly:

In the twentieth century the traditional view of the fully integrated, unique, and distinctive person has been severely compromised by a variety of factors, commonly accepted as causing the fragmentation of self and the perceived decline in the belief that the 'individual' is a legitimate social reality.[6]

Because of these philosophical and social paradigm shifts, the experimentations with identity and role-playing within portraits have become a fundamental part of late twentieth- and early twenty-first-century portraiture.

## Gender, ethnicity, and sexuality in self-portraiture

Cindy Sherman's use of her own image as an intrinsic component in her film stills and concocted baroque paintings is one that she has shared with many other artists since the Second World War. As with the role-playing portraits, much self-portraiture of this period is concerned with different components of identity—primarily ethnicity, gender, and sexual orientation. However, artists also use self-portraiture as a means of narcissistic exploration that goes far beyond the self-aggrandizement in portraits by artists of the past.

Before the late twentieth century portraitists would often take the gender and ethnic signals in their works for granted, assuming a common understanding about gender roles and ethnic stereotypes. With greater awareness about these aspects of identity, late twentieth-century portraitists explore them more self-consciously. Gender, sexual orientation, and ethnicity all appear as themes in the self-portrait photographs of Yasumasa Morimura [**131**]. Like Sherman, Morimura photographs himself in different roles and guises, but like Duchamp

**131 Yasumasa Morimura**
*Portrait (Futago)*, 1988
The Japanese photographer Morimura has demonstrated his special interest in self-portraiture. Since the 1980s he has produced many photographic parodies of old master paintings, and he has used famous self-portraits by Van Gogh and Rembrandt among the sources for his ironic explorations of gender and ethnic difference. This photograph was based on Manet's *Olympia*. Although the source of influence is not in this case a portrait, Morimura's inclusion of himself in the work draws attention to the problems of representing a Japanese man in the role of a white Western woman.

before him, he also masquerades as a woman, without fully concealing the signs of his male identity. In his self-portrait in the character of Olympia from Manet's famous painting of 1863, he creates an ironic but disturbing image of himself as Manet's prostitute. Like Manet's Olympia, his hand covers his genitals, which serves in this case to hide the visible signs of his masculinity; despite the androgyny of the photograph, his musculature and lack of breasts reveal that he is a man. The use of the medium of photography adds a further unsettling element, as we see Manet's painting both realized and subverted. Morimura also plays with issues of ethnic identity here. Manet's Olympia is being brought flowers by her black servant, and Morimura adopts the trope of the female black servant in his photograph. Manet's audiences most likely took for granted this relationship between a white European woman as employer and a black woman of possible African descent as servant, but Morimura's image must be seen in terms of a more complex understanding of the relationship between ethnicity and social hierarchies. Morimura himself is of Asian origin, so he is not European like Manet's Olympia, and the subjugation of black peoples to white Europeans is now seen as a blot on history that cannot be defended or excused. Morimura therefore draws attention to the problems of those gender and ethnic categories that were only implicit in Manet's *Olympia*.

Given these broad intentions, it could be argued that Morimura's

work is not actually a portrait at all; indeed, in the works of artists in the late twentieth century it is sometimes difficult to distinguish what is meant to be portraiture as usually understood. The multiplication of media in the postmodern period means that artists no longer restrict themselves primarily to painting, drawing, graphic work, and sculpture, but may use any materials at their disposal. Their primary concern may not be to convey a likeness of themselves but to reveal something more fundamental about their life. Tracey Emin is one such artist, whose works cannot be described as self-portraiture in a traditional sense, but whose entire oeuvre is geared towards the kind of self-exploration that characterizes self-portraiture of the past. Emin's art is inevitably narcissistic. Using a variety of media creatively, she explores the most intimate aspects of her life history, including her sexual experiences. Her most famous work, *Everyone I Have Ever Slept With 1963–1995* [**132**], is composed of a tent, the inside of which has a series of lists, descriptions, and mementos of people who have shared her bed—friends and family, as well as sexual partners. Through works such as this Emin is able to challenge the traditional boundaries of self-portraiture.

What Emin and other postmodern artists do in their work is shift attention from the iconic qualities of portraiture to the indexical ones.[6] That is, they do not necessarily portray themselves and others in a representational way, but they use a variety of media and methods to refer to themselves. Emin's 'love tent' is as self-referential as any self-portrait,

but it avoids the emphasis on the relationship between the portrayal of physical likeness and the revelation of character. As with the use of masks and the plurality of identity, postmodern portraiture facilitates the exploration of the self and its ethnic, gender, and sexual components. This self could be embodied in different public roles, or in the intimacies of private life, but there is another way that postmodern portraiture shows a breach with the portraiture of the past, namely in its wholehearted emphasis on the body.

## The body

The body has always been an important aspect of portraiture. In the past the gestures and disposition of the body were the means of conveying the character and status of the sitter; artists have also explored the expressive potential of the body in many different ways. However, in portraiture the face was seen as the marker of identity and as the index of the soul, whereas bodies could often be more conventional than individual. In the last decades of the twentieth century in portraiture there has been a strong emphasis on the body. As with issues of social and private identity, the body has been subjected to new social pressures and expectations that have found their way into the wider concerns of artists. Postmodern self-portraits deal overtly with issues of body image, with the objectification of body parts, and with a complex relationship between body and soul.

In the late twentieth and early twenty-first centuries portraiture has embraced the ubiquitous Western concern with beauty and the shape of the body. Body image has become a major issue in the Western world, where widespread wealth has led to extremes of body type and unhealthy obsessions surrounding food. The growth of eating disorders has stimulated aspiration for a body shape that resembles that of a starving person in the Third World. At the other extreme is excessive obesity—a product of unhealthy Western diets and the lassitude of modern car culture. Finally, Western desire for beauty has fuelled the business of cosmetic surgery, which offers a god-like perfecting of body parts. Artists have tapped into all these aspirations in their portraits.

In dealing with these ideas of body image artists have several strategies at their disposal. They can explore cultural expectations by presenting what many consider to be an 'ugly' body, or they can experiment with the ideal bodies that wealthy Westerners think they want. The former strategy has been adopted by the British artist Jenny Saville [133], who uses her own body to make a point about social expectations in the late twentieth century. Saville produces monumental paintings that often cover whole walls. These works represent her body as obese, with pendulous breasts, large folds of fat, and the sorts of visible veins that are also apparent in works by artists like Schiele and Lucian Freud.

**133 Jenny Saville**

*Branded*, 1992

*Branded* has some of the same features of the portraits of male twentieth-century artists like Lucian Freud and Stanley Spencer. It is an unflinching view of a fleshy body that reveals veins, flab, and other imperfections. However, Saville has gone a step further here by using her own body as the model, and by 'branding' this body with such ironic words as 'supportive' and 'delicate' to highlight the differences between a real woman's body and the social expectations of what a woman's body ought to be. Although she uses herself as a model, Saville does not draw attention to her identity in the same way as artists such as Sherman and Emin have done.

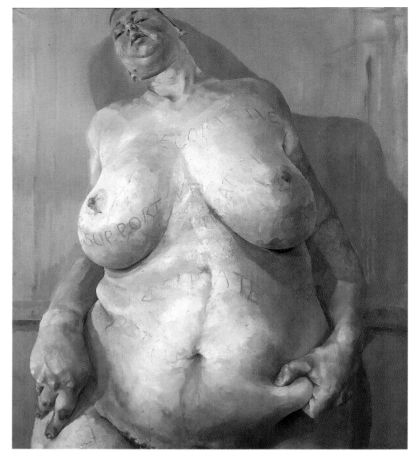

Saville thus shows us a body that is exactly the opposite of the eroticized and perfected models' bodies that appear in glossy magazines. The large physical dimensions of her works mean that the viewer is not able to avoid confronting a body type that they may have been conditioned to find undesirable. Through her self-portraiture, therefore, Saville finds a way of making the viewer question their own expectations about body perfection by facing the reality of an imperfect body.

The performance artist Orlan, who has undergone plastic surgery in order to construct her body in the form she desires, adopts a totally different approach. Orlan uses her own body as her medium, and she has the plastic surgery performed under local anaesthetic only, with a camera filming the operation. Thus she makes the actual act of cutting and revising her body a piece of performance art [**134**]. Orlan has spoken about her performances in terms of self-portraiture—calling herself 'a work in progress'.[7] However, unlike most people who undergo plastic surgery, Orlan did not have her breasts enlarged or her face lifted in order to adhere to Western canons of the beautiful body. Instead, she looked to redesign herself in the model of great works of art in the

**134 Orlan**

*The Face of the Twentieth Century*, 1990
Orlan is a French performance artist whose life's work has been based on using her own body both as a medium and as a subject of representation. In 1984 she dubbed herself 'St Orlan' and depicted herself in the guise of female saints based on old master painting and sculpture. In the 1990s she went a step further by subjecting herself to plastic surgery that was not geared towards physical perfection but was designed to make her look more like figures in selected works of art from the past, such as Botticelli's Venus. These operations were filmed and projected via video link to galleries around the world. Among the many implications of Orlan's work, her operations draw attention to portraiture as an art of deception and identity re-creation.

past—adding horns to her forehead, and aspiring to carve her face into the resemblance of Mona Lisa's smile. Orlan's disturbing work has a number of implications for portraiture and for the place of the body in late twentieth-century art. Her work exposes the pressures that women are under to make their bodies perfect, and their willingness to undergo the pain, anxiety, and humiliation of surgery in order to do this. But Orlan also has seen her work as stressing women's ability to control their own bodies in a technologically advanced culture. Thus plastic surgery becomes the ultimate means of self-control, with women choosing the shape of their own bodies as they would a new garment in a shop. The fact that Orlan conceives of her work as self-portraiture is revealing, as she carries the idea of self-portraiture as self-construction to the ultimate extreme.

Another method used by contemporary artists has been to objectify body parts in their self-portraiture as a way of defamiliarizing the image. The American photorealist Chuck Close, for instance, has produced what look like portrait photographs of his sitters—none of whom is known or famous [135]. However, these are not photographs but painted imitations of photographs. By blowing up his paintings to a massive size, and by not touching up the blemishes, blotches, and wrinkles that inevitably appear in the photographs themselves, he forces the viewer to focus on the formal qualities of these portraits. The relentless use of surface detail compels us to see the image as something almost abstract, with the body taking precedence over the face and the identity of the sitter.

**135 Chuck Close**
*Fanny (Fingerpainting)*, 1985

Close's large-scale portraits appear at first glance to be photographs, but they are actually black and white paintings based on a close study of photographic models. Close was fascinated by the technical capabilities of the photograph in reproducing an exact likeness, and he used his skill to try to mimic the effect of photography through different media. However, because Close's works are so large, they have a distancing, even abstract, effect, despite their apparent lifelike qualities.

Other artists also use photography as a means of focusing on and thereby objectifying the body. This can be seen in Bruce Nauman's hologram series, which includes a variety of photographs of his own distorted facial parts [**136**]. While Close uses the whole face but forces the viewer to look at formal aspects rather than personality, Nauman makes it impossible to see his self-representations as in any way representative of his identity or personality. Instead, he makes a familiar body part such as a mouth appear odd or monstrous. It could be questioned whether Nauman's works are portraits at all, but he was particularly concerned to base his corporeal investigations on his own body.

In addition to the politicizing of the body in Orlan's and Saville's portraiture, and the objectifying of the body practised by Close and Nauman, late twentieth-century artists have explored the mind–body duality that has been prevalent in portraiture from its inception. Artists could, for example, portray their own body as a way of expressing something essential about their identity. This method was adopted by the British artist Jo Spence, who was diagnosed with breast cancer and used

**136 Bruce Nauman**

*Studies for Holograms*, 1970
Like many twentieth-century artists, Nauman has been concerned with the bestiality of human nature, using video, sculpture, and other media to focus on the language of the body rather than that of the face. Works such as this one could be considered experiments in body art rather than portraiture, but Nauman, like artists such as Egon Schiele before him, was fascinated by distorted views of his own features.

photographic self-portraiture as a way of coming to terms with her own response to her illness [**137**]. Spence labelled her naked body 'property of Jo Spence' as a way of stressing her anger at a disease that caused the removal of one of her body parts. Spence called her art 'phototherapy', as she used it partly as a means of working through her own medical and psychological history.

The body could also serve artists as a way of transcending those limitations that they associated with the social veneer and superficial role-playing of postmodern consumer culture. As we have seen in the discussion of Sherman and Mapplethorpe, Deleuze and Guattari describe the dichotomy between the excessive emphasis on face and surface in Western capitalist society and the contrasting power of the body in 'primitive' societies. They see contemporary 'faciality' as

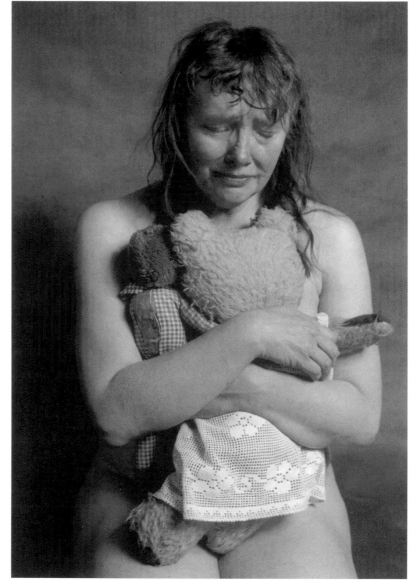

resulting from a rift between mind and body, in which the externals of life have superseded the authority of soul and spirit:

Paintings, tattoos, or masks on the skin embrace the multi-dimensionality of bodies. Even masks ensure the head's belonging to the body, rather than making it a face . . . Shaman, warrior, and hunter organisations of power, fragile and precarious, are all the more spiritual by virtue of the fact that they operate through corporeality, animality, and vegetality.[8]

Although Deleuze and Guattari could be accused of romanticizing primitive cultures, in the way Jean-Jacques Rousseau had done, they

*Self-portrait*, 1972–3

The Austrian artist Rainer was self-taught, but from the beginning of his career in the 1940s he experimented with many different media. Portraiture became an important part of his work from the 1950s, when he produced a series of self-portrait photographs which he slashed and painted over in an often violent and disturbing way. Rainer used these 'overpaintings' to explore the extremes of human emotions.

also express the frustration of many artists with a Western consumer culture that has become increasingly superficial and driven by image. The fascination of many late twentieth-century artists with the monstrous or excessive or ugly body can represent attempts to counter this obsession with image and surface. Among many artists who have employed this idea in their portraiture is the Austrian artist Arnulf Rainer, who was associated with the Vienna Actionist movement in the 1960s. Rainer photographed his own body repeatedly, and he then did violence to those images by painting over them or scratching through them [**138**]. His works thus provide a representation of his body that has been cancelled out or damaged. In these works he deliberately attempts to remove the body from its socialized state and bring out some of its more elemental qualities.[9]

These are only a few examples of artists in the second half of the twentieth century who have found the body a more useful focus for portraiture than facial likeness. In works such as these, portraiture has gone so far that sometimes it is no longer recognizable as portraiture. It could be argued that none of these works are portraits since they do not fulfil portraiture's traditional function of conveying likeness. However, it is perhaps more fruitful to see the portraiture of recent years as contributing to the variety and versatility that has always characterized the genre.

## The globalization of portraiture

From its origins in the skull cults of ancient Jericho, portraiture has retained certain key features and undergone many fluctuations. Portraiture has always involved a work of art that is meant to represent or convey in some way a named individual. Portraiture has always had a

sort of talismanic power. Portraiture has also served functions that other works of art have not, and it overlaps with philosophical and psychological issues in a way that is unique to its genre. However, until the late twentieth century, portraiture was largely a Western phenomenon that reflected concerns with individual character in ways that were alien to many other cultures. With a greater globalization of Western culture, portraiture is no longer narrowly confined to the Western world. With this geographical expansion portraiture has also changed in other ways. Portraits now appear in all kinds of media, and they serve many different purposes. Portraits are still produced for the purpose of conveying likeness and for documenting the appearance, status, or profession of a sitter at a given moment. They continue to be commissioned by individuals and organizations to be displayed publicly. They remain important signals of familial affection, friendship, or group solidarity. They still serve as vehicles for artistic self-exploration and technical experiment. But portraiture has also become a method for artists to explore self-consciously issues of gender, ethnicity, sexuality, and the body. With globalization, the expansion of media, and the co-existence of old and new functions, portraiture at the beginning of the twenty-first century has become a genre of art that has more versatile representational possibilities and functions than ever before.

# Notes

## Introduction

1. The full inscription (which contains both Latin and Greek words) reads:
DISTIKON. In imaginem Georgii Gysenii
Ist refert vultus, quam cernis, imago Georgi
Sic oculos vivos sic habet ille genas
Anno aetatis sua XXXIIII Anno domini 1532.
For good discussions of this portrait in the context of Holbein's other representations of the London Steelyard, see Thomas S. Holman, 'Holbein's Portraits of the Steelyard Merchants: An Investigation', *Metropolitan Museum Journal*, XIV (1980), 139–58; and Oskar Bätschmann and Pascal Griener, *Hans Holbein*, London, 1997, pp. 181–4.
2. This story derives from Giorgio Vasari's 'Life of Michelangelo', in *Le Vite de' più eccellenti pittori, scultori e architettori*, ed. Paola Barocchi, Pisa, 1994, vol. 1, p. 118. The quotation concerns Michelangelo's portrait drawing of Tommaso de' Cavalieri. According to Vasari, Michelangelo 'aborriva il fare somigliare al vivo, se non era d'infinità bellezza' ('hated making a representation from real life unless it was one of infinite beauty'). I am grateful to David Hemsoll for identifying the location of this quotation for me.
3. The best account of very early portraiture is James Breckenridge, *Likeness: A Conceptual History of Ancient Portraiture*, Evanston, IL, 1969.
4. See Audrey Spiro, *Contemplating the Ancients: Aesthetic and Social Issues in Early Chinese Portraiture*, Berkeley, CA, 1990; and Craig Clunas, *Art in China*, Oxford, 1997, p. 49.
5. For a philosophical investigation of the origins of modern ideas of identity, see Charles Taylor, *Sources of the Self: The Making of Modern Identity*, Cambridge, MA, 1989.
6. Stephen Greenblatt, *Renaissance Self-fashioning from More to Shakespeare*, Chicago and London, 1984.
7. Gilles Deleuze and Félix Guattari,
*A Thousand Plateaus: Capitalism and Schizophrenia*, trans. Brian Massumi, London, 1988, pp. 167–90.

## Chapter 1. What Is a Portrait?

1. Lorne Campbell compares the stylistic features of these works in *Renaissance Portraits: European Portrait-painting in the Fourteenth, Fifteenth and Sixteenth Centuries*, New Haven, CT, and London, 1990, pp. 14–16.
2. Bernard Berenson, 'The Effigy and the Portrait', in *Aesthetics and History in the Visual Arts*, New York, 1948, pp. 199–200.
3. Erwin Panofsky, *Early Netherlandish Painting*, New York and London, 1971, vol. I, p. 194.
4. See Giovanni Paolo Lomazzo, *Trattato dell'arte della pittura, scoltura et architettura*, second edition, Milan: Paolo Gottardo Pontio, 1585. The section on portraiture is pp. 430–8. Lomazzo writes that portraits should be 'per memoria de I Rè, iquali viuendo haue a no bene gouernatii popli, acciò che morendo lasciassero di se grandissimo desiderio à posteri, suegliati da quelli pitture ò statoue spesso ripetessero nella memoria i loro fatti illustri & opere gloriose, & s'accendessero ad imitarle' (pp. 430–1).
5. For the Eucharistic implications of these formal elements in northern European altarpieces, see Barbara Lane, *The Altar and the Altarpiece: Sacramental Themes in Early Netherlandish Painting*, New York, 1984.
6. This was argued by Arline Meyer, 'Re-dressing Classical Statuary: The Eighteenth-century "Hand in Waistcoat" Portrait', *Art Bulletin*, 77/1 (1995): 45–64.
7. For examples of this, see Marieke de Winkel, '"Eene der deftigsten dragten": The Iconography of the Tabbaard and the Sense of Tradition in Dutch Seventeenth-century Portraiture', *Nederlands Kunsthistorisch Jaarboek*, 46 (1995), special issue: Image and Self-image in Netherlandish Art 1550–1750, pp. 145–64; and in the same journal: Stephanie

S. Dickey, 'Women Holding Handkerchiefs in Seventeenth-century Dutch Portraits', pp. 333–67; see also Patricia Berman, 'Edvard Munch's *Self-portrait with Cigarette*: Smoking and the Bohemian Persona', *Art Bulletin*, 75 (1993): 627–46.

8. Theophrastus, *Characters* 2: 2, as cited in Andrew Stewart, *Faces of Power: Alexander's Image and Hellenistic Politics*, Berkeley and Los Angeles, 1993, p. 66.

9. Christopher Isherwood, *Goodbye to Berlin*, London, 1939.

10. Graham Clarke, 'Public Faces, Private Lives: August Sander and the Social Typology of the Portrait Photograph', in Graham Clarke, ed., *The Portrait in Photography*, London, 1992, pp. 71–93.

11. For example, Claire Pace claims that there was a change from the Renaissance emphasis on iconic description to an interest in probing the psychological profiles of poetic subjects in the seventeenth century. See her article, 'Delineated Lives: Themes and Variations in Seventeenth-century Poems about Portraits', *Word and Image*, 2/1 (1986): 1–17.

12. See Norbert Schneider, *The Art of the Portrait*, Cologne, 1994, p. 14; and John Pope-Hennessy, *The Portrait in the Renaissance*, London, 1996, pp. 72–3.

13. Erving Goffman, *The Presentation of the Self in Everyday Life*, Edinburgh, 1956, pp. 14–15.

14. See Schneider, *Art of the Portrait*, p. 67.

15. Jennifer Montagu, *The Expression of the Passions: The Origin and Influence of Charles Le Brun's 'Conférence sur l'expression générale et particulière'*, New Haven, CT, and London, 1994.

16. See *Souvenirs of Mme Vigée-Lebrun*, 2 vols, London, 1879, e.g. I, 49–50; and see Mary Sherrif, *The Exceptional Woman: Elisabeth Vigée-Lebrun and the Cultural Politics of Art*, Chicago and London, 1996.

17. Angela Rosenthal, '"She's got the look!" Eighteenth-century Female Portrait Painters and the Psychology of a Potentially "dangerous employment"', in Joanna Woodall, ed., *Portraiture: Facing the Subject*, Manchester, 1997, pp. 147–66.

18. See C. S. Peirce, 'The Icon, Index and Symbol', in *Collected Works*, ed., Charles Hartshorne and Paul Weiss, 8 vols, Cambridge, MA, 1931–58, vol. 2, pp. 156–73. For discussions of this theory in relation to portraiture, see H. Berger, jnr., 'Fictions of the Pose: Facing the Gaze in Early Modern Portraiture', *Representations*, 46 (Spring 1994): 87–120; Wendy Steiner, 'The Semiotics of a Genre: Portraiture in Literature and Painting',

*Semiotica*, 21 (1979): 111–19; and eadem, 'Postmodernist Portraits', *Art Journal*, 46 (1987): 173–7; Stewart, *Faces*, pp. 66–7. See also Robert S. Lubar, 'Unmasking Pablo's Gertrude: Queer Desire and the Subject of Portraiture', *Art Bulletin*, 79/1 (1997): 57–84.

## Chapter 2. The Functions of Portraiture

1. Hans-Georg Gadamer, 'The Ontology of the Work of Art and Its Hermeneutic Significance', in *Truth and Method*, 2nd edn, trans. Joel Weinsheimer and Donald Marshall, London, 1989, pp. 101–69.

2. Richard Brilliant, *Portraiture*, London, 1990, p. 23.

3. Pliny, *Natural History*, XXXV, ix–xi.

4. For details on Giovio's collection, see L. S. Klinger, *The Portrait Collection of Paolo Giovio*, Ann Arbor, MI, 1990; and Édouard Pommier, *Théories du portrait de la Renaissance aux Lumières*, Paris, 1998, pp. 121–7.

5. Wolfram Prinz, *Die Sammlung der Selbstbildnisse in den Uffizien*, Berlin, 1971.

6. Dagmar Eichberger and Lisa Beaven, 'Family Members and Political Allies: The Portrait Collection of Margaret of Austria', *Art Bulletin*, 75/2 (1995): 225–48.

7. One example of this is mentioned by John Ingamells. He refers to Bishop Howley at Fulham in England who painted out an old inscription on a portrait and replaced it with the name of Montaigne—a learned figure missing from his collection of portraits. See *The English Episcopal Portrait 1559–1835*, London, 1981, p. 44.

8. See B. B. Fortune, 'Charles Willson Peale's Portrait Gallery: Persuasion and Plain Style', *Word and Image*, 6 (1990): 308–24.

9. The quotation is from the website of the National Portrait Gallery, London, which contains an excellent summary history of the gallery (http://www.npg.org.uk/live/history.asp). See also Marcia Pointon, *Hanging the Head: Portraiture and Social Formation in Eighteenth-century England*, New Haven, CT, and London, 1993, pp. 227–45.

10. For a catalogue of this collection, see *Porträtgalerie zur Geschichte Österreichs von 1400 bis 1800*, Vienna, 1982. Before the eighteenth century, Schloss Ambras housed the cabinet of curiosities initiated by Ferdinand of Tirol and augmented by his successors. The cabinet included portraits with scientific and natural objects, but by the eighteenth century these were separated into different collections. On portraits in Ferdinand's collection, see Christiane Hertel,

'Hairy Issues: Portraits of Petrus Gonsalus and His Family in Archduke Ferdinand II's *Kunstkammer* and Their Contexts', *Journal of the History of Collections*, 13/1 (2001): 1–22.

11. This is discussed by Charlotte Townsend-Gault, 'Symbolic Facades: Official Portraits in British Institutions since 1920', *Art History*, 11 (1988): 511–26.

12. See Luba Freedman, *Titian's Portraits through Aretino's Lens*, University Park, PA, 1995, p. 2.

13. Jonathan Richardson, *Two Discourses. I. An Essay on the whole Art of Criticism as it Relates to Painting. II. An Argument in Behalf of the Science of a Connoisseur*, London, 1719, pp. 45–6.

14. See Richard Wendorf, *The Elements of Life: Biography and Portrait Painting in Stuart and Georgian England*, London, 1990.

15. John Pope-Hennessy, *The Portrait in the Renaissance*, London, 1966, p. 208.

16. Erwin Panofsky, 'Jan Van Eyck's Arnolfini Double Portrait', *Burlington Magazine*, 64 (1934): 117–27.

17. For just a few of the many discussions of this work, see Margaret Carroll, 'In the Name of God and Profit: Jan Van Eyck's Arnolfini Portrait', *Representations*, 44 (1993): 96–132; Craig Harbison, 'Sexuality and Social Standing in Jan Van Eyck's Arnolfini Double Portrait', *Renaissance Quarterly*, 43 (1990): 249–91; Bernhard Ridderbox, 'In de suizende stilte van de binnenkamer: interpretatics van het Arnolfini portret', *Nederlands Kunsthistorisch Jaarboek*, 44 (1993): 35–74; L. F. Sandler, 'The Handclasp in the Arnolfini Wedding', *Art Bulletin*, 66/3 (1984): 488–91; and Linda Seidel, 'Jan Van Eyck's Arnolfini Portrait: Business as Usual?', *Critical Inquiry*, 16/1 (1989): 54–86.

18. For a discussion of these, see Erna Auerbach, *Tudor Artists: A Study of Painters in the Royal Service and of Portraiture on Illuminated Documents*, London, 1954.

19. There is an example of one of these portraits in the Philadelphia Museum of Fine Arts.

20. National Portrait Gallery, London, press release 2001 (www.npg.org.uk/live/prelgeno.asp).

21. Roland Barthes, *Camera Lucida*, London, 1993.

22. Jodi Cranston, *The Poetics of Portraiture in the Italian Renaissance*, Cambridge, 2000.

23. Louis Marin, *Portrait of the King*, Minneapolis, MN, 1988, especially pp. 7 and 89.

24. Roger Hinks, *Greek and Roman Portrait Sculpture*, London, 1935, reprinted London, 1976.

25. Craig Clunas, *Art in China*, Oxford, 1997, p. 187.

26. James Breckenridge, *Likeness: A Conceptual History of Ancient Portraiture*, Evanston, IL, 1969, p. 266.

27. David Piper, *The English Face*, London, 1992, p. 45.

28. R. R. R. Smith, *Hellenistic Royal Portraits*, Oxford, 1988, p. 27.

29. See Peter Burke, *The Fabrication of Louis XIV*, New Haven, CT, and London, 1992.

## Chapter 3: Power and Status

1. 'i mercanti, & banchieri che non mai videro spada ignuda à quail propriamente si aspetta la penna nell'orecchia con la gonella intorno, & il giornale dauanti si ritraggono armati con bastoni in mano da generali' (Giovanni Paolo Lomazzo, *Trattato dell'arte della pittura, scoltura et architettura*, second edition, Milan: Paolo Gottardo Pontio, 1585, p. 434).

2. Ernst Kantorowicz, *The King's Two Bodies: A Study in Medieval Political Theology*, Princeton, NJ, 1997.

3. Marianna Jenkins, *The State Portrait: Its Origin and Evolution*, New York, 1947, p. 1.

4. See Andrew Stewart, *Faces of Power: Alexander's Image and Hellenistic Politics*, Berkeley and Los Angeles, 1993; and R. R. R. Smith, *Hellenistic Royal Portraits*, Oxford, 1988, p. 19.

5. See Roy Strong, *Gloriana: The Portraits of Queen Elizabeth I*, London, 1987, p. 121, who claims that the queen's image acted as a talisman: 'It was a Protestant use of the sacred image of the Virgin Queen exactly paralleling the wearing of holy images by Catholics.' See also Louis A. Montrose, 'Idols of the Queen: Policy, Gender and the Picturing of Elizabeth I', *Representations*, 68 (1999): 108–61.

6. Joshua Reynolds, *Discourses*, ed. Pat Rogers, Harmondsworth, 1992, especially Discourse IV.

7. See Simon Schama, 'The Domestication of Majesty: Royal Family Portraiture 1500–1850', in Robert Rotberg and Theodore Rabb, eds, *Art and History*, London, 1988, pp. 155–84.

8. Quoted in Colin B. Bailey, ed., *Renoir Portraits: Impressions of an Age*, New Haven, CT, 1997, p. 1.

9. For an example of this argument, see D. R. Smith, 'Irony and Civility: Notes on the Convergence of Genre and Portraiture in Seventeenth-century Dutch Painting', *Art Bulletin*, 69 (1987): 407–30.

10. See the argument of Linda Nochlin,

'Impressionist Portraits and the Construction of Modern Identity', in Bailey, *Renoir Portraits*, pp. 55–71.

11. Andrew Carrington Shelton suggests that attacks on portraiture in the mid-nineteenth century revealed anxieties about the emerging power of the bourgeoisie. See 'The Critical Reception of Ingres's Portraits', in Gary Tinterow and Philip Conisbee, eds, *Portraits by Ingres: Image of an Epoch*, exhibition catalogue, New York, 1999, p. 499.

12. Édouard Pommier, *Théories du portrait de la Renaissance aux Lumières*, Paris, 1998, p. 259.

13. Fuseli Lecture IV, in Ralph Wornum, ed., *Lectures on Painting by the Royal Academicians*, London, 1848, p. 449.

14. Lomazzo, *Trattato*, pp. 432–4.

15. See Ludmilla Jordanova, *Defining Features: Scientific and Medical Portraits 1660–2000*, London, 2000.

16. See John Kerslake, 'The Portrait of "Genius": Spearhead of Eighteenth-century British Taste', *Eighteenth Century Life*, 11 (1987): 155–62; David Piper, *The Image of the Poet*, Oxford, 1982; and Desmond Shawe-Taylor, *Genial Company: The Theme of Genius in Eighteenth-century British Portraiture*, Nottingham, 1987.

17. For further discussion, see Christine Battersby, *Gender and Genius: Towards a Feminist Aesthetics*, London, 1989.

18. See Elizabeth McCauley, *A. E. Disdéri and the Carte-de-visite Portrait Photograph*, New Haven, CT, 1985, pp. 35 and 111.

19. For an illustration of this work, see Mrs Reginald Lane Poole, *Catalogue of Portraits in the Possession of the University Colleges, City, and County of Oxford*, 3 vols, Oxford, 1912, vol. II, pp. 161–2. Cambridge portraits have also been extensively catalogued. See J. W. Goodison, *Catalogue of Cambridge Portraits*, Cambridge, 1955.

### Chapter 4. Group Portraiture

1. For a number of examples, see Katherine Hoffman, *Concepts of Identity: Historical and Contemporary Images and Portraits of Self and Family*, New York, 1997.

2. See Dian Owen Hughes, 'Representing the Family: Portraits and Purposes in Early Modern Italy', in Robert Rotberg and Theodore Rabb, eds, *Art and History*, London, 1988, pp. 7–38.

3. See Shearer West, 'The Public Nature of Private Life: The Conversation Piece and the Fragmented Family', *British Journal for Eighteenth Century Studies*, 18/2 (Autumn 1995): 153–72.

4. See, for example, David Smith, *Masks of Wedlock: Seventeenth-century Dutch Marriage Portraiture*, Epping, 1982.

5. For the origins of these ideas, see Philippe Ariès, *Centuries of Childhood*, London, 1962; and Lawrence Stone, *The Family, Sex and Marriage*, abridged edition, Harmondsworth, 1979.

6. See Patricia Fortini Brown, *Venetian Narrative Painting in the Age of Carpaccio*, New Haven, CT, and London, 1988.

7. For the Dutch contribution to group portraits, see Alois Riegl, *The Group Portraiture of Holland*, Los Angeles, 1999.

8. See *Identity and Alterity: Figures of the Body 1895/1995*, exhibition catalogue, Venice, 1995.

### Chapter 5. The Stages of Life

1. See Sara Holdsworth and Joan Crossley, *Innocence and Experience: Images of Children in British Art from 1600 to the Present*, exhibition catalogue, Manchester, 1992; and Marcia Pointon, *Hanging the Head: Portraiture and Social Formation in Eighteenth-century England*, New Haven, CT, and London, 1993, pp. 177–226.

2. Cathy Santore, 'Picture versus Portrait', *Source: Notes in the History of Art*, 19/3 (2000): 16–21 (p. 16).

3. R. R. R. Smith, *Hellenistic Royal Portraits*, Oxford, 1988, pp. 46–7.

4. See Thomas Martin, *Alessandro Vittoria and the Portrait Bust in Renaissance Venice: Remodelling Antiquity*, Oxford, 1998, p. 92; Martin discusses Vittoria's busts of old men.

5. John Gage, 'Photographic Likeness', in Joanna Woodall, ed., *Portraiture: Facing the Subject*, Manchester, 1997, pp. 119–30.

6. See Frances Borzello, *Seeing Ourselves: Women's Self-portraits*, London, 1998, p. 179; and Marsha Meskimmon, *The Art of Reflection*, London, 1996, pp. 175–9.

### Chapter 6. Gender and Portraiture

1. For a good introduction to issues of art, gender, and portraiture, see Gill Perry, ed., *Gender and Art*, New Haven, CT, and London, 1999.

2. See, for example, Griselda Pollock, 'Woman as Sign in Pre-Raphaelite Literature: The Representation of Elizabeth Siddall', in Pollock, ed., *Vision and Difference*, London, 1990, pp. 91–114.

3. Felicity Edholm, 'Beyond the Mirror: Women's Self-portraits', in Frances Bonner, Lizbeth Goodman, Richard Allen, Linda Janes, and Catherine King, eds, *Imagining*

*Women: Cultural Representations and Gender*, Cambridge, 1995, p. 159.

4. John Pope-Hennessy denies that this lack of individuality was true for all three artists and distinguishes between Palma Vecchio's beauties, which seem to represent types, and those of Titian, which he sees as more clearly differentiated. See *The Portrait in the Renaissance*, London, 1966, pp. 145–6.

5. See Brita von Götz-Mohr, *Individuum und soziale Norm: Studien zum italienischen Frauenbildnis der 16. Jahrhunderts*, Frankfurt, 1987.

6. For two different viewpoints on Titian's portraits and ideal views of women, see Rona Goffen, *Titian's Women*, New Haven, CT, and London, 1997; and Charles Hope, *Titian*, London, 1980.

7. Götz-Mohr, *Individuum*, p. 73 gives examples, such as Agnolo Firenzuola's *Della bellezza della donne* and Federigo Luigini's *Il libro della bella donna*. See also Willi Hirdt, *Gian Giorgio Trissinos Porträt der Isabella d'Este: ein Beitrag zur Lukian-Rezeption in Italien*, Heidelberg, 1981; Édouard Pommier, *Théories du portrait de la Renaissance aux Lumières*, Paris, 1998; and Brian Steele, 'In the Flower of Their Youth: "Portraits" of Venetian Beauties ca. 1500', *Sixteenth Century Journal*, 28/2 (1997): 481–502.

8. See Luba Freedman, *Titian's Portraits through Aretino's Lens*, University Park, Pennsylvania, 1995, p. 87.

9. See Catherine MacLeod, *Painted Ladies: Women at the Court of Charles II*, exhibition catalogue, London, 2001; and Douglas Stewart, 'Pin-ups or Virtues? The Concept of the "Beauties" in Late Stuart Portraiture', in Douglas Stewart and Herman W. Liebert, eds, *English Portraits of the Seventeenth and Eighteenth Centuries*, Los Angeles, 1974, pp. 3–26.

10. See Kathleen Nicholson, 'The Ideology of Feminine "Virtue": The Vestal Virgin in French Eighteenth-century Allegorical Portraiture', in Joanna Woodall, ed., *Portraiture: Facing the Subject*, Manchester, 1997, p. 52.

11. For different arguments about the purposes of these role portraits of women, see Marcia Pointon's article on 'Mrs Hale as Euphrosyne: Graces, Bacchantes and "Plain Folks": Order and Excess in Reynolds's Female Portraits', *British Journal for Eighteenth Century Studies*, 17/1 (1994): 1–26; and Edgar Wind, *Hume and the Heroic Portrait: Studies in Eighteenth-century Imagery*, ed. Jaynie Anderson, Oxford, 1986, p. 29.

12. M. D. Garrard, 'Artemisia Gentileschi's Self-portrait as the Allegory of Painting', *Art Bulletin*, 62 (1980): 97–112.

13. Pam Roberts, 'Julia Margaret Cameron: A Triumph over Criticism', in Graham Clarke, ed., *The Portrait in Photography*, London, 1992, pp. 47–70.

14. See Patricia Simons, 'Homosociality and Erotics in Italian Renaissance Portraiture', in Woodall, *Portraiture*, pp. 29–51.

15. See Norbert Schneider, *The Art of the Portrait*, Cologne, 1994, p. 94 on the significance of androgyny in Renaissance portraiture.

16. For the classic discussion of this association between artists and the melancholy humour, see Rudolph Wittkower, *Born under Saturn: The Character and Conduct of Artists*, New York, 1963.

## Chapter 7. Self-portraiture

1. See Xanthe Brooke, *Face to Face: Three Centuries of Artists' Self-portraiture*, Liverpool, 1995.

2. This is discussed by Joanna Woods-Marsden, *Renaissance Self-portraiture*, New Haven, CT, 1998.

3. See Jacques Derrida, *Memoirs of the Blind: The Self-portrait and Other Ruins*, Chicago, 1993.

4. See the excellent discussion of Dürer's work in Joseph Koerner, *The Moment of Self-portraiture in German Renaissance Art*, Chicago, 1993.

5. See Irit Rogoff, 'The Anxious Artist—Ideological Mobilisations of the Self in German Modernism', in Irit Rogoff, ed., *The Divided Heritage*, Cambridge, 1990, pp. 116–47.

6. For other examples of this, see Carol Duncan, *The Aesthetics of Power*, Cambridge, 1993.

7. For good overviews of issues about gender and women's self-portraiture, see Frances Borzello, *Seeing Ourselves: Women's Self-portraits*, London, 1998; and Marsha Meskimmon, *The Art of Reflection*, London, 1996.

8. See, for example, the self-portrait at the age of 12 by the Swiss artist Anna Waser of 1691 in the Kunsthaus, Zurich.

9. For Anguissola, see Liana de Girolami Cheney, Alicia Craig Faxon, and Kathleen Russo, 'Mannerism: The Self-portrait of the "*nobil* donna"', in *Self-portraits by Women Painters*, Aldershot, 2000, pp. 41–66.

10. See Stephen Greenblatt, *Renaissance Self-fashioning from More to Shakespeare*, Chicago and London, 1984, and my discussion of this in the Introduction.

11. Erving Goffman, *The Presentation of Self in Everyday Life*, Edinburgh, 1956.

12. See, for example, H. Perry Chapman, *Rembrandt's Self-portraits: A Study in Seventeenth-century Identity*, Princeton, NJ, 1990. Perry Chapman claims that even Rembrandt's earliest works were examples of self-exploration (see p. 158). On the other hand, Schneider sees them as an encyclopaedia of expressions (Norbert Schneider, *The Art of the Portrait*, Cologne, 1994, p. 113).

13. Paul de Man, 'Autobiography as De-facement', in *The Rhetoric of Romanticism*, New York, 1984, p. 69.

14. See Felicity Nussbaum, *The Autobiographical Subject: Gender and Ideology in Eighteenth Century England*, Baltimore, MD, and London, 1989.

15. Erika Billeter, ed., *Self-portraiture in the Age of Photography*, Bern, 1985, p. 8.

16. Oskar Kokoschka, *My Life*, London, 1974, p. 33.

17. This is the argument of Alessandra Comini, *Egon Schiele's Portraits*, Berkeley, CA, 1974.

18. See Jacques Lacan, *The Four Fundamental Concepts of Psychoanalysis*, trans. Alan Sheridan, Harmondsworth, 1975.

## Chapter 8. Portraiture and Modernism

1. A good introductory overview to this very complicated issue is contained in Charles Harrison and Paul Wood, *Art in Theory 1900–2000: An Anthology of Changing Ideas*, Oxford, 2003, pp. 2–4.

2. John Berger, 'The Changing View of Man in the Portrait', in *The Look of Things*, New York, 1974, pp. 35–41.

3. Schneider, for example, asserts: 'The few expressive portraits of the twentieth century have come from artists associated with openly figurative movements, or from those who have viewed the critique of society as an integral part of their work' (Norbert Schneider, *The Art of the Portrait*, Cologne, 1994, p. 10). See also the introduction to Joanna Woodall, ed., *Portraiture: Facing the Subject*, Manchester, 1997, pp. 1–25.

4. Clive Bell, 'The Aesthetic Hypothesis', in *Art*, Oxford, 1987.

5. William Rubin, ed., *Picasso and Portraiture: Representation and Transformation*, London, 1996.

6. Elizabeth McCauley, *A. E. Disdéri and the Carte-de-visite Portrait Photograph*, New Haven, CT, 1985.

7. For examples, see Heather McPherson, *The Modern Portrait in Nineteenth-century France*, Cambridge, 2001, pp. 76–116.

8. John Gage, 'Photographic Likeness', in Woodall, *Portraiture*, p. 120.

9. Wendy Steiner, *Exact Resemblance to Exact Resemblance: Literary Portraiture of Gertrude Stein*, New Haven, CT, and London, 1978.

10. See Elizabeth Eastmond, 'Metaphor and the Self-portrait: Frances Hodgkins's *Self Portrait: Still Life* and *Still Life: Self-portrait*', *Art History*, 22/5 (1999): 656–75.

11. Katherine Dreier, *Western Art and the New Era*, New York, 1922, pp. 112–13, quoted in Dawn Adès, 'Duchamp's Masquerades', in Graham Clarke, ed., *The Portrait in Photography*, London, 1992, p. 95.

## Chapter 9. Identities

1. See *Mapplethorpe Portraits*, exhibition catalogue, London, 1988, p. 12.

2. Interview with Paul Taylor in *Flash Art* (Oct./Nov. 1985), p. 78.

3. Rosalind Kraus, *Cindy Sherman 1975–1993*, exhibition catalogue, New York, 1993.

4. Gilles Deleuze and Félix Guattari, *A Thousand Plateaus: Capitalism and Schizophrenia*, trans. Brian Massumi, London, 1988, p. 181.

5. Ernst van Alphen, 'The Portrait's Dispersal: Concepts of Representation and Subjectivity in Contemporary Portraiture', in Joanna Woodall, ed., *Portraiture: Facing the Subject*, Manchester, 1997, p. 250.

6. Richard Brilliant, *Portraiture*, London, 1990, p. 171.

7. Quoted in Frances Borzello, *Seeing Ourselves: Women's Self-portraits*, London, 1998, p. 189.

8. Deleuze and Guattari, *A Thousand Plateaus*, p. 176.

9. Erika Billeter, ed., *Self-portrait in the Age of Photography*, exhibition catalogue, Lausanne, 1985, p. 16.

# Annotated Bibliography

There is a huge literature on portraiture, and any attempt to summarize it will undoubtedly lead to omissions and oversights. I have made my selection on the basis of works that consider the kinds of general issues about portraiture that I have raised in this book. Although there are many excellent monographs on individual artists which consider their portraits in detail, I have referred only to those that also tackle portraiture as a genre. In order to be most helpful to the reader, the following list is organized firstly according to general and period-based studies, and then latterly in relation to the themes explored in this book.

## Primary texts on portraiture

Unfortunately a number of key primary texts on portraiture have never been translated into English, although it is possible to gain access to edited selections from these sources through anthologies. The many ancient writings on portraiture from Pliny the Elder to Cicero were anthologized in the seventeenth century by Franciscus Junius in his *De pictura veterum*, 1637. This was translated into English in 1638 as *The Painting of the Ancients*, London, 1638, and there was a Farnborough reprint of it in 1972. Early modern art treatises that consider portraiture in some detail include Leon Battista Alberti, *Della pittura* (1436), translated into English as *On Painting*, Harmondsworth, 1991, and André Felibien, *Entretiens sur les vies et sur les ouvrages des plus excellents peintres anciens et modernes*, which was originally written in 1666–88 but can be obtained in a Paris edition of 1987. The most focused art treatises on portraiture remain in their original language. Giovanni Paolo Lomazzo's *Trattato dell'arte de la pittura, scoltura et architettura* of 1584 was translated into English by Richard Haydocke as *A Tracte Containing the Artes of Curious Paintinge, Caruing & Building* in 1598 (reprint 1970). However, Haydocke omitted Lomazzo's

section on portraiture, which remains untranslated into English. Perhaps even less accessible to the English-speaking reader is Francisco de Holanda's *De tirar polo natural* (*On Drawing from Nature*) (1549), latest edition Lisbon, 1984, which was one of the earliest complete considerations of portraiture. An excellent and thoughtfully collected anthology of writings about portraiture, which includes sections from each of these earlier works, is Rudolf Preimesberger, Hannah Baader, and Nicola Suther, eds, *Porträt*, Berlin, 1999. This includes passages in their original language and in German translation. Such a useful anthology has not yet been published in English. Other primary writings on portraiture include two significant English works of the eighteenth century: Jonathan Richardson's *Two Discourses. I. An Essay on the whole Art of Criticism as it Relates to Painting. II. An Argument in Behalf of the Science of a Connoisseur*, London, 1719, reprint Menston, 1972, and Joshua Reynolds's *Discourses on Art*, ed. Pat Rogers, Harmondsworth, 1992. Irene Heppner's *Bibliography on Portraiture: Selected Writings on Portraiture as an Art Form and as Documentation*, Boston, MA, 1990, provides a helpful starting point for the student of portraiture.

## General works on portraiture

Since the late 1980s art historians have begun to consider the genre of portraiture much more seriously, and some significant and thought-provoking studies have emerged. Richard Brilliant opened up some of the bigger questions about the history of portraiture with his edited special issue of the *Art Journal: Portraits: The Limitations of Likeness*, 46/3 (1987), which includes several highly influential articles on portraiture. Brilliant's book, *Portraiture*, London, 1990, is a succinct and subtle account of the philosophical and psychological functions of

portraiture. Following this, the study of portraiture blossomed with Marcia Pointon's *Hanging the Head: Portraiture and Social Formation in Eighteenth-century England*, New Haven, CT, and London, 1993; Joanna Woodall, ed., *Portraiture: Facing the Subject*, Manchester, 1997; and Norbert Schneider, *The Art of the Portrait*, Cologne, 1994. Each of these works has something significant to add to the history of portraiture. Although focused on eighteenth- and nineteenth-century Britain, Pointon's study is a thought-provoking and theoretically sophisticated account of portraiture's various functions. Woodall's edited collection presents worthy insights on a variety of case studies from the Renaissance to the present day. Schneider's work, which has the appearance of a book for general readers, is full of important observations about fifteenth- and sixteenth-century portraiture that have not previously been synthesized so well.

Other publications on portraiture equally offer much to the student of the genre. A good general introductory text is Susan Morris, *A Teacher's Guide to Using Portraits*, London, 1992. James Breckenridge's *Likeness: A Conceptual History of Ancient Portraiture*, Evanston, IL, 1969, is both a period study and an attempt to define the limits of portraiture in a way that is provocative if not always convincing. More recently, Édouard Pommier's *Théories du portrait de la Renaissance aux Lumières*, Paris, 1998, offers a fully grounded insight into two centuries of theoretical writings on portraiture, and brings to light theories of portraiture that have received little scholarly attention. An excellent introduction to some issues concerning portrait sculpture is contained in Penelope Curtis *et al.*, *Return to Life: A New Look at the Portrait Bust*, Leeds, 2000.

Other general studies include a special issue of *Word and Image* on 'Verbal and Visual Portraiture', 6/4 (1990), and Shearer West, 'Portraiture: Likeness and Identity', in Shearer West, ed., *The Bloomsbury Guide to Art*, London, 1996, pp. 71–83.

## Theory of portraiture

An arguably separate category of writings about portraiture are those scholarly works that posit theories about what portraits do in terms of representation and how they are responded to by viewers. Although these studies are often more philosophical than historical, they offer some difficult but rewarding reading. One of the earliest

considerations of the social function of portraiture is Bernard Berenson, 'The Effigy and the Portrait', in *Aesthetics and History in the Visual Arts*, New York, 1948, pp. 190–200. Other writers see portraiture as part of larger historical responses to identity politics. This is the case for John Berger, 'The Changing View of Man in the Portrait', in *The Look of Things*, New York, 1974, pp. 35–41. The seminal studies of Erving Goffman, *The Presentation of Self in Everyday Life*, Edinburgh, 1956; and Stephen Greenblatt, *Renaissance Self-fashioning from More to Shakespeare*, Chicago and London, 1984, are not strictly concerned with portraits, but their considerations of the theatrical nature of public roles and social behaviour are integral to any study of portraiture.

A significant consideration of portraiture as part of a semiotic system is contained briefly in C. S. Peirce's brief but challenging 'The Icon, Index and Symbol', in *Collected Works*, Charles Hartshorne and Paul Weiss, eds, 8 vols, Cambridge, MA, 1931–58, vol. 2, pp. 156–73. A more accessible consideration of Peirce's ideas is presented by H. Berger in his article 'Fictions of the Pose: Facing the Gaze in Early Modern Portraiture', *Representations*, 46 (Spring 1994): 87–120.

The place of portraiture within larger philosophical and aesthetic systems is considered in Hans-Georg Gadamer, 'The Ontology of the Work of Art and Its Hermeneutic Significance', *Truth and Method*, 2nd edn, trans. Joel Weinsheimer and Donald Marshall, London, 1989, pp. 101–69. Although not about portraiture specifically, the chapter on faciality in Gilles Deleuze and Félix Guattari's *A Thousand Plateaus: Capitalism and Schizophrenia*, trans. Brian Massumi, London, 1988, is worth struggling through for its suggestive notions of the role of the face within modern global capitalist culture. Another essay which is not about portraiture specifically but has been used to elucidate the autobiographical functions of self-portraiture is Paul de Man, 'Autobiography as De-facement', in *The Rhetoric of Romanticism*, New York, 1984, pp. 67–81. In considering the theory of self-portraiture, Jacques Derrida's *Memoirs of the Blind: The Self-portrait and Other Ruins*, Chicago, 1993, makes some compelling, if not always lucid, observations about the sub-genre of self-portraiture.

## Period studies

*Ancient and medieval*

There are a small number of excellent works on ancient portraiture. Roger Hinks's *Greek*

and Roman Portrait Sculpture, 1935, reprinted London, 1976, is a thorough catalogue of portrait sculptures from the ancient world. The best studies of ancient Greek portraiture are Gisela Richter, *The Portraits of the Greeks*, revised edn, Oxford, 1984; R. R. R. Smith, *Hellenistic Royal Portraits*, Oxford, 1988; and Andrew Stewart, *Faces of Power: Alexander's Image and Hellenistic Politics*, Berkeley and Los Angeles, 1993. Each of these authors combine ideas about the functions of ancient portraiture with a close study of the different categories of work and an analysis of the extant portrait sculptures and fragments. The different, but related, set of issues concerning ancient Roman portraiture are tackled in Jan Bazant, *Roman Portraiture: A History of Its History*, Prague, 1995; Diana Kleiner, *Roman Group Portraiture: The Funerary Reliefs of the Late Republic and Early Empire*, New York, 1977, and her *Roman Imperial Funerary Altars with Portraits*, Rome, 1987; and Charles Rose, *Dynastic Commemoration and Imperial Portraiture in the Julio-Claudian Period*, Cambridge, 1992. Special studies have been made of the strikingly realistic portraits of the Fayum district of Roman Egypt. The best of these studies include M. L. Bierbrier, ed., *Portraits and Masks: Burial Customs in Roman Egypt*, London, 1997; and Susan Walker and Morris Bierbrier, eds, *Ancient Faces: Mummy Portraits from Roman Egypt*, London, 1997. For a general consideration of the issues raised by ancient portraiture, see James Breckenridge's *Likeness: A Conceptual History of Ancient Portraiture*, Evanston, IL, 1969; and Tobias Fischer-Hansen, *Ancient Portraiture: Image and Message*, Copenhagen, 1992.

I have come across very few focused studies of medieval portraiture—not necessarily because there is a dearth of examples but because medieval historians combine the study of portraiture with other historical issues. Examples include Constance Head, *Imperial Byzantine Portraits: A Verbal and Graphic Gallery*, New York, 1982; and Ioannis Spatharakis, *The Portrait in Byzantine Illuminated Manuscripts*, Leiden, 1976.

## World Art

As with medieval art, portraiture in world art—or art not associated with the West—rarely gets separate scholarly attention. In this case the lack of examples of works that could be labelled as portraits is partly responsible. However, some interesting insights can be obtained in J. Borgatti and R. Brilliant, *Likeness and Beyond: Portraits from Africa and the World*, New York, 1990; and Julian Raby, *Qajar Portraits*, London, 1999. Chinese portraiture has a clearer tradition and has been targeted by several scholars, including M. Siggstedt, 'Forms of Fate: An Investigation of the Relationship between Formal Portraiture, especially Ancestor Portraits, and Physiognomy in China', in *International Colloquium of Chinese Art History 1991: Proceedings, Painting and Calligraphy*, 2 vols, Taipei, 1992, pp. 713–48; and Audrey Spiro, *Contemplating the Ancients: Aesthetic and Social Issues in Early Chinese Portraiture*, Berkeley, CA, 1990.

## Renaissance

Given that the autonomous painted portrait is very much a legacy of the Renaissance, it is no surprise that there are many excellent studies of Renaissance portraiture. The three starting points for any student of Renaissance portraiture are Jean Alazard, *The Florentine Portrait*, reprinted New York, 1968; Lorne Campbell, *Renaissance Portraits: European Portrait-painting in the 14th, 15th and 16th Centuries*, New Haven, CT, and London, 1990; and John Pope-Hennessy, *The Portrait in the Renaissance*, London, 1966. Alazard and Pope-Hennessy lay out the conceptual issues about Italian Renaissance portraiture and how it should be interpreted. Campbell's book takes on both Italy and northern Europe and offers a wide-ranging exploration of poses, gestures, and conventions of portraiture in the fifteenth and sixteenth centuries.

Other scholars have explored more deeply the philosophical and conceptual issues of Renaissance portraiture first mooted by Alazard and Pope-Hennessy, including the ways portraiture engaged with early modern notions of selfhood. Among these studies are Gottfried Boehm, *Bildnis und Individuum: über den Ursprung der Porträtmalerei in der italienischen Renaissance*, Munich, 1985; Peter Burke, 'The Presentation of the Self in the Renaissance Portrait', in *Historical Anthropology of Early Modern Italy*, Cambridge, 1987, pp. 150–67; Brita von Götz-Mohr, *Individuum und soziale Norm: Studien zum italienischen Frauenbildnis der 16. Jahrhunderts*, Frankfurt, 1987; and Nicholas Mann and Luke Syson, eds, *The Image of the Individual: Portraits in the Renaissance*, London, 1998. The relationship between portraiture and poetic conventions in the Renaissance period forms an important theme in Luba Freedman's 'The Concept of Portraiture in Art Theory of the Cinquecento',

Zeitschrift für Ästhetik und allgemeine Kunstwissenschaft, 32 (1987): 63–82, and her book, Titian's Independent Self-portraits, Florence, 1990, as well as in Jodi Cranston, The Poetics of Portraiture in the Italian Renaissance, Cambridge, 2000. One of the best general studies of sixteenth-century English portraiture is an exhibition catalogue by Karen Hearn, Dynasties: Painting in Tudor and Jacobean England, London, 1995. For a focused study of a specific portrait and how its iconography functioned, see Margaret Aston, The King's Bedpost: Reformation and Iconography in a Tudor Group Portrait, Cambridge, 1993.

Seventeenth and eighteenth centuries
The significance of portraiture to England, France, and the Low Countries in the seventeenth and eighteenth centuries has resulted in a plethora of studies in recent years. Innovative observations are made about many aspects of Netherlandish portraiture in the Leids Kunsthistorisch Jaarboek, special issue on 'Nederlandse Portretten', 8 (1989) and the Nederlands Kunsthistorisch Jaarboek, 46 (1995), special issue on 'Image and Self-image in Netherlandish Art 1550–1750' (both of which include articles in English). French portraiture of the same period has received less sustained attention, but see Myra Rosenfeld, Largillière and the Eighteenth-century Portrait, Montreal, 1982.

By far the most extensive studies of portraiture of this period are those of British portraiture, where the genre flourished in the seventeenth and eighteenth centuries. David Piper was responsible for the first definitive general studies of English portraiture, most notably his The English Face, which appeared in a new edition in London, 1992. Studies of the political and religious significance of portraiture in seventeenth-century England include Margaret Aston, 'Gods, Saints and Reformers: Portraiture and Protestant England', in Lucy Gent, ed., Albion's Classicism, New Haven, CT, 1995; and a very useful essay by John Peacock, 'The Politics of Portraiture', in Kevin Sharpe and Peter Lake, eds, Culture and Politics in Early Stuart England, Basingstoke, 1994, pp. 199–228.

Given the significance of portraiture to the eighteenth-century English art world, this period benefits from the same kind of classic studies as the Italian Renaissance. Among the best early writings on English portraiture is Edgar Wind, Hume and the Heroic Portrait: Studies in Eighteenth-century Imagery, which

can be read in an excellent modern edition by Jaynie Anderson (Oxford, 1986). Eighteenth-century British portraits form the primary subject of Marcia Pointon's ground-breaking Hanging the Head: Portraiture and Social Formation in Eighteenth-century England, New Haven, CT, and London, 1993; and Desmond Shawe-Taylor's elegant study, The Georgians: Eighteenth-century Portraiture and Society, London, 1990. Richard Wendorf's The Elements of Life: Biography and Portrait Painting in Stuart and Georgian England, London, 1990, offers many original insights about the relationships between verbal and visual portraiture from Van Dyck to Hogarth, and his succinct Sir Joshua Reynolds: The Painter in Society, London, 1996, provides astute observations not only about Reynolds but about the practice and interpretation of portraits in the late eighteenth century. American portraiture of the same period is the subject of Wayne Craven's Colonial American Portraiture, Cambridge, 1986, which argues for America's distinctiveness from traditions of European portraiture.

Nineteenth century
The expansion of portraiture in the nineteenth century has only rarely formed the subject of separate studies. Art historians tend to concentrate on the portrait output of individual artists or groups. Exceptions to this tendency to focus on single artists rather than the genre of portraiture are Anthony Halliday, Facing the Public: Portraiture in the Aftermath of the French Revolution, Manchester, 2000, which sees the role portraiture plays in the post-Revolutionary political culture of France; Heather McPherson, The Modern Portrait in Nineteenth-century France, Cambridge, 2001, which contains an excellent introductory overview, as well as some unusual case studies; and Robin Simon, The Portrait in Britain and America, Oxford, 1987, which is a wide-ranging study of portraits in both the eighteenth and nineteenth centuries. Other general studies take on the role of portraiture within French Impressionism. These include Margaret Farr, Impressionist Portraiture: A Study in Content and Meaning, Ann Arbor, MI, 1993; and Melissa McQuillan, Impressionist Portraits, London, 1986. Although concerned primarily with Renoir, Colin B. Bailey, ed., Renoir Portraits: Impressions of an Age, New Haven, CT, 1997, includes a thoughtful essay by Linda Nochlin that raises some more general issues about the functions and methods of nineteenth-century portrait painters.

*Photography*
Portrait photography is one of the more
fascinating sub-categories of portraiture, but
as with nineteenth-century art, it is often
considered in monographs on individual
artists. Scholars who deal more generally with
issues of portrait photography include
Graham Clarke, ed., *The Portrait in
Photography*, London, 1992, which contains
thought-provoking essays on photographs by
artists as diverse as Julia Margaret Cameron,
Marcel Duchamp, and August Sander.
Elizabeth McCauley's *A. E. Disdéri and the
Carte-de-visite Portrait Photograph*, New
Haven, CT, 1985, notwithstanding the
seeming specificity of its title, is an excellent
study of the general issues faced by portrait
photographers when the medium was in its
infancy.

*Modernism and postmodernism*
Despite the significance of portraiture to
modernism, there are very few general studies
of modernist portraiture—perhaps because of
the associations of portraiture with
convention rather than innovation. An
overview of the issues raised by modernist
portraiture is contained in Norbert Lynton's
introduction to *Painting the Century: 101
Portrait Masterpieces 1900–2000*, exhibition
catalogue, London, 2000; and Shearer West,
'Masks or Identities?', in Christos Joachimides
and Norman Rosenthal, eds, *The Age of
Modernism: Art in the Twentieth Century*,
exhibition catalogue, Stuttgart, 1997,
pp. 65–71. The massive exhibition catalogue
*Picasso and Portraiture: Representation and
Transformation*, ed. William Rubin, London,
1996, contains essays of variable quality, but as
a whole it offers a probing case study of the
ways Picasso engaged with portraiture
throughout his long career. This provides
some important insights into the paradoxes of
modernist portraiture. The same could be said
for John Klein's study, *Matisse Portraits*, New
Haven, CT, and London, 2001; Tobias Natter,
ed., *Oskar Kokoschka: Early Portraits from
Vienna and Berlin 1909–1914*, New Haven, CT,
and London, 2002; and Frank Whitford,
*Expressionist Portraits*, London, 1987.
Although some canonic figures of early
modernist art have inspired such studies, the
portraits of many other modernist artists have
received much less separate attention. A
deeper study of the way self-portraits were
used by modernist artists as part of their self-
construction is Irit Rogoff's article, 'The
Anxious Artist—Ideological Mobilisations of

the Self in German Modernism', in Irit
Rogoff, ed., *The Divided Heritage*,
Cambridge, 1990, pp. 116–47. One of the best
overviews of the theoretical and aesthetic
implications of modernist portraiture is the
introduction to Wendy Steiner's *Exact
Resemblance to Exact Resemblance: Literary
Portraiture of Gertrude Stein*, New Haven, CT,
and London, 1978. However, the bulk of her
study is concerned with examining poetic,
rather than visual, portraits.

Postmodernist artists have embraced
portraiture and self-portraiture as a key tool of
communication. However, given that many of
these developments occurred late in the
twentieth century, discussion of
postmodernist portraiture is largely confined
to exhibition catalogues and other ephemeral
publications. Among the more probing of
these are Melissa Feldman, ed., *Face-Off: The
Portrait in Recent Art*, exhibition catalogue
Philadelphia, 1994; and *Identity and Alterity:
Figures of the Body 1895/1995*, exhibition
catalogue, Venice, 1995. Wendy Steiner has
attempted to provide a more theorized
approach to the phenomena of
postmodernism and portraiture in her articles,
'Postmodernist Portraits', *Art Journal*, 46
(1987): 173–7; and 'The Semiotics of a Genre:
Portraiture in Literature and Painting',
*Semiotica*, 21 (1977): 111–19.

## Power and status

There are some excellent investigations of the
functions of portraiture as conveyors of power
or status. A classic early article, which still
offers many insights for the contemporary
reader, is Marianna Jenkins, *The State Portrait:
Its Origin and Evolution*, New York, 1947,
which attempts to account for the physical and
psychological qualities of portraits of rulers. A
difficult but rewarding read is Louis Marin,
*Portrait of the King*, Minneapolis, MN, 1988,
which draws upon Ernst Kantorowicz's
theories of the King's 'two bodies' as a way of
explaining the effect of French portraiture
during Louis XIV's reign. Changes in royal
portraiture towards a greater domesticity are
examined by Simon Schama in his 'The
Domestication of Majesty: Royal Family
Portraiture 1500–1850', in Robert Rotberg and
Theodore Rabb, eds, *Art and History*, London,
1988, pp. 155–84. The effect of papal portraiture
is the subject of an excellent case study by
Loren Partridge and Randolf Starn of
Raphael: *A Renaissance Likeness: Art and
Culture in Raphael's 'Julius II'*, Berkeley, CA,
1980. Students of the history of portraiture

will find many ideas of value in an article by C. Townsend-Gault, 'Symbolic Facades: Official Portraits in British Institutions since 1920', *Art History*, 11 (1988): 511–26, which considers the function and meaning of the sort of portraits we all see every day in our own public institutions.

## Groups

Early studies of group portraiture concentrated on the compositions chosen by artists and how they balanced the competing demands of compositional clarity and portrait conventions. The most famous of these studies is Alois Riegl, *The Group Portraiture of Holland*, the latest edition of which is published in Los Angeles, 1999; but another very useful work is Mario Praz, *Conversation Pieces: A Survey of the Informal Group Portrait in Europe and America*, London, 1971. Subsequent books and articles have been more concerned with a group ethos—whether of family or professional affiliation. Discussions of family portraiture include Angelika Lorenz, *Das deutsche Familienbild in der Malerei des 19. Jahrhunderts*, Darmstadt, 1985; and Diane Owen Hughes, 'Representing the Family: Portraits and Purposes in Early Modern Italy', in Robert Rotberg and Theodore Rabb, eds, *Art and History*, London, 1988, pp. 7–38. Marriage and betrothal portraiture forms a large category of early modern portraiture, but there are very few sustained studies of this sub-genre. The most notable are Berthold Hinz, 'Studien zur Geschichte des Ehepaarbildnisses', *Marburger Jahrbuch für Kunstwissenschaft*, 19 (1974), pp. 139–218; and (more accessible to an English-speaking reader) David Smith, *Masks of Wedlock: Seventeenth-century Dutch Marriage Portraiture*, Epping, 1982. Katherine Hoffman's *Concepts of Identity: Historical and Contemporary Images and Portraits of Self and Family*, New York, 1997, is a useful introduction, but is a generalized study, as it combines a discussion of the social history of the family with the history of portraiture.

Studies of different professional groups include John Ingamells's worthy but specialized *The English Episcopal Portrait 1559–1835*, London, 1981; and Ludmilla Jordanova, *Defining Features: Scientific and Medical Portraits 1660–2000*, London, 2000. Jordanova's book also offers clear insights on the social and psychological functions of portraiture and is worth reading for these, as well as for its specific focus on the professionalization of scientists and doctors.

## Age and gender

Portraiture's engagement with ageing is considered briefly in several of the more general books on portraiture, but very few studies deal with a specific stage of life and how portraiture engages with it. An exception to this is Sara Holdsworth and Joan Crossley's exhibition catalogue *Innocence and Experience: Images of Children in British Art from 1600 to the Present*, Manchester, 1992, which considers portraits as well as subject pictures representing children and how they interact. Portraits of children have also been considered by Marcia Pointon, *Hanging the Head: Portraiture and Social Formation in Eighteenth-century England*, New Haven, CT, and London, 1993. Youth and old age receive only passing attention in the critical scholarly literature on portraiture.

By contrast, gender issues have not only infiltrated discussions of portraiture but there are some important separate studies of portraiture and gender focusing on different historical periods. For the Renaissance, see especially Catherine King's useful overview, 'Made in Her Image: Women, Portraiture and Gender in the Sixteenth and Seventeenth Centuries', in Gill Perry, ed., *Gender and Art*, New Haven, CT, 1999, pp. 33–60. See also the essays by Patricia Simons that deal with gender, portraiture, and the gaze: 'Portraiture, Portrayal and Idealization: Ambiguous Individualism in Representations of Renaissance Women', in A. Brown, ed., *Language and Images of Renaissance Italy*, Oxford, 1995, pp. 263–301; and 'Women in Frames: The Eye, the Gaze, the Profile in Renaissance Portraiture', *History Workshop* (Spring 1988): 4–30.

There are some useful discussions of portraits of women in the seventeenth century in Catherine MacLeod's *Painted Ladies: Women at the Court of Charles II*, exhibition catalogue, London, 2001. For the eighteenth century, Mary Sherrif's monograph of the portraitist Elisabeth Vigée-Lebrun, *The Exceptional Woman: Elisabeth Vigée-Lebrun and the Cultural Politics of Art*, Chicago and London, 1996, contains rich insights about the gender of the artist and gender in representation. For a sustained discussion of representation in relation to the portraits of a single woman, see Elise Goodman, *The Portraits of Madame Pompadour: Celebrating the 'femme savante'*, Berkeley and Los Angeles, 2000. The relationship between woman artist and male sitter in the eighteenth-century context has been examined with great

sophistication by Angela Rosenthal in a series of articles and books, including 'Angelica Kauffmann Ma(s)king Claims', *Art History*, 15/1 (1992): 38–59; *Angelika Kauffmann: Bildnismalerei im 18. Jahrhundert*, Berlin, 1996; and the English revision of her 1996 book, *Becoming Pictures: Angelica Kauffmann and the Art of Identity*, New Haven, CT, and London, 2004; and '"She's got the look!": Eighteenth-century Female Portrait Painters and the Psychology of a Potentially "dangerous employment"', in Joanna Woodall, ed., *Portraiture: Facing the Subject*, Manchester, 1997, pp. 147–66. One of the most important studies of gender and portraiture was also a ground-breaking analysis of feminist art history: Griselda Pollock's 'Woman as Sign in Pre-Raphaelite Literature: The Representation of Elizabeth Siddall', in Pollock, ed., *Vision and Difference*, London, 1990, pp. 91–114. A succinct overview of some key issues is contained in the exhibition catalogue, Liz Rideal, ed., *Mirror Mirror: Self-portraits by Women Artists*, London, 2001.

In contrast with the many investigations of women and portraiture, there are fewer sustained studies of masculinity in portraiture. Notable exceptions include David Solkin, 'Great Pictures or Great Men? Reynolds, Male Portraiture and the Power of Art', *Oxford Art Journal*, 9/2 (1986): 42–9; and Irit Rogoff's 'The Anxious Artist—Ideological Mobilisations of the Self in German Modernism', in Irit Rogoff, ed., *The Divided Heritage*, Cambridge, 1990, pp. 116–47.

For other important scholarly work on gender and portraiture, see 'Self-portraiture' below.

## Self-portraiture

Self-portraiture is a branch of portraiture that has attracted the most sustained scholarly attention in recent years. Many of these studies focus on gender issues as well, especially the role of women artists. Among these, Marsha Meskimmon's *The Art of Reflection*, London, 1996, provides a lucidly theorized exploration of early and late twentieth-century self-portraits by women. More lavishly illustrated is Frances Borzello's study, *Seeing Ourselves: Women's Self-portraits*, London, 1998, which also focuses more thoroughly on contemporary art. A good introduction to women's self-portraiture can be found in an Open University textbook: see the essay by Felicity Edholm, 'Beyond the Mirror: Women's Self-portraits', in Frances Bonner, Lizbeth Goodman, Richard Allen,

Linda Janes, and Catherine King, eds, *Imagining Women: Cultural Representations and Gender*, Cambridge, 1995.

Historical studies of women's self-portraiture include M. D. Garrard's scholarly analysis, 'Artemisia Gentileschi's Self-portrait as the Allegory of Painting', *Art Bulletin*, 62 (1980): 97–112. The book by Liana de Girolami Cheney, Alicia Craig Faxon, and Kathleen Russo, *Self-portraits by Women Painters*, Aldershot, 2000, chronologically outlines women's self-portraiture from the ancient world to the twentieth century.

The number of writings on gender and self-portraiture seems to indicate that these two areas are inextricably linked, but other publications consider other sorts of issues surrounding self-portraiture. See especially the exhibition catalogues by Erika Billeter, ed., *Self-portrait in the Age of Photography*, Lausanne, 1985; and Xanthe Brooke, *Face to Face: Three Centuries of Artists' Self-portraiture*, Liverpool, 1995. Billeter's catalogue has a short but useful text and dozens of unusual and helpful illustrations.

Some historical investigations of self-portraiture also offer new ways to think about varying approaches of artists at different places and times. The functional and theoretical aspects of early modern self-portraiture are considered by H. Perry Chapman, *Rembrandt's Self-portraits: A Study in Seventeenth-century Identity*, Princeton, NJ, 1990; and Joanna Woods-Marsden, *Renaissance Self-portraiture*, New Haven, CT, 1998. One of the most eloquent and exciting studies of self-portraiture is Joseph Koerner, *The Moment of Self-portraiture in German Renaissance Art*, Chicago, 1993. This is a rewarding rather than an easy read, but it is an essential text for anyone concerned with the historical significance of self-portraiture.

Studies of modernist self-portraiture are usually confined to monographs on individual artists, but for ideas with wider application, see A. Benjamin, 'Betraying Faces: Lucian Freud's Self-portraits', in *Art, Mimesis and the Avant-Garde*, London, 1991, pp. 61–84; and S. Kelly and E. Lucie-Smith, *The Self-portrait: A Modern View*, London, 1987.

## Portrait galleries and collections

Several portrait galleries and collections have received scholarly attention. The most notable of these is Paolo Giovio's portraits of 'famous men' at Como, which is the subject of L. S. Klinger, *The Portrait Collection of Paolo Giovio*, Ann Arbor, MI, 1990. Giovio's gallery

is also discussed thoroughly in all the major books on Renaissance portraiture. The foundation of the Uffizi self-portrait collection and its heritage is considered in detail, with documentary appendices, in Wolfram Prinz, *Die Sammlung der Selbstbildnisse in den Uffizien*, Berlin, 1971. The National Portrait Gallery in London has also been the subject of several publications, starting with Marcia Pointon, *Hanging the Head: Portraiture and Social Formation in Eighteenth-century England*, New Haven, CT, and London, 1993. Other analyses of the National Portrait Gallery are currently in preparation.

The private portrait gallery formed by Charles Willson Peale is the subject of an article by B. B. Fortune, 'Charles Willson Peale's Portrait Gallery; Persuasion and Plain Style', *Word and Image*, 6 (1990): 308–24.

Timeline
Websites
List of Illustrations
Index

| | Portraiture | Events |
|---|---|---|
| **14,000 BC** | | **14,000** Lascaux cave paintings |
| | | **7500** Occupation of Jericho |
| **5000 BC** | **5000** Earliest portraits—skulls modelled in clay | |
| | **3100** First identifiable portraits on funerary monuments of pharaohs in Egypt | **3500** Sumerian cuneiform |
| | **1350** Unidealized portraits in Egypt during reign of Akhenaten | **2700** First pyramids in Egypt |
| **500 BC** | **500** First portraits on coins in Lycia and Persia | **750** Romulus said to have founded Rome |
| | According to Pliny, artist Panainos depicts portrait heads in picture of Battle of Marathon | |
| | **400→** Greek sculpted portraits of Socrates, Sophocles, etc. | **399** Socrates sentenced to death by hemlock |
| | First sculpted and coin portraits of Alexander the Great | **336** Alexander the Great becomes king of Macedonia |
| | | **221–204** Great Wall of China built |
| **0** | **206 BC–AD 220** Portrait murals during Han dynasty in China | **206 BC–AD 220** Han dynasty rules China |
| | | **54** Nero emperor |
| | | **60** Peter becomes first pope |
| | **77** Pliny the Elder's *Natural History* includes discussion of portraiture | **79** Pompeii destroyed by eruption of Vesuvius |
| | **161–180** Equestrian statue of Marcus Aurelius | |
| | **200** Portraiture flourishes in Fayum, Roman Egypt | **c.250** Christians paint Rome catacombs |
| | | **312** Constantine converted to Christianity |
| | **c.315–30** Portrait bust of Emperor Constantine | |
| **AD 500** | **526–48** Mosaics of Emperor Justinian and Empress Theodora at San Vitale, Ravenna | **537** Church of Hagia Sophia built in Constantinople by Justinian I |
| | | **c.570** Muhammad born in Mecca |
| | **600s** Portraiture in Chinese Tang dynasty | |
| | | **655–705** Wu (Tang dynasty) is first woman empress of China |
| | | **868** Chinese invention of printing |
| **1300** | **1300s** Chinese scroll portraits, Ming dynasty | **1300s** Flat mirrors invented in Venice |
| | | **1305** Giotto employed by Enrico Scrovegni for Arena Chapel in Padua |
| | | **1325–1519** Aztec Empire flourishes |
| | | **1327** Petrarch first sees Laura |
| | **c.1340** Simone Martini's portrait of Laura based on Petrarch's love poem to Laura | |
| | **c.1350** Portrait of Jean le Bon, King of France on wood panel: thought to be first profile portrait on panel in Europe | **1347→** Black Death in Europe |
| | | **1368–1644** Ming dynasty, China |
| **1400** | **1400s** Benin bronzes in Nigeria include portrait heads of rulers (until eighteenth century) | **1378–1417** Two popes, in Rome and Avignon |
| | **c.1408** Jacopo della Quercia's tomb of Ilaria del Carretto Guinigi with bust portrait | |
| | **1420s** Donor portraits in Master of Flémalle's *Merode Altarpiece* and Masaccio's *Trinity* | **1415** Battle of Agincourt |
| | Pisanello's portrait medals | |
| | **1425–52** Self-portrait by Ghiberti included on 'Gates of Paradise' bronze doors of Baptistery in Florence | **1431** Joan of Arc burned as a heretic |
| | **1434** Van Eyck's portrait of Giovanni Arnolfini and Giovanna Cenami | **1436** Alberti's *On Painting* includes discussion of perspective |
| | | **1437** Beginning of Habsburg rule of Holy Roman Empire |
| | **1443–53** Donatello's equestrian statue of Gattamelata for the Piazza del Santo in Padua | **1453** End of the Hundred Years War |

## Portraiture

| | |
|---|---|
| 1465–74 | Mantegna's frescoes with portraits of Gonzaga family for palace in Mantua |
| 1473 | Duke Galeazzo Maria Sforza collects portraits of beautiful women |
| 1479 | Verrocchio begins work on equestrian statue of Bartolomeo Colleoni for Campo di Santi Giovanni e Paolo, Venice |
| 1480–90 | Ghirlandaio includes portraits of Sassetti family in his frescoes for chapel at Santa Trinità, Florence |
| 1493 | First in series of three major self-portraits in oil by Dürer (others 1498, 1500) |
| 1496 | Gentile Bellini includes portraits in processional painting for Scuola Grande di San Giovanni Evangelista, Venice |
| 1503–6 | Leonardo da Vinci's *Mona Lisa* |
| 1511–12 | Raphael's portrait of Pope Julius II |
| 1520s | Paolo Giovio begins assembling collection of portraits of famous men for his villa at Como |
| 1524 | Parmigianino's *Self-portrait in a Convex Mirror* |
| | Gian Giorgio Trissino's poem 'I ritratti' ('Portraits') written for Isabella d'Este |
| | Akbar's Mughal court in India encouraged portraits |
| 1528 | Holbein's group portrait of Thomas More and his family |
| | Castiglione publishes *The Courtier* |
| 1532 | Holbein's portraits of the London Steelyard |
| 1534–41 | Michelangelo includes self-portrait in flayed skin held by St Bartholomew in Sistine Chapel *Last Judgement* |
| 1536 | Titian's *La Bella* |
| 1537 | Holbein's dynastic portrait of Henry VII and Henry VIII for Whitehall Palace |
| 1546 | Titian's portrait of Pope Paul III and his grandsons |
| 1548 | Titian's equestrian portrait of Emperor Charles V at Mühlberg |
| | Katharina van Hemessen's self-portrait |
| 1549 | Francisco de Holanda's *On Drawing from Nature* is written—includes substantial discussion of portraiture |
| 1550 | Giorgio Vasari's *Lives of the Artists* first published |
| 1563 | Queen Elizabeth's proclamation indicating that all images of her should be based on a perfect model |
| 1568 | Second, augmented, edition of Vasari's *Lives* |

## Events

| | |
|---|---|
| 1455 | Gutenberg bible printed with movable metal type |
| *c.*1465 | Antonello da Messina brings oil paint to Italy from Flanders |
| 1485 | Henry VII crowned first Tudor king of England after Battle at Bosworth Field ends Wars of the Roses |
| 1492 | Columbus's first voyage to San Salvador and Cuba |
| 1497 | Savonarola's bonfire of vanities in Florence |
| 1509 | Henry VIII crowned king of England |
| 1516 | Charles V becomes king of Spain |
| 1517 | Martin Luther posts 95 theses on door of castle church at Wittenberg |
| 1519 | Cortes arrives in Aztec lands |
| *c.*1520 | Paracelsus' 'doctrine of signatures' links macrocosm of world with microcosm of the human body |
| 1526–1761 | Mughal empire in India |
| 1527 | Francis I plans Fontainebleau palace |
| 1528 | Castiglione's *The Courtier* published |
| 1543 | Copernicus's discovery that the earth travels around the sun is published |
| 1545–63 | Council of Trent |
| 1558 | Elizabeth I crowned queen of England |
| 1558–62 | Benvenuto Cellini's *Autobiography* |
| 1564 | William Shakespeare born |

**1500**

**1550**

## Portraiture

| | |
|---|---|
| **1582** | Gabriele Paleotti's *Discourse on Sacred and Profane Images* published |
| **1584** | Lomazzo's *Trattato dell'arte* |
| **1598–1603** | Nicholas Hilliard writes *The Arte of Limning* |
| **1600s** | Mughal portraiture flourishes in India |
| **c.1600** | Annibale Carracci produces portrait caricatures |
| **1616–40s** | Frans Hals's civic guard portraits |
| **1622–5** | Rubens paints 24 narrative and allegorical scenes of the life of Marie de' Medici for the Palais du Luxembourg |
| **1623** | Martin Droeshout's engraved portrait of William Shakespeare appears in publication of Shakespeare's First Folio |
| **1628–69** | Rembrandt's self-portraits |
| **c.1630** | Artemisia Gentileschi's *Self-portrait as 'La Pittura'* |
| | Gianlorenzo Bernini's realistic bust of Scipione Borghese |
| **1630–7** | Philippe de Champagne and Simon Vouet produce series of 63 painted and sculpted portraits of French worthies for Cardinal Richelieu |
| **1632–4** | Anthony Van Dyck's portraits of King Charles I of England |
| **1637** | Franciscus Junius's *De pictura veterum*, an anthology of ancient writing on portraiture, is published |
| **1640** | Velázquez' portrait of the dwarf Calabacillas |
| **1642** | Rembrandt's *Company of Frans Banning Cocq* ('*The Night Watch*') |
| **1650** | Velázquez' portrait of Pope Innocent X |
| **1656** | Velázquez' *Las Meninas* |
| **1698** | Charles Le Brun's *A Method to Learn to Design the Passions* published |
| **1716–44** | Bartolomeo Rastrelli's equestrian statue of Peter I for St Petersburg |
| **1719** | Jonathan Richardson's *Two Discourses*, linking portraiture with history is published in England |
| **1720s** | Beginning of fashion for pastel portraits |
| **1730s–60s** | Popularity of conversation piece as type of group portraiture |
| **1734–5** | William Kent designs Temple of British Worthies at Stowe in England, including bust portraits by Michael Rysbrack and Peter Scheemakers |

**1600**
**1650**
**1700**

## Events

| | |
|---|---|
| **1581** | Catholic Philip II deposed in Protestant Low Countries |
| **1588** | Elizabeth I defeats Philip II of Spain's navy ('Spanish Armada') |
| | Republic of 'United Provinces' declared |
| **1607** | First British colony in America at Jamestown |
| **1620** | *Mayflower* takes pilgrims to America |
| **1623** | Shakespeare's First Folio published |
| **1637** | Descartes's *Discourse on Method* argues *cogito ergo sum* ('I think, therefore I am') |
| **1642** | Beginning of English Civil War |
| **1649** | King Charles I beheaded |
| **1651** | Hobbes's *Leviathan* |
| **1660** | Pepys begins his diary |
| **1666** | Great Fire of London |
| **1685** | Huguenots leave France because of persecution |
| **1687** | Newton's discovery of the laws of gravity |
| **1688** | Dutch king William of Orange (and Mary) on British throne |
| **1689** | Peter the Great, Tsar of Russia |
| **1690** | Locke's *Essay Concerning Human Understanding* |
| **1707** | England and Scotland united |
| **1713** | End of War of Spanish Succession |
| **1721** | Peter called Emperor of all Russia |
| | Bach's *Brandenburg Concertos* |
| **1737** | Last Medici duke in Florence |
| **1739–40** | Hume's *Treatise on Human Nature* |

## Portraiture

| | |
|---|---|
| 1740 | Kabuki actors represented on prints in Japan |
| | Hogarth's portrait of Captain Coram |
| 1742 | William Hogarth's *The Graham Children* |
| 1760 | James Granger's *Biographical History of England from Egbert the Great to the Revolution* |
| 1770s | Silhouette popular after invention by Étienne de Silhouette (1709–67) |
| | Charles Willson Peale's 'Gallery of Illustrious Personages' in Philadelphia |
| 1771 | Sir Joshua Reynolds's *Discourse IV*, with commentary on 'Grand Manner' portraiture |
| 1773 | Hester and Henry Thrale complete their new library at Streatham Place in London, and commission Joshua Reynolds to produce portraits |
| 1775–8 | Johann Caspar Lavater's *Physiognomische Fragmente* |
| 1777 | Messerschmidt begins producing his sculpted self-portrait busts in Austria |
| 1770s–80s | Elisabeth Vigée-Lebrun's portraits of Queen Marie-Antoinette |
| 1781 | Joseph Wright of Derby's portrait of Brooke Boothby |
| 1790s | Beginning of Persian Qajar dynasty, flourishing of portraiture |
| 1795 | Gilbert Stuart's 'Lansdowne portrait' of George Washington |
| 1800 | Goya's portrait of the family of Charles IV |
| 1806 | Ingres's portrait of Napoleon seated |
| 1818 | Thomas Lawrence commissioned to produce series of portraits of heroes for Waterloo Chamber at Windsor Castle |
| 1820s | Géricault's portraits of insane patients at the hospital of Bicêtre |
| 1854 | André-Adolphe-Eugène Disdéri takes out patent on *carte-de-visite* photographs |
| 1856 | Founding of English National Portrait Gallery, London |
| 1860s | Mathew Brady's photographs of soldiers in the American Civil War |
| 1860s–70s | Julia Margaret Cameron's photographic portraits of Tennyson, Carlyle, *et al.* |
| 1862–70 | Dante Gabriel Rossetti's portrait of Elizabeth Siddal, *Beata Beatrix* |

## Events

| | |
|---|---|
| 1755 | Winckelmann's *Reflections on Painting and Sculpture of the Greeks* |
| 1756 | Mozart born |
| | Beginning of Seven Years War |
| 1759 | Voltaire's *Candide* |
| 1760 | Laurence Sterne publishes *Tristram Shandy* |
| 1768 | Captain Cook sails for the Pacific |
| 1776 | American Declaration of Independence |
| 1782 | Jean-Jacques Rousseau's *Confessions* |
| 1788 | United States constitution |
| | First convicts sent to Australia |
| 1789 | Fall of Bastille in Paris |
| | Tennis Court Oath at Versailles |
| 1791 | Thomas Paine's *Rights of Man* |
| | James Boswell's *Life of Samuel Johnson* published |
| 1798 | Alois Senefelder discovers technique of lithography |
| 1799 | Napoleon makes himself First Consul |
| 1804 | Napoleon declares himself Emperor |
| 1806 | Abolition of Holy Roman Empire |
| 1814 | Spanish forces recapture Venezuela, Bogotá, Chile |
| 1815 | Napoleon defeated at Waterloo |
| 1818 | Mary Shelley's *Frankenstein* |
| 1819 | Byron's *Don Juan* |
| 1820s | Invention of photography |
| 1821 | Mexican independence |
| 1837 | Accession of Queen Victoria in England |
| 1848 | Marx and Engels publish *Communist Manifesto* in Paris |
| | Founding of the Pre-Raphaelite Brotherhood of artists in England |
| 1859 | Darwin's *Origin of Species by Means of Natural Selection* |
| 1860 | Garibaldi captures Sicily and Naples |
| 1860–5 | US Civil War |
| 1870–1 | Franco-Prussian War |

Left-margin decade markers: 1750, 1800, 1850

## Portraiture

**1871**  James McNeill Whistler's portrait of his
mother (*Arrangement in Grey and Black*)

**1880s**  Founding of Scottish National Portrait
Gallery, Edinburgh

**1885–90**  Vincent Van Gogh's self-portraits

**1891**  Auguste Rodin commissioned to
produce monument of Balzac by the
Société des gens des lettres

**1900**

**1900–18**  Gustav Klimt's society portraits

**1902**  Max Klinger's statue of Beethoven for
the Fourteenth Vienna Secession
exhibition

**1905**  Henri Matisse's portrait of his wife
(*Portrait of Madame Matisse with a
Green Stripe*)

**1905–6**  Pablo Picasso's portrait of Gertrude Stein

**1919**  Marcel Duchamp's *L.H.O.O.Q.* parody of
the *Mona Lisa*

**1920s**  August Sander's photographic series,
*People of the Twentieth Century*
Charles Demuth's 'poster portraits'

**1922**  Max Ernst's group portrait of Dada
artists—*Au Rendez-vous des amis*

**1925**  Beginnings of 'New Objectivity'
movement in Germany creates new
interest in portraits

**1930s–40s**  Frida Kahlo's self-portraits

**1946–7**  Jean Dubuffet's Art Brut portraits of
artists and writers (e.g. Artaud, Michaux)

**1948–9**  Francis Bacon's six portrait heads
inspired by Velázquez' *Pope Innocent X*

**1950**

**1954**  Houses of Parliament in London
commission Graham Sutherland to paint
portrait of Winston Churchill (later
destroyed by Churchill's wife)

**1960s**  Andy Warhol's silkscreen images of
Marilyn Monroe, Jackie Onassis, and
Elvis Presley

**1960s–80s**  Chuck Close's photorealist portraits

## Events

**1880**  Dostoevsky publishes *The Brothers
Karamazov*

**1880s**  Alphonse Bertillon's use of photographic
portraits in criminal investigation

**1885**  Invention of box camera

**1890**  Oscar Wilde's *Picture of Dorian Gray*

**1891**  George and Weedon Grossmith's *Diary of
a Nobody* first serialized in *Punch*
magazine

**1904**  Chekhov's *Cherry Orchard*

**1905**  Einstein's Special Theory of Relativity
Freud's *Three Essays on the Theory of
Sexuality* published

**1906**  Gandhi leads passive resistance in Natal

**1908**  Arnold Schoenberg invents atonal music

**1912**  Sinking of the *Titanic*
Scott reaches the South Pole

**1913**  Stravinsky's *Rite of Spring* causes a riot
in Paris

**1914**  Austrian Archduke Franz Ferdinand
assassinated in Sarajevo

**1914–15**  James Joyce's *Portrait of an Artist as a
Young Man* serialized

**1914–18**  First World War

**1917**  Russian Revolution

**1922**  USSR formed

**1923**  Massive inflation in Germany

**1924**  Charlie Chaplin's *Gold Rush*

**1930s**  Great Depression

**1933**  Hitler becomes German Chancellor
Gertrude Stein's *Autobiography of Alice
B. Toklas*

**1939**  *Gone with the Wind* and *The Wizard
of Oz*
Christopher Isherwood publishes
*Goodbye to Berlin*

**1939–45**  Second World War

**1947**  Partition of India

**1953**  Chemical structure of DNA discovered
by James Watson and Francis Crick

**1960**  Bridget Riley invents Op Art
Some African states (such as Ivory
Coast, French Congo, and Nigeria) win
independence

**1963**  US President John F. Kennedy
assassinated

**1965**  American troops arrive in Vietnam

## Portraiture

| | |
|---|---|
| **1968** | Founding of American National Portrait Gallery as part of Smithsonian Institution in Washington, DC |
| **1970s** | Robert Mapplethorpe's first photographic portraits |
| | Cindy Sherman's first 'film stills' including self-portrait |
| **1980s** | Jo Spence's 'phototherapy' self-portraits |
| **1985–present** | Yasumasa Morimura's self-portraits |
| **1995** | Tracey Emin's *Everyone I Have Ever Slept With, 1963–1995* |
| **1996** | Major travelling exhibition on 'Picasso and Portraiture', Museum of Modern Art, New York |
| **1998** | Founding of Australian National Portrait Gallery in Canberra |
| **2001** | Marc Quinn's DNA portrait of Sir John Sulston, commissioned for National Portrait Gallery, London |

## Events

| | |
|---|---|
| **1969** | Astronauts Neil Armstrong and Edwin Aldrin walk on the moon |
| **1972** | Watergate break-in tied to President Nixon's re-election campaign in United States |
| **1980s** | Advent of personal computers |
| **1981** | AIDS first diagnosed |
| **1988** | Lockerbie air disaster |
| **1989** | Berlin wall taken down |
| | Chinese students killed demonstrating for democracy in Tiananmen Square |
| **1991** | USSR becomes Commonwealth of Independent States |
| **1993** | Steven Spielberg's film *Schindler's List* |
| **1994** | Taliban formed in Kandahar, Afghanistan |
| **2001** | Terrorist attack on World Trade Center in New York |

**2000**

http://www.npg.org.uk
National Portrait Gallery, London; includes over 46,000 searchable works, many illustrated

http://www.npg.si.edu
National Portrait Gallery, Smithsonian Institution, Washington, DC, USA; includes online exhibitions as well as searches by artist and subject, many illustrated

http://www.portrait.gov.au/content/menu.htm
National Portrait Gallery of Australia, Canberra; includes search engines for collection, illustrations, and portrait of the month

http://www.natgalscot.ac.uk
Royal Scottish National Portrait Gallery, Edinburgh; basic site but moving towards online viewing of works in the collection

http://www.nga.gov/collection/gallery/gg53/gg53-main1.html
National Gallery of Art Online Tour of Eighteenth-century France: Chardin and Portraiture

http://www.nga.gov/education/american/portraiture/htm
National Gallery of Art Themes in America Art: Portraiture; good overview with cross-references for many images

http://www.vam.ac.uk/vastatic/microsites/photography/theme.php?themeid=th002
Victoria and Albert Museum Exploring Photography: Portraiture; includes a range of illustrations of photographic portraits with personal responses from historians, artists, and other well-known individuals

http://www.netkin.com/portraits/history/history1.php.3
Netkin Portrait Galleries; a very general but useful overview of the whole history of portraiture

http://www.bartleby.com/65/po/portrait.html
Columbia Online Encyclopedia, 6th edn, 2001; entry on portraiture

http://www.americanpresidents.org/gallery/index.asp
CSPAN American Presidents Life Portraits; includes illustrations of portraits of all American presidents, based on a 1999 television programme

http://www.artcyclopedia.com/subjects/portraits.htm/
Artcyclopedia: Artists Specializing in Portraits; chronological listing with illustrations

http://collections.ic.gc.ca/portraits/
Canadian Portraits/Portraits canadiens; portraits from the National Archives of Canada

www.powercat.de/portraits/
Frauen-portraits auf der Powercat; online exhibition of painted and photographed portraits of women

http://www.ibiblio.org/wm/paint/auth/gogh/portraits/
Webmuseum, Paris, Vincent Van Gogh Portraits

http://www.ibiblio.org/wm/paint/auth/renoir/portraits/
Webmuseum, Paris, Renoir: Portraits

http://portraits.fayoum.free.fr/
Portraits de Fayoum; examples with illustrations

http://www.kfki.hu/~arthp/html/t/tintoret/5portrai/
Web Gallery of Art: Portraits by Tintoretto; with brief commentary

http:www.ibiblio.org/wm/paint/auth/Rembrandt/self/
Webmuseum: Rembrandt's Self-portraits

http://www.cab.u-szeged.hu/wm/paint/auth/gogh/self
Webmuseum: Vincent Van Gogh's Self-portraits

http://www.portraits.gc.ca/
Portrait Gallery of Canada/Le Musée du portrait du Canada; update on the progress of the forthcoming Canadian Portrait Gallery in Ottawa

http://www.vangoghgallery.com/painting/main_se.htm
Vincent, the self-portraits

http://www.research.umbc.edu/~ivy/selfportrait/intro.html
University of Maryland Baltimore County research database; essay on the history of self-portraits

http://www.museumonline.at/1997/schulen/bg1-/english/schiele/htm
Gymnasium Etten Reichgasse; essay on Egon Schiele's self-portraits

http://www.newcastle.edu.au/discipline/fine-art/pubs/ernst/gombrich.html
Reprint of Ernst Gombrich's essay on caricature

http://perso.wanadoo.fr/caricaturnet/histoire.htm
'Histoire de la caricature'; history of caricature in French

http://www.artlex.com/ArtLex/p/portrait.-1700.html
Artlex Art Dictionary; section on portraits includes western and non-western portraits, with good links to other sites and illustrations

http://www.middleeastuk.com/culture/art/qajar
Sophie Kazan, 'Royal Persian Paintings: The Qajar Epoch 1785–1925'; overview of Qajar portraits

http://www.guardian.co.uk/arts/portrait/archive/0,11097,752942,00.html
Guardian Portrait of the Week; an unusual selection of portraits from all periods of history

# List of Illustrations

1. Hans Holbein the Younger: *George Gisze*, 1532. Oil on panel, 96.3 × 85.7 cm. Gemälde-galerie, Berlin/Bildarchiv Preussischer Kulturbesitz/photo Jörg P. Anders.

2. Pablo Picasso: *Portrait of Daniel-Henry Kahnweiler*, 1910. Oil on canvas, 101 × 73.3 cm. Gift of Mrs Gilbert W. Chapman in memory of Charles B. Goodspeed (acc. 1948.561). Art Institute of Chicago, IL. All rights reserved. © Succession Picasso/DACS 2004.

3. Anonymous: *'Isidora': Portrait of a Woman*, AD 100–110. Encaustic on wood, gilt, linen, 48 × 36 × 12.8 (entire assemblage). The J. Paul Getty Museum (acc. 81.AP.42), Malibu, CA © The J. Paul Getty Museum.

4. Anonymous: *Justinian I* (centre). San Vitale, Ravenna. Mosaic, c.546–8. Photo Alinari, Florence.

5. Anonymous: *Grebo Mask* from Liberia, date unknown. Wood, paint, vegetable fibres, 64 × 25.5 cm. Musée Picasso, Paris (1983.7)/© photo RMN/Beatrice Hatala.

6. Giuseppe Arcimboldo: *Fire*, 1566. Oil on panel, 66.5 × 51 cm. Kunsthistorisches Museum (GG.1585), Vienna.

7. Jan Van Eyck: *Madonna with Chancellor Rolin*, c.1433. Oil on panel, 66 × 62.2 cm. Musée du Louvre, Paris/© photo RMN/Hervé Lewandowski.

8. Rogier van der Weyden: *The Donor, Chancellor Rolin, Kneeling in Prayer*, from the reverse of the *Last Judgement Polyptych*, c.1445–50. Oil on panel. Hôtel Dieu, Beaune/photo Giraudon/Bridgeman Art Library, London.

9. Johann Zoffany: *Francis I*, c.1770s. Oil on canvas, 232 × 149 cm. Kunsthistorisches Museum (PG.6389), Vienna.

10. Anonymous: *Socrates*. Marble bust, c.200 BC–AD 100, height 27.5 cm. Trustees of the British Museum (1925, 11-18.1), London.

11. August Sander: *Rural Bride*, 1921–2. Photograph. © Die Photographische Sammlung/SK Stiftung Kultur—August Sander Archiv, Cologne/DACS 2004.

12. Oswald Birley: *Arabella Duval Huntington*, 1924. Oil on canvas, 127 × 101.6 cm. Courtesy of the Huntington Library Art Collections, and Botanical Gardens, San Marino, CA.

13. Pompeo Batoni: *George Gordon, Lord Haddo*, 1775. Oil on canvas, 259 × 170.2 cm. Haddo House, Grampian/photo The National Trust for Scotland.

14. Lorenzo Lotto: *Young Man before a White Curtain*, c.1505–8. Oil on panel, 42.3 × 35.3 cm. Kunsthistorisches Museum (GG.214), Vienna.

15. Johann Caspar Lavater: Silhouettes of clerics, from *Essays on Physiognomy*, 1792. The British Library, London (L.R.255.d.10; *Physiognomische Fragmente*, 1789–98, vol. 2, pt 1, p. 24).

16. Franz Xavier Messerschmidt: *An Intentional Buffoon*, after 1777. Marble bust, height 22 cm. Österreichische Galerie Belvedere (inv. 2284), Vienna.

17. Richard Gerstl: *Laughing Self-portrait*, 1908. Oil on panel, 40 × 30.5 cm. Österreichische Galerie Belvedere (inv. 4035), Vienna.

18. William Dickinson, after Henry Bunbury: *A Family Piece*, 1781. Stipple engraving, 24.6 × 36.4 cm. Trustees of the British Museum (P&D SAT.5921), London.

19. Lucian Freud: *Benefits Supervisor Resting*, 1994. Oil on canvas, 160.5 × 151 cm. Acquavella Contemporary Art, New York/courtesy the artist.

20. Diego Rodríguez de Silva y Velázquez: *Las Meninas*, 1656. Oil on canvas, 316 × 276 cm. Museo del Prado, Madrid/photo Giraudon/Bridgeman Art Library, London.

21. Stefano Gaetano Neri: *Room of Self-portraits in the Uffizi*, 1753–65. Engraving.

22. Philippe de Champagne: *Gaston de Foix*, 1630–7. Oil on canvas, 216 × 140 cm. Châteaux

de Versailles et de Trianon (inv. 3105)/© photo RMN/Arnaudet; J. Schormans.

23. James Sharples Sr: *James Madison*, c.1796–7. Pastel on paper, 22.9 × 17.8 cm. Independence National Historical Park, Philadelphia, PA.

24. Anonymous: 'Welcome!' Cartoon from *Punch*, 11 April 1896. Mary Evans Picture Library, London.

25. Lucas Cranach the Elder: *Dr Cuspinian and His Wife*, 1502–3. Oil on panel, 59 × 45 cm. Oskar Reinhart Collection, Winterthur/photo Artothek, Weilheim.

26. Anonymous, after an engraving by Simon Van de Passe: *Pocahontas*, after 1616. Oil on canvas, 76.8 × 64.1 cm. National Portrait Gallery, Smithsonian Institution (inv. 65.61), Washington DC/photo Art Resource, New York.

27. Anonymous: *Portrait of Abd el-Quahed ben Messaoud Anoun, Moorish Ambassador to the Court of Queen Elizabeth I*, 1600. Oil on panel, 114.5 × 79 cm. Shakespeare Institute, Stratford-on-Avon, on loan to the Barber Institute, Birmingham.

28. Jan Van Eyck: *Portrait of Giovanni Arnolfini and Giovanna Cenami ('The Arnolfini Marriage')*, 1434. Oil on wood, 81.8 × 59.7 cm. © National Gallery (NG.186), London.

29. Alphonse Bertillon: *François Bertillon*, 1902. Photograph. Prefecture de Police (Archives et Musée), Paris. Tous droits réservés.

30. Nicholas Hilliard: *Sir Walter Raleigh*, c.1585. Miniature on vellum, 4.8 × 4.1 cm. National Portrait Gallery (reg. 4106), London.

31. Jean-Étienne Liotard: *Portrait of Maria Frederike van Reede-Athlone at 7 Years of Age*, 1755–6. Pastel on vellum, 57.2 × 47 cm. The J. Paul Getty Museum (acc.83.PC.273), Los Angeles, CA. © The J. Paul Getty Museum.

32. Hans Holbein the Younger: *Anne of Cleves*, 1539. Oil on canvas, 64.8 × 48.3 cm. Musée du Louvre, Paris/© photo RMN/Hervé Lewandowski.

33. Anonymous: *Portrait of a Woman*, AD 190–220. Painted plaster coffin lid. Musée du Louvre/© photo RMN/Chuzeville.

34. John Souch: *Thomas Aston at the Deathbed of His Wife*, 1635. Oil on canvas, 203.2 × 215.1 cm. Manchester City Art Gallery/photo Bridgeman Art Library, London.

35. Edvard Munch: *Self-portrait with Skeleton Arm*, 1895. Lithograph, 46 × 32 cm. © Munch Museum/Munch-Ellingsen Group, BONO, Oslo, DACS 2004/photo Andersen de Jong.

36. Anonymous: *Constantine I*, c.AD 315–30. Marble, height 2.6 m. Palazzo dei Conservatori, Rome/photo Alinari, Florence.

37. Anonymous: Coin with the head of Alexander the Great from Pergamum, c.297 BC. Tetradrachma of Lycimachos. Diameter 32 mm. Trustees of The British Museum (Coins and Medals 1919-8-20-1), London.

38. Jean-Auguste-Dominique Ingres: *Napoleon I on His Imperial Throne*, 1806. Oil on canvas, 259 × 162 cm. Musée de l'Armée, Paris/photo Giraudon/Bridgeman Art Library, London.

39. Marcus Gheeraerts the Younger: *Elizabeth I* (the 'Ditchley portrait'), c.1592. Oil on panel, 241.3 × 152.4 cm. The National Portrait Gallery (reg. 2561), London.

40. Gilbert Stuart: *George Washington* (the 'Lansdowne portrait'), 1796. Oil on canvas, 97.5 × 62.5. National Portrait Gallery, Smithsonian Institution (NPG 68.19, acquired as a gift to the nation through the generosity of the Donald W. Reynolds Foundation), Washington DC/photo Art Resource, New York.

41. Bartolomeo Carlo Rastrelli: *Equestrian Statue of Peter I*, 1716–44. St Petersburg. Photo Paul Larsen, Lechlade.

42. Titian: *Emperor Charles V at Mühlberg*, 1548. Oil on canvas, 332 × 279 cm. Museo del Prado, Madrid/photo Bridgeman Art Library, London.

43. Andrea Mantegna: *Meeting between Ludovico and Francesco Gonzaga*. Fresco. Camera degli Sposi, Palazzo Ducale, Mantua, 1465–74. Photo Scala, Florence.

44. Elisabeth Vigée-Lebrun: *Portrait of Marie-Antoinette*, 1778–9. Oil on canvas, 273 × 193.5 cm. Kunsthistorisches Museum (PG.2772), Vienna.

45. John Singleton Copley: *Paul Revere*, c.1768. Oil on canvas, 89.2 × 72.4. Gift of Joseph W. Revere, William B. Revere, and Edward H. R. Revere (inv. 30.781), Museum of Fine Arts, Boston, MA.

46. Edgar Degas: *Place de la Concorde (Vicomte Lepic and His Daughters)*, 1875. Oil on canvas, 79 × 118 cm. State Hermitage Museum, St Petersburg/Novosti Photo Library, London.

47. Honoré Daumier: *Le Salon de 1857*, 1857. Lithograph. Bibliothèque Nationale (Estampes et Photographies), Paris.

48. Joshua Reynolds: *Dr Samuel Johnson*, 1772/1778. Oil on canvas, 75.5 × 58.4 cm. © Tate, London 2004.

49. Auguste Rodin: *Monument to Balzac*, completed in 1898. Boulevard Raspail, Paris. Mairie de Paris, Direction des Affaires Culturelles.

50. Max Klinger: *Beethoven*, 1902. Contemporary photograph of the installation of the Fourteenth Vienna Secession exhibition. Bildarchiv und Porträtsammlung, Österreichisches Nationalbibliothek, Vienna.

51. **Michele Gordigiani**: *Elizabeth Barrett Browning*, 1858. Oil on canvas, 73.7 × 58.4 cm. **National Portrait Gallery (reg. 1899), London.**

52. Jane Bown: *Samuel Beckett*, 1976. Bromide print, 33.5 × 49.3 cm. National Portrait Gallery, London/© Jane Bown.

53. Walter Richard Sickert: *Minnie Cunningham at the Old Bedford*, 1892. Oil on canvas, 76.5 × 63.8 cm. © Tate, London 2004.

54. Lev Bakst: *Portrait of Sergei Diaghilev with His Nanny*, 1904–6. Oil on canvas, 161 × 116 cm. State Russian Museum, St Petersburg/photo Bridgeman Art Library, London.

55. Andy Warhol: *No. 204: Marilyn Diptych*, 1962. Acrylic on canvas, 144.8 × 205.4 cm. © Tate, London 2004/© The Andy Warhol Foundation for the Visual Arts, Inc/ARS, NY and DACS, London 2004.

56. Diego Rodríguez de Silva y Velázquez: *Don Juan Calabazas, called Calabacillas*, 1640. Oil on canvas, 106 × 83 cm. Museo del Prado, Madrid/photo Bridgeman Art Library, London.

57. British School: *John Mellor's Black Coach Boy*, c.1730. Oil on canvas, 73 × 62.3 cm. Erddig House/The National Trust Photographic Library.

58. Jan Steen: *The Baker Arent Oostwaard and His Wife Catharina Keizerswaard*, 1658. Oil on panel, 38 × 32 cm. Rijksmuseum (inv. SK-A-390), Amsterdam.

59. Johann Zoffany: *John Cuff and His Assistant*, 1772. Oil on canvas, 89.5 × 69.2 cm. The Royal Collection © 2004, Her Majesty Queen Elizabeth II.

60. Titian: *Pope Paul III, Cardinal Alessandro Farnese, and Duke Ottavio Farnese*, 1546. Oil on canvas, 200 × 173 cm. Galleria Nazionale di Capodimonte, Naples/Bridgeman Art Library, London.

61. Hans Holbein the Younger: *Sir Thomas More and His Family*, 1528. Pen, brush, and ink over chalk, on paper, 38.9 × 52.4 cm. Kupferstichkabinett (inv. 1662.31), Öffentliche Kunstsammlung Basel/photo Öffentliche Kunstsammlung Basel.

62. Remigius van Leemput, after Hans Holbein the Younger: *Henry VII, Elizabeth of York, Henry VIII, and Jane Seymour* (the 'Whitehall portrait'), 1667. Oil on canvas, 88.9 × 98.7 cm. The Royal Collection © 2004, Her Majesty Queen Elizabeth II/photo Stephen Chapman.

63. Jacob Jordaens: *The Artist, His Wife Catharina, and Daughter Elizabeth*, c.1620–2. Oil on canvas, 181 × 187 cm. Museo del Prado, Madrid/Bridgeman Art Library, London.

64. Anonymous: *The Sargent Family*, 1800. Oil on canvas, 97.4 × 128 cm. Gift of Edgar William and Bernice Chrysler Garbisch (acc. 1953.5.49), National Gallery of Art, Washington, DC.

65. Edgar Degas: *The Bellelli Family*, c.1858–60. Oil on canvas, 200 × 250 cm. Musée d'Orsay, Paris (FR.2210)/© photo RMN.

66. Piero della Francesca: *Federico da Montefeltro and His Wife Battista Sforza*, c.1472. Tempera on panel, each 47 × 33 cm. © 2001 Galleria degli Uffizi, Florence/photo Scala, courtesy of the Ministero Beni e Attività Culturali.

67. Piero della Francesca: *The Triumphs of Federico da Montefeltro and Battista Sforza*, c.1472. Tempera on panel. © Galleria degli Uffizi, Florence/photo Scala, courtesy of the Ministero Beni e Attività Culturali.

68. Daniel Mijtens: *Thomas Howard, 2nd Earl of Arundel and Surrey*, c.1618. Oil on canvas, 207 × 127 cm. The National Portrait Gallery (reg. 5292), London.

69. Daniel Mijtens: *Alathea, Countess of Arundel and Surrey*, c.1618. Oil on canvas, 207 × 127 cm. National Portrait Gallery (reg. 5293), London.

70. Anthony Van Dyck: *Thomas Howard, 2nd Earl of Arundel, with His Grandson, Thomas, later 5th Duke of Norfolk*, 1635–6. Oil on canvas, 149.9 × 109.2 cm. Private collection/Philip Mould, Historical Portraits Ltd, London/photo Bridgeman Art Library.

71. William Hoare: *Christopher Anstey and His Daughter*, c.1779. Oil on canvas, 126 × 99.7 cm. The National Portrait Gallery (reg. 3084), London.

72. Gentile Bellini: *Procession in Piazza San Marco*, 1496. Tempera on canvas, 367 × 745 cm. Galleria dell'Accademia, Venice/photo Scala, courtesy of the Ministero Beni e Attività Culturali.

73. Frans Hals: *The Banquet of the Officers of the St George Militia of Haarlem*, 1616. Oil on canvas, 175 × 324 cm. Frans Hals Museum (inv. 123), Haarlem.

74. Rembrandt Harmenszoon van Rijn: *The Militia Company of Captain Frans Banning Cocq* ('*The Night Watch*'), 1642. Oil on canvas, 363 × 437 cm. Rijksmuseum, Amsterdam/photo Bridgeman Art Library, London.

75. Werner Jacobsz. Van den Valckert: *Three Governors and the Matron of the Amsterdam*

*Leperhouse*, 1624. Oil on panel, 134 × 192 cm. Rijksmuseum (inv. SK-C-419), Amsterdam.

76. Stuart Pearson Wright: *The Six Presidents of the British Academy*, 2001. Oil on linen, 191.5 × 171.5 cm. The British Academy, London/photo The National Portrait Gallery, London.

77. Henri Fantin-Latour: *Studio in the Batignolles*, 1870. Oil on canvas, 204 × 273.5 cm. Musée d'Orsay, Paris (RF.729)/photo © RMN/Hervé Lewandowski.

78. Johann Zoffany: *Academicians of the Royal Academy*, 1771–2. Oil on canvas, 100.6 × 147.3 cm. The Royal Collection © 2004, Her Majesty Queen Elizabeth II.

79. Jean-Frédéric Bazille: *The Studio in the rue La Condamine*, 1870. Oil on canvas, 98 × 128.5 cm. Musée d'Orsay, Paris (RF.2449)/photo © RMN/Hervé Lewandowski.

80. Max Ernst: *Au Rendez-vous des amis*, 1922. Oil on canvas, 130 × 195 cm. Museum Ludwig, Cologne/photo Rheinisches Bildarchiv. © ADAGP, Paris and DACS, London 2004.

81. William Hogarth: *The Graham Children*, 1742. Oil on canvas, 160.5 × 181 cm. © The National Gallery (NG.4756), London.

82. Diego Rodríguez de Silva y Velázquez: *Infanta Margarita in a Blue Dress*, 1659. Oil on canvas, 127 × 107.3 cm. Kunthistorisches Museum (GG.2130), Vienna.

83. Gerrit Dou: *Prince Rupert of the Palatinate and His Tutor in Historical Dress*, c.1631. Oil on canvas, 102.9 × 88.3 cm. The J. Paul Getty Museum (acc.84.PA.570), Los Angeles, CA. © The J. Paul Getty Museum.

84. Fernand Khnopff: *Jeanne Kefer*, 1885. Oil on canvas, 80 × 80 cm. The J. Paul Getty Museum (acc.97.PA.35), Los Angeles. © The J. Paul Getty Museum.

85. Sandro Botticelli: *Portrait of a Young Man with a Medal of Cosimo de' Medici*, c.1465. Tempera on panel, 57.5 × 44 cm. Galleria degli Uffizi, Florence/photo Bridgeman Art Library, London.

86. Jan Van Eyck: *Cardinal Niccolò Albergati*, c.1432. Oil on panel, 34.1 × 29.3 cm. Kunsthistorisches Museum (GG.975), Vienna.

87. Alice Neel: *Self-portrait*, 1980. Oil on canvas, 139 × 100.6 cm. © National Portrait Gallery, Smithsonian Institution, Washington DC/photo Art Resource, New York.

88. Sofonisba Anguissola: *Self-portrait*, c.1610. Oil on canvas, 96.5 × 76. Kunsthaus Zurich. Gottfried Keller Foundation. © 2004 Kunsthaus Zurich.

89. Helene Schjerfbeck: *Self-portrait with Red Spot*, 1944. Oil on canvas, 44 × 37 cm. Ateneum Art Museum, Helsinki/photo Central Art Archives. Courtesy Carl Appelberg.

90. Agnolo Bronzino: *Cosimo I de' Medici*, c.1538–40. Oil on canvas, 93.7 × 76.2 cm. Gift of Mrs John Wintersteen (acc. 1950.86.1), Philadelphia Museum of Art/photo Graydon Wood, 1994.

91. Lotte Laserstein: *Self-portrait with Cat*, 1928. Oil on canvas, 61 × 51 cm. New Walk Museum, Leicester City Museums Service/photo Bridgeman Art Library, London.

92. Otto Dix: *Portrait of the Journalist Sylvia von Harden*, 1926. Oil and tempera on wood, 121 × 89 cm. Centre Pompidou-MNAM-CCI, Paris (AM.3899.P)/© CNAC/MNAM/RMN. © DACS 2004.

93. Domenico Ghirlandaio: *Giovanna Tornabuoni*, 1488. Mixed media on panel, 77 × 49 cm. © Museo Thyssen-Bornemisza, Madrid.

94. Titian: *La Bella*, c.1536. Oil on canvas, 89 × 75.5 cm. Galleria Palatina, Palazzo Pitti, Florence/photo Scala, courtesy of the Ministero Beni e Attività Culturali.

95. Joshua Reynolds: *Mrs Hale as Euphrosyne*, 1766. Oil on canvas, 236 × 146 cm. © Earl and Countess of Harewood and the Trustees of the Harewood House Trust.

96. Dante Gabriel Rossetti: *Beata Beatrix*, c.1862–70. Oil on canvas, 86.4 × 66 cm. © Tate, London 2004.

97. Artemisia Gentileschi: *Self-portrait as 'La Pittura'*, c.1630. Oil on canvas, 96.5 × 73.7 cm. The Royal Collection © 2004, Her Majesty Queen Elizabeth II.

98. Elisabeth Vigée-Lebrun: *Self-portrait in a Straw Hat*, after 1782. Oil on canvas, 97.8 × 70.5. © The National Gallery (NG.1653), London.

99. Julia Margaret Cameron: *The Mountain Nymph Sweet Liberty (Cyllene Wilson)*, 1866. National Museum of Photography, Film and Television, Bradford/photo Science and Society Picture Library, London.

100. Joseph Wright of Derby: *Brooke Boothby*, 1781. Oil on canvas, 148.6 × 207.6 cm. © Tate, London, 2004.

101. Robert Mapplethorpe: *Self-portrait*, 1980. Gelatin silver print, 50.8 × 40.6 cm. Copyright © The Estate of Robert Mapplethorpe. Used by permission.

102. Parmigianino: *Self-portrait in a Convex Mirror*, 1524. Oil on panel, 24.4 × 24.4 cm. Kunsthistorisches Museum (GG.286), Vienna.

103. Renée Sintenis: *Nude Self-portrait*, 1917. Pencil, 26.8 × 20 cm. Städtische Kunsthalle, Mannheim/photo Margita Wickenhäuser/© DACS 2004.

104. Albrecht Dürer: *Self-portrait*, 1500. Oil on linden panel, 67 × 49 cm. Alte Pinakothek, Munich/photo Artothek, Weilheim.

105. Alfredo Dino Pedriali: *Self-portrait with Camera*, 1979. © DACS 2004.

106. Laura Knight: *Self-portrait*, 1913. Oil on canvas, 152.4 × 127.6. The National Portrait Gallery, London. Reproduced with permission of Curtis Brown Group Ltd, London, on behalf of the Estate of Dame Laura Knight. © Dame Laura Knight.

107. Katharina van Hemessen: *Self-portrait*, 1548. Tempera on oak panel, 31 × 25 cm. Kunstmuseum (inv. 1361), Öffentliche Kunstsammlung, Basel/photo Öffentliche Kunstsammlung, Basel.

108. Rembrandt Harmenszoon van Rijn: *Self-portrait in a Cap, Open-mouthed*, c.1630. Etching. Rijksmuseum (RP-P-OB-697), Amsterdam.

109. Rembrandt Harmenszoon van Rijn: *Self-portrait as the Laughing Philosopher*, c.1669. Oil on canvas, 82.5 × 65 cm. Wallraf-Richartz Museum, Cologne/photo Bridgeman Art Library, London.

110. Max Beckmann: *Self-portrait in Tuxedo*, 1927. Oil on canvas 139.5 × 95.5 cm. Courtesy of the Busch-Reisinger Museum, Harvard University Art Museums, Association Fund (acc. BR41.37)/photo Rick Stafford © President and Fellows of Harvard College/© DACS 2004.

111. Ernst Ludwig Kirchner: *Self-portrait as a Soldier*, 1915. Oil on canvas 69.2 × 61 cm. Charles F. Olney Fund (acc. 1950.50.29), Allen Memorial Art Museum, Oberlin College, Ohio/photo John Seyfried/© by Dr Wolfgang and Ingeborg Henze-Ketterer, Wichtrach/Bern.

112. David Hockney: *The Student: Homage to Picasso*, 1973. Etching, 68.6 × 53.3 cm. © David Hockney.

113. Vincent Van Gogh: *Self-portrait Dedicated to Paul Gauguin*, 1888. Oil on canvas, 59.5 × 48.3 cm. Bequest from the Collection of Maurice Wertheim, Class 1906, Fogg Art Museum, Cambridge, MA/photo Bridgeman Art Library, London.

114. Egon Schiele: *Self-portrait Nude Facing Front*, 1910. Pencil, charcoal, body colour, and gouache, 55.8 × 36.9 cm. Graphische Sammlung Albertina (inv. 30.766), Vienna.

115. Frida Kahlo: *Broken Column*, 1944. Oil on masonite, 39.8 × 30.5 cm. Museo Dolores Olmedo Patiño, Xochimilco, Mexico/courtesy the Trust of Diego Rivera and Frida Kahlo.

116. André-Adolphe-Eugène Disdéri: *Self-portrait*, c.1860. Daguerreotype. Bibliothèque Nationale (Estampes et Photographies, EO.19b.PET FOL), Paris.

117. John Singer Sargent: *Daughters of Edward Darley Boit*, 1882. Oil on canvas, 221.9 × 222.6 cm. Gift of Mary Louisa Boit, Julia Overing Boit, Jane Hubbard Boit, and Florence D. Boit in memory of their father Edward Darley Boit (acc. 19.124), Museum of Fine Arts, Boston.

118. Gustav Klimt: *Adele Bloch-Bauer I*, 1907. Oil, silver and gold leaf on canvas, 140 × 140 cm. Österreichische Galerie Belvedere, Vienna.

119. Pablo Picasso: *Gertrude Stein*, 1905–6. Oil on canvas, 100.3 × 81.28 cm. Bequest of Gertrude Stein, 1946 (acc. 47.106). Metropolitan Museum of Art, New York/© Succession Picasso/DACS 2004.

120. Henri Matisse: *Portrait of Madame Matisse with a Green Stripe*, 1905. Oil on canvas, 40.5 × 32.5 cm. Statens Museum for Kunst (KMSR.171), Copenhagen/DOWIC Photographs/© Succession H. Matisse/DACS 2004.

121. James McNeill Whistler: *Arrangement in Grey and Black: Portrait of the Painter's Mother*, 1871. Oil on canvas, 144.3 × 162.5 cm. Musée d'Orsay (RF.699), Paris/photo © RMN/J. G. Berizzi.

122. Alberto Giacometti: *Portrait of Annette*, 1964. Oil on canvas, 70 × 50 cm. Alberto Giacometti Foundation (GS.76), Kunsthaus, Zurich/© ADAGP, Paris and DACS, London 2004.

123. Frances Hodgkins: *Self-portrait: Still Life*, 1941. Oil on cardboard, 76.2 × 63.5 cm. Auckland Art Gallery Toi o Tamaki (acc. 1963/11/2), courtesy Kay, Simon, and Jane Brown.

124. Charles Demuth: *I Saw the Figure 5 in Gold: Portrait of William Carlos Williams*, 1929. Oil on composition board, 91.4 × 75.6 cm. Alfred Stieglitz Collection, 1949 (acc. 49.59.1), The Metropolitan Museum of Art, New York.

125. Gabriele Münter: *Listening (Portrait of Jawlensky)*, 1909. Oil on canvas, 49.7 × 66.2 cm. Städtische Galerie, Munich/photo Artothek, Weilheim/© DACS 2004.

126. Stanley Spencer: *Portrait of Patricia Preece*, 1933. Oil on canvas, 83.9 × 73.6 cm. © City Art Gallery, Southampton/photo Bridgeman Art Gallery, London.

127. Francis Bacon: *Three Studies of George Dyer*, 1969. Oil on canvas, each panel 36 × 30 cm. Louisiana Museum of Modern Art, Humlebaek/© Estate of Francis Bacon 2004. All rights reserved DACS.

128. Marcel Duchamp: Replica of *L.H.O.O.Q.* from *Boîte-en-Valise*, 1919. Collotype, hand coloured with watercolour. The Louise and Walter Arensberg Collection (acc. 1950-134-934), Philadelphia Museum of Art/photo Lynn Rosenthal, 1998/© Succession Marcel Duchamp/ADAGP, Paris and DACS, London 2004.

129. Cindy Sherman: *Untitled #216.* Colour photograph, 170 × 142.2 cm. Courtesy the artist and Metro Pictures, New York.

130. Rabindra K. D. Kaur Singh: *From Zero to Hero* (from the 'SPOrTLIGHT' series), 2002. Poster colour and gouache on conservation board, 66 × 80 cm. The Singh Twins Collection.

131. Yasumasa Morimura: *Portrait (Futago)*, 1988. Colour photograph, 209.5 × 299.7 cm. Courtesy of the artist and Luhring Augustine Gallery, New York.

132. Tracey Emin: *Everyone I Have Ever Slept With 1963–1995*, 1995. Appliquéd tent, mattress, and light, 122 × 245 × 215 cm. Courtesy The Saatchi Gallery/© the artist/Jay Jopling/White Cube (London)/photo Stephen White.

133. Jenny Saville: *Branded*, 1992. Oil on canvas, 213 × 183 cm. Courtesy The Saatchi Gallery, London, and the artist.

134. Orlan: *The Face of the Twentieth Century*, 1990. Photo Sipa Press/Rex Features, London, courtesy the artist.

135. Chuck Close: *Fanny (Fingerpainting)*, 1985. Oil on canvas, 259.1 × 213.4 × 6.4 cm. Gift of Lila Acheson Wallace (acc. 1987.21), National Gallery of Art, Washington DC/© Chuck Close.

136. Bruce Nauman: *Studies for Holograms*, 1970. Screenprints, each 66.5 × 66.5 cm. Cabinet des Estampes (E.77/85–89), Geneva/© ARS, New York and DACS, London 2004.

137. Jo Spence: 'Included', from *Narratives of (Dis)ease*, 1989. Courtesy the Jo Spence Memorial Archive, London.

138. Arnulf Rainer: *Self-portrait*, 1972–3. Oil crayon on photograph, 50 × 60 cm. © Arnulf Rainer/photo Franz Schachinger/Galerie Ulysses, Vienna.

The publisher and author apologize for any errors and omissions in the above list. If contacted they will be pleased to rectify these at the earliest opportunity.

# Index

Abd el-Quahed ben
    Messaoud Anoun,
    portrait of 55
Académie Royale *see* Royal
    Academy, France
Accademia del Disegno,
    Florence 155
Actionist movement 219
Aeschylus 26
aesthetic emotion 187–8
Africa 17, 19
age 11, 131–42, 205
AIDS 161
Albergati, Cardinal Niccolò
    139, 140
Albert, Prince 81
Alberti, Leon Battista 78
Alexander the Great 14, 41,
    67–8, 72
    coin with head of 68
Alexandria 44
allegory 148–9, 157–8
altarpiece 23, 24, 25, 113, 207
Altissimo, Crisofano dell' 45
America *see* North America;
    South America
Amsterdam 174
androgyny 159, 211
Anguissola, Sofonisba 142,
    164, 172
    *Self-portrait* 142
Anne of Cleves 60
Anstey, Christopher 117–18
    *The New Bath Guide* 117
antique 31
Antonello da Messina 32
Antwerp 157
Apelles 41
Arcimboldo, Giuseppe 21, 31–2
    *Fire* 21, 31–2
Aretino, Pietro 50, 59, 152
Aristotle 14, 32
Arles 61, 180
Arnolfini, Giovanni 57
*Arte of Limning, The see*
    Hilliard, Nicholas

Arundel, 2nd Earl of *see*
    Howard, Thomas, 2nd
    Earl of Arundel and
    Surrey
Aubrey, John 52
    *Brief Lives* 52
Austria 26, 34, 35, 48, 182, 183,
    202
autobiography 17, 164, 178–80,
    185
Autun Cathedral 23
avant-garde 12, 13, 38, 124, 188,
    194, 198, 201–3

Bacon, Francis 202–3
    *Three Studies of George Dyer*
    202–3; Velázquez' *Pope*
    *Innocent X* 203
Baghdad 69
Bakst, Lev 95, 96
    *Portrait of Sergei Diaghilev*
    *with His Nanny* 95, 96
Ballets Russes 95
Balzac, Honore de 89, 90, 91
banknotes 13, 43, 68
Baretti, Giuseppe 88
Barthes, Roland 59
    *Camera Lucida* 59
Bath 117
Batoni, Pompeo 30–1, 40
    *George Gordon, Lord Haddo*
    30–1
Bazille, Jean-Frédéric 125, 129
    *Studio in the rue La*
    *Condamine* 125, 129
Beaune 23, 24
beauties 152
Beckett, Samuel 92–3
Beckham, Brooklyn 209, 210
Beckham, David 209, 210
Beckham, Victoria 209, 210
Beckmann, Max 176, 202
    *Self-portrait in Tuxedo* 176
Beethoven, Ludwig van 89, 91
Belgium 135
Bell, Clive 187–8

Bellini, Gentile 119
    *Procession in Piazza San*
    *Marco* 119
Bellini, Giovanni 50
Bembo, Pietro 50, 59
Berber, Anita 147
Berend, Charlotte 169
Berenson, Bernard 24
Berlin 27
Bernard, Émile 180
Bernhardt, Sarah 190
Bernini, Gianlorenzo 155
    *The Ecstasy of St Theresa* 155
Bertillon, Alphonse 58
    *François Bertillon* 58
Billeter, Erika 182
*Biographical History of*
    *England from Egbert the*
    *Great to the Revolution, A*
    *see* Granger, James
biography 17, 50–2, 178
Birley, Oswald 28, 29
    portrait of Arabella Duval
    Huntington 28, 29
Blanche, Jacques-Émile 191
Blaue Reiter 200
Blue Rider *see* Blaue Reiter
Böcklin, Arnold 45
body 29–37, 213–19, 220
Boldini, Giovanni 191
Bonaparte, Napoleon *see*
    Napoleon Bonaparte
Boothby, Brooke 159–60
Boston 111
Botticelli, Sandro 137–8, 215
    *Portrait of a Young Man with*
    *a Medal of Cosimo de'*
    *Medici* 137–8
bourgeoisie *see* middle classes
Bown, Jane 92–3
    *Samuel Beckett* 92–3
Breckenridge, James 63–4
Bridge, The *see* Brücke, Die
Brilliant, Richard 44, 210
Britain *see* Great Britain 110
British Academy 121–2

Bronzino, Agnolo 16, 145, 159, 161
  *Cosimo I de' Medici* 145, 159, 161
Browning, Elizabeth Barrett 91–2
Browning, Robert 91, 92
Brücke, Die 177
Brussels 136
Bunbury, Henry 38
Burney, Charles 88
busts *see* portrait sculpture
Byzantine 73

cabinets of curiosities 47
Cambridge 99
Camera degli Sposi *see* Mantegna, Andrea
*Camera Lucida see* Barthes, Roland
Cameron, Julia Margaret 157, 158
  *The Mountain Nymph Sweet Liberty (Cyllene Wilson)* 158
Campaspe 41
Caravaggio 169, 208
  *Bacchus* 208
cardinal virtues 114
caricature 35, 36, 85, 147, 200
*Caricature, La* 85
Carline, Hilda 200
Carlyle, Thomas 157
Carracci, Annibale 35–6
*carte-de-visite* 158, 189, 190
Castagno, Andrea 44
  series of famous men 44
Castiglione, Baldassare 25, 34, 50, 173
  *The Courtier* 25, 34, 173
Catholic 16, 68, 106, 179, 208
celebrity 93–7
Cellini, Benvenuto 179
  autobiography 179
Cenami, Giovanna 57
Chadwick, Rev. Prof. Owen 122
Champagne, Philippe de 46
  *Gaston de Foix* 46
character 17, 21, 31, 32, 37, 52
Charcot, Jean-Martin 182
Charles I 67, 114, 116
Charles V, Emperor 77, 106, 168
Charlotte, Queen 68, 79, 100
Cheshire 64
Chester 64
chiaroscuro 164, 169, 174
childhood 131–6

children 116–18
China 17, 63
Churchill, Winston 29
Cicero 14
Circe 157
civic portraits 118–23
Clement VII, Pope 165, 166
Close, Chuck 140, 215, 216
  *Fanny (Fingerpainting)* 216
Cobham, Viscount 87
coins 13, 14, 43, 57, 68, 77–8, 113, 150
Collioure 195
Cologne 129
commemoration 62–5
Como 44, 45, 152
conduct manuals 34
confraternities 118–19
Connecticut 48
Constantine 66, 67
  colossal head of 66, 67
conversation pieces 111
copies 67
Copley, John Singleton 82–3
  *Paul Revere* 82–3
Corinth, Lovis 169
costume 118
Council of Trent 16, 106
Cranach, Lucas 51, 202
  *Dr Johannes Cuspinian and His Wife* 51, 52, 53
Cubism 12, 13, 194, 199

da Vinci, Leonardo *see* Leonardo da Vinci
Dada 129, 206
Daguerre, Louis-Jacques-Mandé 189
Dante 153, 154
  *La Vita nuova* ('The New Life') 154, 155
Daumier, Honoré 85
  *Le Salon de 1857* 85
David, Jacques-Louis 45, 71
de Chirico, Giorgio 202
de Man, Paul 178, 180
  'Autobiography as De-facement' 178
death 62–5
death masks 21
Declaration of Independence 46
Degas, Edgar 16, 22, 84, 94, 111–12
  *The Bellelli Family* 111–12
  *Place de la Concorde (Vicomte Lepic and His Daughters)* 84

Deleuze, Gilles 17, 208, 217–18
della Porta, Giacomo 32
Democritus 174
Demosthenes 27
Demuth, Charles 199
  *I Saw the Figure 5 in Gold: Portrait of William Carlos Williams* 199
  poster portraits 199
Denmark 152
deportment 31, 34, 37
Deverell, Walter 153
Diaghilev, Sergei 95, 96
Diana, Princess of Wales 210
Dickinson, William 38
  *A Family Piece* 38
Dionysus 72
diptych 61, 113
*Discorso intorno alle immagini sacre e profane see* Paleotti, Gabriele
Disdéri, André-Adolphe-Eugène 190
  *Self-portrait* 190
Divine Right of Kings 72, 81
Dix, Otto 146–8, 176, 201–2
  portrait of Alfred Flechtheim 147
  portrait of Hugo Erfurth 202
  *Portrait of the Journalist Sylvia von Harden* 146–8, 202
DNA 58–9
document 53–9
*doelenstuk* 119, 121
Domenichino 45
Donatello 76
  equestrian statue of Gattamelata 76
Dou, Gerrit 134–5
  *Prince Rupert of the Palatinate and His Tutor in Historical Dress* 134–5
Dover, Sir Kenneth 122
drawings 13, 43, 167, 183
Dreier, Katherine 200–1
Dubuffet, Jean 200
Duchamp, Marcel 200–1, 206–7, 210
  *L.H.O.O.Q.* 206–7
  photographed by Man Ray as Rrose Sélavy 206
Dürer, Albrecht 58, 77, 164, 166–8, 171, 173
  *Knight, Death and Devil* 77
  *Self-portrait* of 1500 168
  self-portraits 166–8

Duret, Théodore 82
Dyer, George 202

Eakins, Thomas 16
École des Beaux-Arts, Paris
    125
Edholm, Felicity 148
Edward VI 109
ego 182
Egypt 14, 15, 63, 107, 132
Eisenhower, Dwight D. 29
Elizabeth I 55, 60, 73, 74, 75, 76,
    97, 138
    'Ditchley portrait' of 74, 75
    proclamation of 1563 73
Elizabeth of Bohemia 135
Elizabeth of York 109
Éluard, Paul 129, 207
Emin, Tracey 212–13, 214
    Everyone I Have Ever Slept
        With 1963–1995 212–13
encaustic 63
England 13, 19, 25, 28, 36, 40,
    58, 60, 68, 73, 81, 87, 114,
    133, 152, 153, 158, 189, 190,
    191, 199
engraving 11, 13
Enlightenment 33
equestrian monuments see
    portrait sculpture
Erasmus 61, 108
Erddig House, Wales 99
Ernst, Max 129
    Au Rendez-vous des amis 129
Este, Isabella d' 24, 150
etching 164
ethnicity 205, 210–13, 220
Eton College 61
Eucharist 25
Euripides 26, 27
Euterpe 148
expression 34, 37
Expressionism 34, 146, 164,
    176, 182, 200
Eyck, Jan Van 22, 23, 57, 163
    Portrait of Giovanni
        Arnolfini and Giovanna
        Cenami 57, 163
    Madonna with Canon van
        der Paele 163
    Madonna with Chancellor
        Rolin 22, 23

faciality 17, 208, 217–18
family portraits 107–18
fans 43
Fantin-Latour, Henri 125, 129
    Studio in the Batignolles 125

Farnese, Cardinal Alessandro
    106, 107
Farnese, Duke Ottavio 106, 107
Fayum portraits 14, 15, 63, 132
Federico da Montefeltro see
    Montefeltro, Federico da
femmes fatales 193
Ferdinand I of Vienna 21, 45
Finland 142–3
First World War 29, 176, 199
Flanders 16, 19, 22, 25, 110–11,
    163
Fleet Street, London 102
Florence 26, 45, 79, 92, 112, 149,
    155, 163, 165
Foix, Gaston de 46
Fontana, Giovanni Battista 21
Fox Talbot, Henry 189
Fragments on Physiognomy see
    Lavater, Johann Caspar
France 22, 25, 36, 40, 60, 81, 85,
    94, 95, 152, 180, 182, 189,
    190, 191, 195
Francesca, Piero della see Piero
    della Francesca
Francia, Francesco 24
Francis I of Austria 25, 26, 35
Francisco de Holanda 16
Frederick III, Elector of
    Saxony 52
Frederick V, Elector Palatine
    135
Freud, Lucian 38–9, 202, 213
    Benefits Supervisor Resting
        38–9
Freud, Sigmund 182, 184, 185
Fuseli, Henry 86

Gadamer, Hans-Georg 44
Gage, John 191
Gainsborough, Thomas 50,
    117, 159
'Gallery of Illustrious
    Personages' see Peale,
    Charles Willson
Garrard, Mary 157
'Gates of Paradise' see
    Ghiberti, Lorenzo
Gauguin, Paul 61, 180
gaze 41
gender 11, 29, 118, 141–3,
    146–61, 165–73, 205, 208,
    210–13, 220
genius 87–93, 173
genre painting 84
Gentileschi, Artemisia 155, 157
    Self-portrait as 'La Pittura'
        155, 157

George III 68, 79, 100, 192, 125,
    133
George, St 163
Géricault, Théodore 102
    portraits of insane in
        Bicêtre asylum 102
German states see Germany
Germany 19, 27, 28, 35, 36, 45,
    51, 89, 146, 147, 148, 152,
    168, 169, 171, 176, 191, 200
Gerstl, Richard 34, 36
    Laughing Self-portrait 36
gesture 34, 37, 102
Gheeraerts the Younger,
    Marcus 75
    Elizabeth I (the 'Ditchley
        portrait') 75
Ghiberti, Lorenzo 163, 179
    comentarii 179
    'Gates of Paradise' 163
    self-portraits on Baptistery
        doors in Florence 163
Ghirlandaio, Domenico 28,
    79, 149–50
    frescoes of the life of
        St Francis in Sassetti
        Chapel 79
    Giovanna Tornabuoni
        149–50
Giacometti, Alberto 196, 197,
    198
    portraits of Annette 196, 197
    portraits of Yanaïhara 196
gift 59–62
Gilbert and George 205
Giorgione 137, 143, 150
Giovio, Paolo, Bishop of
    Nocera 44–5, 55, 152
    collection of portraits of
        famous men 44–5
Gisze, George 9–11, 16
    see also Holbein the
        Younger, Hans
globalization 219–20
Goebbels, Joseph 68
Goffman, Erving 30
Gonzaga, Eleanora 152
Gonzaga family 78, 79
Gordigiani, Michele 91–2, 93
    Elizabeth Barrett Browning
        91–2, 93
Gospels 31
Grand Manner 88, 153
Grand Tour 30, 31
Granger, James 50
    Biographical History of Eng-
        land from Egbert the Great
        to the Revolution, A 50

Great Britain 94, 110, 111, 159, 187
Grebo 19
  *Grebo mask* 19
Greece 14, 15, 25, 26, 27, 41, 63, 68, 77
Greenblatt, Stephen 17
group portraiture 105–29
Guattari, Félix 208, 217–18
guilds 118

Haarlem 120
Habsburg family 26
Hague, The 114
hair portraits 13
Hals, Frans 119–20, 122, 192
  *The Banquet of the Officers of the St George Militia of Haarlem* 120
Hampton Court 152
Han dynasty 17
Hanseatic League 9
Harden, Sylvia von 146, 147
Hart, Emma, Lady Hamilton 41
Hartford 48
Hebe 148
Heffernan, Joanna 196
Helsinki 143
Hemessen, Katharina van 171, 172
  *Self-portrait* 171, 172
Henry VII 109
Henry VIII 9, 60, 73, 75, 109
Hercules 72
Hilliard, Nicholas 16, 60
  *The Arte of Limning* 16, 60
  *Sir Walter Raleigh* 60
Hitchcock, Alfred 207
Hitler, Adolf 68
Hoare, William 117–18
  *Christopher Anstey and His Daughter* 117–18
Hockney, David 179, 180
  *The Student: Homage to Picasso* 179, 180
Hodgkins, Frances 198, 199
  *Self-portrait: Still Life* 199
Hogarth, William 65, 132–3
  *The Cholmondeley Family* 65
  *The Graham Children* 65, 132–3
  *A Rake's Progress* 133
Holanda, Francisco de *see* Francisco de Holanda
Holbein the Younger, Hans 9–11, 16, 60, 62, 66–7, 82, 83, 108–9, 202

*Anne of Cleves* 62
*George Gisze* 9–11, 16
portraits of Henry VIII 66–7
*Sir Thomas More and His Family* 108–9
Whitehall portrait of Tudors 108, 109, 111
Holland 19, 94
Hollywood 207
Horace 14
House of Lords 48
Howard, Thomas, 2nd Earl of Arundel and Surrey 114–15, 116
human genome project 59
humours 51
Hunter, William 124
Huntington, Arabella Duval 28, 29
Hussein, Saddam 69
  statue of in Baghdad 69

Iberian sculpture 194
icon 81, 209
id 182
identity 29, 32, 105, 106, 165, 172, 185, 205–20
*imprese* 51
Impressionism 95, 125, 129, 164, 192, 200
India 17
Indian miniature painting 209, 210
Industrial Revolution 187
Ingres, Jean-Auguste-Dominique 71, 208
  *Napoleon I on His Imperial Throne* 71
  *Odalisque* 208
Innsbruck 48
institutional portraits 118–23
Iraq 69
Irving, Henry 190
*'Isidora': Portrait of a Woman* 15
Isherwood, Christopher 27
Islam 17
Istanbul 61
Italy 14, 16, 19, 37, 44, 59, 71, 76, 78, 137, 139, 142, 148, 150, 152, 159, 165, 167, 172, 187, 191
itinerant artists 100, 111

James I 114
Jane Seymour 109
Japan 211
Jawlensky, Alexei 200

Jenkins, Marianna 72
Jericho 14, 219
Johnson, Dr Samuel 88
Jordaens, Jacob 110–11
  *The Artist, His Wife Catharina, and Daughter Elizabeth* 110
Judith 193
Juno 148
Justinian 14, 194
Justus of Ghent 44
  series of famous men 44

Kahlo, Frida 164, 184, 185
  *Broken Column* 184, 185
Kahnweiler, Daniel-Henry 12, 13
Kandinsky, Vassily 188, 200
Kantorowicz, Ernst 72
  'king's two bodies' 72
Kauffmann, Angelica 41, 124, 157
Kennedy, President John F. 97
Kenny, Sir Anthony 122
Khnopff, Fernand 135–6
  *Jeanne Kefer* 135–6
'king's two bodies' *see* Kantorowicz, Ernst
Kirchner, Ernst Ludwig 176–8, 191
  *Self-portrait as a Soldier* 176–8
Klimt, Gustav 91, 193–4
  *Adele Bloch-Bauer I* 193–4
Klinger, Max 89–91, 92
  *Beethoven* 89–91
Kneller, Godfrey 152
  portraits of 'beauties' at Windsor Castle 152
Knight, Laura 170, 171
  *Self-portrait* 170, 171
Kokoschka, Oskar 179, 182–3
Kollwitz, Käthe 142, 164
  self-portraits 142
*kore* 25
*kouros* 25
Krafft-Ebing, Richard von 184
  *Psychopathia Sexualis* 184
Kunsthistorisches Museum, Vienna 48

Lacan, Jacques 185
Largillière, Nicolas de 152
Laserstein, Lotte 146–8
  *Self-portrait with Cat* 146–8

Lavater, Johann Caspar 32–3, 139
*Physiognomische Fragmente (Fragments on Physiognomy)* 32–3, 139
Le Brun, Charles 34, 35
*Méthode pour apprendre à dessiner les passions (A Method to Learn to Draw the Passions)* 34
Leemput, Remigius van 109
Whitehall portrait of Tudors 108, 109, 111
Lely, Peter 11, 152
portraits of 'beauties' at Hampton Court 152
Lenbach, Franz von 191
Leonardo da Vinci 35, 207, 215
*Mona Lisa* 207, 215
Liberia 19
Liddell, Alice 157
life masks 22
likeness 10, 11, 12, 21–9, 69, 105, 118, 206, 212, 220
Liotard, Jean-Étienne 60, 61
*Portrait of Maria Frederike van Reede-Athlone at 7 Years of Age* 61
lithography 66, 85, 164
Lomazzo, Giovanni Paolo 16, 24–5, 71, 86, 150
*Trattato dell'arte della pittura, scoltura et architecttura* 16, 71, 150
London 9, 38, 47, 48, 54, 61, 83, 93, 94, 102, 153, 159, 179, 196
Lotto, Lorenzo 31–2
*Young Man before a White Curtain* 31–2
Louis XIV 67
Louis-Philippe 85
Louvre 207
Low Countries 23, 25, 62, 110, 119, 142
Lucian 50
Luther, Martin 68
Lycia 68

Madison, James 47
Madonna 210
Madrid 142
Mander, Karel van 168
*Het Schilderboek* 168
Manet, Édouard 125, 129, 211
*Olympia* 211
mannerism 166
Mantegna, Andrea 78, 79

*Meeting between Ludovico and Francesco Gonzaga*, Camera degli Sposi, Palazzo Ducale, Mantua 78
Mantua, Duke of 152
Mantua 44, 78, 79
Mapplethorpe, Robert 13, 206–7, 208, 209, 210, 217, 160, 161
*Self-portrait* 160, 161
Marcus Aurelius 76
equestrian statue of 76
Margaret, St 57
Margarita, Infanta of Spain 40, 133–4, 135
Maria of Hungary 45
Maria Theresa, Empress 26, 35
Mariana, Queen 40
Marie-Antoinette 81
Marin, Louis 63
marriage portraits 112–16
Mars, God of War 176
Mary Magdalene 148
Masaccio 16
*Trinity* 16
masculinity 158–61
mask 17, 18, 19, 206, 209
*see also* death masks; life masks
Master of Flémalle 16
*Merode Altarpiece* 16
Matisse, Amélie 194, 195
Matisse, Henri 194–5, 196, 198
busts of Jeannette 196
*Portrait of Madame Matisse* 195
Maximilian I, Holy Roman Emperor 168
medals 13, 77–8
Medici family 45
Medici, Cardinal Leopoldo de' 45
Medici, Duke Cosimo I de' 45, 137, 138, 145, 159, 161
medieval age 14, 72
melancholy 51, 161
*memento mori* 65, 66, 122
*Menschen des 20. Jahrhunderts see* Sander, August
Messerschmidt, Franz Xavier 34–5, 202
*An Intentional Buffoon* 35
Messina, Antonella da *see* Antonello da Messina
*Method to Learn to Draw the*

*Passions, A see* Le Brun, Charles
*Méthode pour apprendre à dessiner les passions see* Le Brun, Charles
Metsys, Quinton 61
portrait of Erasmus 61
Mexico 58, 164, 184, 185
mezzotint 38
Michelangelo 12, 166
middle classes 81–7
Mijtens, Daniel 114
*Alathea, Countess of Arundel and Surrey* 114–15
*Thomas Howard, 2nd Earl of Arundel and Surrey* 114–15
Millais, John Everett 153
mimesis 187, 195, 205, 210
miniatures 14, 43, 59–60, 189
*Mir Iskusstva see World of Art*
mirror 164, 191
model 37, 124, 171
modernism 12, 187–203
Modigliani, Amadeo 196
Monet, Claude 125, 129
Monroe, Marilyn 96, 97
Montefeltro, Federico da 44, 112–14
monuments *see* portrait sculpture
More, Sir Thomas 61, 108–9
Morimura, Yasumasa 210–12
*Portrait (Futago)* 211–12
mosaic 13, 43, 73
Moser, Mary 124
Mughal dynasty 17
mugs 43
mummy 63
Munch, Edvard 65, 66, 191
*Self-portrait with Skeleton Arm* 65, 66
Münter, Gabriele 199–200
*Listening (Portrait of Jawlensky)* 200

Napoleon Bonaparte 71, 73
National Portrait Gallery, London 47–8, 49, 59
National Portrait Gallery, Smithsonian Institution, Washington DC 48
National Socialism 68
Nattier, Jean-Marc 152
Nauman, Bruce 216, 217
*Studies for Holograms* 217
Neel, Alice 141
*Self-portrait* 141
Neri, Stefano Gaetano 45

*Room of Self-portraits in the Uffizi* 45
Netherlands 14
*neue Sachlichkeit see* New Objectivity
New College, Oxford 100
New Objectivity 27, 146
New York 199
New Zealand 28, 29, 199
Niepce, Joseph-Nicéphore 189
Nietzsche, Friedrich 89, 92, 177
*Night Watch, The see* Rembrandt
Nochlin, Linda 84
non-objectivity 188, 195, 200–1
North America 16, 17, 54, 68, 73, 75, 82, 83, 92, 111, 189, 191, 215

O'Keeffe, Georgia 199
*Observer* 93
occasionality 44, 50, 53
Oceania 63
old age 131, 138–43
Onassis, Jackie 96, 97
Orlan 214–15, 216
  *The Face of the Twentieth Century* 215
Orpheus 159
otherness 102
Oxford 99, 100
*Oxford English Dictionary* 11

Padua 76
Paleotti, Gabriele 16
  *Discorso intorno alle immagini sacre e profane* 16
Palma Vecchio 137, 150
Panofsky, Erwin 24, 57
Paris 58, 71, 94, 125, 129, 194, 207
Parmigianino 165–6, 169, 171
  *Self-portrait in a Convex Mirror* 165–6
Passe, Simon Van de 54
passport photographs 58
pastels 59–60, 61
patronage 37, 71–2
Paul III, Pope 106, 107
Peale, Charles Willson 46–7
  'Gallery of Illustrious Personages' 46–7
Pedriali, Alfredo Dino 169–70
  *Self-portrait with Camera* 169–70
Peirce, C. S. 41
*People of the Twentieth Century see* Sander, August

Pergamon 44, 68
Persia 68
personality 11, 17, 29, 31, 32, 37, 105
Peru 13
Peter I of Russia 76
Philadelphia 46, 47, 111
Philip II 142
Philip IV 40, 97, 98, 133
Philip the Good, Duke of Burgundy 22
photo-fit 58
photography 11, 12, 13, 22, 27, 28, 43, 54, 58, 59, 92–3, 95, 139, 157, 158, 161, 169–70, 187, 188–91, 206, 207–8, 211
photorealism 139–40, 215
*Physiognomische Fragmente see* Lavater, Johann Caspar
physiognomy 32, 34, 37, 55, 139, 150
Picasso, Pablo 12, 13, 176, 179, 180, 188, 194, 198
  *Gertrude Stein* 194
  portrait of Daniel-Henry Kahnweiler 12, 13
Piero della Francesca 112–14
  *Federico da Montefeltro and Battista Sforza* 112–14
  *The Triumphs of Federico da Montefeltro and Battista Sforza* 113
Piper, David 64–5
Pisanello 16
plastic surgery 214, 215
Plato 14
Pliny the Elder 14, 44
Pocahontas 54
politics 65–9
polychrome sculpture 91
Polynesia 14
polyptych 23
Pomona 157
Pop Art 96
Pope-Hennessy, John 51
portrait collections 44–50
portrait galleries 44, 152
portrait jars 13
portrait photographs *see* photography
portrait sculpture
  busts 13, 14, 43, 88, 95
  equestrian monuments 14, 73, 76–7, 82, 158
  monuments 14, 89–91
  tomb sculpture 14, 43, 64, 65, 114

portrait transaction 37–8, 39, 41
poses 102
poster portraits *see* Demuth, Charles
post-Impressionism 200
postmodernism 205, 209, 212, 213
pottery 13
Prague 21
Preece, Patricia 200, 201
Pre-Raphaelites 153
Presley, Elvis 96, 97
Pressburg 35
prints 12, 43
Prix de Rome 71
profile portrait 77–8, 149–50
propaganda 65–9
Protestant 179
proxy 59–62
psychoanalysis 180, 182, 184, 185
psychology 35, 37, 182
*Psychopathia Sexualis see* Krafft-Ebing, Richard von
*Punch* 48

Quinn, Marc 58–9
  portrait of Sir John Sulston 58–9
Quintilian 14, 34
Quirk, Lord 122

race 29
Rainer, Arnulf 219
  *Self-portrait* 219
Ramsay, Allan 68
Raphael 25, 50, 164
  portrait of Castiglione 25
Rastrelli, Bartolomeo Carlo 76
  *Equestrian Statue of Peter I* 76
Ravenna 194
Rawsthorne, Isabel 202
Ray, Man 206
  photographs of Marcel Duchamp as Rrose Sélavy 206
Reformation 64
Rembrandt Harmenszoon van Rijn 119, 120–1, 141, 142, 143, 164, 173–4, 175, 178, 181–2, 184, 202, 211
  *The Militia Company of Captain Frans Banning Cocq* ('*The Night Watch*') 120–1
  *Self-portrait in a Cap, Open-mouthed* 174

*Self-portrait as the Laughing Philosopher* 174, 175
self-portrait etchings 173–4
self-portraiture 173–5, 178, 181–2, 184
Renaissance 12, 14, 17, 25, 28, 31, 32, 33, 44, 59, 72, 78, 79, 87, 137, 138, 139, 145, 152, 160, 163
Reni, Guido 45
Renoir, Pierre Auguste 125, 129
Revere, Paul 82–3
Reynolds, Sir Joshua 30, 38, 40, 45, 50, 79, 88, 91, 93, 124, 152, 153, 159
*Mrs Hale as Euphrosyne* 153
*Dr Samuel Johnson* 88, 91, 93
Richard II 73
Richard the Lionheart 209
Richardson, Jonathan 50
Richelieu, Cardinal 46
Ripa, Cesare 157
*Iconologia* 157
Rockefeller Museum, Williamsburg, Virginia 48
Rodin, Auguste 89–91, 92
*The Burghers of Calais* 89
*Monument to Balzac* 89–91
*The Thinker* 89
Rolfe, John 54
Rolin, Nicolas, Chancellor of Burgundy 22–4
Romanticism 29, 89, 93, 135, 139
Rome 14, 15, 21, 26, 27, 30–1, 40, 61, 76, 77, 78, 88, 132, 139, 145, 150, 166, 169
Romney, George 41, 152, 159
Rossetti, Dante Gabriel 41, 153–4, 155
*Beata Beatrix* 153–4, 155
Rotterdam 61
Rouault, Georges 176
Rousseau, Jean-Jacques 118, 160–1, 218
Royal Academy, England 86, 88, 94, 124, 125, 153, 165, 171, 196
Royal Academy, France 12, 34, 165
Royal Court Theatre, London 93
Rubens, Peter Paul 110, 157
*Susannah Fourment* 157
Rudolf II of Prague 21

*sacra conversazione* 124
St Ives 199

St Mark's Square, Venice 119
St Petersburg 76
Salome 193
Salon 71, 85
San Vitale, Ravenna 14, 16
mosaic of Justinian 14, 16
Sander, August 27, 28
*Menschen des 20. Jahrhunderts* (*People of the Twentieth Century*) 27, 28
*Rural Bride* 28
Santa Maria Novella, Florence 16, 149
Santa Trinità, Florence 79
Santore, Cathy 137
Sargent family 111
Sargent, John Singer 16, 191, 192–3
*Daughters of Edward Darley Boit* 192–3
Saville, Jenny 213–14, 216
*Branded* 214
Schiele, Egon 164, 182–4, 185, 191, 202, 213, 217
*Self-portrait Nude Facing Front* 183
*Schilderboek, Het see* Mander, Karel van
Schjerfbeck, Helene 142–3
*Self-portrait with Red Spot* 142–3
Schloss Ambras, Innsbruck 48
Schneider, Norbert 31
Schopenhauer, Arthur 176
Schweizerische Landes-museum, Zurich 48
Scuola Grande di San Giovanni Evangelista, Venice 119
Second World War 12, 139, 193, 205, 210
self 29, 206
self-fashioning 173–8
self-portraiture 34, 65, 66, 141, 142, 143, 145, 155–6, 161, 163–85, 190, 191, 199, 208, 212–14, 215, 217, 218, 219
semiotics 41
servants 99–100
*Sex and Character see* Weininger, Otto
Seymour, Jane 60, 62
Sforza, Battista 112–14
Sforza, Duke Galeazzo Maria 152
collection of portraits of beautiful women 152
Shakespeare, William 55, 138–9, 153

*As You Like It* 138–9
*Othello* 55
Sharples, James Sr 47
*James Madison* 47
Sherman, Cindy 13, 206, 207–9, 210, 217
*Untitled #216* 208
Sickert, Walter Richard 94–5, 96
*Minnie Cunningham at the Old Bedford* 94
Siddal, Elizabeth 41, 153–4, 155
significant form 187–8
silhouettes 13, 33
silkscreen 96
*Simplicissimus* 200
Singh twins 209–10
Singh, Rabindra K. D. Kaur 209
*From Zero to Hero* 209
Sintenis, Renée 165–6, 167, 169, 171
*Nude Self-portrait* 165–6, 167
Sisley, Alfred 129
sitter 11, 21, 37–41
Smith, R. R. R. 66
Socrates 26, 27
bust of 27
Sorel, Charles 85
*Description de l'île de portraiture* (*Description of the Island of Portraiture*) 85
Souch, John 64, 65
*Thomas Aston at the Deathbed of His Wife* 64, 65
South America 63
Spain 19, 45, 97, 98, 99, 194
Spartali, Maria 157
Spence, Jo 13, 140, 216–17, 218
'Included', from *Narratives of (Dis)ease* 218
Spencer, Stanley 200, 202, 214
*Portrait of Patricia Preece* 200, 201
stained glass 43
stamps 43
Stanhope, Philip Henry 48
Steelyard 9
Steen, Jan 100, 102
*The Baker Arent Oostwaard and His Wife Catharina Keizerswaard* 100, 102
Stein, Gertrude 199
Stowe 87–8
Stuart, Gilbert 22, 73, 75
the 'Lansdowne portrait' of George Washington 73, 75

superego 182
Surrealism 129, 182, 185
Switzerland 48
Symbolism 135, 136

tapestries 13, 58
Tate Gallery, London 179
Temple of British Worthies at
  Stowe 87–8
Tennyson, Alfred, Lord 153,
  157, 158
*têtes d'expressions* 35
textiles 58
Thalia 148
Theodora 14, 194
theological virtues 114
Theophrastus 27
Thomas, Sir Keith 122
Thrale, Hester 88
Three Graces 152
Tilley, Sue 39
Titian 16, 24, 39, 50, 77, 106–7,
  137, 143, 150
  *La Bella* 150, 151
  *Emperor Charles V at
    Mühlberg* 77
  *Pope Paul III, Cardinal
    Alessandro Farnese, and
    Duke Ottavio Farnese*
    106–7
tomb sculpture *see* portrait
  sculpture
tomb stelae 63
Tornabuoni family 79
Tornabuoni, Giovanna 149,
  150
Tornabuoni, Lorenzo 149
*Trattato dell'arte della pittura,
  scoltura et architecttura see*
  Lomazzo, Giovanni
  Paolo
Trissino, Gian Giorgio 150
*I ritratti* ('Portraits') 150
*trompe l'œil* 135
type 21–9

*Übermensch* 89
Uffizi Gallery, Florence 45,
  165
underclass 97–103
United States 73
  *see also* North America
Urbino 44, 112, 150
Urbino, Duke of 150

Valckert, Werner Jacobsz. Van
  den 122
  *Three Governors and the
    Matron of the Amsterdam
    Leperhouse* 122
Van Dyck, Anthony 39, 67, 77,
  116
  *Thomas Howard, 2nd Earl of
    Arundel, with His
    Grandson Thomas, later
    5th Duke of Norfolk* 116
  portraits of Charles I 67, 77
Van Eyck, Jan 16, 23, 24, 73, 82,
  139, 140
  *Cardinal Niccolò Albergati*
    139, 140
  *Ghent Altarpiece* 73
Van Gogh, Theo 180
Van Gogh, Vincent 36, 61, 164,
  211, 180–2
  *Self-portrait Dedicated to
    Paul Gauguin* 180, 181
van Reede-Athlone, Maria
  Frederike 61
Vasari, Giorgio 45, 52, 163
  *Lives of the Artists* 52
Velázquez, Diego Rodriguez
  de Silva y 16, 39–40, 97–9,
  100, 102, 133–4, 192, 203
  *Don Juan Calabazas, called
    Calabacillas* 97–9, 100, 102
  *Infanta Margarita in a Blue
    Dress* 133–4, 135
  *Las Meninas* 40
  portrait of Pope Innocent X
    203
Venice 76, 118, 164
Veronica, St 167
Verrocchio, Andrea del 22, 76
  equestrian statue of
    Bartolommeo Colleoni
    76
Victoria, Queen 81
Vienna 21, 36, 48, 52, 89, 179,
  182, 183, 184, 193, 194, 219
Vienna Secession 89, 91
Vigée-Lebrun, Elisabeth 38,
  40, 45, 81, 156, 157
  *Portrait of Marie-Antoinette*
    81
  *Self-portrait in a Straw Hat*
    156, 157
Virginia 48
Vouet, Simon 46

Wadsworth Atheneum,
  Hartford, Connecticut
  48
Walpole, Robert 88
War of Independence,
  American 46, 47, 82
Warhol, Andy 96, 97
  *No. 204: Marilyn Diptych* 96
Washington, George 73, 75, 76
watercolours 183
Watts, G. F. 47
Weininger, Otto 184
  *Sex and Character* 184
Westerwald 28
Weyden, Rogier van der 22–3,
  24
  *Last Judgement Polyptych* 22
Whistler, James McNeill 141,
  195–6, 198
  *Arrangement in Grey and
    Black: Portrait of the
    Painter's Mother* 141,
    195–6
Whitehall Palace, London 109
Williams, William Carlos
  199
  *The Great Figure* 199
Williamsburg 48
Winckelmann, Johann
  Joachim 30
Windsor Castle 152
*World of Art* 95
Wright of Derby, Joseph
  159–60
  *Brooke Boothby* 159–60
Wright, Stuart Pearson 121–2,
  123
  *Six Presidents of the British
    Academy* 121–2, 123
Wrigley, Tony, Sir 122

Xenophon 14

Zeuxis 174
Zoffany, Johann 25, 26, 100,
  101, 102, 124, 125, 126–7
  *Academicians of the Royal
    Academy* 124, 125, 126–7
  *John Cuff and His Assistant*
    100, 101, 102
  portrait of Francis I of
    Austria 25, 26
Zola, Émile 125
Zurich 48